T0068268

Also by Brian Murphy

THE NEW MEN: INSIDE THE VATICAN'S ELITE SCHOOL
 FOR AMERICAN PRIESTS

BRIAN MURPHY

THE
ROOT OF
WILD
MADDER

CHASING THE HISTORY, MYSTERY, AND LORE OF THE PERSIAN CARPET

SIMON & SCHUSTER PAPERBACKS
New York London Toronto Sydney

SIMON & SCHUSTER PAPERBACKS
Rockefeller Center
1230 Avenue of the Americas
New York, NY 10020

Copyright © 2005 by Brian Murphy
All rights reserved,
including the right of reproduction
in whole or in part in any form.

SIMON & SCHUSTER PAPERBACKS and colophon
are registered trademarks of Simon & Schuster, Inc.

For information regarding special discounts for bulk purchases,
please contact Simon & Schuster Special Sales at 1-800-456-6798
or business@simonandschuster.com

Designed by Karolina Harris

Manufactured in the United States of America

10 9 8 7 6 5 4 3 2 1

Library of Congress Cataloging-in-Publication Data
Murphy, Brian, date.
The root of wild madder: chasing the history, mystery, and lore of the Persian carpet /
 Brian Murphy
p. cm.
Includes bibliographical references.
1. Rugs, Persian—History. I. Title.
NK2809.P4M87 2005
746.7'55—dc22 2005044148

ISBN-13: 978-0-7432-6419-8
ISBN-10: 0-7432-6419-3
ISBN-13: 978-0-7432-6421-1 (Pbk)
ISBN-10: 0-7432-6421-5 (Pbk)

All photos courtesy of Hasan Sarbakhshian except 20: F.J. Hakimian and 22: Brian
Murphy.

For Toula and Zoe,
who weave color and wonder into my life

CONTENTS

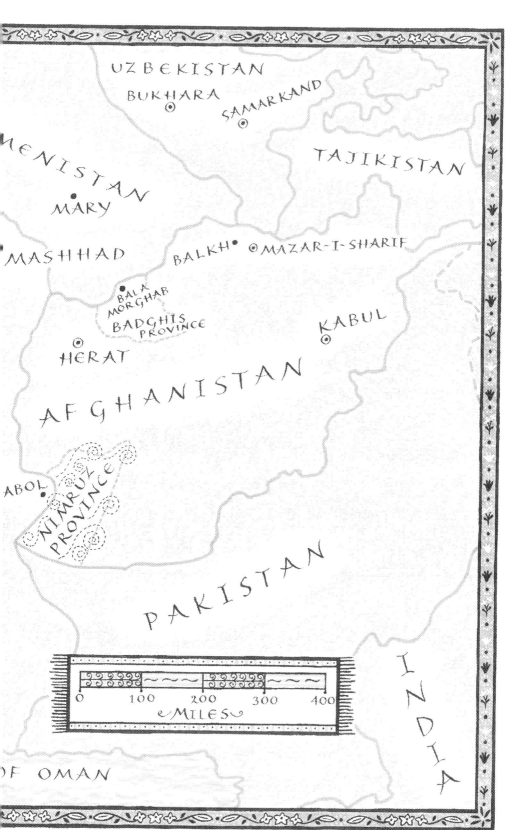

© Melanie Marder Parks

THE ROOT
OF WILD
MADDER

AUTHOR'S NOTE

This is a work of nonfiction. All the events occurred, and the dialogue is verbatim or reconstructed from notes.

But some points need to be mentioned.

The names of a few characters have been changed at their request to avoid possible political or commercial complications. Also, the sequence of some events has been reordered for the sake of clarity and narrative flow. For similar reasons, I often have hidden the presence of my translators and others who assisted me. They were, of course, invaluable. Many of the interviews and conversations—especially in villages—would have been impossible without them. But I felt that adding these third parties in all the scenes would be an unnecessary distraction. It is in no way a judgment on their vital roles.

I do not believe that any of these considerations diminish the overall objective of this book: the faithful reconstruction of my experiences during frequent trips to Iran and Afghanistan from 1999 to 2004.

Finally, a comment on spelling and quotations.

There is no universal standard for English transliteration of Farsi or the other languages of the region. I have endeavored to use the form that appears most widely accepted or that I feel best represents the pronunciation. For example, I use *Hafez, Mashhad, Turkmen,* and *Quran.* Other sources have variants such as *Hafiz, Mashad, Turkomen,* and *Koran.* The differences, however, are never significant enough to cause confusion.

The quotations from Hafez and other writers come from various

sources. For Hafez, I have tried to use mostly the translations in *The Hafez Poems of Gertrude Bell*. But—in the spirit of the journeys in the book—I also use verses from other editions of Hafez that I carried at the time.

TIMELINE

- c. 8000 B.C.: Permanent settlements established in area of present-day Iran.

- c. 3000 B.C.: First urban centers begin to develop in present-day Afghanistan.

-1700 B.C.–1200 B.C.: Beginnings of Zoroastrianism, according to most sources.

- c. 600 B.C.–c. 330 B.C.: Achaemenian dynasty. The first clear Persian Empire. Named for Achaemenes, an Aryan chieftain in southwestern Iran. Kings included Cyrus the Great, Darius, and Xerxes. The empire had contact with the Greeks through war and diplomacy, which were among the first significant and sustained exchanges between East and West.

- 334 B.C.: Alexander the Great enters Persia.

- c. 323 B.C.–c. 60 B.C.: Greek-influenced Seleucid dynasty established following Alexander's death. Named for Seleucus I, a Macedonian general under Alexander.

- c. 247 B.C.–c. A.D. 225: Tribal rulers known as Parthians begin taking control of Persian lands. Parthia was named for a region in Iran's present-day northeast.

- c. 224–c. 650: Sassanian dynasty. Rulers seek to revive culture of the Achaemenian kings and promote Zoroastrian faith. Dynasty named after an

ancestor, Sasan, who was claimed by the first king, Ardashir I. Arab forces bringing Islam defeat last Sassanian ruler.

- 820–1220: Series of Persian rulers gradually diminishes Arab influence. Modern Persian language takes shape.

- c. 1220: Mongol conquerors under Genghis Khan invade Persian territory.

- Late 1300s: Timur, or Tamerlane, begins conquest of Persia.

- c. 1500–1720s: Safavid dynasty rules Persia. The royal line drew a connection to Shaykh Safi od-Din, a Sufi leader who claimed family ties to an earlier Shiite imam. Period of significant artistic and architectural advances. Safavid rulers brought dominance of Shiite Islam. The dynasty begins to collapse with losses against invading Afghan tribesmen.

- 1779–1925: Qajar dynasty begins after Mohammad Qajar wins power struggle among feuding tribes and rulers. Persian political and commercial contacts with Western world increase. An army officer, Reza Khan, takes control of government in a 1921 coup.

- Mid-1800s: Afghans assert independence. British battle to maintain influence.

- 1893: The Durand Line fixes border between Afghanistan and British-controlled subcontinent.

- 1925: Coup leader in Persia declares himself king and takes the name Reza Shah Pahlavi, the name of the language from Sassanian times.

- 1935: Reza Shah Pahlavi officially renames country Iran.

- 1941: Allies occupy Iran, forcing Reza Shah to abdicate in favor of his son, Mohammad Reza Pahlavi, who becomes the new shah.

- 1979: Islamic Revolution in Iran. Soviet invasion of Afghanistan.

- 1989: Last Soviet troops withdraw from Afghanistan.

- 1996: Taliban begins taking control of Afghanistan.

- *May 1997: A political moderate, Mohammad Khatami, elected president of Iran.*

- *June 2001: Khatami reelected in landslide.*

- *Late 2001: Taliban toppled in U.S.-led attacks following refusal to surrender Osama bin Laden.*

- *February 2004: Conservatives regain control of Iranian parliament in contested elections.*

- *June 2005: Arch-conservative Mahmoud Ahmadinejad wins Iranian presidential elections.*

Oh, you painters who ask for a technique of color—
study carpets and there you will find all knowledge.

—Paul Gauguin

A PROLOGUE

MADDER
AND BONE

 I came a long way to stand in a field of wild madder.

My driver stopped. I stepped off the one-lane road that pierced the dust bowl of central Iran. Then I walked down a path. It slithered atop a narrow ridge.

I liked that. It gives an idea of how I ended up here: definitely not a straight line and always struggling to keep some balance.

I had set out to write about carpets and the people who make them, sell them, cherish them, and, above all, see them with the same wonder that I do. At first, as a journalist, I poked around the edges of their lives on frequent assignments to Iran and Afghanistan, two important landmarks on the vast carpet map. But when I started to look more closely, I confronted the dilemma of any cartographer: what features to enhance and what details to omit. In other words, how do you find the right scale and relevance amid unlimited possibilities?

This is my attempt.

The things that intrigued me—handwoven carpets, the art of

making dyes from nature and the expressions of beauty and faith they produce—already had an old and rich topography. There were imperial kings and swordsmen, folktales and cauldrons of steaming colors, lumbering caravans and cunning merchants. And—perhaps most delightful of all—mystic poets whose images dance in purple shadow and amber light. It could be rewarding enough just to explore the ground that others had covered and look for scraps and stories they had missed. But there was more out there if I searched harder. I had it on good authority.

A leafy little plant called madder told me so. I had been reading about its rich history as a dyestuff for carpets. Then I came across a quirky reference that is all but forgotten.

It can turn our bones red.

I first spotted this in a medical paper on skeletal development. It's now just an obscure footnote from nearly three centuries ago. But at the time—as the Enlightenment was driving away medieval phantoms—it caused a sensation and upended prevailing ideas about physiology. To me, this bit of historical flotsam was still impressive.

I decided madder would serve as my polestar. It would help me negotiate the noisy bazaars, musty workshops, distant villages, and other places I couldn't even yet imagine.

Madder seemed an ideal beacon to keep me on course. I could drift off on any detour in the carpet world and never really lose sight of madder's influence and the fiery palette held in its roots.

The bone story stayed my favorite. But I'd learn there were many others.

They flow generously from sources both illustrious and arcane. Madder's diary goes back as far as history's earliest written pages. And it most likely tumbles even further into the past.

The madder root—dried and ground into dyers' powder—was carried by Phoenician traders and mentioned in Egyptian hieroglyphics. The Greek historian-wanderer Herodotus noted that it produced the striking vermilion shades on the goatskin cloaks of Libya's most elegant women. The Bible refers to madder as *pu'ah*, which some scholars believe was also a lullaby sound used to calm

crying infants. To the Romans, it was *rubia,* which has endured as its scientific name. Pliny the Elder believed the most bountiful madder flourished in gardens near Rome.

Genus *Rubia,* family *Rubiaceae,* order *Rubiales.* The linguistic lineage fans out in many directions: ruby, rubric, rubella.

Alchemists pored over its properties in hopes of coaxing magic from nature. Artists made their canvases glow with madder-based glazes. As the Dutch master Jan Vermeer was finishing his famous *Girl with a Red Hat* in 1666, colonies were taking root across the Atlantic that would rebel a century later against the British crown. The soldiers of King George III sent to fight the American patriots wore madder-dyed red coats.

Healers, too, were drawn to the madder root's tentacles, which are full of swollen joints and crooked angles like those of an arthritic patient. The colors it bestowed must have seemed too powerful, too close to our own blood, to be medically benign. Extracts were prescribed—with little recorded success—for complaints ranging from jaundice to irregular menstruation to chronic bruising.

Then in about 1735 a British surgeon named John Belchier chronicled a remarkable observation. Animals fed madder leaves had red-tinged bones. And not everywhere. Only in the places where bones were growing and developing.

Belchier's research won him the prestigious Copley Medal and sharply redirected studies in anatomy. A prominent and ambitious London physiologist, John Hunter, led the pack toward the new frontiers in medicine. He extensively explored the use of madder in bone studies during a long career that included some unconventional offshoots. Hunter, according to some accounts, maintained dark alliances with grave robbers in order to get research cadavers. The stories claim he paid a substantial bribe in 1783 to obtain the body of the "Irish giant," Charles Byrne, who was more than eight feet tall and made a sad and meager living as a carnival freak. Byrne, shortly before his death, apparently caught wind of Hunter's plans. He reportedly tried to avoid Hunter's dissection table by requesting burial at sea inside a lead-lined coffin. But Hunter's resources and network were too strong. Byrne's skeleton remains in the collection

of The Royal College of Surgeons of England along with other forensic oddities and relics of Hunter's age, such as a pig's skull stained a pinkish red from its madder diet.

Most may consider it all just an eccentric bit of pre-Victorian science. But I felt that Belchier's interplay of bone and madder was crying out for more attention. It seemed to me a rare convergence of the physical and mystical, a union, I believe, that also graces carpets. Madder—coveted and used for millennia—has this power to penetrate us so deeply and leave its mark so unmistakably. Carpets can do that, too, for those open to the possibilities.

I was lucky. I chose well. Madder led me—with confidence and eloquence—through the important first stages of my carpet education. It always had something important to say, and it tugged me along with one interesting connection after another: from texts on the craft of natural dye making, to the essential reds, peaches, and oranges produced by madder, then to its many guises throughout history, and on to Belchier's bones.

And, inevitably, to the madder plants at my feet.

Each step left sharp and perfectly formed footprints in the dry flatlands. In the distance, a jumble of low-slung buildings hugged the narrow road leading to the town of Ardakan, which sits on the southern fringe of an emptiness known as Dasht-e-Kavir, the Great Salt Desert.

It was early fall. There had been no rain for months. It's considered the best time to harvest madder. The mature plant is pulled up easily then. The roots hang in a jumble like a toddler's first scribbling. There are relatively few areas of wild madder left. Most growers prefer the cultivated *Rubia tinctorum,* known as the dyers' madder, which yields more powerful, color-rich powder. Wild madder is now more of a novelty or vestige of the plant's heyday that ended more than a century ago.

But it was something I needed to see. Wild madder is possibly the source for the shades of the earliest carpets. Red—with its connotations of birth and mortality and the mysteries and yearnings in between—has remained a fundamental color for carpet weavers. I felt it appropriate to pay my respects.

When I moved, clouds of tiny grasshoppers breached over the plants, then disappeared in the flame-shaped leaves with tiny barbs that grabbed at my ankles. I crouched low to give the illusion of the emerald green field rising up to swallow me, replacing the panorama of tan plains and the steel gray foothills.

The guide who brought me here grinds the dried madder root into coarse, rust-shaded powder. It's used by the wool and silk dyers who, for various reasons, still resist the easier and cheaper synthetic colors. This timeless process is under considerable pressure. Traditional dye masters were in steady decline until some carpet houses and other preservationists started efforts to revitalize the craft in the 1980s. Their interventions may have rescued natural dye making from becoming the stuff of hobbyists and concocted quaintness like the butter churners at country fairs.

In Iran, as recently as 2000, no more than 10 percent of new carpet production had naturally dyed material. Four years later, it was up to about 25 percent, said Majid Montazer, head of the dye division at the state-run Persian Carpet Research Center in Tehran.

"I would like to say it's because of some intellectual or cultural reawakening," he told me. "But it seems to be more about economics. This is what the customer wants. People are starting to understand that the natural dyes are just more attractive."

Considering the steamroller that calls itself progress, it's remarkable that the natural dyeing techniques were still around to save. Chemical colors have been commercially available since the mid-nineteenth century, constantly improving and supplanting the dye makers' livelihood and knowledge. Reds from the madder root. Yellows from pomegranate rind. Blues from the indigo plant. Browns from walnuts.

Chemical dyes may make sense from the perspective of the bottom line. Carpet making is, after all, a business, and businesses seek profits. But some wince at this equation. For them, something venerable and virtuous is being sacrificed. It's worth fighting back.

I sense a touch of this in Ali Akbari, who led me to the madder field. It's not sadness, exactly. But it's close. Maybe this was the look seen aboard clipper ships or in telegraph offices as the walls of the

future began to close in. Akbari, a massive, moonfaced man constantly leaking sweat, wants to express it. He just can't find the words. He's silent for a long time. Then, finally:

"It's like this," he said. "Death comes. We leave this world for another. This is the cycle. We cannot change it. But I see other types of death around us, too. These are little deaths. I'm talking about losing the stories of our grandparents. I'm talking about how we feel distant from nature now. Will generations from now know the beautiful colors locked in this simple root? I often think the answer is no, and my heart breaks."

He looked at me hard.

"Tell this story," he urged. "Tell it well if you can."

I will try.

First, geographical boundaries were set. This book will not stray from the Persian realm: Iran and parts of Afghanistan linked by traditional culture and Dari, a language closely related to Farsi, or Persian. The precise origin of carpets is a question that may never be fully answered, but few places have nurtured the craft and artistry of carpets more than the Persian world. There are, of course, other important voices to be heard. Places such as Turkey, central Asia, the Caucasus, and elsewhere are, without doubt, essential to obtaining a full understanding of carpets. Others have written masterfully about these areas and will continue.

Next, intellectual frontiers were drawn. I am not an expert on carpets or the elements of their production. There are countless excellent sources for those seeking such detailed knowledge. I, too, learned much from these scholars and researchers. The only important attribute I possess is a true passion for the subject. For years, I struggled to define my fascination with carpets.

A crystallizing moment came during one of my visits to the Carpet Museum of Iran in Tehran. It occurred to me that almost all the masterworks on display are anonymous. The names of the weavers and designers are simply lost to history. I can think of no other art form, and one so widely known and appreciated, in which the creators are unknown and unheralded. Paintings are signed. Credits

roll on films. Cornerstones bear the names of architects. Even graffiti artists make their personal mark.

Only a precious few carpets come with such birth certificates. The rest are, to me, gifts without a card.

I want to repay the present in my own way. Call it a scrapbook from a world that, if not yet vanishing, is certainly under threat.

I imagine my goal could seem too modest or lightweight compared with the immense body of literature on carpets and their history. I would reply by repeating a snippet from a Turkmen folk saying from central Asia: *Carpets are our soul.* I've heard this said in many different ways and voices by the common weavers, merchants, and others who are often ignored in carpet scholarship. I hope others will listen.

I like to think that, maybe, a few more people will skim their palms over a carpet's knots, marvel at the colors, and wonder: Who was here before? What dyer, with arms stained by madder, mixed these colors? What would the weaver want to say to me?

As Akbari, the madder grinder, urged: Tell the stories.

PART I

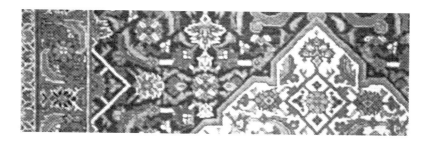

ACTS OF CREATION

Themistocles said that a man's discourse was like to a rich Persian car-pet, the beautiful figures and patterns of which can be shown only by spreading and extending it out; when it is contracted and folded up, they are obscured and lost.

—Plutarch, from "Life of Themistocles"

CHAPTER ONE

THE TEHRAN BAZAAR

 Last night's tea sits cold on the samovars. It's that early. And I'm alone in the House of Rahim. The guard is gone. I guess he's off getting the fresh morning flatbread Iranians eat with soft cheese made from cow's milk. I wonder for a moment whether I should leave. No. It's just too inviting to stay.

I walk through canyons of folded carpets that rise off wooden pal-lets. Some of the stacks are six feet or more, well over my head. The sides show layer upon layer of changing colors, textures, and pat-terns. It reminds me of a hillside sliced open, exposing the lines of deposits and minerals set down over many epochs. I let my fingers pluck over the rounded elbows of the carpet folds. They offer only hints of what's hidden. What I want to—but cannot—see.

A band of deep-sea blue and copper yellow, mixing like swirls in marble, catches my attention. I look closer. The work is tight and dense. The knots are no bigger than a freckle. I scrape my thumb-nail over the weave. I've watched carpet sellers do this and always liked that little drumroll sound it makes. It seems earthy and sub-

stantial, like an ax striking good timber or a shovel driven into dirt. But these walls of carpet give up nothing more than this: just different hints of sound and color. They may remain folded for months. Or maybe just a few more hours.

Outsiders like me could never know. The *bazaari* of Tehran follow their own rhythms and deals. Soon they would be back for another day.

There must be thousands of carpets around me. Maybe more. No one has ever done a real inventory of Tehran's carpet bazaar, a warren of shops, storerooms, repair lofts, and chambers within chambers. Hundreds of thousands of pieces flow through the bazaar each year. A few of the best pieces will eventually end up in showrooms or auctions abroad, including big-money places such as London, Tokyo, Dubai, or New York. Most others work their way around Iran's markets: sold, swapped, or bartered through methods and family networks that defy any fixed rules. Tehran's bazaar is Iran's largest concentration of carpets and certainly one of the biggest anywhere on earth. But there are dozens of other major bazaars scattered around Iran, also cutting the same type of murky deals and shipping pieces throughout the world.

The Iranian government can make only an educated guess as to the size of the business. The Persian Carpet Research Center estimated about $550 million in carpet exports in 2004, accounting for about 28 percent of the global market. Some other sources place the Iranian export figure higher.

The tallies, however, don't include the millions of carpets already out there in the market or the carpets remaining in Iran. Their value is certainly far greater than the annual exports, but it's nearly impossible to track or quantify. Iran has a much clearer idea of its oil and natural gas reserves than its carpet wealth.

Think of it this way: millions of carpets in constant motion through channels designed over the centuries to keep out prying eyes. It can all seem overwhelming for anyone seeking a precise picture of the industry. I decided on a different approach. I wasn't interested in bouncing over the surface of the carpet trade, although I knew the ride would be fascinating. I wanted to burrow into it.

Somewhere in these depths, I hoped to find essential features such as natural dyers and madder, and, with some luck, come across some pieces and people that would make the effort worthwhile.

But it was still mostly a mission without a plan.

This is why I wandered into the Saraye-Rahimiye—the House of Rahim—before most of Tehran was even awake. It seemed a good place to think. The high ceilings, more than a hundred feet overhead, reminded me of a cathedral or stately mosque. Iron grates at the top let in light and the occasional bird that zips around in panic—maybe dumping a load of guano on the carpets—before making an escape.

The House of Rahim—three airy halls linked by tight corridors—is named after the patriarch of a *bazaari* family that prospered more than a century ago. The family's carpet trade eventually stumbled, but one descendant remains as a watchman. Other merchants have moved in. Their carpet shops were still locked and dark at this early hour. But the honeyed sheen of a clear dawn was spreading. The glow caught the glass on the portraits that hang above almost every desk in the shops. It's a gallery of faces from the past: fathers, grandfathers, and long-dead forebears and partners. They look over the House of Rahim from eternity with their finest pose from life: freshly trimmed beards, oil-slicked mustaches, and the sleepy-eyed contentment of someone satisfied that he has made his mark—or at least crafty enough to fake that impression. The warm light gave an unnerving sense of life to the black-and-white images. I felt uncomfortable looking back. It was as if they were all peering at me and wondering why I was here so early and all alone. What was I after?

I really couldn't provide these ghosts with an adequate answer.

I had been in Tehran for about two weeks and had visited the immense bazaar several times. Always I was pulled—sometimes quite literally—toward the dens of the carpet sellers. The carpet touts who prowl the bazaar ambushed me the instant I entered. Their job is to funnel customers to the shops, getting a maximum cut of 2 percent if a sale is made. Their main targets are foreigners with presumably fat wallets they are willing to lighten for a carpet.

This time, I wanted to beat the carpet boys to the bazaar. At least

I could roam in peace for a while. Maybe, I thought, if I arrived early enough, I could find someone willing to indulge me. But it would have to be an exceptional kind of benevolence. I wanted answers to questions I hadn't even formed yet.

Just this much I knew: traditional carpets entranced me in a way no object had before. But what was it? Their beauty is obvious. The mastery of the craft is impressive. This, however, could apply to any type of artistry. There was something else. It beckoned me, but left few clues to guide me. All I could pinpoint was that I felt good around carpets. To a journalist, carrying the profession's natural aversion to vagueness, it was a maddening enigma. Too shallow and too insubstantial. Yet it's precisely the same thing I was told once in Rome. I even jotted it down because it seemed so poignant in its simplicity and spirituality. A genteel older woman said she came almost every day to Piazza Santa Maria in Trastevere to take coffee in the same spot facing the piazza's namesake church and its splendid thirteenth-century mural of the Madonna. She did it because the mural's golds and greens made her happy, *contenta*. It was her private deliverance. Now I was feeling this same tug—an inexplicable gravity being exerted by carpets.

It was still dark when I arrived at the Cobblers' Gate, one of the main entrances into the Tehran bazaar. I had been this way before. Through the arched opening of mustard yellow bricks and blue inlaid tile, down the sloping and covered passageway, past the sellers of kitchenware and dowdy nightgowns. Then brushing by alcoves with pirated computer games such as *Grand Theft Auto* and coils of fake brand-name tags for knockoffs of Levi's or Timberland. A few more paces to pass under the hand-colored photos of "martyrs" from the hellish 1980–88 war with Iraq that left one million dead and ended with nothing really changed except for a lot of ruined lives. Above are rows of small domes built of brick in a herringbone pattern. Each dome is capped by round skylights about the size of a full moon.

This is where the carpet shops begin. It's deep in the bazaar near the shoemakers' district that gives the Cobblers' Gate its name.

Only a few *bazaari* were around at this early hour. Most were just

boiling water for the day's first tea or heading for sunrise prayers at the bazaar's central mosque, where the clock between the minarets is broken and last ticked years ago at 6:38. When the bazaar is packed with shoppers, it takes a while to slither through the crowds—and fend off the shop scouts—to reach the carpet sellers. This morning, it took just a few minutes to walk alone from the gate to the House of Rahim.

The guard returned. He didn't see me. He was too preoccupied with a glass of scalding tea. He held the glass by the lip and the steam leaked through his fingers. I was right about the bread. He cradled four or five thin, oval-shaped loaves. I moved quickly toward the far wall, not knowing if I had broken some rule about being un-attended amid the carpets. There was a small nook out of his line of sight. I leaned against the cool stone wall. My plan was to wait for the merchants to arrive and then stroll out. It wouldn't be long. The bazaar was coming to life.

Then I heard a sound below me. It was an odd scratching I couldn't place. Down a flight of stairs, a thin Afghan man—actually more of a boy—was clipping at a moldy corner of a carpet with a pair of oversize shears.

I had seen similar operations before: old, tired carpets fixed with such skill that sometimes only a trained eye could spot the repairs. The Afghan looked up at me for a moment and returned to work. I walked down the stairs into a brick-lined corridor known as a barrel vault, a round-roofed passage associated with Persian design for at least two thousand years. It was lined with heavy doors, some wood, others metal. They were all bolted shut.

"Carpets?" I asked the Afghan, pointing at the doors. He gave a pained expression of incomprehension. I remembered the Persian word for carpet, one of the few I knew. *"Farsh?"*

He nodded. But before we could continue, the Afghan rose stiffly. His boss was coming down the stairs.

"Oh, hello," the man greeted me in comfortable English, appar-ently not at all troubled or surprised to see me there. "Can I be of service?"

"I'm just looking around at some carpets," I replied.

"Then you are in luck. Come with me. Would you like some tea? It's just ready."

We walked through the bazaar, now full of crisp-edged shadows from the shops' garish lights. The gold sellers had their high-wattage lamps bearing down on displays of bangles and chains. In the kitchen shops, stainless steel pots and pans gleamed under naked bulbs. The carpet boss, whose first name was Mohammad Reza, was stooped with age, but he moved with quick, sure strides. A swishing sound came from his baggy trousers, which had frayed cuffs but were otherwise clean and pressed. I had trouble keeping up. He explained what was under the House of Rahim: dozens of vaults where carpet merchants kept some of their most valuable pieces in controlled humidity and temperature. He told me there were similar *cavas* all over the bazaar, which roams over six square miles in a disorienting hodgepodge of alleys, courtyards, refined Persian stonework, and slapdash construction with the feel of a cheap warehouse.

"So how many carpets are here in the bazaar?" I asked.

He smiled at such an innocent question. "*Agha,*" he answered, addressing me with the common courtesy title with roots in Persian royalty, "can you count the stars?"

The word *bazaar* has a Persian pedigree.

It springs from ancient necessity. Security was essential to maintain and expand the trade routes that became known as the Silk Road. Fortresslike way stations called caravanserais acted as havens against the wrath of weather and the plots of thieves. Without them, the deserts and wastelands would have been impassable barriers.

The earliest caravanserai designs have been lost. But from the ninth century onward, the Persian construction became remarkably consistent: high outer walls with entry through a single, easily defended portal. The central court was typically surrounded by stalls and arcades designed for the caravan's every need, from camel stables to guest rooms to hot meals. The late Arthur Upham Pope, one of

the most respected voices on Persian architecture, called the caravanserai "one of the triumphs of Persian architecture" and believed there was no "more complete accord of function and structure."

The traditional bazaar is a modification of the caravanserai stronghold. The standard plan consists of two covered avenues intersecting in a domed central court. It's called *chahar-su,* liberally translated as "four corridors" or "four waters." Small roof openings allowed enough light but kept out the summer heat and retained warmth in winter.

The rapid Arab conquest of Persia in the seventh century brought the new faith of Islam. Old Persian ideas, such as the bazaar, were later exported back to Arab lands and beyond. Adding a mosque to the bazaar complex was a natural instinct. Some historians believe that this helped encourage the cross-pollination between society and religion that is now fundamental to Islam. Meanwhile, the bazaar became one of the hallmarks of the Muslim world and brought awed travelers to places such as Istanbul's Kapali Carsi, or Grand Bazaar, and Isfahan's Great Bazaar, whose Qaisarieh gateway is decorated with the city's astrological patron, Sagittarius, depicted in chimera form with the archer emerging from the body of a lion.

Tehran's bazaar may lack the wonders of the world's most seductive covered markets. But like the twelve-million-strong megalopolis it serves, it compensates with size, energy, and variety. If it's worth selling, it can probably be found in Tehran's halls and stalls. Carpets are no exception. Within a five-minute stroll, it's possible to grimace at a golfing Mickey Mouse on a machine-woven carpet and gawk at a century-old Tehran carpet known as a "hundred faces" for its superbly rendered—and nonrepeating—array of animals and huntsmen. Bargaining for this piece starts at $80,000, insisted the merchant who has it.

"I don't think of the bazaar as a place. To me, it's a thing with a life and a personality," I was once told by carpet merchant Ali Al-lahbaf. "It changes, but survives."

We reached Mohammad Reza's shop, which was little more than an oversize closet with a cubbyhole over his desk. A boy brought tea on a dented metal tray. Mohammad Reza drank Iranian style, first popping a sugar cube in his mouth and then sipping the tea over it. I looked in vain for a spoon. I let my lump of sugar sink to the bottom of the glass and slowly dissolve.

Mohammad Reza claimed no interest in politics. But almost every Iranian will tell strangers the same thing. "We're a country of liars," a young Iranian friend once told me. "We tell the authorities one thing, we tell our parents another, we tell our friends another. There's a truth to fit every occasion." In some ways, that could apply anywhere. In Iran, however, the consequences can be severe for those who cast off their masks. Ask the families of dissidents killed in the late 1990s, or the writers and journalists imprisoned. I always thought the simple act of drinking tea in Iran was an instructive lesson into the country. The sugar—like truth or candor—is there but hidden behind the lips. You must be quick to catch a glimpse of it before it melts away.

So I was surprised when Mohammad Reza got right to the point.

"What's this you say? You truly want to learn more about carpets?" he said in English learned at a British school before the 1979 Islamic Revolution that brought down the U.S.-backed shah.

"You want to know what I think? I don't think you're ready," he finished.

I recoiled. But he didn't see my reaction. He was using the cuff of his shirt to blot at his eyes, which watered constantly from some ailment. He complained he couldn't see the carpets as well as he used to and that probably had cost him in some deals. He said he was a sick man. His heart, too, was not well.

I doubted it. Just more *bazaari* smoke and mirrors, I guessed, to give him some perceived advantage in bargaining. More sugar behind the lips. He was well into his seventies, I estimated. But he sat cross-legged on the floor with his shoulders so squared that the small of his back arched like a bow. He kept a flyswatter in his left hand, using it mostly to rap on the floor as a way to hammer home his comments. I hadn't seen any flies.

"No, most definitely, you are not ready." One tap of the swatter.

"What do you mean?" I pleaded, a little stunned by his very un-Persian bluntness. "I agree I'm not expert, but I'm very interested in learning. Can't you suggest a book or a museum—"

"This is what I mean, *agha*," he cut me off. "Forgive me, *agha*, but you are—what is the right word?—naive. Is this correct? Naive means you are not knowing? Yes?"

"In a way," I said. "Really, it's more like simpleminded or unable to see the big picture."

A mighty rap from the flyswatter. "Then it is the most perfect word," he said. "You must approach carpets with the right knowledge. Yes, definitely. Do you have this knowledge? I don't think so."

I was growing a bit defensive. "I still don't know what you mean."

"Patience," he cautioned. "I will tell you something important. Listen to me: To understand carpets you must first understand Persia. To understand Persia you must read Hafez."

He rose and walked to the tiny desk with a hinged top—just like the one I had in grammar school. He returned with a thick volume of poems. I had a vague recollection that Hafez was some kind of poet. I knew no more.

"This, *agha*, is Hafez," the merchant said, putting aside the flyswatter for a moment and handing me the book with two hands in another gesture of Iranian decorum.

"It's in Farsi," I said apologetically. "I can't read it."

"Pity." He smiled, clearly expecting me to lack Farsi. "It is so much better in his language. I will read, then. Listen."

He picked a poem, lowered his voice an octave, and read:

Where are you going, O heart, in such a hurry?
Since the kohl of our insight is the dust of your doorway,
Please tell us, where do we go from this threshold?
Do not cover rest and sleep from Hafez, O friend.
What is rest? Which is patience? And where is sleep?

"See?" he said after translating the verse into English for me. "Even the great Hafez, the great memorizer, advises us to examine

what we assume we understand. But, more important, we must accept there is always much, much more to learn."

"You didn't select that poem at random, did you?" I asked.

He gave me a big tea-stained smile. I asked because it was one of the few things I did know about Hafez: many Iranians select passages at random as an oracle on important decisions or for insights with problems, especially involving romance.

"No, I did not," Mohammad Reza said. "I've read it to others before. I always read Hafez to foreigners." He closed the book. "You see the point?"

I wanted to be cautious. He must have already thought I was a fool for my ignorance of Hafez. "I think so," I said. "This is what you were telling me about carpets?"

"Indeed, *agha,* it is." He winked. "Read Hafez. You will see our country in a new way, a more true way."

He went on to tell me more. Hafez literally means "memorizer," for his impressive ability to recite the Quran. Hafez—a coal merchant's son whose real name was Shams od-Din Mohammad—was also known by other, more evocative, titles during his life in fourteenth-century Persia, the "Tongue of the Hidden" and the "Interpreter of Secrets" among them. Hafez's verses remain hugely popular in Iran as a kind of lyric expression of the Persian soul. Within a single poem he can appear pious, rebellious, befuddled, and wise. Most Iranians I know are not troubled in the least by these complexities and conflicts. In fact, the combination is seen as a badge of honor and part of the historical stew in one of the world's oldest civilizations. The Islamic Revolution has also been good to Hafez and other Persian mystics. Their popularity has jumped as a counterweight to the chiefly one-dimensional rule of religious conservatives.

Hafez never tired of losing himself in the limitless variations of sensuality: an unexpected breeze on a hot day; the exquisite moment just before a lover's kiss, the pleasant warmth of good wine. The imagery, I was told, worked on two levels: to celebrate the obvious pleasures and to represent the strivings for self-knowledge and hints of the divine.

"Hafez groped for God's hand," Mohammad Reza said. "That's all I will say. You must figure the rest out on your own."

I asked the merchant whether Hafez also wrote of carpets.

"Yes, some," he answered, seeking to change the subject. "But you ask the wrong question, *agha*. A carpet is poetry itself. You just have to learn to read them."

A stained, threadbare carpet in the back of the shop then caught my eye. "May I see?" I asked, also happy to move away from Hafez's mysteries for a while. He bowed his head. I crawled to the corner. The carpet seemed so old, I expected it to be stiff and brittle. Instead, it draped over my hand like expensive satin. The colors, though muted with age, retained their power to seduce.

I drew closer. In the weak light, my eyes adjusted to the subtle interplay of hues. Jade green lines slithered through a field of rust red; flares of deep indigo moved through the borders. The central medallion was a yellow pattern of points and leaves. At first it looked like the starburst. Then it seemed as if I were staring into the center of a pale rose.

He explained it was an antique Heriz, named for the main town among a group of several dozen important carpet-weaving villages near Tabriz in northwestern Iran. Madder red is their principal color. The designs normally have a bold central medallion embellished with leaf patterns or similar motifs.

Mohammad Reza said the carpet was about eighty years old. I nodded with a solemnity I hoped would pass for knowledge. It's almost impossible for a layman like myself to accurately judge the age of a carpet. Even for an expert, it's often pure guesswork. This is one of the many weapons in the lopsided duels between carpet merchants and customers, who are often convinced that new carpets are inferior to their older counterparts. Many carpets of exceptional quality are still produced with natural dyes and the finest wool. The trick always is to distinguish the gems—both new and old—in the anarchy of unscrupulous merchants and low-grade carpets carrying exemplary, but false, résumés. Even age can be manufactured. Carpets can be chemically treated or left exposed to the elements to make them appear to have generations behind them. There are stories, perhaps apocryphal but certainly plausible, of sellers running their cars over new carpets to accelerate the "aging process."

In my experience, every carpet had a price. I was wondering what it would take for Mohammad Reza to part with his. He must have read my mind.

"That one is not for sale, *agha.*" He chuckled. "It's too precious."

He went on about how the colors reminded him of his boyhood in Iran's central desert, far away from Heriz. The blues, he said, were like the desert sky in the last moments of sunset.

We sat in silence. Maybe I offered a thin smile. I don't remember clearly. I just recall thinking that I suddenly felt overwhelmed. I didn't know what I expected when I passed through the Cobblers' Gate in the dark. It certainly wasn't this.

There was a special Persian irony to it: someone telling me to seek clarity by tackling metaphors and allegories from a poet who lived more than six hundred years ago. But I would take Mohammad Reza's advice. It seemed as good as any: Hafez leading to Persia, Persia leading to carpets, and carpets leading me to places I couldn't now even guess.

I've long been fascinated with pilgrimages, the intricate interplay of something collective yet highly personal. Carpets, I was beginning to see, were like that as well. Each weaver draws from a common well of knowledge and technique. But every carpet also carries its own distinctive voice. I suddenly wanted to hear them. It was as if the stacks of thousands and thousands of folded carpets in the bazaar had turned into a library. But in a language, as Mohammad Reza reminded me, I didn't yet grasp.

I left Mohammad Reza in his shop holding his volume of Hafez. I needed to walk and think. I knew if I headed uphill I would eventually find my way out. The bazaar, like almost everyplace in Tehran, has a natural north-south orientation. The city is built on the slopes of the mighty Elburz range. Uphill is north and downhill is south. I left Mohammad Reza's shop and seemed to be heading to higher ground. But, instead, I was plunging deeper into the bazaar.

Some Tehran historians believe the present bazaar may encompass the site of the area's original settlements. Nothing survives from those days because there was almost nothing to begin with: the area now covered by central Tehran was just a rustic outpost. The real power was nearby: the onetime Persian capital of Rey, also known as Rages and other names.

In the Bible, Rey is believed to be the setting for some of the principal events in the Book of Tobit in the Apocrypha, which tells tales of troubles and faith in the Diaspora. Rey still flourished when Islam burst in from the west. The warriors of Persia's Sassanian dynasty began to waver against the Arabs. The invaders turned the tide with a decisive victory at Nahavand in 642, and the Sassanid king, Yazdegerd III, fled and died in exile.

As Islamic rule took hold, the area of present-day Tehran steadily grew prosperous enough to draw the attention of roving bandits and highwaymen. For protection, the nervous inhabitants built bunker-like dwellings that apparently inspired the city's name, *tah* meaning "underground" and *ran* for "town" or "place." Genghis Khan's Mongols sacked Rey in 1220. Tehran, the "underground town," inherited the mantle as the regional center. A bazaar was born.

Pierre de Laval, a French-speaking traveler who visited Tehran in 1618, remarked more about the gardens and orchards than commerce. In 1789, however, the Qajar dynasty then ruling most of Persia moved their capital from Shiraz to Tehran, drawn by its pleasant high-altitude climate and the shade of its many plane trees. Within a century, the Tehran bazaar would be among the world's biggest. Some feel this was the bazaar's best days—before the galloping growth of Tehran since World War II. Older, elegant arcades were demolished or sidelined to make way for—in the words of the Iranian historian Abbas Moghaddam—"the unharmonious growth of the bazaar with unprincipled alterations."

"The bazaar has suffered greatly," he wrote.

"Out?" I asked a shopkeeper, realizing my puny Farsi vocabulary didn't include any concepts for exit. "Street," I persisted, making hand motions for cars.

He somehow understood. He pointed to a man lugging carpets on a back harness called a *chool*. I got it. The human mule would lead the way out.

The mule was a thick stump of a man. Sweat matted the coarse hairs over his arms and shoulders, which cradled two large carpets. The carpets were wedged into the wood-and-rope contraption on his back. The other ends jutted ahead of him like two cannons. He effortlessly cut through the swarm of shoppers and hawkers and shoeshine boys who tug at your trousers with hands gleaming with ebony polish. The mule had no shoes. His sturdy feet—dotted with cuts and bruises—slapped against the ocher paving stones. He didn't break stride no matter how thick the crowd.

I was moving higher. The musty smell of the bazaar's recesses was replaced by new scents: mint tea, saffron, freshly tanned leather, and, finally, acrid whiffs of Tehran's smog-heavy streets.

The sun first hit the tips of the mule's carpets. I was startled at the vibrant reds that seemed so muted in the bazaar's shadows and artificial light. Then we both pushed through a knot of people. I paused for a moment, squinting in the light that seemed annoyingly bright after my hours underground. The mule kept moving. I caught sight of his bobbing carpets. I had an impulse to follow. But I hesitated and he was gone. I stood still and allowed the hive of Tehran to sweep around me.

On rare clear days—through the concrete forest of apartment blocks and towers—you can see the lonely Damavand mountain to the east, rising nearly 19,000 feet. This was one of these days.

Out past Damavand, continuing on for close to a thousand miles, was the historical territory of the Persian world. Down far to the south was Hafez's gentle city of Shiraz. It would have to wait. Events would first pull me to the edge of the Persian world—to Afghanistan.

I walked more and came across four workers—almost certainly Afghans lured to Tehran by the chance for meager wages—who were

sitting together on a carpet laid out in a construction site. I drew closer. They paid me no attention as they ate hunched over their lunch. Bees, attracted by their sweet tea, did lazy circles overhead. Through the bricks and girders I could glimpse Damavand's snowy summit. Legend says it once breathed fire.

Iranian tales say two heroes, the royal Feraydun and the simple blacksmith Kaveh, captured the evil ruler Zohak of Syria, who is often depicted in myths as an invading Arab prince whose shoulders produced snakes that needed daily rations of two human brains. Despite endless proclamations of Islamic unity, this story speaks ever louder about the unflattering way many Iranians perceive Arabs. Zohak, the story goes, was chained inside the crater of Damavand, a dormant volcano. Parents will still tell their children that any tremor near Damavand is Zohak trying to escape.

Damavand has also been one of the nation's reference points, visible from desert plains to ships on the Caspian. It even amplifies the winds, generating channels of hurricane-force squalls that sweep down onto the plains.

I, too, fixed my bearings for the trip ahead: around the southern rim of Damavand, through the chaparral of eastern Iran where the mountain is last seen as a creamy smudge through a heat mirage, then a pause in the holy city of Mashhad, and on to the Afghan border.

Man is a witness unto his deeds.

—*The Quran*

CHAPTER TWO

FLORENCE OF THE EAST

 I took Mohammad Reza's advice.

Shortly after leaving the bazaar, I found the *Divan of Hafez,* a collection of more than five hundred verses and other works compiled after his death in the late fourteenth century. It was not what I expected. This translation seemed stiff and uninspired. It all felt too clumsy to fully convey Hafez's marriage of language and imagery that, Farsi speakers tell me, can move them to tears. The bookstore where I found the *Divan* also carried, to my surprise, a Farsi translation of Walt Whitman. Well, I thought, if his full-strength Americana could survive this cultural journey, maybe the essence of Hafez could be there in English if I looked harder. I'd give Hafez a chance.

It would be many months between meeting Mohammad Reza and setting off for Afghanistan. I read and reread Hafez.

The challenges of taking literature across languages are huge and thoroughly discussed. Poetry takes the chore to a higher level. The late Nobel laureate Octavio Paz saw poetry to be like a potter's

hand: shaping clumps of words into something more graceful and better than its constituent parts.

I slowly started to see these contours in my translation of Hafez. It was like eyes adjusting to a new light. It took some time. Hafez wrote at about the same period Geoffrey Chaucer was creating *The Canterbury Tales*. But while Chaucer's characters took broad swipes at society, Hafez's pen turned inward. He found inspiration in the little blessings that quicken heartbeats and snap the senses to attention. The lines, especially in his early writings, reminded me of the highly charged perceptions of new love: noticing the gentle curve of a lip, basking in the smell of blooming roses, getting lost in the music of the harp. He was, I believe, trying to celebrate this world and the next in a single stroke.

I was on the road when I suddenly remembered the Persian custom of opening Hafez at random to seek guidance. I pulled out my heavy volume.

O breeze! From the dust of the beloved's path, a perfume bring . . .

I couldn't continue. The book was jolted from my hands and hit me square in the chin. I grabbed at the car door. My other hand braced against the roof. We hit another bump. I was airborne. The driver, a turbaned sadist named Ikbol, just went on doing what he did best: punching the gas, avoiding the brakes, and somehow keeping the car moving in approximately the right direction.

He was twisting the steering wheel with wild hands that looked as if he were trying to juggle and drive at the same time. His Toyota station wagon—charging ahead on bald tires and a sagging suspension—seesawed through a series of gullies, then tilted on a sloped embankment and scraped bottom in a deep rut. Gravel pelted up like BBs through holes in the floorboards.

Mile by stomach-churning mile, we were on the road to the ancient jewel known as Herat.

Maybe there was perfume ahead in the city that once so brimmed with pleasures and treasures it was hailed as the Florence of the East. The dust part of Hafez's stanza was certainly accurate. The road from the Iranian border at that time was little more than a dirt track. But there was some payback for the discomfort. The trip was a self-

contained timeline of Afghanistan's recent history—seen through the mud-smudged windows of Ikbol's Toyota.

A few roadside teahouses displayed sun-bleached British pounds probably carried by backpackers bound for Nepal or India along the "hippie trail" of the 1960s.

In some patches, the dirt road gave way to the remains of pocked concrete-block lanes used by the Soviets during their doomed decade of occupation. The last Red Army troops pulled out in 1989 to seal the victory of the U.S.-backed Islamic "holy warriors." Among them was a wealthy Saudi-born zealot named Osama bin Laden. His later hosts, Islamic puritans who called themselves the Taliban (loosely translated as students of the Quran), had tried to impose their cloistered vision of righteousness. Medieval ideas mixed dangerously with modern firepower.

Along the Herat road, a billboard for mint toothpaste was riddled with a Kalashnikov barrage. The face on the sign took the brunt of the fire and was nearly obliterated. The Islam of the Taliban forbade representations of the human form in art. It was another excuse to pull the trigger.

Iranian officials—who were no friends of the Taliban—promised to rebuild the road to Herat from the border after the regime fell in 2001. It was more than just a neighborly gesture. To Iranians, Herat is as much a part of Persia as anything in the Islamic Republic. A new road would physically bolster Herat's links to the Persian motherland, a relationship that has been broken, restored, and remolded in one of the world's longest-running political soap operas.

The only saga I was contemplating, though, was my ride with Ikbol and how it would end. It seemed about an even bet as to whether we'd make it to Herat at all. The road was a kind of endurance test of machinery against nature. I wasn't sure Ikbol had the edge. He'd turn around from time to time with a big smile that would send any dentist into fits. I took that as a sign of confidence that he'd beat the elements one more time for me.

Ikbol had made the 160-mile round-trip from Herat to the border dozens of times in his right-hand-drive Toyota. In one of the stranger sideshows of international smuggling, used Japanese cars reach

Afghanistan through the mountains from Pakistan. Afghan authorities have tried to crack down on the cars. It wasn't the smuggling that was the main concern. Afghan roads are notoriously insane. Officials feared the mix of Japanese-style and legal left-hand-drive cars adds an extra element of danger. If that's possible. The only real rules of the Afghan road were basic: keep forward motion and be ready for wild improvisation.

A muddy pool of unknown depth lay ahead. Ikbol detoured. He rumbled onto the grassy, rolling hills like a pioneer. No furrow was too big, no rock too jagged. Ikbol found a way. Village boys—and sometimes their fathers—pitch in, too. They fill potholes in hopes that a passing driver will toss money from the window in gratitude.

I let an Iranian 10,000 rial note fly. It was worth about $1.25. The kids scrambled for the bill in our wake of yellow dust. Ikbol was horrified.

"No, no, no," he told my colleague and translator, Afshin, who was accompanying me. "Too much!"

Ikbol handed me some limp and utterly filthy afghanis, the national currency. The most valuable bill in the fistful was worth about a quarter. "This is okay," Ikbol said as we all rocked from side to side through a shallow streambed. "Enough for them." In a country that has seen the hardships suffered by Afghanistan—where a forty-seven-year-old woman has beaten the average life expectancy—there really is no such thing as enough.

The Taliban had fallen in Herat just a few weeks before I arrived. Crossing the border, however, still required special permission from Iranian authorities. The frontier was a delicate zone from Tehran's perspective. No tears were shed for the Taliban's demise. But the rise of another American-friendly government next door added to Iranian leaders' claustrophobia. It's part of the regional fallout after September 11 that could someday pour across Iran.

Both the Islamic Republic of Iran and the Taliban followed similar paths to power: religious fervor and street muscle joining forces

against politically bankrupt regimes. But Iran started mellowing significantly in the 1990s. The ruling clerics restored many international ties—with Washington a glaring exception—while watering down many of the postrevolution restrictions such as bans on popular music and dating. Iran's new image building required serious distance from the Taliban even if some hard-line Iranians shared bin Laden's disdain for Western culture and power.

But there was something even more important guiding Tehran's attitudes toward the Taliban. They had Iranian blood on their hands. In August 1998, the Taliban overran the northern city of Mazar-i-Sharif. It turned into a mass slaughter that targeted the Shiite Muslim minority and envoys of the main Shiite center of power, Iran. Eight Iranian diplomats and a correspondent for the state Islamic Republic News Agency were killed. A senior researcher at Human Rights Watch called it a "a particularly brutal episode" in a "very brutal war."

The battles highlighted not just Afghanistan's complex ethnic patchwork, but also internal rifts within Islam itself. This discord affects post-Saddam leadership in Iraq and feeds violence in Pakistan and elsewhere.

Islam has been divided into two main branches—now known as the Sunnis and minority Shiites—since soon after the death of the Prophet Mohammad in 632. Sunnis accepted Abu Bakr, a respected contemporary of the prophet, to lead the nascent political and spiritual movement during a critical period of revolts and tribal rivalries on the Arabian peninsula. A small group believed Mohammad should be succeeded by his closest male relative, his cousin and favored son-in-law Ali. They were later called the *shi'at Ali*, or Partisans of Ali. These early decades of Islam can make modern sectarian turmoil seem tame. Ali was killed in 661 by members of a hard-line clique. Nineteen years later, Ali's son, Hussein, met his end in a battlefield slaughter on the plains of Karbala in what is now Iraq. This is why martyrdom has such a powerful symbol for many Shiites, and Karbala remains one of their main places of pilgrimage.

Another place revered by Shiites is the eastern Iranian city of Mashhad, which also features in the Sunni-Shiite friction. The

Mashhad story starts more than one hundred years after the Karbala bloodshed.

The eighth Shiite imam—known to Persians as Imam Reza and to others as Ali ar-Rida—was summoned from Medina by a Sunni caliph in the early ninth century. The Persians say the caliph wanted Reza to become his successor and marry his daughter. The gambit, many believe, was intended to heal the growing rifts in the faith and possibly strengthen Sunni domination. But the streets had a different view. Factional riots erupted. Neither side apparently liked the arrangement. But then Imam Reza suddenly died. Shiites still contend Reza was poisoned by the Sunni leaders to quell the unrest. More than twenty million pilgrims visit the immense shrine to Reza each year in Mashhad.

For me—this time at least—Mashhad was just a stop at an office for foreign journalists to receive permission to enter the border zone. I promised myself to return another time and visit the Imam Reza complex.

I arrived at the press office before business hours, hoping to get the pass and reach Herat before nightfall. I was led into a small office and told to wait. "Please," said an attendant, "watch some television." He hit the remote control and gasped. The last channel watched was a German soft porn satellite station. Naked women in sneakers were playing basketball.

"Ah, well, ah," he babbled. "It must be those Afghan cleaners at night. Damn them." He fumbled with the remote. BBC World replaced the jiggling dribblers. The border clearance arrived in record time.

At the metal gate that was the last stop in Iran, the guard squinted east into the morning sun and bid us farewell in English: "Good night and have a good time."

It was evening by the time we reached Herat.

I felt seasick from the ride. More than once, I broke into a cold sweat and nearly asked Ikbol to stop so I could puke. I was probably

saved the indignity because of the light rations: just some bread and crackers since daybreak. Herat made me instantly forget the rigors of reaching it.

I had done much advance reading about the city. Nothing, though, had prepared me for this.

It didn't matter that I was in the backseat of a smuggled Toyota. Or that Ikbol was playing Persian music cassettes that were, until recently, banned under the Taliban. I felt transported back in time. This, I thought, was perhaps what a Silk Road traveler experienced after crossing from the wilderness to the city gates. Silhouettes slid past small fires. Mule carts rattled by. The sounds were old ones: of leather, rope, hooves, wood. The air was gauzy with smoke, dirt, bits of dried mud, and anything else that can be carried along by the wind. Men's faces, peeking out from under dirty turbans and scarves, emerged in our headlights, then quickly disappeared in the darkness. There was the occasional woman under a turquoise blue burqa. It was a city of shadows.

It's easy for us, with lives of amazing convenience, to forget the potency of the night; how it can render us helpless and frightened. We simply flick a light switch to make the darkness flee. But here, in a corner of shattered Afghanistan at a time just after the Taliban, the night was in command. The electricity grid had collapsed. The rhythms of earlier days had—temporarily—reclaimed their place.

The British writer-scholar Robert Byron had also come this way in his first encounter with Herat. The similarities were startling: the same road, the same month of November, the same post-sunset arrival. Except Byron was here in 1933.

"This kind of night is always mysterious; in an unknown country, after a sight of the wild frontier guards, it produced an excitement such as I have seldom felt," wrote Byron in his classic *The Road to Oxiana*.

Here, Byron decided, was "Asia without an inferiority complex." A place where "they carry rifles to go shopping as Londoners carry umbrellas."

Not much has changed except the weapons of choice. We heard a roll of automatic gunfire. Then another. Ikbol drove on.

"Just in the air," he assured me, making his right hand into a pistol and pointing it skyward. "It's happy shooting. Good-bye, Taliban."

Then we stopped to watch two men fight over a piece of bread.

My plan was to find some leads in Herat.

Mohammad Reza had put me on the trail of Hafez. But I still knew next to nothing about carpets. Herat seemed an ideal starting point.

Perhaps no place in the Persian world has so intimately witnessed the ebb and flow of cultures and allegiances over the centuries. Its name also holds a place of instant recognition throughout the carpet trade.

Herat is one of the oldest Persian weaving centers and is considered the cradle of Herati designs, which are among the standard-bearers in the region. The classic Herati field consists of repeating flower-and-diamond motifs, often called "fish" because of their tapered shape. The Herati borders—stylized florets in curved or geometric forms—also may be important to the understanding of carpets' evolution. Some experts believe the borders show the interplay between eastern and western styles. The grace and delicacy come from arabesque-inspired traditions, the theories suggest. The snakelike flow of the designs, meanwhile, could be inspired by the so-called cloud band style developed in China.

Such patterns may have been first carried from central Asia by Genghis Khan and the Mongol raiders in the thirteenth century, when Herat was razed, looted, and later rebuilt by the survivors. This has been Herat's recurring fate over the many centuries: times of glory and wonders and eras of misery and obscurity.

In one of the good times, a Moghul potentate widely known as Babur spent a year enjoying Herat's famous diversions in about 1505. No other place within a month's ride offered the concentration of art, music, literature, and passionate indulgences. It was, in some sense, a farewell frolic. Herat was about to be engulfed by the regional power plays that would leave Afghanistan divided between

Persian and Indian spheres of influence. Herat's golden age as an artistic and cultural hub was ending. Babur, in his famous memoirs, wrote an epitaph-tribute that the "whole habitable world had not known such a town."

Five centuries later, I wandered through a place the world had forgotten.

Starving dogs licked the muck around the abandoned pool at my hotel. Sinister gunmen loyal to the local warlord, Ismail Khan, set their own laws. Outside the city's stunning Friday Mosque—a study in exquisite tile work that has survived for nine centuries—the antechamber was filled with worshippers' shoes. Among them were stalks of artificial legs. They were a reminder of the decades of warfare and the more than five million land mines the United Nations estimated littered Afghanistan before aggressive clearing operations began in 2002.

I walked along the mosque's outer walls and wondered why clumps of hair were bouncing along like tiny tumbleweeds. My answer was just around the corner: sidewalk barbers were busy shaving away the beards that the Taliban demanded as homage to the be-whiskered Prophet Mohammad.

Some boys tried their hand at washing cars, which were dirty again before they could even finish. Other children squealed as they went round and round on a small, rusty Ferris wheel. It had no motor. And even if it did, there was no electricity to run it. It was kept spinning by a man with a pistol tucked in his trouser sash.

I had the name of someone to see in the bazaar: Farid. That's all. I asked the Ferris wheel spinner if he knew of this Farid, the carpet seller. He gave the wheel a big push, then pointed to three broken concrete stairs leading to a small opening adorned with colorful nomad weavings. I peeked in.

"Mister, please, come in," cried a wiry young man with long, delicate fingers. "Yes, please, don't be afraid. Just look. No need to buy." He tugged my arm. I had found Farid. I also discovered he won't cool down until he sells a carpet.

"Someone gave me your name. I was told you could help me," I said. "I'm looking for carpet weavers."

"Oh, yes. Whatever you need. But later. We have time. Now, mister, please look. I have some nice carpets. What do you like? How many? You have dollars?"

"I'm really interested in reaching some of the village weavers," I continued, trying to stay on track. "Do you know any who still make their own dyes? Could you introduce me to someone who could take me? This is very important to me. You see, I've decided to try to look for how much is left of the old traditions and what is changing. You understand? It's like a journey. I don't know how to describe it—maybe like a hajj."

I immediately regretted using the analogy to the hajj, the Muslim pilgrimage of prayer and ritual that culminates in Mecca. Would I destroy my first serious carpet contact in a moment of insensitivity? Farid couldn't care less.

"Hajj for carpets!" He laughed. "Oh, yes, very good. I see. Mister, oh yes, we'll fix it. No problems. Very good. I tell you. But first, look. Mister, look."

I guess I had to look. The only problem was, it was hard to see. Farid had dozens of candles burning in his small shop, where stacks of carpets reached almost to the ceiling. A man with an enormous belly sat silently in a dark corner. He had a gold tooth that sometimes caught the candlelight with a twinkle.

One by one, Farid laid carpets at my feet. I was soon on my knees examining the growing stack in the poor light. I think Farid sensed he had an easy mark. I knew it, too. Long ago, I discovered that I'm a carpet seller's dream. I'm weak and prone to self-defeating inner dialogues. When I see an attractive piece, I'm smitten and start down a slippery slope: What if I don't get it? In the big picture, it's not *that* much, is it? Won't someone else snap it up if I wait? And so on. I try to control it by periods of a sort of carpet celibacy. I stay out of shops and stay away from temptation.

Up until my trip to Herat, my collection was modest. It was highlighted by a large, but very average, Turkmen bought in Istanbul—with its hallmark geometric cells—and a semivaluable antique floral-pattern kilim from the Ottoman days in Bulgaria. I knew I was about to add some more. Farid tensed, preparing to pounce.

"Good, mister," he chirped. "Buy, please. We are poor. The Taliban killed our business."

I settled on two four-by-three-foot carpets from the Maliki tribe, part of a network of clans from Iran to Tajikistan linked by a common language. I brought the carpets out to the street to see them better. They were decorated with camel figures—which looked oddly like llamas—and a tree motif in the center. The edges were a sturdy kilim and the weave was reasonable: about forty-five knots per square inch. The price for both was $200, about the average per capita income for Afghans. The deal was struck. Finally, Farid was quiet.

The man in the corner spoke for the first time. "Can I show you something?" He groaned as his moved his bulk over one of the Maliki carpets.

"See this?" he said, running his finger down the motifs, often called *guls,* after the Persian word for flower. "See how they are all slightly different: the lines, the number of dots? This is the hand of man. In a handmade carpet, the kind you seek, there can be no design exactly the same. Even if you try, *agha,* it's impossible. The wool thread may be a different size and they could make only five knots when before it was six. Or the dye is a slightly different color. Small things, but important. This is the beauty you must see. There is beauty in these inconsistencies. It is human. It is life. But the gift of imagination and creativity comes from God. So you see, these carpets show the perfect hand of God in the inspiration and the imperfect hand of man in trying to follow it. Listen well, do you understand this?"

"I think so."

"Are you a believer?" he continued.

"I am not Muslim," I said.

"No, I mean do you believe in God?"

"Yes."

"Good. Very good," he said. "Then you must think hard about what I told you."

"I will," I assured him. "Did you hear what I asked Farid? Can you help take me to the weavers? To their villages?"

"It can be arranged, *insha'allah*."

"When?"

"As you like." This actually is Persian code for "we'll see."

The man was called Nourulhaq Ibrahimi, an Afghan who shuttled carpets to sell in Mashhad. It's prohibited to import Afghan carpets into Iran. Iranian authorities fear, with some justification, a flood of outside carpets into an already saturated market. Ibrahimi has his ways, though. Smugglers' routes and modest bribes to border guards were just some of the options.

Ibrahimi said he maintained good ties with Ismail Khan, who was a famed mujahideen fighter against the Red Army and returned from self-exile in Iran to claim the Herat region as a personal fiefdom. In perhaps more appropriate mafia parlance, Khan was *il capo.* With the Taliban gone, the Khan cartel cashed in. Khan's boys—part of his thirty-thousand-man private militia—controlled the border with Iran, charging serious entry fees to Iranian truckers carrying goods and even humanitarian supplies. Arms, opium traffic, rent paid by U.N. agencies and others—Khan's kleptocracy always got its cut. Any decision, no matter how small, apparently had to be cleared with "his excellency," as his minions called him. Khan called himself emir. I once watched Khan try to teach his ragtag fighters how to properly march for a parade. The message was clear: get the steps right or else.

There were a number of similar warlords all over Afghanistan at the time, frustrating attempts by the post-Taliban leadership to extend their influence outside the capital, Kabul. But Khan was perhaps the most imperious and independent of them all before he was brought under the thumb of the Kabul government in 2004. His clout reached such levels that U.S. Secretary of Defense Donald Rumsfeld flew in for a bizarre courtesy call in April 2002. They met for an hour on a runway of the bombed-out Herat airport, bathed only in the light of a full moon.

If Ibrahimi actually had a relationship with Khan—as he claimed—I knew I was at least in the right company if obstacles ever loomed.

"Let me show you something else," Ibrahimi said, taking my hand.

We walked around the corner from Farid's shop into a courtyard filled with cast-off parts from cars and bicycles. A century ago, it was a marketplace of some obvious prestige. The carved wooden doors are as thick as a fist. Inlaid stones in the shape of stars decorate the columns. Ibrahimi led me to the second level.

"I want to show you another side of the carpets. This, alas, is where it's all heading, I think," he said. "I will be honest with you, *agha*, this is the type of carpet that I trade in, too. I am ashamed, but you need to eat."

In a small workshop, two brothers, ages seven and ten, worked on a loom. The pattern they were following—a classic Herati—came from a scrap of paper torn from a magazine. A clock on the wall loudly ticked each passing second like a musician's metronome. The boys were tying and cutting the knots at about the same tempo.

Their boss, Abdulmanon, kept watch. The wool was factory spun and chemically dyed. "So?" He shrugged. "You really think anyone cares? This is a business, not a museum. We need to make money."

"What did I tell you?" Ibrahimi whispered.

Abdulmanon did the math: the dyed wool cost about $30; the boys are paid about $1 each a day; it may take them six weeks to finish an intricate Herati of about three by four feet. That's less than $120 for production.

Ibrahimi may buy it for $200. Then he would offer it to his stable of shopkeepers for maybe $250 to $300. The merchants could perhaps start the bargaining at $500.

"It's a pity for these boys, no?" said Ibrahimi as we walked away. "I am sad that it is this way. But, in the name of Allah the merciful, I thought you should see it all. You remember what I said about man and God? There is one thing I left out. Money is involved and this invites the devil. It can't be any other way."

We started to leave, but I was stopped by the sight of another carpet. There was that slippery slope again. The carpet was a red Turkmen-influenced design with a central field of twenty-one squares. Their scalloped borders led to a red starburst core. The north-south ends were trimmed with kilim in a red and blue key

pattern. The fringe was silk, suggesting the possibility of an unusual silk foundation.

The merchant banged off the dust. He claimed it was a fifty-year-old piece from the Timuri, a respected carpet-producing tribe with sketchy historical ties to one of the region's most idiosyncratic figures, the warrior-mystic Timur, a swashbuckler who called himself the "scourge of God" on a divine mission to judge and punish sinners.

Timur—sometimes called Tamerlane or Timur the Lame—carried a lifelong limp from being hit in the right leg with an arrow while trying to rustle sheep as a youth. By the time of his death, in 1405, he led an empire that rivaled that of his Mongol predecessor Genghis Khan and stretched from the Black Sea to the Indian subcontinent. Timur was ruthless with his foes, but also styled himself as a patron of artisans and scholars. Some sources say he once crossed paths with Hafez, who may have cleverly charmed Timur by appealing to his dual nature: a nomad with a desire to put down roots. Timur lavished considerable energy on creating an imperial legacy and set the tone for the grand projects of his successors. He also found another type of immortality as a conflicted hero for luminaries such as Christopher Marlowe and Edgar Allan Poe.

Under Timur's son, Shah Rokh, Herat became famous as a seat of learning, refinement, and architectural achievements that drew comparisons to Renaissance Florence. Shah Rokh's widow, the dynamic matriarch Queen Gawhar Shad, built a staggering complex in Herat that included a women's college, mosque, and later her mausoleum, known collectively as the Musallah, or a place of prayer.

"What do you think?" I asked Ibrahimi after the merchant insisted he would go no lower than $400 for the Timuri. "Is he telling the truth about this carpet?"

"What is truth in the carpet trade?" Ibrahimi scoffed. "Truth is just what the customer will believe."

"But what about this one?"

"Maybe yes, maybe no."

I knew this much: there is always much more going on during carpet wheeling and dealing than I could possibly know. Why was

Ibrahimi so indecisive? It could range from genuine uncertainty about the carpet to some sort of incomprehensible feud with this merchant. The buyer is often a bit player in bigger, ongoing dramas.

"Put the carpet aside," I told the merchant. "Let me think about it."

It was a small personal victory, my walking away without a purchase. I expected the merchant to shout back a lower price. But nothing.

Back in Farid's shop, he had a present waiting. He brought out his prized memento from another time: the 1965 *Scorpion*, the yearbook from the long-defunct American International School of Kabul. It was difficult to reconcile the perky old photos with the downtrodden Afghanistan around me now. On the pages were girls with bangs and flip-end hairdos, a driver's ed class sitting on a Chevy, cheerleaders practicing their kicks. The football team went 2-2 that year.

"Maybe again?" Farid wondered.

"Maybe," I offered.

What else could I say?

I set off for Queen Gawhar Shad's resting place.

It's easy to find. Five of the minarets of her once grand Musallah are still standing. Each is more than a hundred feet high. They've often been described as resembling old factory smokestacks. Byron, back in 1933, when seven minarets were still standing, first thought he'd encountered "a grove of giant chimneys." The description is apt. Most of the fabulous blue and green tiles have flaked off, leaving a chocolate brown brick foundation that is crumbling under Afghanistan's demanding weather. After walking amid the ruins for a while, I conjured a different imagery. Each minaret seems like a finger, pointing skyward and defying all that conspires to bring them down. They remind me of the entire battered and weary city: Take heart, they say, there was something once great and noble here. The Musallah has been ravaged by time, looters, earthquakes, and

British soldiers who in 1885 wanted clear firing lines for a feared Russian attack that never came. The Musallah won't go quietly.

The full glory of the complex can be imagined from the grandeur of the queen's other major architectural commission, the sweeping dome and twin minarets on the Grand Gawhar Shad Mosque in Mashhad that outshines even the nearby Imam Reza shrine. In 1830, an envoy of the British East India Company counted twenty minarets at the Musallah site, including one that offered a panorama of gardens and vineyards "so varied and beautiful, that I can fancy nothing like it, except, perhaps, in Italy."

An Italian, in fact, came to the rescue in 2003. Giorgio Macchi, an engineer who helped stabilize Pisa's leaning tower, led a team that used steel cables to support the most precarious minaret. Pisa's tower reached a maximum of more than 5.3 degrees off center before it was brought back to about 5 degrees. The so-called Fifth Minaret—the one with the most critical tilt—has an even more dramatic angle, with a base only a third the size of Pisa.

"The minaret was on the verge of collapse," Macchi told me.

I wandered over to what's left of the queen's tomb. A rust-encrusted lock hung from the gate. I rattled it, half expecting it to break apart. Afshin, my colleague, shouted something in Farsi. A guard—very old and carrying a gnarled walking stick—came out of a shack.

"Go away," he said.

"We want to come in," Afshin shouted in Farsi. "Please, open."

"Tourists?" the guard gasped, as if the very word was hard to comprehend.

"Um, yes," said Afshin. "From Iran and America."

Afshin whispered to me: "Give him a green Khomeini." It's the way traders and beggars in Azerbaijan refer to the emerald Iranian 10,000 rial note that features the stern visage of the father of the Islamic Revolution, Ayatollah Ruhollah Khomeini. We, too, had adopted the nickname.

The gate opened. The green Khomeini gratuity was passed.

The tomb had become home to pigeons. Their white droppings soiled the floor and walls. Some of the gorgeous glazed tiles—blues,

mustard, and cream—were piled in a corner. The queen was more than eighty years old when put to death by an invader—the great-grandson of Timur—who felt she was foiling his plans. Her epitaph called her the Queen of Sheba of her age.

From the ledge at the base of the tomb's dome, it's simple to see why the region's power struggles have often been played out over Herat, which draws its name from the Hari Rud river valley that serves as a natural passageway for trade from Persia to India.

Alexander the Great, who called the city Aria, took it in 330 B.C. and founded a citadel that has been continually expanded and fortified. Herat remained mainly in the Persian orbit until Genghis Khan swept through in 1221. Then came Timur and the next wave of conquerors from the steppes of central Asia.

The sway of Timur's dynasty lasted until the Uzbeks moved on Herat in 1506. Later, Herat would be reclaimed again by Persia. The revolving door would then begin spinning faster. In one forty-year stretch in the early eighteenth century, Herat changed hands five times in battles between Persian tribal factions and Uzbek attackers. Later, it emerged a coveted outpost in the Great Game for influence between the Russian and British empires.

Persia made one last bid to reclaim control of Herat. A Persian force, encouraged by Russia and led by the shah himself, left Tehran in June 1837 for a 155-day march to Herat. The Heratis left scorched earth in their wake as they retreated behind the city walls to await the siege. It didn't come until noon on June 24, 1838. Persian infantry managed to breach the defenses but were driven back by Heratis who were aided by an unlikely comrade-in-arms, Lieutenant Eldred Pottinger, a young British artillery officer and quasi diplomat. It's never been made clear whether Pottinger was dispatched to Herat to help with the battle or if he simply had wandered in, Forrest Gump style, to become an accidental hero. Pottinger's adventures were not over after Herat. He would pop up in all the Afghan hot spots in the coming years. He ended up as a

captive in Kabul and avoided one of the darkest moments of British military history: the slaughter of British soldiers and civilians allowed by Afghans to "retreat" over the Khyber Pass in 1842 after failing to hold rule in Kabul. The full death toll at the Khyber Pass is imprecise, but most agree that it exceeded fifteen thousand. It's been called the worst British military rout since William the Conqueror swept over King Harold's forces at the Battle of Hastings in 1066. Pottinger, only thirty-two, fell ill and died in 1843 while visiting his father in Hong Kong.

Herat joined a united Afghanistan in about 1880 and was considered the western outpost of British colonial influence during the waning decades of the Great Game.

"We must revive this historical city," the mayor, Mohammad Rafiq Mojaddadi, told me. "It is our duty to Afghanistan and the world."

Mojaddadi was elected in November 2002 in voting supervised by, of course, Ismail Khan.

"So we must beg," he continued. "It is painful but necessary. We need the help of the international community. Herat is too important to remain forgotten."

The mayor had just returned from a meeting relating to one of Herat's least-known chapters: its role as one of central Asia's centers of Judaism for centuries. The last Jews left Herat after the 1979 Soviet invasion. Just a few remained in Kabul despite the difficulties under the Taliban, which confiscated the only Torah in the only synagogue in the capital. The scroll was last known to be in the hands of a former Taliban interior minister, who later became the governor of Herat province.

The mayor had promised a group of Jewish researchers that he would do what he could to help with the hunt. But, of course, he would have to check with Ismail Khan, who was hosting a gathering for the *Eid al-Fitr,* the holiday that falls at the end of the Muslim holy month of Ramadan and its dawn-to-dusk fasting.

The mayor invited Afshin and me to come along. We entered a vast hall behind the Herat governor's office and were led to a special VIP spot at the front of the room. Plastic flowers poked from vases

43

even though lovely roses were in full bloom just outside the door. In Afghan style, everyone was seated on the floor on huge carpets. I ran my hands along the pile.

"Machine made," whispered Afshin.

The hundreds of guests—all men—rose when Khan entered. Banners breathlessly proclaimed his self-described magnificence: "The hero in combat, the victorious leader on the path to independence and freedom, the model of bravery and piety." Small plates were set out with peanuts, pumpkin seeds, raisins, and Iranian candies. The scene reminded me very much of a lavish banquet scene in a Persian translation of Babur's memoirs.

The guests politely nibbled until Khan left. Then came a frenzy. I had no idea what was happening. Men tore off their turbans and sashes. I thought some kind of battle had broken out. Then I realized. It was the food. Plates were emptied into unrolled turbans or the laps of the loose Afghan trousers. I plucked a last nut just in time.

There was one last mission before leaving Herat. I couldn't stop thinking of the carpet I saw with Ibrahimi. I even dreamt about it. It was that bad. The problem was timing. It was Friday, the Muslim holy day. Farid's shop was closed, and the old marketplace around the corner—where I'd seen the carpet—was locked tight. We were leaving the next morning at sunrise.

Only a small boy was around. My only hope.

"You know the owner with the carpet?" Afshin asked him.

"Yes, *agha.*"

"Can you get the key?"

"Yes."

"Now?"

"Yes."

I was beginning to love this kid. I could see green Khomeinis in his future.

Within ten minutes, the boy was climbing over a roof and drop-

ping down through a crawl space into the market. The guard dog was barking madly. I looked through the keyhole, expecting any minute to see the dog tearing apart the boy.

"Look," said Afshin.

The boy, his hair frosted with dust, was walking up the street with the carpet. I gave him four $100 bills for the carpet and a few green Khomeinis for himself.

We left Herat the next morning in a fog. It was as surreal as our arrival. At a refugee camp just west of the city, Afghan men appeared to us for just an instant before disappearing in the gray mist. Groups of boys headed off into the Hari Rud flood plain, going farther each day to dig desert scrub for cooking fires. A funeral procession passed and was swallowed by the mist. Then a man came along, pushing the limp form of his wife in a wheelbarrow. Her head lolled from side to side.

"No, no," he said. "She's not dead, just sick."

It wasn't until I crossed back into Iran that I had a chance to really examine the carpet snatched for me by the boy in Herat.

To protect its own industry, Iran doesn't allow carpet imports from Afghanistan. I pushed the carpet to the bottom of my rucksack and managed to pass the border guards with no trouble.

The border patrols were on the watch for fleeing Taliban—or maybe even an al-Qaeda fugitive. A Western journalist with a valid Iranian visa—and a few stowaway carpets—was just whisked through.

The first thing I noticed about the carpet was its smell. It was stale and musty—something akin to an old basement or a ripe subway platform. I opened the balcony door of my hotel room in Mashhad and flung the carpet outside. It left a trail of yellow-brown dirt. About an inch of the same stinky dandruff was at the bottom of my rucksack. I gave the carpet a shake. Amazing quantities of dust, dirt, and even bits of wizened food crumbs rolled off. I kept at it until my arms ached and my glasses were frosted over.

It was now time to give this carpet a first good look.

One of the easiest ways to assess a carpet's basic structure is by studying the back. Here is the foundation, known as warps and wefts.

Warps are the north-south threads bound together in pairs—and sometimes in lines of fours—by knots of wool or silk. Wefts are the east-west threads that snake through the warps and help hold the carpet together. Carpet experts like to see straight lines. This suggests proper tension on the loom for the warps and nicely packed wefts.

I was happy so far. This carpet showed well-skilled weaving. In some areas the white cotton weft threads poked through. But that's common in nearly every handmade carpet.

Cotton, because of its durability and suppleness, is the most widely used foundation material. Wool foundation threads can be found on carpets from areas without native cotton production or from nomads who may not wish to buy cotton. Wool, however,

may shrink unevenly if wet and may cause the carpet edges to buckle or wave. Some special carpets have silk foundations.

I looked more closely at the underside of the carpet. Again, good news. The knotting was tight and straight.

There are two main knots.

This carpet had the symmetric knot—also called the Turkish knot—which involves looping the wool in a pretzel-shaped fashion around the north-south warps. This is also known as a Ghiordes knot, named for a western Turkish town known for its prayer rugs. This technique is most common to Turkey, the Caucasus region, northwest Iran, and some Turkmen tribes.

The other is the asymmetric knot—or Persian knot—which loops fully around one warp, then hooks below the second. This shape resembles an ampersand. It's mainly found in Iran, parts of central Asia, and China. It's sometimes called a Senneh knot. But in the fuzzy history of carpets, it's a confusing misnomer. The Iranian city of Senneh—now called Sanandaj—is best known for finely woven carpets with symmetric knots.

References to Persian and Turkish knots are often used but can be misleading. Many symmetric-knotted carpets are made in Iran, and asymmetric knots are found across Turkey.

Knot counts appear in almost every carpet book, catalogue, and auction guide. It's a convenient yardstick to compare the intricacy of the work. Carpets can range from a bumpy weave of fewer than thirty knots per square inch to two thousand or more in some exceptional silk carpets to create a finish as smooth as sanded wood.

But it's a seriously flawed method to assess quality or beauty. Most experts and experienced collectors pay little attention to the knot count and, instead, look for originality of design, the balance and interplay of colors, and the dyers' craftsmanship—among other factors. One expert described using knot count to determine the quality of a carpet as like counting pixels to critique a digital photograph.

"Judging a carpet solely on knot count is like deciding about a house based on its doorknobs," quipped Bahram Ravan, who has a carpet shop in Tehran. "It has nothing to do with whether the piece

is interesting or important or beautiful. It can simply mean that the weaver was using thick wool or thin wool."

Still, I admit I'm often a closet counter. I did the math with my new Herat piece: a very respectable 175 knots per square inch.

I flipped the carpet over and ran my fingers over the pile to the top and bottom edges. This is what first attracted me to the piece: end borders of red and blue kilim, durable flatweave, and fringe that appeared to be silk.

Many carpet merchants promise silk, but there can be deceptions. What's advertised as silk can actually be mercerized cotton, which is made stronger and glossier by treatment with alkali and pressure.

One of my carpet manuals offered a simple test. All that's required is a match.

A clipping of real silk does not easily sustain a flame and gives off an odor described as burned feathers. Cotton ignites easily and smells like burned paper.

This time, at least, I wasn't duped. The fringe was, indeed, silk.

On the lip of oblivion we linger, and short
Is the way from the lip to the mouth where we pass.

—Hafez

CHAPTER THREE

THE SANDSTORM

 The mourners could sense they had little time left.

The breeze, snapping at the edges of their soiled turbans, suddenly turned harsh and erratic. It howled, paused, and howled again. In a moment of calm, they lowered the infant boy's body into the shallow grave. The hole was about elbow deep for the men. They didn't have the tools to dig it any deeper. This would have to do. The boy's face was tilted on a flat stone to the southwest: toward Mecca.

The gusts returned. They were stronger than before. The men squatted together in a tight cluster, trying with little success to keep their backs to the shifting gale. Clouds of talc-like sand began to swirl, making the men cough and spit.

The men were now crouching lower, almost crawling. They sank their fingers into the edge of the grave to avoid being toppled over by the storm. They pushed the earth—dry and flecked with jagged stones—into the grave with their hands. Every few seconds, they glanced over at the northern horizon.

It seemed to be lifting up, forming a mountain ridge where there should be only the crisp outlines of the western Afghan badlands. "It's coming," growled one of the mourners through a scarf pulled tight over his face so only his eyes were visible. "We must go."

They tugged at the dead boy's father. He refused to move. He sat, lost in his grief and memories, smoothing the dirt on the tiny burial mound with his palm. The storm had found its focus. Sand was racing madly across the ground in a single direction. It reminded me of the time-lapse films that compress hours into a few wild seconds: sand drifts rose up instantly against any windbreak. "Please," the men begged the father. "Sandstorm. We must go right away."

I had left behind the ghosts of Herat. Before me now were the other wraiths of Afghanistan: hunger, war, hopelessness, extreme poverty. I had first come to this camp of displaced Afghans near the Iranian border with a group of journalists. It was in the final days of the Taliban in this part of the country. We were told we had permission to enter. But apparently no such order was passed to the lone Taliban watchman at the border, which was marked by just a single rope sagging across a dirt track.

For a few minutes, the guard dutifully stood his ground. Finally, we cleared the way with a bribe: the elixir of their enemy, a liter of Coca-Cola. We spent only a few hours in the camp, where a Taliban thug, conspicuous in his pink plastic flip-flops, whacked fellow Afghans with a length of rubber hose as they waited for help outside an Iranian Red Crescent medical tent. The cornflower-blue sky was crisscrossed by cat-claw marks from the contrails of U.S. warplanes, whose bombs can turn Afghan mud hovels into powder just from the shock wave.

A small boy, maybe six years old, took my hand. I had no idea where his parents were. He just came up and snatched my hand, his small fingers pressing into my palm like pebbles. He leaned into my leg. We stayed that way for a few minutes. What could I do? What assurances could I give? In the end, I gently pried our hands apart. I can still feel the resistance in his fingers. Our cultures and lives couldn't have been more different. But his hand in mine felt just the same as my young daughter's. I gave him some Iranian rials and

went back to my clean sheets and cold bottled water in the best hotel in Zahedan, an Iranian city near the border.

Normally, I wouldn't have wanted to return to the camp. I've seen many disturbing examples of man at his worst—from Balkan killing fields to Rwanda to the 2003 Iraq war—and always tried hard to put some comfortable distance between myself and the memories. But it's a wobbly buffer with many weak points. This time, it didn't stand up. Maybe it was that boy. I couldn't really say. But my thoughts kept spinning back to that lonely expanse. I made plans to return.

My attempts to learn more about carpets were also carrying me across Afghan history, with all its majesty and flaws. So much of Afghanistan seems like an echo of an echo. These scared families in the camp—some digging trenches as their only shelter—probably do not look much different from their ancestors who fled to the hinterlands to survive Genghis Khan's riders. Or Timur, the limping conqueror. Or the cannon shells from the Persian siege of Herat as Lieutenant Pottinger encouraged them from the ramparts.

I left Farid and Ibrahimi back in Herat. They gave me promises to arrange a visit to some traditional village carpet weavers. I had no way to check on the progress of the plans. There were no international phone connections to Herat. I thought about making that wearying journey from the Iranian border again.

But first I needed to revisit the camp.

There were no more Taliban this time. Their rule had come to an abrupt end. But that didn't lessen any of the misery. The displaced kept arriving. They were chasing sketchy—and sadly false—rumors that there was ample food and shelter at the camp. Some straggled in just ahead of the sandstorm.

The towering sand cloud moved over the midmorning sun, casting a sepia-colored pale over the whole wretched panorama: the child's

fresh grave in a haphazard cemetery; Afghan families in sagging shelters of sticks, cloth, and plastic; the more fortunate in sturdy tents donated by the Iranian government.

"Come, please, we must run," one of the mourners shouted.

We were only a few steps from the grave site when the sandstorm washed over us. My eyes burned. I fumbled for the secondhand scarf I had bought from a street vendor before crossing into Afghanistan. The fabric smelled of diesel fuel and sweat. I ran close behind Mohammad Rahmin, who had served as my interpreter at the grave. His job back in Kandahar was hauling Afghan carpets over the border to Pakistani merchants.

"Come, please, down here!" shouted Rahmin over the distinctive rage of a sandstorm: part hollow rumble, part hiss.

We ducked behind a small berm that offered some protection. Here, Rahmin's family had cobbled together a hovel of rags and plastic sheeting that was knotted to sticks. Rahmin unrolled a carpet that was wedged into a corner. He draped it over my shoulders. Then he joined me underneath. His wife and two young sons had already taken cover under a thin shawl, where sand was collecting in the folds. It was much quieter in our carpet cocoon. Pinpricks of daylight—like unknown constellations in a strange sky—appeared through the places where the weave was loose or worn. Rahmin pulled his knees into his untrimmed beard. He knew of my fascination with carpets. He had a story to tell.

"My grandmother made this carpet when I was a boy. We lived near Herat, a capital of great importance since the times of Persia. You must see it. I only left to make money with these awful Pashtuns in the south. I must have been very young, because I can remember only little fragments of her making this carpet. There was a big pot where she made the dyes from different things. There were some leaves and dry plants. I remember the colors so well. I had never seen such things. It was from nature, the world where we walk, but also—how can I say?—part from somewhere else. Maybe from God. At least this is what was in my mind as a silly boy. It all seemed somehow magical, I tell you. It was just a carpet, I know. But to a boy's imagination it was *too* much more. I mean, so much

more. I am sorry, *agha,* for my English. This carpet was a wonder to me. You want to know a secret? I still think I was right. A child can see the truth easier than we can sometimes. Is this not true?

"See these designs, these *guls?*" he continued. "All the homes in our village make similar ones. Similar, yes, but not all the same. My grandmother made hers always with an extra border of a bright yellow. This is how anyone would know it was hers. You can't see it now. It's too dark under here. I will show you when the storm ends.

"Where was I? Oh, yes. When my grandmother died, I was still young. I remember whispering into the carpets, thinking my grandmother could hear me. Does this sound strange to you, *agha?* It is not, believe me. On the contrary. I do not believe it strange at all. And why is that? I think what we make, what we say, what we do are all little parts of our soul. We leave these things for others to find and collect. This carpet was from my grandmother's hand and her mind. It is now with me and my family. My wife has fixed the rips. She has beat the dust out and cleaned it and let it dry in the sun. I carried it to this camp on my back as if it were a sick child. Life is in this carpet. So why is it wrong to believe that my grandmother is not still connected to this carpet she made; that she can feel the love we put in keeping it clean and repaired? I know the mullahs—and, of course, all these Taliban—would find what I say very bad. They would say, 'Rahmin, you are not a Muslim. You are talking to a carpet when you should be talking to God.' I do talk to God. I pray. God has not told me what I believe is wrong. What I am telling you is true and from my heart. How could God object?"

Rahmin was done. There was not a word from him for a long while as we listened to the wind gradually ease. Fog lifts. Rain rolls past. A sandstorm settles. The effect is like a Polaroid slowly coming into focus. First, a misshapen stump, hacked apart for firewood, became visible about twenty feet away. The camp came into view next. Finally, the horizon emerged, a brown line below a yellow sky. Rahmin, silently, watched his pitiful new surroundings return.

He made no move to pull away the carpet that still shrouded us. His wife and children slithered out from under the shawl. But Rahmin sat rigid, half in the carpet's dark shadow and half in the partic-

ular gauzy daylight that follows a sandstorm. I found myself afraid to move and intrude on whatever thoughts had snared him. I recalled what he said: *Life is in this carpet.* Yes, I thought, he's right. The moment felt almost embarrassing; it was as if I'd stumbled across someone's love letters or most intimate secrets. Here, around me, protecting me, was perhaps the most deeply personal possession of a man I barely knew.

Taken as a snippet—a chance encounter—Rahmin's tale would have been one of those dazzling folk monologues that journalists are often privileged to hear. But now, for me, it was spice for a bigger meal. Wasn't this what old Mohammad Reza advised back in the Tehran bazaar? Be open to the poetry of carpets and it will find you, he said. Back in Herat, Ibrahimi, too, spoke of the divine.

I started calling it the theology of the loom.

It began as a raw, ill-formed concept built on intuition and hints. Gradually, like the sandstorm lifting, I started to discern some clearer lines. Some I recognized from different times and places.

Years ago, in a Bulgarian monastery during a bitterly cold evening, I was led to a candlelit sanctuary to see the monks' main treasure: *The Virgin with Three Hands.* The icon, a two-hundred-year-old copy of a much earlier original, is sought out by pilgrims who believe in its miraculous powers. Two hands cradle the infant Jesus. A third hand, crafted of silver, floats at the bottom of the icon and represents the story of John Damascene, or John of Damascus, an eighth-century civic-spiritual councillor who strongly opposed the iconoclasts and their fight to scrub Christianity clean of man-made objects of devotion. Legend has it that John was falsely accused of conspiring to overthrow the Muslim rulers of Damascus. His punishment was a scimitar blow at his wrist. But, legend says, his severed hand was miraculously reattached after prayers to the Virgin. The monk who escorted me turned away from the icon and took a simple, rough-hewn wooden cup from a table.

"You may marvel at the icon and all the beautiful objects as ways

to contemplate God. That's perfectly fine," he told me. "But don't ignore the ordinary. For me, this old cup is as close to God as any icon or thing of gold."

Drawing spiritual inspiration from the works of man or nature is as old as the oldest talisman. It could be as awesome as cathedrals and temples, or as simple as this monk's cup. Children imagine heaven floating on clouds. A physicist can contemplate the Almighty in the nervous electron. Islamic calligraphers strive to unite the flowing strokes and swirls of Arabic with the sacred words of the Quran. The Chinook tribe of America's Pacific Northwest has a lovely saying: Pray with your senses. It was expanded by the Nicaraguan priest-poet Rev. Ernesto Cardenal, who wrote: "There is a style, a divine style, in everything that exists, which shows it was created by the same artist."

I have come to believe that carpets are one of the great crossroads of these fundamental spiritual and creative yearnings.

Carpets could predate the earliest known forms of writing. Pottery and other utensils may have an older legacy, but it's rooted more in function and practicality. Carpets add elements of flair and fancy. In their *guls* and patterns, they possess unbroken links to the earliest forms of expression and self-awareness. Sociologists and others have explored the spiritual side of carpets. But it's always done with a bit of academic caution. There is no hard codex, no sacred text, to point the way. Weavers and sellers and others immersed in carpets have no hesitation in heading in that direction, though. They often draw clear lines between carpets and what I can describe only as a protospirituality. It's not an organized and codified set of beliefs. It's more of a sense of wonder and possibilities. The challenge for weavers is the same that has taunted artists forever: trying to sense a divine power and represent this feeling in form and color.

It's the quest to preserve the special "luminous knowledge," in the words of Seyyed Hossein Nasr. In a lecture in May 2003 at Harvard Divinity School, the Iranian-born author and Islamic scholar suggested that the backbone of traditional societies—"the empowering and illumination of our consciousness"—has been shattered by

modern appetites: gobbling up as much information as possible without resting to look for deeper connections. He didn't mention carpets at all in his address. But I wouldn't have been stunned if he had.

Rahmin had whispered of such things during the sandstorm.

Rahmin stirred. The ground shook as a truck passed. It was bringing more Afghans to the camp.

"Let us see who has come," said Rahmin, grabbing the carpet and shaking loose some sand from the now dying storm. "Perhaps I could trade this for some food."

"You would give this up?" I asked. "This carpet? Your grandmother's?"

He looked at me gravely. "You cannot eat memories or stories, no matter how sweet."

He crouched down and whispered to his wife. It was rare to see an Afghan couple acting with such intimacy in public.

"I told her I would try to barter the carpet," he told me.

"And she said?"

"She said only that she is hungry. The children are hungry. It is a bad time. I should do it."

A 1980s vintage Soviet transport snaked among the squatters. The truck seemed like some sort of desert beast trailing a squall of coffee-colored dust. In the front, its uncovered engine snapped and growled and spit beads of hot oil. Its chassis shuddered as if trying to shake off its miserable cargo. The truck that carried them also bore another deep truth about Afghanistan that deserves repeating in Washington and other capitals during the latest attempt to recast the region in a new image. Invaders and occupiers have always paid heavily in blood.

Armies from Alexander the Great onward were often pinned down by stubborn local revolts. Powerful Persia was rebuffed. At least fifteen thousand Soviet soldiers died in Afghanistan during the 1979–89 intervention. The jetsam of the Kremlin's folly dots

Afghanistan: disabled tanks stripped of any valuable parts, ammo boxes now used to store carpets during the summer, and the trucks bringing the displaced Afghans to the camp. But perhaps the epic British losses are the ones most picked clean by military historians.

About a generation after the Khyber Pass slaughter of "retreating" British forces, another bloodbath occurred in a place called Maiwand off to the east of the camp where Rahmin and I huddled under his carpet.

On a blistering late July day in 1880—with some reports estimating the temperature at 120 degrees in the shade—a column of twenty-seven thousand British-Indian foot soldiers and cavalry met an irregular Afghan force of tribesmen and Islamic zealots loyal to Ayub Khan, the governor of Herat who sought to overthrow the pro-British emir in Kabul. The British side included an Indian infantry with very little field experience but possessing overwhelming firepower led by the feared Snider .577 BL rifle and artillery capable of firing nine- and twelve-pound balls. But Khan's side also had artillery and had swelled to at least twenty-five thousand riders and footmen as it moved south from Herat. They included Muslim religious warriors known as *ghazi,* "fanatics who fought like fiends," according to the account by Captain Mosley Mayne of the 3rd Bombay Cavalry. He described a withering Afghan artillery barrage while "the enemy, cleverly using dry watercourses and folds in the ground" moved within five hundred yards. "Only their banners and the heads of their mounted leaders were visible," he wrote. A last British-led cavalry charge failed. By dusk, the British and Indians were in retreat. But Kandahar was forty-five miles away. The survivors had few supplies and almost no water, and were constantly under hit-and-run attacks. The death toll exceeded a third of the original force, or more than 950 soldiers. The British newspaper *The Graphic,* displaying a jingoism that still haunts journalism, noted that many of the dead were "European." One hundred and sixty-one were wounded.

Rudyard Kipling, like many proud Victorians, was deeply affected by the troubles in Afghanistan. Many believe it was Maiwand that was behind the gloomy patriotism of *The Young British Soldier,* published in 1892:

When you're wounded and left on Afghanistan's plains,
And the women come out to cut up what remains,
Jest roll to your rifle and blow out your brains
An' go to yer Gawd like a soldier.

The first soccer match in Kabul after the fall of the Taliban was between teams named Sabawun, "daybreak," and Maiwand, which is also the name of a main street in the capital.

But it's probably the fiction of Sir Arthur Conan Doyle that's most responsible for keeping the memory of Maiwand alive.

His creation, Dr. John Hamish Watson, was struck by a bullet from an old, but still lethal, Jezail musket and was saved by an orderly who threw him onto a packhorse that managed to reach British lines. In his first Sherlock Holmes novel, Doyle crafted a pivotal encounter: the humble and steady doctor, still nursing his wound and weakened from fever, meeting the brilliantly eccentric detective. It was a year after the battle, and Watson was about to take up residence with Holmes at the fabled No. 221B Baker Street. "How are you?" were the first words Holmes spoke to Watson. "You have been in Afghanistan, I perceive."

In reality, Doyle was sailing in the Arctic on a whaler when the Maiwand rout occurred. He was also dabbling in spiritualism and the paranormal. He was a resolute believer in the afterlife. I wish I had his unwavering convictions with what I saw around me in the camp.

"Food! Anything! Bread, rice!" cried Rahmin as about a dozen newcomers clambered off the truck. "Food, please. For my family. Food for this carpet. Please. Very nice. You will need it in the night here. It's cold. Please! Food!"

There were no takers. Right now, even one loaf of the thin Afghan bread was more valuable than Rahmin's coveted carpet. The money I paid him to translate had no value here. The last man out of the truck's flatbed also carried a small carpet rolled under one arm. In the other, he held a small girl, his daughter Idema.

He rocked her for a while, stopped to check her breathing, then started rocking her again. He couldn't tell if this still gave her any

comfort. It had before. Just a few weeks ago. She would smile and giggle a bit, and for a moment there was a hope she would recover. But Idema had stopped laughing. Then talking and, finally, eating.

It happened during their meandering passage from Kandahar, the epicenter of power for the reclusive, one-eyed Taliban leader Mullah Mohammad Omar. Idema's clan—uncles, aunts, cousins—first followed the baked mud paths threading between the southern Afghan villages of the Taliban heartland. They assumed the American bombs would hit only main cities and roads. So did many others. Day by day, the exodus grew thicker and more panicked. The horizon to the west was mostly clear of bombers and jet fighters. This is where they streamed. It was said over and over again, as if words alone could make it true: food and medical tents were being set up near the Iranian border.

It was clear Idema was slipping away. Her legs, now no fatter than her father's thumb, were stained with watery feces. Dysentery, severe and relentless, was devouring the four-year-old who loved to decorate her wrists with bracelets made of colored foil. They now slipped, one by one, from her frail arms. The family raced toward the main southern highway, a rutted and broken patchwork of asphalt and dirt. They jettisoned anything deemed unnecessary: cooking pots, clothes. They never considered leaving their carpet, a simple swath of coarse wool dyed and woven before Idema's father was born.

Mismatched threads used for repairs zigzagged on the edges. The stains and dirt were so dense, the carpet at first appeared as a dull monotone. Then, as if you were looking through eyes adjusting to a darkened room, images and details took shape. They were hidden like fossils below the grime: a field of strong iron red and a series of ocher eight-sided *guls* running in lines of three through the center.

In the camp, Idema's family dug a small trench and lay down. They set Idema gently on the carpet. Her head flopped to one side. Her eyes seemed like oversized marbles wobbling in her emaciated face. She blinked slowly.

"I see her like a ghost now," said her father. "She is here in this world with us. But this is like a lie. God is just waiting to take her."

The family huddled in the narrow pit and chipped at the sides for more room. I couldn't shake the image that they were digging their own graves.

I heard that Idema died a few days later, her hollow cheek touching the center of the carpet.

The family left the camp and did not return to their village. Perhaps they crossed into Iran to join the nearly two million Afghan refugees already there. Maybe they found another village. I probably will never know. Our time together was like the sandstorm: sudden and intense and then over.

That night, I turned to Hafez. I had found a book with less stilted translations. I didn't open it at random this time for counsel. I looked for some comfort. I found a line that I read over and over.

Only when the demon has gone out will the angel come in.

The next morning, a colleague in Tehran called. The Afghan embassy said I could pick up my new visa at any time. I'd started making plans to return to Herat within the month. Ikbol and his Toyota would be waiting.

Water is a Turkmen's life, a horse is his wings, and a carpet is his soul.
 —Folk saying from central Asia

CHAPTER FOUR

GIRLS AT A LOOM

 Herat was behind us.

The old city wore a crown of smoke and yellow dust that had settled low enough to allow a few landmarks to poke through. Most prominent among them were the crumbling minarets of the Musallah. I looked back toward the city. From this distance, as we moved from the river valley of the Hari Rud and into the mountains, they were the size of matchsticks. Then we turned into a grove of stubby pine and juniper.

Herat was gone. Wilderness spread out ahead.

The wilds of Afghanistan toy with me—more so than any place I've been to before. It's the loneliness I noticed first. It somehow seemed bigger and more opaque. It's as if the miles between me and what's safe and familiar were stretched wider and made harder to retrace. There's a paradox, though. Other distances appeared to shrink in the clear highland air. Peaks that are more than a day's travel away were crisp and vivid.

Danger, too, took on a sharper edge. Mistakes and mishaps can

turn ugly with dizzying speed. As in the days of the caravans, getting along here requires wits, planning, and always a dash of good fortune. What surprised me most, however, was a pang I hadn't felt in a very long time, probably since my first backpacking jaunts abroad. It was a yearning for the certainties of home, knowing what's around the corner and what's hidden in the shadows of the cupboards. Hafez, I learned, very rarely left Shiraz. There's just one credible account of an extended trip away from his birthplace in what's now southern Iran. Many scholars assume it was his love of his city that kept him rooted. I wondered if it also could have been an unsteady moment, like mine leaving Herat, that convinced him travel just wasn't worth the bother.

I pressed on.

The mountain spurs that jab into the desert north of Herat are serious places. So much so they even gave pause to the hardened army of Alexander the Great. His forces opted to go the other way—south into the dry flatlands—in pursuit of new conquests. They were also driven by Alexander's personal demons. He was chasing a king slayer named Bessus, who had mortally wounded his liege, the Persian king Darius III, to claim the throne. For Alexander, it was a personal offense that required revenge. The murder spoiled Alexander's plans. He wanted to take Darius alive and declare himself the unchallenged lord of Persia. Bessus's band headed east through the mountains. Alexander chose speed. His soldiers flanked south across easier ground.

I took Bessus's route, which slithered up from the Hari Rud in an accordion line of curves. This was the main road into the mountains. But there was very little traffic. An occasional truck rattled by, sending arcs of mud over our vehicle. A few groaning taxis also passed. Their overflow passengers were packed along with the cargo in the trunks, which were propped open with sticks. I'm normally not superstitious. But this wasn't a normal trip. I started to see omens. Little ones at first: a flat front tire just a few miles out of Herat; a hole in my boot that I fixed with silver duct tape; a leaky tea jug that also received a patch of duct tape, one of the truly indispensable items in any traveler's bag. These incidents fed the appetite of bigger, spookier apprehensions.

What if the rain turns to sleet in the higher elevations? It did. Mine fields? Rusty triangle-shaped warning markers started to appear just off the road's edge. It would have been easy to add up the portents and give the order: Let's head back to Herat until the weather clears. But I stayed silent, telling myself it would most likely be more dangerous going downhill on the slick road. So we rumbled higher into a tongue of rock and crags and shadows and bandits, the Paropamisus range.

The name itself is a linguistic artifact of Alexander, just as some Afghans still call Western medicine *yunani,* or "Greek." The forces of the young Macedonian apparently took the Persian word *uparisena,* or "peak over which eagles cannot fly," and remolded it for the Greek tongue into Paropamisus, the name they gave to the entire Afghan mountain chain that joins the Hindu Kush in eastern Afghanistan and continues, ever rising, to become the lofty Himalayas. Our pass through the Paropamisus circled under a snowy 11,800-foot summit that does not seem to have a fixed name. On the other side was a downtrodden land known as Badghis. The meaning of the name has differing interpretations. To some, it translates to Land of Desert and Rain. Others believe it's from the Farsi word *baad,* or "wind."

They did not appear to be blowing in my favor.

It had taken more than two months to reconnect with Nourulhaq Ibrahimi, the carpet seller I met in Farid's shop. I had become annoyed by the delays. But this is how it goes in the places with few telephones or reliable mail delivery. With our handy cell phones, satellite links, and email, it's easy to forget that such unplugged lands still exist.

Patience, one of my translators once told me in his delightfully fractured English, is a virtual. He didn't know how right he was. Time, and how it passes, is something that's perceived in different ways. To Ibrahimi, it seemed perfectly ordinary to pick up our conversation after a long gap. He even seemed a bit baffled by my sour mood. *Agha,* I have not forgotten you, he cooed. Yes, he said, I know I promised to arrange a trip to tribal weavers. No, he continued, there was no problem. Let me know when you are ready, *agha,* he told me. Any week is good, *insha'allah.* It had simply not occurred

to him that the calendar, in my tightly coiled world, was something that needed to be corralled and controlled. It seemed to me scary—almost irresponsible—to allow things to run loose and unstructured. Ibrahimi was baffled. Time was just a wisp to him. About as substantial as a cobweb.

"What is it, really?" he asked me after I had calmed down with the help of some sweet tea. "Time is something man created to bring order. Am I right? We are the ones who long ago sliced it up into hours, minutes, days. Are these pieces the same length for all? Yes, that is true, you could answer. But think again. It is not true at all. Is an hour praying the same as an hour digging a ditch? Is an hour making a carpet the same as an hour making bricks? The same time has passed, yes, but what this hour means is different for each person. Think about this."

I did. It was another valuable—and unsolicited—lesson in my education into carpets. An average-size carpet—say, four by six feet with a good knot count—can take up to two months for two weavers working eight hours a day. Few tasks I can think of, apart from specialized work such as archaeology or delicate surgery, require so much effort with such incremental progress. The weavers' clock, I was learning, is calibrated far differently from mine. Minutes and hours are just too small to matter. Bigger blocks—weeks, months, or even years—are much more relevant. It's almost an agrarian point of view: season to season, carpet to carpet. I would need to slow down, too. If not, I was at risk of being like a car zipping along on a good road. I would see the sights but roar past the more interesting tidbits and trifles noticed by someone taking it slower. I told myself: For a while, at least, stop tallying and weighing each hour like a bookkeeper. Patience is, indeed, a virtue.

Ibrahimi had arranged for a driver, a four-wheel-drive Suzuki, and a translator. Ikbol, my usual driver, stayed behind in Herat. Even he admitted that his workhorse Toyota was no match for the mountain road to Badghis in northwestern Afghanistan. He knew what he was talking about.

The sleet was coming down more heavily. The wipers did little

except slosh it back and forth. The driver had to stop every fifteen minutes to wipe the windshield clean with an old sock that I think was once white. There was no option of turning back now. We had not seen any other vehicle for more than an hour. Then, just ahead, we caught a glimpse of something. At first I thought it was a clump of trees that managed to hold on at this altitude. But the objects moved. Our headlights glinted off soaked blankets and oilskin cloaks. It was a family—two young boys and a couple I guessed to be their parents—walking from Badghis to the aid camps near Herat.

The driver appeared ready to just swerve around them and leave them in our exhaust.

"Stop, please," I demanded. We skidded to a halt.

The family crowded around the passenger-side window. Small icicles hung from the man's beard. One boy wore a sweatshirt that had obviously made its way through the international relief network. Had anyone but me noticed the cruel irony? It had one of those yellow smiley faces, originally designed in 1963 by a graphic artist as a morale-boosting symbol at a Massachusetts insurance company. It later became the chirpy symbol of the have-a-nice-day crowd. Now, it was grinning its eternal grin in Badghis.

I handed them some money, bread, and packs of powdered soup. The driver revved the engine as a sign we must keep moving. He popped the clutch and we lurched ahead. The family vanished in the falling sleet. We were more than thirty miles from Herat. There was no way the family could make it before sunset.

In 1913, a British poet and diplomat, James Elroy Flecker, described a similar encounter in "The Golden Journey to Samarkand." In his verse, a caravan of well-stocked merchants is bound for the ancient city—in present-day Uzbekistan—where Timur is buried under a massive slab of jade. The caravan crosses paths with bedraggled pilgrims at the gates of Baghdad.

The Master of the Caravan:
But who are ye in rags and rotten shoes,
You dirty-bearded, blocking up the way?

The pilgrims:
We are the Pilgrims, master; we shall go
Always a little further; it may be
Beyond that last blue mountain barred with snow,
Across that angry or that glimmering sea, . . .

Flecker's lines brim with desires unfulfilled and the heady mix of adventure and peril ahead. Our meeting on the road to Badghis was only heartbreak.

If it's possible to measure sadness, Badghis in the early twenty-first century would certainly offer one of the benchmarks.

The province, like all of Afghanistan, had been bleeding population since the 1980s. It wasn't just conflict that forced families to seek the borders of Iran and Pakistan or aid camps near Herat. A long drought made even subsistence farming a losing battle. The rains finally were starting to return when I made my way across the Paropamisus. Young wheat shoots would soon poke through the long-fallow hills. But few refugees had started making the trip home. That would gain steam later. At this moment—between the Taliban era and uncertainty of what would follow—Badghis was a portrait of life left to fate.

There was the resignation that takes over after the punishment no longer hurts. I've seen it among those trapped in war zones or ravaged by famine. There's nothing left. Just waiting. We passed through mud-hut settlements like this. Blank expressions. People too weak to beg anymore.

I've been told there were more desperate places in the interior mountains of Afghanistan. It was hard to imagine. World Vision, a Christian charity and aid group, was one of the few relief agencies working in the region at the time. The needs were endless.

"In general, Badghis is still on the slow road to recovery after being hit so hard by the drought," said Geno Teofilo, a spokesman for World Vision. "They've had little development, especially in

rural areas. Communities off the main roads remain hard to reach. For every school that's built, there are another ten communities that still need one. The numbers that need clinics are even higher."

There is an area of southeastern Badghis called the Jawand plateau. World Vision has worked to build passable roads into Jawand. Teofilo described the project as "kind of like opening up the lost world of Afghanistan."

"It's like stepping into a time warp: no electricity, no plumbing, no health services," he said. "Little has changed there in the past two thousand years. They have no roads at all. Zero. There has never been a road vehicle in this region in their entire history. Ever. Their major means of transportation is by donkey."

Our heated Suzuki seemed like an almost obscene luxury. In a stinging sleet storm, with daylight fading, we came to a stop. I thought we had become bogged down in the semifrozen mud. Instead, the driver smiled with relief, perhaps tinged with disbelief. We had made it.

"We're here?" I asked.

"No, just for the night."

We were still some distance from the provincial center of Qala-i-Naw, where I guessed there could be some type of basic hostel. The driver said it was too dangerous to continue at night. I certainly didn't argue. He began looking around the village for a place to stay. In many parts of the world, we'd be left to fend for ourselves. I knew enough about Afghanistan to relax. Doors would open for strangers. They always do.

A few minutes later, we were in the mud brick home of Ruhollah, a wizened village leader with spectacularly rotten teeth and eyes that oozed a watery pus from some type of infection. He was forty-two years old—exactly my age at the time—but looked decades older. It didn't surprise me. It's a depressing fact of life in the world's hard-knock places. Youth evaporates at a startling rate.

Our mud-caked shoes were left outside. We sat with Ruhollah on the floor in a bare room covered by carpets with the geometric motifs typical of the Turkmen, descendants of nomads who may trace their roots back to Mongolia. In one corner a dented metal urn

caught a steady drip from a leak in the roof. The drops made a loud popping sound when they hit. In the other corner was a reminder of the instability that helped turn Ruhollah into a prematurely old man: two antique bolt-action rifles—loaded, clean, and well oiled—sat atop a box of ammunition. One of Ruhollah's boys brought in tea and plates of fresh pistachios, a principal source of revenue that survived the drought because of the trees' deep roots. Soon, other men from the village arrived. Each time, we rose to shake hands solemnly and offer the standard greeting of the Islamic world: *salaam alakum,* "peace be upon you." More men. More tea. More than a dozen filed in and sat with their backs to the wall. The boy emptied the urn under the roof hole and replaced it before another drop fell. The men waited for their host to speak to me first.

"Welcome, mister. You will pass the night in our home," said Ruhollah, who goes by a single name, as do many Afghans. "Was your journey good?"

I was about to recount the treacherous road and the hungry family but stopped myself. I didn't think I needed to enlighten these men about the hardships around them. "It was very good," I said simply, touching my chest with my right hand in a symbol of gratitude. "Thank you for letting us stay in your home."

He also touched his chest. "To have a guest is a blessing," he said. "You are sent by God."

There is an Afghan proverb that says: The first day you meet, you are friends. The next day you meet, you are brothers.

Afghan hospitality is the stuff of legends. But so often legends prove to be just campfire stories. Not here. An Afghan welcome is, in my experience, genuine and generous to the point of embarrassment.

I've been offered carpets, knives, and, most touching, a sack of eggs from a family who obviously couldn't afford the loss. The codes governing Afghan largesse toward strangers haven't changed much even as the world around them has outgrown many of the old customs of the road.

"Afghan hospitality, so widely heralded, has a flavor all its own," wrote Ernest Fox, a member of an American geologic team that spent

parts of 1937 and 1938 exploring Afghanistan for oil and minerals, often on horseback or on foot. "It often intoxicates the newcomer with sweetness, but leaves him with a headache afterward."

Even Friedrich Engels turned his attention briefly to Afghanistan's culture in an article published in 1857, nine years after *The Communist Manifesto*. He observed that Afghan hospitality "is so sacred" that it will extend to even the most "deadly enemy." A report earlier that century by Mountstuart Elphinstone, an official with the British East India Company, was full of the empire's stereotypes of Afghans as valiant but shifty. "Yet," Elphinstone continued, "he would scarce fail to admire their martial and lofty spirit, their hospitality, and their bold and simple manners."

The Taliban resistance to turn over Osama bin Laden—even at the threat of their own demise—comes from the same spring.

"Where is your home and the home of your father?" one of the men asked me.

"I am American. I was born in a place called New Jersey. It is near New York."

The men nodded gravely. I steeled myself for a barrage of questions about the September 11 attacks, bin Laden, and the world's sudden preoccupation with Islam and terrorism. But one man spoke up with an unexpected twist: "Do the American people know about Badghis? Do they know that we are weak and poor, but we will be strong again someday?"

"Oh, yes," I lied. "Badghis is well known."

I couldn't tell if they believed me. They knew the Pentagon had attacked their country. They barely knew why.

From another room, I could hear women preparing food around a fire. There also was the low whistle of a propane camp stove. I whispered to my translator if it was possible to refuse the meal. I was afraid this family was tapping precious food stockpiles. The translator winced. No, he said, we mustn't be rude. Afghan hospitality cuts both ways. The guest must be a gracious and grateful recipient.

We ate our fill of pilau, a traditional dish of rice, meat, vegetables, and raisins. It was growing dark. The boy brought in a kerosene lamp and set it in the middle of the room. Hulking shad-

ows of the men rippled over the uneven walls. Their beards and fingers were varnished by the drippings from the chicken in the pilau. I was stuffed, warm, and sleepy. It was a good night. I offered the men the small cigars I like to smoke. A few accepted and puffed away. I was thinking how interesting it would be to bring these men to my reality. Their gentleness and generosity to strangers may change some frightening generalizations about the Muslim world. That is, if anyone in middle-class America would be willing to open their homes in the same way as here.

The driver, translator, and I slept on carpets in the room where we ate. In the middle of the night, I faced a tough decision. I had to pee. This meant getting out from under my woolen blankets, slipping on my cold boots, and trudging through the mud to try to find an outhouse—if there was one. At least the sleet had stopped. I made my move. When I was outside, however, the idea of hunting for a privy was instantly abandoned. The darkness was overpowering. I felt my way along the wall of the house. Men in this part of the world squat to urinate. It reduces the risk of being splashed by drops of urine, which is considered a shocking impurity. I figured I should do the same on the remote chance anyone was watching. I used one hand to brace myself against the wall and hunched down. The operation was a flop. I relieved myself, but mostly on my boots. Thank goodness for the duct tape over the hole. But the reward for the embarrassment was priceless: a clear sky and stars as bright as fireflies.

I awoke shivering. A lacework of ice crystals covered the windows. Frost dusted the ceiling beams. My fingers felt frozen and sluggish. At least it was a sunny day. Ruhollah was waiting with warmed-over tea, which was bitter and the color of dirty copper. I put a fresh strip of duct tape on our leaky jug and filled it with the brew. We were off.

By afternoon, we were coasting downhill alongside the gin-clear Murghab River. The land began to flatten. We were on the cusp of a region that was widely known as Turkestan well into the last century. To the north—over the border into the former Soviet republic of Turkmenistan—was the forbidding desert called Kara-Kum, or

Black Sands, and the oasis city of Merv. It was renamed Mary by the Russians in 1937, long after they had brought the area under their control.

Like Herat, Merv was once a great hub of learning and culture until the Mongol onslaught in the thirteenth century. The Merv carpets, however, remained a source of dignity for the locals. In Russian war chronicles from the late nineteenth century, there are accounts of Turkmen forced to pay a losers' bounty. Even though cash was scarce, the Turkmen refused to give up their carpets at cut-rate prices to pay off the Russians. "They simply named their price, and you might take the article or leave it, as you pleased," said one report following an 1872 Russian victory over a Turkmen tribe.

We were near Bala Murghab in Afghanistan's Turkmen belt, which accounts for no more than 3 percent of the country's ethnic jigsaw. The differences between here and the other side of the Paropamisus range were instantly noticeable. The cultural ripples of central Asia were strong. The women here favored colorful head scarves instead of the burqa; men wore quilted coats and the broad fur caps of the steppes. My carpet connection, Nourulhaq Ibrahimi, has intermediaries and minions combing the area for pieces to smuggle to Mashhad. But few carpet hunters—or any outsiders, for that matter—had yet to venture to these outposts. We were engulfed by villagers all talking at once and looking me over as if I were a zoo attraction. It happens everywhere in Afghanistan, but mostly by people looking for a break in the routine. This time, I felt like a genuine curiosity. A bold boy even touched the pale skin on my hand. The last time this happened to me was in central Africa.

I had come to see weavers. It took only a few minutes to reach my goal. We were led immediately to a mud-and-straw house. The girls were still at work in a room connected to the main house by a corridor too narrow for my shoulders. The loom covered almost the entire floor. We inched along a wall and wedged ourselves into a corner. About a third of the carpet was finished.

The girls—two sisters and a cousin—squatted in bare feet despite the cold. The toes on the youngest, an eleven-year-old, were done up with light pink polish to match her shimmering head scarf. There

was no pattern to follow next to the weavers. No leader directed the knotting. It was just intuitive, a series of well-practiced flicks of blade and wool. Somehow, the *guls* and lines of the three girls merged flawlessly. They acknowledged me with shy smiles, then returned to their carpet.

Their tribe, the Saryk, is on the southern edge of central Asia's Turkmen homeland, stretching from the Caspian shores to Tajikistan and Kazakstan more than a thousand miles to the east in an area bigger than California. The precise origins of the Turkmen people are lost in the unwritten history of inner Asian migrations. It's believed that a group known as the Oghuz left Mongolia in the eighth century. They drifted over the steppes and became the ethnic base for the more than two dozen Turkmen clans and other branches speaking related languages. Mongol invasions pushed the Turkmen farther west into desert areas in Persia and around the Caspian, where they would encounter a less-than-friendly reception from Russian speakers and their allies. It later flared into open conflict.

The Turkmen fared better with the Persians. Perhaps a shared interest in carpets was an important bond. The Turkmen were used to adapting. It's an essential survival skill of nomads. They soaked up elements of Persian carpet designs and coloring that were later incorporated in the distinctive Turkmen *guls*. The Persians, too, borrowed some of the Turkmen influences: the sturdy weaves needed for horses; depictions of animals and caravans; stylized floral patterns and eye-pleasing geometric repetitions.

The ethnic foundation for present-day Turkey comes from the same stock, although their language picked up different influences as it rumbled west to rub against the Byzantine and Roman empires. To carpet collectors, some of the Turkmen tribal names are well known and important, particularly Tekke, Salor, and Yomut.

In New York in December 2003, bidders at a Sotheby's auction exceeded nearly all the expected prices for Turkmen pieces, including a nineteenth-century Saryk carpet (7'10" by 8'8") that sold for $24,000, a Yomut carpet (5'4" by 9') from the same era that fetched $16,800, and a Tekke *torba*—a type of small woven bag—that brought $10,590.

Most—but not all—Turkmen *guls* are variations on an octagonal design. Typical features are alternating blocks of color with a dominant red-to-brown palette that was once obtained exclusively from madder. The carpets, however, are often deceptively intricate. The larger blocks contain so-called minor *guls.* These offer an interesting subtext, serving as stylistic signatures for tribes. There are also possible hints of the long-ago nomadic beliefs that were washed away or heavily diluted by Islam. Some scholars of the Turkmen carpet motifs—what have been called Turkmenoglyphs—see touches of the shamanistic past in designs that suggest trees, birds, or rams' horns. Others see patterns designed to scare away spirits and ill fortune—the Turkmen "evil eye"—on motifs adorning *ensi,* the felt or pile rug coverings originally made for the entrances of Turkmen tents.

I sat for a while to watch the girls work in the fading light.

A crowd of family members stayed by the door. Afghan hospitality has its limits. One of them is allowing an unrelated man to be alone with their daughters. Still, it was easy to forget the hawkeyed chaperones and absorb myself in the weaving. After a two-day trip over the mountains, I finally had my prize: my first real contact with the lifeblood of carpets. Hafez-quoting merchants or the young boys in the Herat workshops are part of the tableau. But these girls represent something far more essential. Carpets in this part of the world have a deeply feminine soul. I felt privileged to be in its presence.

It wasn't until later that I fully appreciated how much of an honor it was. A letter of introduction from the carpet merchant Ibrahimi allowed me to cross one of the most impenetrable barriers of Afghan society: the purdah and its many rules that govern the separation of the sexes. The word, from Persian, literally means curtain. The burqa obviously comes to mind. But that's only a part. Purdah is everywhere. Many homes have clearly defined spaces for men and women. Taken to the extreme—as during the Taliban—it can mean seclusion for girls and women and access to only rudimen-

tary homeschooling or health care. The system is reinforced by traditional Islam and Afghanistan's complex codes of family pride and honor.

The pressure for conformity on women was boiled down by a judge in Herat who deals with domestic issues. Women, the judge told me, are the bedrock of society, and any deviations from the norm are interpreted as a dangerous social disintegration. In other words, women have immense social power but face equally strong limits. Women are told: The future of society is in your hands, so listen to the men. The men hear: The future of society is in your hands, so make sure the women listen to you. This kind of social tug-of-war is at play in many places beyond Afghanistan. The glass ceiling of the Western workplace could be seen by some as a distant cousin.

I watched the girls work and thought about the shortfalls of written history. Heroics and daring make good reading. But simplicity, dutiful repetition, and the safety of domestic spaces—the stuff often shunned by historians—are perhaps closer to the foundation on which everything rests and connects. Hafez was teaching me that. So was this scene in front of me, my brief peek through purdah. These girls, barely able to write their names, were adding to a historical record no less important than any political transcript. These carpets mean something, and the weavers are part of a vast and ancient sisterhood.

"In the rural areas," said a U.S.-funded research paper on Afghanistan in 1997, "interrelated responsibilities between men and women establish a bond of partnership that builds mutual respect. Carpet making is but one example. The men herd and shear the sheep, the women spin the wool, the men dye the wool, the women weave the carpet, and the men market the product."

It's a nice, tidy summary. But as with almost everything in the carpet world, the reality is not nearly so neat. Women are undoubtedly the caretakers of carpet weaving and design in most parts of the

Persian world and central Asia. The murkiness enters with attempts to evaluate how much freedom they really have to pursue their imaginations and innovations.

The nomadic cultures that may have produced the first weavings depended on mobility and meticulous attention to their stable of horses. These duties fell to the men. Sedentary and time-consuming chores such as making clothes or carpets would almost certainly have been part of the women's sphere.

"There is no way to separate the history of carpets and women," said Henry Glassie, a professor of folklore studies at Indiana University and a leading expert in carpet production and gender studies. "It's always been a women's art and, probably, it always will be to some extent."

But it gets a bit blurry.

In fact, ambiguities may have started to creep in long ago when carpets first became objects to barter or sell. Men generally cut the deals and sometimes had family competing against family. This naturally required close study of the type of carpet that was most attractive to buyers. Their ideas—a kind of rudimentary market research—were then brought back to the women and girl weavers for future carpets.

"So you have the male influence—or really the commercial interest—exerting itself," Glassie said. "Suddenly, women were losing their control."

It has further eroded with the shift from the type of independent, home-based weaving I witnessed in Afghanistan. Now, many carpets are woven in workshops or by villagers using what are called cartoons, or designs sketched on graph paper. Factory looms have taken it a step further. Computer templates allow a customer to custom-tailor a carpet for patterns, color, or even the depth of the wool pile.

"The women even have a word for a carpet done from a design," said Glassie, who spent nearly a decade researching Turkish weavers and others involved in carpets for his highly regarded book *Turkish Traditional Art Today.* "They call it a picture of a rug. To them it's not a genuine thing. It's not a carpet that's organic. It's not a thing

that comes out of itself, but something that has an overlay on it."

As Glassie told me about his work, I realized how fortunate I was to spend time with the Turkmen girls. This type of purely domestic carpet weaving has been mostly lost in Turkey and many points east. Conflict, poverty, and harsh geography had kept away many modern currents from Afghanistan. But for how long? I wondered if the daughters of the Turkmen weavers would work in the same tradition as their mothers. Glassie was not shy about offering a dose of pessimism.

"Male intrusion has killed off the best of Turkish weaving," he said. "The carpets made and designed specifically for the market have none of the freedom and flavor of what I'll call the 'real' ones. This is a force that is happening everywhere—and it's hard to see any place escaping."

Glassie has also spent considerable time looking at the gender divide in the way carpets are interpreted.

He's found that carpet merchants—almost exclusively men—tend to see carpets through "rigorous Islamic sensibilities." For example, the central medallion typical of Persian designs is often seen by men as a godhead with elements of mercy and creation radiating out, Glassie said.

But he has encountered many women weavers who speak a different language. Theirs is more attuned to the vocabulary of the abstract artist, focusing on the relationships of color and form rather than the confines of the Quran.

"I've found the women are much more attuned to the feeling of the carpet rather than trying to put a name or definition to each pattern or motif," Glassie said.

But he also saw no contradiction in the differing views. This is part of what intrigues, and often infuriates, me about the carpet world. It's a bottomless pit of opinions, guesses, hypotheses, and just about anything else. Why shouldn't there be a classic "he said, she said" dichotomy tossed in as well?

"Look at it this way," Glassie advised. "Forms can persist when meanings shift."

I asked him to elaborate. The point is that cultural and con-

temporary reference points are not constant, but symbols and designs, such as carpet motifs, may remain the same. A form that was seen as thin trees in pre-Islamic times could now be interpreted as stylized minarets. A swastika is another potent example. Its meaning in the West is clear and chilling. In the East and elsewhere, it's a common form that to some represents the sun or the cycle of the seasons.

These disjointed impressions are not just for carpets. It happens to many Westerners in places such as Afghanistan. What's seen in the streets, markets, or mosques offers only a partial rendering of society. The rest of the picture exists in the world behind the gates and walls that typically enclose Afghan homes. Here, it's the men who seem diminished and meek. The matriarchs often control the purse strings, doling out allowances and setting the family's economic priorities. I once watched a militiaman—with an AK-47 slung over his shoulder and bandoliers crossing his chest—beg his wife for some pocket money for tea and biscuits before heading off to battle the gang of a rival warlord in northern Afghanistan.

But more was going on besides tapping into the family piggy bank. Women in the home assume a confidence that, to an outsider such as myself, was hard at first to reconcile with their sidelined role in public. I, too, was guilty of seeing the burqa only as a barrier and mistaking silence for submission. Understanding carpets better also required a deeper look at the lives of their principal makers.

I studied Noor, the mother of two of the girl weavers and the aunt of the third. Her name means light. She was initially wary of our intrusion into her special domain. She didn't wear a burqa in the house—almost no Afghan woman does—but she kept her head scarf tightly fastened and modest in my presence. She watched me closely the first day. I guess she wanted to make sure there were no questionable overtures to the girls. Her defenses gradually dropped. She even laughed at my troubles with eating on the floor and constantly spilling spoonfuls of pilau down my shirt. I tiptoed toward the topic of gender. She surprised me with her candor.

"What do you see when you see an Afghan woman?" asked Noor. "Do you see someone who fights and makes problems like these

men? What nonsense it all is. What a lot of noise. Women are the real strength. Without the home, there is nothing. Without women, there is no home."

"And there are no carpets," I added.

"And no carpets," she agreed.

That night, by a single candle flame, I hunted through my copy of the *Divan* to see what Hafez might say about the creative powers of women. But, once again, I felt lost and stupid. I had finally become accustomed to Hafez's imagery of taverns and nightingales and the glances of lovers. I was now struggling to take it to a deeper, more spiritual level. His admirers assured me it was there. They told me I just needed to reinterpret his colorful verse in another context.

How to do it, though? I had turned to other mystics for help. Finally, with the candle nearly spent, I found *Golshan-e Raz*, or *The Mysteries of the Flower Garden*, from a poet who died about the time Hafez was born. In it, the Persian Sufi Mahmud Shabestari answers questions about widely used metaphors and allusions that would become favored by Hafez, such as wine, lips, and wavy tresses of hair.

Shabestari was clear and helpful. These mystics were simply "using the words we know" to describe the inexplicable: God, life, creation.

I would get back to Hafez. But before closing the book and blowing out the candle, a line from Shabestari caught my eye: Patience and victors are both old friends.

I learned that the girls were making a dowry.

Asli, the oldest of the three weavers, was fifteen. Normally, she could have been married years ago. But life in Badghis was hugely disrupted by man and nature. Hope, however, is stubborn. On this loom, it took the form of a deep red carpet with indigo and ivory *guls*. Someday, maybe, it would be part of the collection brought to her husband's home.

"Are you engaged?" I asked innocently.

Asli blushed and cast down her eyes. I noticed her long eyelashes and thought of Hafez. Eyelashes are among the recurring images he uses for beauty and fragility.

"We don't talk of such things in advance," interjected her father, Mohammad. "She will marry soon, *insha'allah.*"

I was now the one embarrassed. I should have known better. Again, I'd stumbled over a cultural tripwire. Marriages for love may happen in Herat and Kabul. In most villages, it remains an almost unknown concept. Parents often arrange the matches, preferably with a cousin or other relative. It seemed Mohammad had something in progress, but he wouldn't crack. What was clear, however, was that Asli's weaving skills certainly enhanced her prospects.

"Husbands want a good carpet maker," said Mohammad without a hint of awkwardness in assessing the value of his eldest daughter. "She can always make money."

That is, until her eyesight fails or her fingers lose the suppleness to tie the knots.

"Well, then she teaches her daughter," clucked Mohammad as if I was a moron.

So it goes. Mohammad told me of a family of a skilled weaver who received six sheep—a considerable gift—as part of a marriage pact. Another family in a distant village, he said, received $1,000 from the groom's clan, the equivalent of more than four years of the average annual income. I think this was just a rural legend. But I got the point.

I had been too focused on carpets' mystical and spiritual sides. There was no halo here. This was a luxury these villagers could not afford. Carpets meant income and that meant survival. I thought about other societies. In China, cases of abandoning or drowning unwanted baby girls are well documented. Even in contemporary Italy—so modern and hip—old prejudices are still expressed to pregnant women: "Congratulations and have baby boys." Here, out on the edge of the Black Sands desert, carpets gave girls and women some stature as artisans, but they also turned them into a human commodity that can be measured and priced.

"When Asli marries we will have the dowry carpets out for all the

guests to see," said Mohammad, who supplements the carpet income with chickens and their eggs. "They will say, 'Your daughter's family is lucky. These carpets are very good.' We will fire our guns in celebration."

"Can I ask your daughter something?"

"Please, you are our guest."

I turned to the girls. Asli crouched in the center. Her eleven-year-old sister and thirteen-year-old cousin were on either side. Each wore a long, shiny robe over ankle-length flower-print skirts. Their hair was set in twin braids as a sign they were unmarried. They had been whispering and giggling as I spoke with Mohammad. I conceitedly imagined they were gossiping about me.

"Asli, what do you think about when you are making your dowry?"

She looked me straight in the eye and didn't hesitate. "I think about my mother and her mother and how I will be as a mother."

"So these carpets connect you all?"

"These carpets are us. Well, I mean, part of us. Can you separate a shepherd from the flock? One is part of the other. One needs the other."

"But would you like to do something other than make carpets?"

She paused. "I can't think of such things."

But soon she may. Afghanistan will not remain frozen. Without doubt, new points of reference will barge into the lives of Asli and her children the same way I came rolling in unannounced.

It may be things as innocuous—but powerful—as Turkmenistan television pulled in by the makeshift aerials of hubcaps and bicycle spokes or the growing popularity of Bollywood films with their flirty plots and hip-swinging dances. In early 2003, Afghan women were able to get driver's licenses for the first time in more than a decade.

It will be events such as International Women's Day in 2002, when a crowd in Kabul flipped off their burqas to urge for greater freedoms, opportunities, and education. "We want every Afghan girl to have a pen and book in her hands and go to school," declared Sima Samar, who was then the minister of women's affairs. During

the Taliban, women were not allowed to leave their homes unless they were accompanied by a close male relative, and were banned from working except in health care. Schools for girls over age eight were closed.

In 2003, a twenty-three-year-old Afghan student at California State University, Vida Samadzai, became the nation's first beauty contest participant in three decades, ignoring the condemnation in her homeland and donning a red bikini along with the other Miss Earth hopefuls in Manila. She won a special "beauty for a cause" prize. But she can't go home until Afghanistan offers an olive branch and waives the threat of prosecution, which once included a sentence of stoning.

Under a huge tent in Kabul, the post-Taliban officials met in January 2004 and passed a new constitution that gave women equality before the law and guaranteed them 20 percent of the seats in a future national assembly.

But decrees and promises do little to alter the reality, said a U.N. special representative, Jean Arnaux, two months after the vote.

"Physical and psychological threats and violence against women in the public and private domain continue to cast a long shadow," she told a gathering of Afghan women. "There remain very, very heavy constraints that must be overcome if current initiatives to enhance women's situation are to succeed."

Afghanistan has seesawed this way before. In 1959, the king, Zahir Shah, supported the voluntary end to old-style purdah and women began trickling into the public sphere in places such as schools and clinics. It took another step in 1978. The Kremlin-backed government issued the quixotic Decree No. 7, which outlawed the "unjust patriarchal feudalistic relations" such as setting a price for brides. The decree—and everything that supported it— was quickly tossed in the rubbish by the Islamic government that took over after the Soviet withdrawal. The Taliban then restored purdah with a vengeance. No one has ever had an easy time leading Afghanistan. The friction between Western ways and family tradition is just one of the hot spots.

"How do you see your future?" I asked Asli.

"Why do you ask these things?" She shrugged. "God decides, not me."

"But you have some role, don't you?" I pressed.

"Maybe in your country there is planning like this," she replied again, looking me square in the eye. "Here, there isn't."

"Why not?"

"Why be disappointed?" she said.

We sat again in silence. The wooden loom creaked. Wind rattled a loose pane of glass. The room smelled of earthy mud walls and baking bread from the oven outside.

"You try," Asli said suddenly, handing me the knife and a finger-long length of spun red wool.

I tried three times to make the symmetric knot they were using. I failed miserably. Asli smiled.

"You need practice," she said, returning to work.

"Asli," I said, "do you know that some people think there is something very sacred about carpets—"

"If you mean do I think I am special in God's eyes, then no. That is not right," she cut me off, clearly becoming tired of my odd questions. "If you mean do I sometimes sense God while I'm working, then the answer is yes. There are times when I finish a difficult border or *gul* and must stop just to look at it. It is like a small world all alone and separate: perfect and peaceful. God must be guiding our hands, I think. This is how he gets us to look beyond this world. This is what I feel sometimes."

I was stunned. This girl—illiterate and unexposed to any culture beyond her village—was mulling the very questions of metaphysics and theology that have occupied such seekers as Aristotle, Immanuel Kant, and Martin Heidegger.

"And?" I asked, hoping for more.

"Nothing," she said. "Life is a gift. Carpets are just part of the gift."

"And life must go on: marriages, babies, family," Mohammad chimed in. "It cannot be any other way. God does not pity those who give up."

I spent a total of three days with Mohammad's family but never

again had the chance to talk with the girls. There apparently was some family quarrel about me talking so plainly to Asli, even with her father present. I was allowed to watch them work. But, I was told, no more questions.

On the day before we left, Mohammad proposed a trip. We would visit a natural dye maker in another village reachable only by footpath. The dyers were the last ones in the area, he said. The carpet wool used in this part of Badghis is almost all chemically dyed and bought in Herat or other places. It's been that way as far back as Mohammad can remember.

We walked for more than an hour through treeless hills the color of old leather. This was the type of land so favored by Genghis Khan, Timur, and other horsemen able to cover more than fifty miles a day on a hard ride. Turkmen history, too, is intertwined with their magnificent horses, particularly the long-necked and fleet Akhal-Teke breed. Now, keeping a horse was a burden few could afford. A vehicle was even further out of reach. The clock was spinning in reverse. We were back to a time of simple wanderers humbled by the hugeness of the steppe and sky.

The breeze was coming from the north, in the direction of Merv. It smelled of wet grass and thawing earth.

We found the dyer's shack with little trouble. But we were months too late. The dyer and his family had left for the camps near Herat. All that was left behind were some dried pomegranate skins, brittle and wrinkled, used to make yellows. In a bin, there were some clumps of dyed wool. Some of it was madder red.

At least I was on the right track.

Any study of carpets funnels back to one obvious question: Where did it all begin?

There are many guesses. Some are based on archaeological or historical clues. Others are pure conjecture aimed at giving some added glory to domestic carpet industries. The premise with the widest support points back to the central Asian steppes—and some of the earliest sparks of human ingenuity.

Many carpet scholars believe that nomads, roaming long before recorded history, devised tents or windbreaks from flatweaves made of goat hair or other material. The next logical step, the theories suggest, would have been similar ground coverings.

Just when and where the refinement occurred to knotted pile carpets—individual pieces of spun wool or other material wrapped around foundation threads—is a source of endless speculation among scholars, collectors, and historians.

The only certainty is that loom work was already a highly developed craft by the time a fine carpet—with border figures of horsemen and elk—was placed in a royal tomb in the mountains of southern Siberia more than twenty-two centuries ago.

The Pazyryk carpet is named for the valley in which it was found, in 1949, near the borders of Russia, Mongolia, and Kazakstan. It has long been the last major landmark for those trying to peer into the origins of carpets. There are just small hints from earlier times that could someday unseat the Pazyryk: bits of older carpet fragments or possible carpet-making tools found in graves from the Bronze Age, between 4000 B.C. and 3000 B.C.

But for decades the Pazyryk has remained the most celebrated find.

It is a gift from nature, like mastodons locked in the tundra or the five-thousand-year-old "Ice Man" found frozen in a glacier in the Alps in 1991. The tomb with the carpet apparently filled with water and then froze solid.

The carpet, now part of the collection of the Hermitage Museum in St. Petersburg, was found remarkably preserved inside a kurgan,

the timber-reinforced burial mounds for the rulers of the Scythian nomad-conquerors and related tribes. By the seventh century B.C., the Scythians had reached the plains of eastern Europe and later pushed into Mesopotamia and Syria. Some historians believe the prophet Jeremiah was warning of the Scythians when he told the Israelites to prepare for mounted warriors who show "no mercy."

It has not been proven whether the Pazyryk carpet was Scythian-produced or Scythian plunder. But there is little doubt that they had appreciation for superior carpet making. The carpet—about six by six and a half feet—has an average of 225 knots per square inch. That's comparable to a well-made modern piece. The central field is composed of squares filled with eight-pointed stars.

Next is a border with images of a mythical creature similar to a griffin with the head of an eagle and the body of a lion. The borders feature grazing elks and a row of horsemen alternating between riding and walking alongside their steeds. The outermost border is another set of griffin figures.

One of the two Russian archaeologists who discovered the carpet, Sergei I. Rudenko, believed the motifs showed the influence of the Achaemenian dynasty in Persia because similar horse processions were carved at the ceremonial complex in Persepolis in what's now southern Iran.

Other scholars question such possible links and suggest that carpets could have developed as part of the interplay between nomads and settled villagers in the steppes. The nomads would have provided the wool and other raw materials. The villagers would have had the stability and time to devote to carpet making. Some experts contend that the red dyes obtained from insects and other evidence suggest that the Pazyryk was woven in central Asia near where it was discovered. One researcher, writing in *Hali* magazine in 2004, proposed that the Pazyryk weaver could have been an artisan exposed to Persian urban workshop techniques who traveled to central Asia to live among a group closely related to the Scythians. But others, including Hermitage curator Ludmila Barkova, believe the carpet came from farther west in areas near present-day Turkmenistan and Afghanistan.

This theory is appealing. It would place my Herat carpet on a glorious family tree.

I look at this carpet and believe that I'm seeing timeless simplicity: seven rows of three squares, each with a red design that could represent a starburst or flower at its center. Rows of uncomplicated borders proceed outward: a line of red circles, then more starbursts, then waving lines, and finally a spiked *gul* that some experts consider a rising sun. The last major border includes primitive red animal forms and lozenge-shaped *guls* adorned with lines and dots. The border background is a muddy brown.

I brought the carpet to the Tehran bazaar to see if I could get it cleaned before my departure from Iran in a few days. No one could handle the deadline. The carpet was just too filthy.

I passed by a carpet shop whose owner specialized in older Turkmen pieces. He agreed with the carpet merchant's claims in Herat: it appeared to be several decades old and bore the hallmarks of the Timuri weavers.

"This is why I love these classic Turkmen carpets," said the merchant, Nader Ameri. "It's like looking back in the past. These designs, I believe, are very old indeed. But I'm troubled by one thing. You paid too much for this carpet."

"I paid four hundred dollars."

"Too much," he insisted. "Maybe half that would be a good price."

O pigeon! Be expectant, for the falcon hath come.
—Line from Hafez verse selected at random on the way to Mazar-i-Sharif

CHAPTER FIVE

TOMB OF THE SAINT

 I arrived just in time for the Friday dog fights.

I had directions. But the crude map, drawn for me by a hotel clerk, proved impossible to decipher. I was lost in the gritty outskirts of Mazar-i-Sharif.

By chance, I came across a few boys leading a deranged-looking mutt by a rope leash. I did a silly pantomime of brawling dogs. The boys immediately understood and nodded—and then added some disturbing barks and growls of their own. I followed them to the fight grounds and bought my ticket for a price equal to about fifteen cents.

I'm often struck by how many scenes in Afghanistan feel like a time-bending look backward. Before making this latest trip, I came across a book with selections from a Russian collection of century-old photographs from central Asia. Many of the prints seem as if they were made last week. One image, taken in about 1900 by the gifted Russian explorer-artist (and insatiable carpet collector) Samuil Martynovich Dudin, shows a Turkmen boy in a ragged jacket playing with an archer's bow.

Across the dog fight "arena" —really just a patch of packed dirt in a walled lot—I watched Dudin's photo come to life. A boy was firing homemade arrows into a pile of trash. The two children—Dudin's and this one—were separated by a century yet appeared nearly identical, right down to their bare feet. It was just above freezing when the dog fight crowds were assembling.

I had a few minutes before the action. I tried a bit of time travel myself. I imagined what it was like roaming central Asia with Dudin. His bulky glass-plate camera must have seemed like a sorcerer's eye to the nomads and villagers. I then floated back even further. I envisioned myself on a medieval caravan heading to nearby Bukhara or Samarkand and stopping for a little wagering on the dog fights.

It was easy to flit around the ages like this. The setting around me was stripped of almost any modern reference. About five hundred men and boys crowded around the clearing. Bets were taken by a grubby man with a hunched back and some kind of skin-eating fungus on his face. Some spectators nibbled on unleavened flatbread or sweet cookies sprinkled with pistachio crumbs.

The first match was beginning. Two lumbering dogs, both missing patches of fur and with wounds in various stages of repair, were led into the ring. Their owners unclipped the leashes and quickly stepped back. The canine brutes collided. Their jaws snapped. The sound was a sickening combination of gnashing teeth and slapping jowls. Thick cords of steaming drool were flung onto the cold ground. It was over in less than a minute. The losing dog left the ring whimpering and limping on a bloody paw.

"Who will challenge me now? No one? Cowards?" shouted the owner of the winner, whose tail was taped up like a boxer's fist. All the dogs had the hardened look of warriors, a far cry from the willowy Afghan hounds long associated with the country.

One dog owner, Mohammad Rabbani, almost rose to the challenge. Then he thought twice and backed down. His dog was smaller, and he could not risk any injuries. On a successful Friday, Rabbani's dog could bring in the equivalent of $7 in winnings, the bulk of the family's weekly income. "This dog helps us eat," Rabbani told me. "I don't want to take any chances."

He follows a strict prefight routine on Friday mornings to prep Palang, or Tiger: a little running, a lopsided brawl with a weaker dog, a meal of bone marrow for endurance, and a sound beating. "To get him in the mood," explained Rabbani, who kept Palang tied up for the entire morning of fights. The competition was a little too wild this Friday. Tiger would fight again another day.

The Taliban banned the weekly dog fights. The violence was not the issue. It was the gambling that was very wrong in the Taliban's eyes. "And what's the point of the fights if we can't bet?" said Rabbani. "The Taliban never understood this country." The fights returned to the northern city of Mazar-i-Sharif the first Friday after the regime fell.

I sat through about a dozen fights and got up to leave. My guide, a skinny young man named Rostam who had arranged to meet me at the dog fights, grabbed my arm.

"No, wait. One more," he said.

The featured clash was just starting. Two massive dogs appeared. One dog was missing an eye. The other had a torn bottom lip that had healed bloated and ugly.

They were unleashed. Both dogs stood their ground. The referee nervously nudged the dogs' flanks. Still nothing.

The crowd was yelling and growing impatient.

"My humble apologies," cried one of the owners after about five minutes of the standoff. "My dog does not feel like fighting today. God willing, next week you will see much blood."

"Let's go," said Rostam, clearly disappointed that the fight was a bust. "It's getting boring. We have carpet man to see."

The struggles inside the dog ring would be a good introduction to the Darwinism of the carpet trade in Mazar. Profit-hungry alliances—led by the carpet houses in Pakistan—were bearing down on the turn-of-the-century world that Dudin photographed and that, sadly and amazingly, still survives.

My original plan was to travel along Afghanistan's northern border from Badghis to reach Mazar. The insanity of the idea was quickly evident.

We had battled to make it back to Herat from the Turkmen

weavers. The driver told me to pay up and forget about attempting the three-hundred-mile road journey from Herat to Mazar. There were no other options except to join an aid convoy going to a provincial center called Maimana, about halfway to Mazar. The British writer Robert Byron, carrying a copy of Proust, made the trip in 1934 and described his rattletrap Ford jumping in and out of ruts "like a tennis ball." I was assured it's gotten no better. I surrendered.

It was several months before I returned to Afghanistan, this time walking alone across the gray steel Friendship Bridge from Uzbekistan, where the last Soviet troops rolled out of Afghanistan in 1989. Below were the spongy, reed-clogged banks of the wide Amu Darya river, known from antiquity as the famous Oxus.

Then I rode south through a sand dune sea to a city that exists because of a dream.

It came to a local mullah about a thousand years ago.

According to lore, he saw a vision of Ali, the fourth caliph, or ruler, of Islam. Ali also was the cousin and son-in-law of the Prophet Mohammad. Ali's spirit carried a secret to the sleeping cleric, the story goes. In the dream, Ali told of the place where a white camel carrying his lifeless body collapsed from exhaustion.

The mullah organized a dig. Afghan religious myth says Ali's perfectly preserved body was found alongside a sword and Quran. Soon, pilgrims were coming to a lonely shrine they called Mazar-i-Sharif, sometimes translated as the Tomb of the Saint.

Most Muslims believe Ali was buried near the holy Shiite city of Najaf in Iraq, where he was murdered by a follower of an ultrafundamentalist sect in 661. But believers of the Mazar tale offer a wildly different postmortem. They say his remains were lashed to a female camel by his supporters, who feared Ali's enemies would desecrate the corpse. The camel wandered east—about fourteen hundred miles—all the way to a spot on the edge of the central Asian steppes.

The first tomb to Ali was razed in the thirteenth century by Genghis Khan's invaders in a vain quest to find treasure under its pillars. The destroyed site lay forgotten for two centuries before a new shrine rose. Rebuilding and embellishments have erased almost all traces of the rebirth. But it's doubtful it could have been more grand than what now stands.

It's one of the true marvels of all Afghanistan. A vast stone court-yard surrounds a stunning complex adorned with turquoise-hued mosaic tiles, some from the same workshops that produced the glazed ceramics for Herat's awesome Friday Mosque. The blue domes in Mazar seem more flawless than the clearest autumn sky. The most recent refurbishment was funded by Adbul Rashid Dostum, the whiskey-swilling ethnic Uzbek militia leader who has long held sway over this part of northern Afghanistan. Dostum later achieved some level of political legitimacy after being accepted into the post-Taliban government. He has since taken on several roles.

"You see all those white pigeons around the shrine?" my guide, Rostam, asked. "There is a story with them, too. They say that if a gray pigeon joins them, he will turn white in forty days because the place is so pure and holy. We joke that it must be the only place in Afghanistan where something is getting whiter and not grayer. But don't tell anyone I said that. They might get mad. So you believe this story about the birds?"

"Well, it's weird."

"Why?"

"You know Hafez? Well, I was opening the book at random as they say to do. One of the lines I marked was about pigeons watching out for falcons."

"Oh, Mr. Brian, you are becoming very mysterious. Soon you'll start thinking like an Afghan."

We laughed. I hadn't done much of that since coming to Afghanistan. It felt good.

"What's funny?" asked a man sitting cross-legged near the shrine.

Rostam grabbed my arm.

"No, come back. I want to know what's so funny," the man shouted. Rostam dragged me away.

"What's that all about?" I asked.

"Fortune-teller," Rostam said flatly. "He wants to read your palm. It's just a game. Plus he'll charge a foreigner too much."

I was tempted to go back. I'd like to have some idea about what's ahead, even from a sidewalk seer. We walked away, wading through beggars' outstretched palms that bobbed like lily pads on a pond.

I was soon going up a back alley staircase. Money changers were everywhere, holding pocket calculators and waving bricks of afghani bills printed by Dostum's gang but not recognized in Kabul or elsewhere. The building had no electricity. Some sort of crud dripped from the ceilings and formed lines of mini stalactites. The cement floor was damp and slippery.

"This is it? There's a carpet seller in here?" I asked Rostam, who is named for a Persian warrior and star-crossed folk hero created by the famed poet Ferdowsi. The literary Rostam's greatest tragedy came by mistakenly slaying his son in battle.

My Rostam, a lanky twenty-three-year-old sporting a felt cap, seemed unburdened by any real troubles, although he must have had many that he didn't share with me. His favorite refrain was a chirpy, tongue-rolling *Dooh-int woo-ree*. He must have been the most carefree Afghan I had ever met even though he was born just before the Soviets roared in. Ikbol the driver was dropped to second place on the easygoing scale. He had a kamikaze cool. Rostam was just plain loose.

"Yes, this is it," he said as we walked through the building. "Everything is good."

I knew what was coming next.

"Don't worry, Mr. Brian."

Trouble is, I'm always expecting the worst. My wife calls it my biggest fault.

A boy ushered us into a room. The kid had an earnest air of someone trying to appear much older. "We are welcome," he said with a bow and then left. We waited for the carpet dealer and examined some of his stock.

"You see this?" whispered Rostam, pointing out the large floral-motif medallion in the center surrounded by a lighter field of paisley buds. "This isn't a local design. It's all made for export."

"I heard you. You're right! It's Tabrizi," said a man striding into the room. He wore a handsomely tailored *shalwar kameez,* the baggy trousers and knee-length tunic common in Pakistan. "Quality work, too."

He introduced himself as Fatihullah, but I wondered if that was actually his name. He was clearly suspicious of a foreigner sniffing around his carpet business. He regarded me closely. Then, I guess deciding I was harmless, he gave me a handshake and two pecks on my unshaven cheeks. Fatihullah had wide, Oriental features common among some ethnic Uzbeks. I noticed that his fingernails were manicured and he smelled of spicy cologne. Probably Dubai Duty Free, I thought. Fatihullah looked as if he gets around, like his carpet designs. Tabriz, in northwest Iran, is closer to Europe's borders than it is to Mazar.

"Why do you look surprised?" he asked.

"I'm just wondering why a Tabrizi design is here."

"Again, I say to you, why not? So what if it's Tabrizi? We make what the market wants," he said in the controlled manner of a schoolteacher. "It's business, after all."

"I guess I'm wondering about the local Afghan designs. Why don't you make them?" I asked.

"No money in them."

"None?"

"I don't think so."

"But what about the culture?"

He smiled in a patronizing way. "I can tell you're not a businessman."

Fatihullah described how it goes. He commissions local village weavers to follow designs, such as the popular Tabrizi or less intricate Baluch tribal motifs from areas straddling borders of Iran, Afghanistan, and Pakistan. The production is shipped east to Fatihullah's other shop, in the Pakistani frontier town of Peshawar, which was the 1980s staging ground for the mujahideen guerrillas fighting the Soviets. Now it's a center for Pakistan's carpet assault on the world markets.

"We'll do, maybe, twenty to thirty carpets a month," he said.

"We don't want to build up too big an inventory. We watch the market closely to see what's selling and then make our adjustments."

Fatihullah's modest enterprise is just part of much bigger shifts in the global carpet tectonics.

For decades, the economic center of gravity in the carpet world has been drifting east.

Pakistan, India, and China have emerged as new giants in hand-woven carpet exports, taking in at least $1.8 billion annually by conservative estimates. Add smaller, but still significant, production from Nepal and Bangladesh, and it approaches four times Iran's exports.

That hasn't sat very well with some carpet purists. The historical links to carpets on the subcontinent and in the Far East are sketchy and certainly less illustrious than in Iran or central Asia. India and its neighbors, however, don't aspire to satisfy history and mystique. For them, its mostly straight-up capitalism: a reasonable product for a competitive price.

"Carpets are treated as a commodity," observed Thomas Cole, a California-based antique carpet collector and writer. "It's the law of the market. If someone is producing for five dollars a square foot, then a competitor will make it for four dollars and ninety cents."

Consumers may benefit. But children often pay the price. The backbone of many carpet production sites, particularly in Pakistan and parts of India, is child labor. Children work cheaply—if they are paid at all—and their small and flexible fingers are ideal for intricate weaving. Rights groups have tried to pressure governments to take stronger measures against using children as weavers, but the economic importance of carpet exports often makes authorities tread lightly.

"People must realize there could be some very sad stories behind the carpets that are sitting in their living rooms," said Nina Smith, executive director of the Washington-based Rugmark Foundation, a

nonprofit group that is working in India, Pakistan, Nepal, and elsewhere to encourage weavers to stop using child labor and earn a Rugmark certificate.

"The most beautiful carpets can contain an ugly background," she said.

Carpet production on the subcontinent is not well documented before the sixteenth century, but some scholars believe pile weaving techniques may have been introduced centuries before by traders from central Asia and armies bringing Islam from the west. The Moghul rulers, perhaps inspired by the hedonist Babur's affinity for Herat and Persian culture, encouraged carpet making and commerce in what is now India and Pakistan.

But the end of the Moghul dynasty in 1859 signaled a change in attitudes about carpets. They became widely seen as an important moneymaker in foreign markets, particularly in mother England. Workshops sprang up making copies of the most salable designs, often Persian, at sharply lower prices. There was enough expertise—and market savvy—to please European and American buyers, who began placing orders directly with some of the bigger workshops. But these carpets are widely dismissed by collectors and experts because of the assembly line approach and shortcuts such as the *jufti*, or double, knot that grabs together four warps instead of two. Such practices even took hold in Kashmir, the only area in the region with a clear tradition in carpet weaving.

In 1947, the subcontinent was partitioned. Mostly Muslim Pakistan was born. With it came a new and independent force in carpets. The Islamabad government was less inward-looking than New Delhi. The nimble Pakistani merchant class moved aggressively to cater to Western carpet tastes. With some clever marketing, Pakistani sellers began to invent a local carpet tradition in a region with no clear legacy of weaving or native carpet design. The Pakistani spin is that many of its regions are historically linked to central Asia, Afghanistan, and Persia. Pakistan also encourages the notion that carpets would be a natural outgrowth of the woven garments in the ancient Indus River civilizations. The arguments are logical but often dismissed by many carpet historians and others as too tenuous.

One of the early successes was the attractively named Pakistani Bokhara. It's essentially a knockoff of Turkmen motifs with modifications, such as simplified *guls,* and distinctive colors, such as green or ivory. Western buyers also took to Pakistan's use of the soft wool from merino sheep, sometimes imported from as far away as New Zealand. It's less durable than the coarser wool favored in Persian carpets, but it adds a sense of luxury that many Westerners find appealing.

The Soviet invasion of Afghanistan in 1979 sent millions of refugees into Pakistan. The carpet industry took another abrupt turn. The Afghans were a godsend to the Pakistani carpet houses. The refugees brought weaving skills and tradition and could be exploited at rock-bottom pay. Pakistani carpet exports soared, reaching about $300 million in 2000. One distinctive design started in the 1980s was the so-called war carpet showing tanks, MiG warplanes, and, of course, the fighter's best friend, the AK-47. The weavers even modified the traditional paisley-style motifs into hand grenades.

Some Afghans trickled back after the Soviet withdrawal. The big return, however, didn't begin until after the fall of the Taliban in late 2001. Pakistani carpet workshops were gutted. About 60 percent of Pakistan's carpet exports were produced by Afghan refugee weavers before 2002. Exports fell by more than 25 percent during 2001–2002 under double blows: the global economic fallout from September 11 and the mass return of Afghans to their homeland.

The Pakistani carpet makers have been forced to adapt. Carpet exporters have turned to Pakistani weavers in greater numbers to replace the departing Afghans. Meanwhile, Pakistani carpet representatives blitz some of the industry's key exhibitions, including the annual Atlanta Carpet Fair and the Domotex Fair in Germany, looking to make bulk sales and sniff out consumer trends. In March 2004, Pakistani officials announced plans for a "textile city" at Port Qasim near Karachi that will include dye works, weaving operations, and other facilities.

But it is China that may shape the carpet market the most in coming decades. With its size and well-oiled export machinery, it

theoretically can take as big a bite as desired. From the beginning, Western tastes set the tone.

Chinese carpets did not have a significant role in the world market until World War I, when traditional routes to Iran and the Middle East were blocked. Two main weaving centers emerged in Beijing and the port of Tianjin. Both closely followed American preferences. The designs gradually moved away from traditional motifs such as interlocking "cloud bands" and mythical creatures like the dragon and the temple guardian fu dog, which is depicted with a flowing tail and its mouth agape. Instead, a more generic style emerged with geometric motifs and flowing lotus blossoms.

But China didn't stop there. Increasingly, Chinese workshops are turning out Persian designs and anything else that sells. "China is good at mass production," said a well-traveled Pakistani exporter, Khuram Haroon. "Pakistan is trying to copy the ideas . . . of continually adding new designs, new coloration, and weaves. In a certain way, this is similar to the fashion industry."

There could be a dark side to the carpet scramble. More competition usually means that players need to lower costs to stay in the game. In the carpet trade, this has led in one direction in the past: more child weavers.

The International Labor Office, a U.N. agency, estimated that the millennium opened with about 186 million child laborers under the age of fifteen. Of these, at least 5.7 million were involved in forced or bonded labor in activities that include carpet weaving. But that's as close as it comes to an accurate figure. There are simply no reliable tallies on illegal child labor in the carpet trade. Government reports low-ball it to several hundred thousand around the world. Some activist groups place the number at close to three million, concentrated in India and Pakistan.

For the carpet business, the advantages of child labor are chilling but obvious: long hours, few complaints, and pay of just a few dollars a day or less. It's nothing new. The same logic applied in Victorian factories and among the textile mills in nineteenth-century New England.

But the carpet world is not made up of redbrick complexes that

rights groups can picket and inspectors can target. It happens in places like the little chamber in the Herat bazaar where I found the two boys weaving copies.

"Just finding these places is half the battle," said Rugmark's Nina Smith.

Then there is a vast cultural divide to overcome. Western sensibilities recoil from the idea of indentured servitude, in which families of child weavers receive a regular payment from the carpet bosses. But to a destitute family, it could mean food and survival.

"We immediately think, how dare they do that? You know, who would have the heart to allow a seven- or eight-year-old child to weave a carpet?" a carpet importer, Mehmet Yalchin, told Common Ground Radio in an interview broadcast in November 2002. "We don't realize the conditions they live in. We don't realize sometimes that if it weren't for the seven-year-old weaving, his six-member family could be dying of hunger.

"Sure you will see a four-year-old Afghan boy or girl weaving—this is when they start doing these things. Anyway, this is part of life for them. But I don't think it's fair to call that child slave labor. I mean it's like sending one of our kids to piano lessons. There, they're weaving carpets."

Not all can accept these types of cultural rationalizations.

"This is just an excuse by governments and the carpet industry not to do anything," said Ehsan Ullah Khan, a former leader of the Pakistani branch of the Bonded Labor Liberation Front, a group that tries to expose issues of slavery and illegal child workers. "This is not about cultural differences. It's about children's rights—basic, universal human rights—in all countries."

Tragedy brought his group to the headlines. On April 16, 1995, a former child carpet weaver–turned–activist, Iqbal Masih, died after being torn apart by more then 120 pellets from a shotgun blast. He was just twelve. But he was credited with liberating more than three thousand children from work in carpet workshops, tanneries, steel plants, quarries, and other industries. Ehsan Ullah Khan immediately blamed the Pakistani "carpet mafia" for the slaying. Authorities looked elsewhere. An initial police report claimed Masih

was killed by an embarrassed farmhand who was caught "in a compromising position" with a donkey. A week after Masih's murder, thousands of children joined protests in Lahore to demand an end to child labor.

Ehsan Ullah Khan and this group faced an all-out assault: police intimidation, court probes, relentless criticism, and innuendo in the government-friendly press.

He fled Pakistan just months after the killing. He eventually took Swedish citizenship and travels the world speaking about child labor practices. His group—widely known as the BLLF—believes there has been some success in reducing the child workforce in industries such as the manufacture of garments and sporting goods. The reason: a combination of consumer awareness and political will. The carpet industry lags badly, though. Its fragmented nature and millions of looms complicate attempts to monitor and regulate labor practices.

"There is a lot of lip service going on," Ehsan Ullah Khan told me. "Child labor is still a pillar of the carpet industry in some parts of the world. But there continues to be a denial of the problem. If there is a will, there is a way, I say. Market pressure and consumer pressure are important. We can build it. But you also need political will. That will come only if governments and carpet makers fear a loss of revenue because consumers will turn away from their carpets because of child labor use."

Iran has been considered a leader in stamping out child weavers since the practice was outlawed by the shah in the so-called White Revolution that began in the 1960s. But it still continues, some activists claim. The Iranian Children's Rights Society published a transcript of an interview with a small child. The group claims he was "rented" to a workshop by his parents.

Question: How much did the middleman who brought you charge?

Answer: I don't know.

Question: How much did your parents receive?

Answer: 20 [thousand] toman [about $2,500].

Question: Is your work difficult or easy?

Answer: No, it's very difficult.

Question: Do you go anywhere for fun? To movies?

Answer: I've never been to a cinema.

Question: Do you like to work or go to school?

Answer: Now that I'm here, I have to work.

"We can't say it doesn't happen," said Suleyman Karimi, coordinator of social programs for the Iranian government's Carpet Research Center. "We say we have to reach out to the parents first. They are the ones who control whether their children will work or be allowed to be children."

Karimi said a top goal is to create a network of carpet-oriented schools to give children an education and also a grounding in carpets.

"They should know about all aspects of carpets: weaving, dyeing, the history, the cultural aspects of carpets," he told me. "It's our duty to future carpet makers and the many who have gone before."

On the edge of a dingy room in Mazar, the future didn't look very cheery.

Four boys—all under ten years old—worked on upright looms copying Persian tribal designs ripped from magazines. Some of the intricate patterns had been enlarged on a photocopier and were marked by grids. Piles of wool were scattered at their feet. An electric space heater, which looked like a glowing butterfly, buzzed in a corner. A crate held some pottery and samples of Mazar's famous handblown blue glass goblets. The whole place screamed of impermanence, as if they could close up shop and hit the road at a moment's notice. In fact, I learned that this was precisely the idea.

Fatihullah had given me the address, but he wouldn't come along. Carpet competitors keep a healthy distance from one another. There's a good reason. In a city where almost everyone is armed, it's best to steer clear of possible quarrels. The workshop was near a gym, one of the last things I expected in hungry Afghanistan. The face of the painted Atlas, with his comically pumped-up muscles

holding up the earth, had been blasted to oblivion by the Taliban.

A little man in plastic sandals came scurrying in. "Yes?" he panted, thinking we were there to shop. He took my hand and led me inside. The four boys didn't stop working. The plump Fatihullah seemed almost regal compared with this bony and unwashed specimen now hanging on my arm.

"Can I show you something?" he asked.

"Yes," I decided. "I'd like to see carpets of local design."

"What do you mean?"

"Things made by Mazar weavers, like Waziri, maybe."

Hah! For once I felt I had the advantage. I had done some reading about Mazar carpets and at least could bluff my way a bit. The Waziri design features a typical eight-sided *gul* with broken and nontraditional motifs inside.

"But, sir, I have none of these now. Come back tomorrow, yes? I will bring you to my cousin's shop," the merchant said.

There's always a cousin.

"Okay," I said. "But tell me about your place."

He squinted. "What is there to say?"

"I want to know what the boys are weaving."

"Carpets."

"Yes, I know. I mean what designs? Where are the carpets going?"

He could tell I wasn't going to back off.

"You aren't with the U.N., are you?" he said, growing suspicious.

"No, I'm a journalist. I'm interested in carpets."

"Ah, a *joor-ne-list.*" He smiled, using one of the English words he'd picked up. "Then you are welcome. I will tell you."

These carpets, too, would eventually end up in Pakistan for export. It's very possible the buyers would never even know the carpets came from Mazar, thinking perhaps they were authentic Mashhad Baluch.

The boys were also part of a shadow world, one that is still outside the full scrutiny and pressure of international child labor groups.

They came from villages scattered around northern Afghanistan.

Their families, I was told, made contact with workshops such as this. The boys had what the operators needed: young, supple fingers. The workshops, in return, offered a small wage, food, and a place for the boys to stay. Here again, it reminded me of the life of the mill girls recruited by the old New England textile barons. Except the cultural rules in Afghanistan made it impossible for girls to seek out work. Their young brothers, instead, get the opportunity to toil for twelve hours for about $1.

"This is not a bad life for them," the merchant insisted, not too convincingly. "It could be worse. You know some parents sell their children."

It's an incredible statement. But I knew he was right.

I had already met those who had sold their infants to better-off families for desperately needed money to feed the brood left behind. Off the main Kabul highway east of Mazar, I found hundreds of starving and displaced Afghans living in dank caves—many of which were lined with carpets—dug into a hillside. A widower, Mohammad Hashim, told me he had sold his two-year-old son to a merchant family in Mazar who wanted a boy. They weren't interested in his older son, who is almost completely deaf from an ear infection. Hashim received $30 for the toddler, about half of what I was paying my translator per day.

It's possible to take issue with the dowry system and how it sets values for prospective brides. But at least it could be understood. I couldn't begin to appreciate the desperation of putting a price tag on your child. My wife knows I still dream about that place, how Hashim hugged the deaf son he wanted to sell, how coughs and sobs rose up from the caves below as if the earth itself were sick. "We get information about baby selling. We know this happens among the poorest of the poor," said Mahboob Shareef, the head of UNICEF's operations in northern Afghanistan.

I followed the boys from the carpet workshop to their quarters in the same building. Bedrolls were pushed against the walls and clothes hung from hooks. One boy had made a picture of his perfect moment: a huge sun, a family picnic, and birds overhead. He didn't include any carpets.

"Do you miss your family?" I asked him.

"Yes," he confided, "but we are helping them."

He showed me a sock filled with afghanis. "I will come home and they will be proud," he said.

"How long will you work here?" I asked.

"That is not my decision," he said softly.

"They may be home soon," whispered the merchant, who refused to leave my side as I spoke with the boys. "We could leave any day."

The sinking security situation among rival groups in Mazar was making him and his partners nervous. They were seriously considering pulling up stakes for Peshawar.

I left him with a promise that I would return to look at some local carpets. But first I had a date with a warlord.

Abdul Rashid Dostum's compound resembled a motel that had its glory days back when Sputnik was in orbit. Two security goons in sunglasses and too-tight Western suits led me into the compound. A couple of Americans—soldiers or spooks, I couldn't tell—were also waiting in the flagstone courtyard. They waved me off when I approached.

"Sir," one of them drawled. "No comment."

About what? I hadn't asked a question yet.

I could only assume they were here for talks about the suspected Taliban prisoners. Dostum's stronghold was in Sheberghan, about sixty miles west of Mazar-i-Sharif and the site of a prison where, at one time, nearly four thousand POWs were packed into cells or shivered in the yard, wrapped in thin blue blankets. The hospital ward included soap donated by the International Committee of the Red Cross, but even a bigger supply of flea powder. Some of the Pakistani prisoners begged my translator to call their relatives to tell them they were alive. He did. Gradually, the prisoners were being released, transferred to other Afghan holding sites, or shipped off to Guantánamo Bay.

I was led by a Dostum aide to a waiting room. It had a bed with a

carved bald eagle headboard and doorknobs that came off at the slightest tug. Dostum, like many of the militia leaders and hired guns, had fled Afghanistan during the Taliban. To stay would have been suicide. The Taliban had left its unique mark on the Dostum headquarters, carefully cutting out the heads of any animals in Dostum's collection of landscapes on velvet. It seems any lifelike representation, even of deer and rabbits, was too much for some Taliban zealots. For some reason, however, they didn't demolish Dostum's Western-style toilets as they did elsewhere.

Finally, I was ushered into a long room. Some local men were wedged together on a couch, packed so tightly that they sat with their knees clamped together. At the end of the room sat Dostum, wearing his trademark Castro-style military fatigues in homage to his bygone days as a general. He seemed comically overblown compared with the elfin Ismail Khan in Herat, although Khan probably wielded more influence and firepower.

The interview went predictably. Dostum commented on the prisoners ("they are treated well"), his expectations for strong ethnic Uzbek representation in the new government ("a must"), and efforts to control factional clashes around the north ("I'm a man of peace").

As many as two thousand Taliban were massacred in 1997 around Mazar-i-Sharif. A year later, the Taliban recaptured the city and exacted widespread revenge on the minority Shiite group, called Hazara. Mass graves have turned up hundreds of Hazara bodies, but their leaders claim the death toll is much higher. The post-Taliban power plays were less bloody but still very messy.

I continued: "There are other warlords who propose—"

"I am not a warlord!" he shouted, banging his hand on the table. "I am a member of the new government. Do not call me a warlord!"

Bad move. I scrambled for some safe ground.

"General Dostum, sir, I'm very interested in carpets. I know you are busy with other matters, but do you have any thoughts about the carpet industry?"

"No," he snapped, still angry. "Let the Americans worry about such things. They are the ones who want the carpets anyway."

To my surprise, there are some in Washington thinking along these same lines.

The U.S. Department of Commerce has issued several reports on efforts to revive the "massive earning potential" of the Afghan carpet industry. The conclusion: serious potential, but serious problems. The list of challenges includes the obvious instability, warlord extortion, and lack of any organized commercial transport or export networks in Afghanistan after decades of strife. It's not an entirely gloomy prognosis, though. The return of refugees from Pakistan and Iran gives an important boost to the Afghan reservoir of weaving talent and business acumen.

Trouble is, the Commerce reports say, Afghan exports are dependent on travel through neighbors trying to protect their slice of the carpet pie. Iran does not want to help get Afghan carpets to market. Neither does Pakistan. And Uzbek trade routes, as the Commerce report notes in classic bureaucratic understatement, "are choked by high-level corruption on both sides of the border."

I had heard that Dostum sometimes tried to give journalists gifts of carpets or Uzbek saddlebags. Of course, I would have to gracefully decline because of professional ethics. But I was, nevertheless, curious to see what would come my way. A big fat nothing, it turned out. Maybe it was my warlord quip. All I left with was a handshake and an updated satellite phone number for his spokesman.

I'd had enough of the personality of Afghanistan's future. On the way back to Mazar, I paid another visit to its past: one of the Silk Road graveyards, the great and ancient Balkh.

For more than twenty-five hundred years, the city had rebounded dozens of times from the swords and firestorms of invaders. Now the raiders were coming from within and carrying shovels and buckets.

I watched in disbelief as boys and men dug for pottery shards, oil lamps, coins, daggers, and any other morsels from antiquity at a place known locally as Jewelry Hill, which legend says was the site

of a bazaar fourteen hundred years ago. Of course, everything dug up was for sale. Children ran up to me with artifacts—some reasonably intact and others just fragments—rattling around in plastic shopping bags.

"Old, old, mister," they jabbered in English. "Old, old, old."

That's about the only honesty I could find left in lawless, mystic, mournful Balkh, seat of ancient Bactria, a pre-Islamic outpost of Buddhism, a glory of the Silk Road, and, some believe, the last place visited by a prophet named Zoroaster preaching a faith based on a single, wise God and rejection of evil. The dates of Zoroaster's life and the birth of the religion that bears his name, Zoroastrianism, are subject to huge swings in speculation. Most scholars settle on a period between 1700 B.C. and 1200 B.C. But there's widespread agreement of its influence on the three main monotheistic faiths.

"We can't worry about people looting old things," said Saleh Mohammad, Balhk's police chief, giving me a tour of the town and the semiprotected ruins of the twelve-hundred-year-old Masjed No Gumbad, or the Mosque of Nine Domes, the oldest Islamic structure in Afghanistan. "Our worries are much bigger. But have no fear. Balkh will survive. It always has."

It was the capital of prosperous and strategic Bactria when Alexander the Great arrived in 329 B.C., still hunting Bessus to avenge the death of Darius. Bessus made a tragic gamble: crossing the swollen Oxus and heading into the highlands of central Asia. But the ruler there, seeking Alexander's favor, betrayed Bessus and delivered him to the Macedonian. Bessus was punished "in the Persian way," his nose and ears hacked off before he was put to death.

There's no way to know, but I wondered how different his end was from that of CIA agent Johnny "Mike" Spann, who was killed near Mazar in a November 2001 prison uprising that included the now-famous "American Taliban" John Walker Lindh. Washington has never released full details of Spann's death.

During his time in Bactria, Alexander also laid the foundations for cities—including one known informally as Alexandria on the Oxus—that served as far-flung ambassadors of Hellenist culture for centuries. Again, one also draws parallels to the West's efforts in

Afghanistan after the Taliban and whether they will be as enduring.

Alexander also took a bride during his stay. He married Roxane, the daughter of a local nobleman, who followed Alexander on his campaign to India and was pregnant when he died in 323 B.C. A little more than a decade later, Roxane and the boy king would be put to death by the paranoid leaders who were trying to hold together Alexander's empire.

Genghis Khan's armies destroyed Balkh and massacred its people outside the city walls, but again Balkh rebounded to become a center of Islamic scholarship centuries later. Its latest decline began in the nineteenth century when Mazar took over as the provincial hub.

I watched the boys swap artifacts the way I used to trade baseball cards. A not-so-original thought: Was I getting a sneak preview of the fate of my own civilization in the distant future? Would young looters hawk Tupperware and rusty computer gizmos and wonder about our dreams?

Back in Mazar-i-Sharif, I looked in again on the workshop boys. This time, I brought them each a bag of sweets and fruit from the market. The only change was that the heater was turned off. Winter was ending. There were already a few warm days that dry the puddles and bring an explosion of chubby, lethargic flies.

"Ah, yes, sir, you returned," gushed the workshop boss. "You still want carpets from Mazar? Yes? Good, come with me to my cousin's."

He led me to a row of shops near the shrine. The city is a mostly depressing study of Soviet-style planning: long boulevards and cement layer-cake buildings. Some of the business signs are in joyfully liberal English. One pathologist promised his clients "bodily probations of all functions." A dentist advertised "root searment and cement." I almost went in to ask what they meant, but was afraid of some misunderstanding that would end up with my roots seared and cemented.

So, again, I found myself in an Afghan carpet shop.

The merchant, a bowlegged sprite with a mouth full of gold teeth, spread out his offerings. I was weakening. It was already clear to me that I would buy something. I'd been in Mazar more than a week without taking a carpet, which was something of a personal record. I must admit, there are few indulgences I enjoy more: sitting in the place of honor in a carpet shop, sipping sweet tea, and watching the creations being laid at my feet. There's always that delicious anticipation that the next carpet will be the one. It's addictive.

The merchant, Mohammad Ismail, kept tempting me with some well-made Uzbek and northern Afghan carpets. But the colors were obviously chemical: too jarring and uniform. A common characteristic of natural dyes is subtle variations in hue. It's known as *abrash*, from the Arabic word for dappled, and caused by factors including slight differences in how wool batches and dyes interact. Even the most masterful natural dyers cannot re-create the exact shade over and over. Nature just won't allow it. So a carpet using, say, three different batches of madder red wool may have three noticeable shifts in color. Many collectors appreciate the *abrash* as part of a carpet's uniqueness. But beware. Some commercial carpet houses purposely imitate the *abrash* to effect a sense of originality.

"Now I know what you want," Ismail said with a wink.

He reached into a saddlebag and produced a misshapen Turkmen carpet. I knew enough from book illustrations to notice the classic distortions of a wool thread warp and weft. Cotton foundations—far more common since the nineteenth century—hold a carpet's shape better after wear and washing. Wool tends to shrink and stretch. But a wool foundation is a good tip-off that the carpet probably came from the loom of nomads, who often take down and restretch unfinished carpets during their moves to cause further disruptions in the shape. This carpet was nothing special. The *guls* were basic, and the low knot count made the designs appear fuzzy-edged. It was the *abrash* that got me: a series of lovely variations of salmon red.

The bargaining commenced. Again, I hurt myself and aimed too high at the start. We settled on $220. It was certainly too much for a low-quality carpet of average size. There's an old chestnut that carpet sellers often serve up to wavering buyers: Forget the

price, what does your heart say? I guess there's something to it, after all.

The carpet was folded and packed neatly in black plastic, which I was certain would be ripped apart by the Uzbek border guards when I headed back. My collection was growing. Since the first trip to Herat, I had the two from Farid's shop, the wonderful carpet plucked by the boy burglar, and now this one. Total outlay: $820.

"You happy?" asked the workshop boss.

"I always feel good after buying a carpet," I confessed.

"Good, you will be my guest tomorrow. We will go to *buzkashi*. You know it?"

I did and happily accepted the invitation. I had planned to go back to the dog fights for another Friday. *Buzkashi* was a much better option. The sport, which translates to something like "goat grabbing," dates back to the days of Genghis Khan's cavalry and developed as a test of riding skills, bravery, and machismo.

There is no rule book. Essentially, it's a mounted battle over a headless animal carcass, preferably a goat, but calves or whatever is handy will do. Some versions are kind of like a galloping game of tag, riders chasing whoever has the goat. A slightly more organized variation, called *qarajai,* requires someone to carry the carcass around a pole or flag and deposit it into an area sometimes called the "circle of justice." This is what was on tap in Mazar.

The field was out past an old bread factory destroyed by the Taliban. The workshop boss and I took a place on a low mound at about the midpoint. He brought a dirty kilim for us to sit on.

"But be ready to run if they ride up here," he advised.

The field was ringed by a full spectrum of Mazar's mighty and weak: militia fighters in four-wheel-drive vehicles, some U.S. Special Forces discreetly off in one corner, bikes, pushcarts, vendors selling popcorn. The only women were from a French film documentary team.

Our hotel, the Barat, had donated the headless remains of a black calf. A singer belted out an ode to horsemen. The prize was announced for the first successful drop in the "circle of justice:" cash equal to about $5.

An announcer said, "Please try to ride as well as possible and be safe."

A moment later, about thirty riders were battling for the dead calf. Only the best could keep their grip for more than a few seconds.

"It gets harder to hold when the blood and guts come out," my host explained.

"And they continue no matter what?"

"Basically, yes."

Literature on *buzkashi* says the traditional method of preparing the carcass is a twenty-four-hour soak in cold water to toughen the flesh. Then the internal organs are removed and the legs are severed below the knee. The group playing that day didn't bother with such details. They had a freshly decapitated calf with legs and innards intact.

Within a half hour, the carcass had been battered to the consistency of a rag doll. Intestines and other bloody bits dangled from its belly. Two winners had already claimed their cash. The Hotel Barat owner upped the ante: a new radio for the next champion.

The riders were inspired. Elbows and whips were flying. The calf, by this time, was flattened and leaking entrails. Some of the moves were worthy of a street fight. I saw one rider flail another on the neck with a homemade crop. Another lowered his head like a battering ram and plowed his horse into the pack jostling for the calf. An Afghan government summary of *buzkashi* says it's all part of the game: "A skull fracture, bleeding hands, a cut in the ear, broken nose or a cut in the lips does not hinder the horsemen from continuing."

The pack of horses started to veer in our direction with the dead calf bouncing under the pounding hooves.

"Move!" cried my host.

We dodged just in time, clinging onto the side of a jeep as the riders roared past, skimming the back of my legs. The contest was now weaving through the cars and out into a gravel pit.

"Bring back the calf!" the announcer cried.

The morning I left Mazar I awoke just after the call to prayers. I wanted to have a full day to deal with the expected complications at the Uzbek border.

I watched a favorite spectacle for a last time. In the grainy dawn, men arrive with carpets they hope to sell to dealers or peddle on their own. They exchange no words. There are no stray movements. The brightening sky turns the tiles on the shrine from deep indigo to a brilliant cobalt blue.

The men are etched by Mazar's dust, a talc-fine powder that works its way into everything. It streaks their beards the color of milky tea and forms little crescents of grit under their fingernails.

They unwind part of their turbans and place the loose strip over their mouths. Then they start to pound the carpets before the shop-keepers arrive with their jingling keys and nicely trimmed beards. Yellow-brown clouds rise with each blow and float downwind like ghosts. For hours, as the city awakens and the bazaar stalls reopen, the thump of the carpet men keeps a familiar, steady rhythm.

It sounds like a heartbeat.

PART II

MIGRATIONS

One should avoid performing the prayer on the street, in places where there is artificial decoration and on colored carpets.

—Abu Hamid al-Ghazali (1058–1111)

CHAPTER SIX

ALCHEMY OF HAPPINESS

 Mashhad is near.

In some places, the land is as flat and featureless as a calm sea. Then it abruptly churns up in wind-sculpted hillocks full of holes and crevasses. They can seem—just for an instant—like clusters of unblinking eyes. I later pass convoys of old, lumbering buses coughing blue diesel exhaust. They are bringing pilgrims to the immense and gilded shrine of the eighth Shiite imam, Reza, who died in Mashhad some twelve hundred years ago.

I envy the pilgrims. Their goal is clear. Mine still feels like a moving target.

It's been more than two years since the Tehran carpet seller, Mohammad Reza, introduced me to Hafez. I had fully expected something uplifting, maybe even illuminating, by now. Instead, I'm caught in the quicksand of Persian mysticism and its slippery wordplay. The more I thrash, the deeper I sink.

There's at least the perverse comfort in knowing that others—much more accomplished and smarter than I—have struggled here

before. A Hafez scholar, Farhad Shirzad, points out the challenges in making Hafez relevant and rewarding when separated from the language of Persia.

"The musicality, play on words and intentional vagueness, which makes the poems especially attractive in Persian, make them almost impossible for the translator," he wrote in a foreword for the respected translations by Gertrude Bell.

I used to feel that way, too, about carpets. I finally sense some progress. My travels in Afghanistan improved my rather spotty carpet knowledge. I could now sometimes impress a dealer enough to treat me with a small degree of respect. Or maybe he would start the bargaining a bit lower than the stratosphere reserved for most foreigners. I was getting more comfortable in their world of haggling, preposterous claims, and fake bonhomie. I know the whole show is often as thin as the money they hope to extract. That's fine. At least I could identify what was behind their act.

The mystics were a very separate riddle.

There are double-edged allusions straddling Islam and ancient Persia. Below that, it's even trickier. The borders between divinity and humanity start to blur. Just when it starts to make a bit of sense, other doors start creaking open.

Behind them comes the hypnotic flow of Islamic music and prayer. Follow that, and it leads to the restless spirituality of the Sufi. Their ancient "purifications" of body and mind, such as fasting and rhythmic dance, are part of attempts to achieve clearer perceptions of God and existence. Which, it turns out, comes full circle. This is what drives mysticism in the first place.

It's tiring. I needed a breather before plowing forward. So I went in the other direction.

My attempts to appreciate Hafez started a backward progression to earlier mystic poets and thinkers: Shabestari, Rumi, Attar, Omar Khayyam. These names are powerful in the East but hold only weak recognition in Westernized cultures with far less tolerance for the abstract. Their writings helped restore my confidence that I wasn't incurably dim. The more I read, the more I realized that the mystics aren't a single code to be cracked. They pose questions but don't pre-

tend to have the answers stashed away for themselves and aren't arrogant enough to draw a roadmap to spiritual clarity. They just offer a gentle shove in that general direction—and freely admit their own frailties in coming up short. I started to see mysticism as a buffet rather than a fixed menu. I'd sample what I wanted and pass on the rest.

In my notes, I wrote and underlined the word *lodestone*. I don't recall what even stirred that image at the time. But seeing it again months later, it seemed to fit nicely. It's an idea of seeking things that give off a special, mystic magnetism—tugging at elements that make this life livable: faith, beauty, imagination, sensuality. I felt it with carpets. But the mystics advise: Don't stop looking.

Sufis speak of finding a *pir*, a spiritual guide or mentor. Hafez often made obtuse references to his *pir* and left generations of scholars guessing about the identity or whether there were several over his long life. Hafez would remain mine for as long as I poked around the Persian soul. But there was a growing cast of other voices joining him.

One of the strongest roared back from nearly a thousand years ago. I had worked my way to the mighty Persian thinker Abu Hamid al-Ghazali. He was unknown to me, but in much of the Islamic world, he is considered an intellectual giant: jurist, theologian, and philosopher. Here, I finally felt some firm footing.

Al-Ghazali, born in 1058 in the region of Toos, just north of Mashhad, gained renown as a scholar with an unusual forte. He would often use reason and Aristotelian logic to support Islamic views and practices. This provided some important depth to the faith at a time when many clerics simply told followers to look no further than the Quran. The learned elite took notice. Al-Ghazali was beckoned to Baghdad as head of the Nizamiyyah college, at the time one of the most influential centers of Islamic scholarship.

But after four years, he fell into a deep spiritual crisis, perhaps aggravated by his conclusion that study and rhetoric alone were bringing him no closer to God. He wandered for years as a Sufi before returning to Toos, most likely taking the same desert route I used to reach Mashhad. Al-Ghazali had decided that spiritual truth was only attainable in the ecstatic state of the Sufi, best known in the West by the trancelike whirling dervishes.

Al-Ghazali, though, never put aside his interest in clear-eyed analysis. He wrote many essays and monographs in a style—in translation, at least—that was direct and without the intentional ambiguities of many mystics who followed him. In one commentary on finding "inner serenity," he advised not to pray on colored carpets at the risk of distraction. But I found his *Alchemy of Happiness* most moving. He succinctly describes the preparations for the Sufi's mystical dance: fast for three days, then eat a savory meal. And, if the *pir* agrees, the dance begins.

In the best moments, the Sufi's heart can reach a "condition as clean as silver in the flame of a furnace," he wrote.

"The Sufi," he went on, "then becomes so keenly aware of his relationship to the spiritual world that he loses all consciousness of this world and often falls down senseless."

I read his *Alchemy* several times before reaching Mashhad. Was I, too, trying too hard? Maybe I should follow the Sufi path and let go a bit.

"Show him the *golbang*," the Sufi said.

A wiry man with baggy cotton pants stood in the middle of a small room. The floor was covered with two machine-made copies of Qajar dynasty carpets with peacock designs. He hooked the big toe of his right foot over the left big toe. He folded his arms over his chest, also right over left. Then, with his arms still folded, he placed the index and middle fingers of each hand over his ears.

"Look," said my *pir* of the moment, Nazam. "It's like an electrical circuit, isn't it? It's a cycle of energy. We do this to rest and reenergize."

"Can I try?"

"Please," said Nazam.

I did my first *golbang*. It wasn't hard. But there was no restful feeling washing over me, either. I was too self-conscious. I looked at the Sufis sitting around me and expected them to fall over in fits of laughter. There must be some serious comic value in an American guest kicking off his boots for a *golbang*. If they thought it funny,

however, they kept it to themselves. In fact, most were smiling with approval.

There was burly and soft-spoken Nazam, who looked like a cross between Buddha and a biker with his ample belly and shaggy hair and beard. The other Sufis made an interesting crew: a short man with a shiny bald head and a big silver hoop earring in his right lobe; a stocky laborer with thick ropes of muscle visible under his tight coveralls; and the thin man who first demonstrated the *gol-bang*. The eldest of the group, who was at least in his seventies, wore a long strand of amber beads.

"Do you know what *golbang* is?" asked Nazam, whose own name comes from the root of the Persian word for order. "It means 'voice of the flower.' Perhaps it's somehow related to the lotus position. What do you think?"

"Why not?" I said, sitting back down on the floor. "I mean Buddhists were in Afghanistan. Everyone knows about Bamiyan where the Taliban blew up the Buddhas. There's all sorts of overlap. So maybe."

Nazam looked me over for a few uncomfortable moments. It seemed as if I had been undergoing some kind of test. It's not often that foreigners drop in unexpectedly on a Sufi *khaneghah,* or meeting place. Especially one in a working-class quarter of Mashhad.

"So," he said, peering over his wire-rimmed glasses, "tell me again why you're here."

I repeated my personal blurb, which by now was honed through practice. I told him how my interest in carpets led to Hafez and how Hafez led to mystics and how that led to Sufis. And that brought me to a place in Mashhad called the Green Dome. It's the resting place of a Sufi master and mystic *pir,* Mohammad Momen, who died about 1600. At night, the turquoise dome is bathed in candy green light. Locals call it the "breath of the dervishes."

I told Nazam how someone had pointed out the *khaneghah* across the street from the tomb. I rang the bell several times without any response. I was about to leave when a frail and very old caretaker shuffled out from a side door. He didn't look pleased. I explained my interest in visiting some Sufis. Would someone, I asked, have the time to talk to me that evening? He didn't say a word. He

walked past me, his plastic sandals scratching on a brick walkway. I followed across a small courtyard. I noticed that his turban looked as if it hadn't seen soap in a very long time.

He pushed open a metal door. The room's walls were pale green. A tea kettle steamed atop a samovar in the corner. The Sufi I would later know as Nazam sat alone at the far wall under a framed photograph of a late *pir*. To the side was the collection of symbolic items common to many Sufi halls: an ax, a drinking gourd, and the snout of a swordfish.

The other Sufis were scattered around other parts of the room. Nazam was the only one who rose to welcome me.

"Yes, yes," Nazam said after I had recounted the story. "That tells me how you got here. I was asking a different question. I'm asking: *Why* you are here?"

"I mentioned it at the beginning," I answered calmly, trying not to be pushy. "I started with carpets and then was told by someone to study Hafez. Then I got interested in other mystic poets and that brought me to Sufis. Now I am trying to connect the dots."

"The dots? What dots? I don't understand," he said.

"I mean that both carpets and mysticism are so deeply part of Persian culture," I stammered. "It just makes sense to me to look at them together—part of the same forest, I guess we could say, rather than just separate trees."

The man in the cotton trousers brought us tea and sticky fresh dates. Nazam took a noisy sip. He put his hand on my shoulder.

"You are in the right place. Welcome to the house of the forgotten."

"What do you mean?" I asked.

"This is a *khaneghah* for workers, common people, poor people. This isn't where the rich come. They have other *khaneghah*. We are like your Robin Hood, the good bandit of the forest. We give to the poor."

"What do you give them?"

"Sometimes things or food if they need it. But mostly it's a spiritual compensation. We give them a place to find some peace and find a path. It's hard to explain."

"Please try."

"You said you were interested in carpets, is this not right?"

I nodded.

"Well, let me try to explain it this way. Imagine a carpet is God. There can be millions of knots making up this carpet. The single knot itself is nothing. Am I right? We are like this little knot. We know we are part of God's plan in this big fabric. But we don't want to remain just a knot. We are trying to imagine—to feel—the whole. You understand?"

"Sure," I said. "Like connecting the dots, as I said before."

"I see what you mean now." Nazam smiled. "Yes, making lines between dots. Very good. I will remember that."

I was about to ask some questions about the photo of the *pir* hanging above Nazam, but some new men entered the room. They went around to everyone and greeted them in the same fashion, leaning over to kiss their hand and then pressing it to their forehead. I was startled when they did the same to me. Some people, especially in conservative Mashhad, refused to make physical contact with non-Muslim "infidels."

"Yes, I believe I get it," I said after the men sat down. "This is what the dervishes are doing, aren't they? They are trying to get in a mystical trance. Do you ever dance?"

"Sometimes. We also chant, pray, meditate, fast," he said. "We all are trying to get to the same place. It's up to the person to find his best way."

"And what place are you trying to get to?" I asked again.

"I've been trying to tell you," Nazam said, pointing to the heavens. "We want to experience God. Everyone wants this. They just don't know it. Or they don't know that God can be sitting right there—in a kind word or a simple laugh. Just be open to Him. That's what we tell people."

"Well, some people have told me they see God in carpets," I offered.

He said softly, "Why not? He is there. He is everywhere, like I said."

The way of the Sufi is too personal and unstructured to be neatly summarized. But at its core is a stunning notion: Forget about wait-

ing for the afterlife for revelation and seek contact with the divine in this world. The Persians call it *erfan*, or the knowledge of true existence. It involves much the same kind of spiritual surgery suggested by some Western transcendentalists: hacking off baggage such as ambition, pride, and vanity.

God, to many Sufis, is happy to have the company. The Almighty is not seen as a remote and unapproachable deity. God is considered organic and accessible, almost begging to share illumination. A dedicated Sufi once explained to me that man-made devices such as microscopes or telescopes make it possible to extend the range of perception. The Sufis, he said, just use their own techniques to expand their horizons. It sounded similar to the descriptions I've heard from Christian monks about deep prayer and its uplifting powers. Sufis often jump-start the process with physical release: the "sacrament of sweat," as one imaginative American theologian once described the act of pushing the body to seek a spiritual boost.

The Sufis are not alone with this notion. I've seen Christian penitents in Mexico crawl toward shrines on shredded knees and palms. Shiites engage in stylized flagellation to end the mournful ten-day period marking the battlefield death of the early Shiite martyr Hussein. Few, however, can match the kinetic energy of the Sufis.

Perhaps the best-known Sufi ritual is carried out by the dervishes of the Mevlevi Order, who can spin for several hours or more in search of a trancelike bliss. Some Sufi writers describe it as a break from the "enslavement" of the material world. The order traces its roots to a mystic forebear of Hafez, the thirteenth-century poet Rumi. He is known in his adopted homeland of Turkey as Mevlana. There are many other Sufi orders, perhaps more than 175, with different traditions that have evolved depending on the *pir* and the interests of the followers.

This lack of firm structure and doctrine is what unnerves—or downright frightens—the Islamic establishment. In Saudi Arabia, the guardians of Islam's holiest sites, Sufism is outlawed. In other Muslim countries, it's permitted with varying degrees of tolerance, from acceptance as colorful brethren to scorn as Islamic subversives. The Sufis don't seem to mind being cast as rebels. They have always bucked convention. Some mystics even consider the Sufi

connection to Islam little more than historical happenstance.

The precise origins of Sufi thought are unclear. Even the root of the name is debated. The scholarly consensus is that it comes from *suf*, the Arabic word for wool, as a reference to the coarse and undyed garments favored by the ancient wandering mystics in Iraq and elsewhere. Others have suggested it derived from *ahl-e-suffa*, literally people of the bench, a group of early Muslims who lived near Medina. Another possibility is *safa*, or "purity" in Arabic.

Many sources now simply call Sufism a mystical branch of Islam. But there are tantalizing clues that Sufi inspiration could predate Mohammad. Some possible pre-Islamic borrowings could be from early Christian monks and ascetics, who sought enlightenment by testing the limits of endurance and solitude.

The story of the eighth-century slave girl Rabia al-Adawiyya—one of the rare references of Sufi devotion by a woman—fits seamlessly with the early Christian mystic traditions. As the tale goes, she was granted freedom after her master saw a light appear over her head while she was in prayer. She then set off for a life of contemplation in the deserts beyond Mesopotamia, which then was still populated by a weird cast of hermits, zealots, and self-exiles seeking extreme forms of isolation. Among them were the stylites, who would perch themselves, alone, atop pillars for months or even years.

Some Sufi scholars also discern the fingerprints of Greek philosophy and metaphysics. Both made room for mortal inquiries into the unknown. Sufis may also have absorbed another Greek idea: pragmatism. Some experts suggest Sufis could have adopted Muslim trappings to avoid a full-scale backlash from Islamic leaders who felt threatened by the Sufis' free-form worship and devotion to the *pirs*.

It was serious business. In the early tenth century, with Islam just three hundred years old, a Persian mystic and Sufi named Husayn al-Hallaj was executed for blasphemy after he started bellowing that he "was the truth" while in the state of religious euphoria. Al-Ghazali helped bring some peace by eloquently smoothing over perceived contradictions between Sufis and mainstream Islam.

The Sufi orders attained their greatest influence during the rise of

the Ottomans and are widely credited with being highly effective Islamic missionaries.

"But can a Christian also become a Sufi?" I asked Nazam. "Can anyone adopt the Sufi ways?"

He fell into a whisper. "Maybe someday when all these Islamic fundamentalists fade away. God is God. Remember that."

I turned to leave. Then Nazam thought of something.

"Wait," he said. "You said you were interested in Hafez. You know, we have something directly like his poetry. I forgot to tell you. Hafez spoke often of wine. Maybe he drank wine, maybe he didn't. Who knows? But we think of it as the symbolic, ah . . ."

"Intoxication," another Sufi said.

"Yes, right," Nazam continued. "The symbolic intoxication with God. We have this ceremony. We fill a drinking cup with sherbet and add grape bits. We drink it as if we are drinking wine. You see, the great Hafez lives in many ways."

Mashhad had other surprises for me.

The biggest one was sitting in the hotel lobby in a nice gray suit.

"Mr. Brian, good to see you," said Hossein as we hugged.

"Been carpet hunting?" I asked.

"You know me." He smiled. "I never stop looking. We'll go and see some later."

"I'm always up to see some carpets." I smiled back.

"You, my friend, have the bug," Hossein said with a laugh.

In fact, he helped infect me.

On my first trip to Iran in 1999—even before my introduction to Hafez in the Tehran bazaar—I sat transfixed in Hossein's shop off the giant Imam Square in Isfahan and listened to him hold court. He described his trips in search of nomad carpets with the verve of a master storyteller.

He took out an antique piece. It was a mix of carpet and kilim. He asked me what I saw. I've forgotten my answer. But I remember his. I took out my notebook and wrote it down.

"I see God in my carpets. I truly do," said Hossein Payghambary. "What is God? Beauty, devotion, awe, love. I see this in the carpets. I feel I'm in the presence of God in some way."

It was pure luck to cross paths again in Mashhad. He'd learned from a carpet seller that I was in town. He was there for a wedding and had arrived early to search some nearby villages for old carpets. "Just a few worthwhile pieces this time," he complained. "It's getting harder and harder."

Yes, I thought, I've heard that before. It's part of the stock repertoire of the carpet seller. Times are always tough. Good carpets are always getting scarcer. The deal offered to you is always a steal.

Hossein, somehow, makes all the hot air seem fragrant and refreshing.

He does something few carpet sellers can manage: he actually listens. He still pounces with the best of them when it's time to close a sale. But he also enjoys the foreplay. He'll quietly explain a carpet, answering questions about the knots or dyes with what appears to be genuine sincerity.

He's a small man—no more than five feet six—and when he squats down on the carpets he compresses into a little form topped with a swath of frizzy black hair with just flecks of gray. He has a ring he never removes: a syrup-brown Yemeni agate set in silver. It's also the kind favored by Shiite mullahs.

Hossein was born in 1959 in a village south of Mashhad, but a long drought forced the family to move into the city when he was young. Hossein started working at a watchmaker's shop with his cousin. One day, Hossein was dumbstruck at what his cousin could do: speak English.

"I'll always remember that day," Hossein told me. "I just couldn't believe it. My cousin could talk to foreigners. It was like the world just opened up wide for me that day. I started learning English the next day.

"Then, about a year later, a Canadian came in the watch shop. I wanted to talk to him to practice my English. He asked me if I knew a good place to buy carpets. I didn't, but I found a shop and started looking at the carpets. Watches were okay, but this was an-

other thing. The carpet world was a world of endless wonders."

Soon he had a job in the carpet bazaar. His English, although still very choppy, made him indispensable with the many foreign oil workers and Western teachers in Iran during the shah's final decade.

"I'd still make crazy mistakes, like asking someone, 'How many fathers do you have?' " recalled Hossein. "Who cares? I was learning the carpet business. It was a joy."

By sixteen, Hossein had gone off on his own and rented a shop. The stirrings of the Islamic Revolution were just beginning. Hossein was a believer. He fully supported the idea of dumping the monarchy. It was nothing more than a lapdog of Washington, London, and other centers of power, he felt along with millions of other Iranians. Hossein joined the marches through Mashhad. He closed his shop in an anti-shah protest with many other merchants. He celebrated when the shah's last loyalists took flight in early 1979.

He stood by, but with growing unease, as Islamic vigilantes demolished wine cellars, smashed record collections, and abused anyone—especially Westernized women—who did not share their austere vision for the new Islamic Republic of Iran.

This is when Hossein, and many other Iranians who backed the revolution, started having doubts. He expected Khomeini and the other clerics to play a supporting role to an elected leadership. Instead, the world's most pervasive theocracy outside the Vatican began to take root. The clerics may have despised the shah, but they had little trouble mimicking his autocratic style. The revolution—and what it stood for in many minds—began to drift.

There's no better example of the revolution's hijacked dreams than parliament.

In the molten period after the shah's fall, the stunned and overwhelmed new leaders groped for a new system. A Western-style democratic model—with legislative, executive, and judicial branches—offered some firm footing at first. For a while, the mullahs stayed in the wings. Khomeini blocked clerics from running

for president in the first postrevolution election in 1980.

But things soon got ugly. Former supporters of the revolution grew disenchanted. Other opponents looked for weak links to strike. Scores were settled. The first president, Abolhassan Bani-Sadr, was forced to go underground—some say dressed in a woman's chador—and later turned up in France. The next president, Mohammad Ali Rajaei, was killed in bombings in August 1981 that claimed the lives of about seventy other high-ranking officials, including the chief justice and prime minister. The attacks were blamed on the most powerful Iranian militant faction, the Mujahideen-e Khalq, or the National Liberation Army of Iran, which received indirect U.S. backing in the 1980s through Saddam Hussein's Iraq.

Khomeini and his allies feared events could spin out of control with two fronts to worry about: the escalating war with Iraq and internal violence that could tear apart the learning-on-the-job revolutionary government. The mullahs started taking over piece by piece.

They were sharp and selective. They took control of everything that really mattered: the courts, the Revolutionary Guards, the levers of the vital import and export commerce. Other institutions simply were watered down.

Parliament became just a fancy talking shop with leather seats and green marble walls. There was lots of noise but no real authority. All important decisions needed the backing of the clerics. They also devised a system giving them the last word on who could even run for the chamber: all candidates must pass through the gauntlet of clerics and jurists on the Guardian Council, which can block anyone's political ambitions and is answerable only to the supreme leader. And hard-liners say the supreme leader answers only to God.

The irony was deep. Khomeini used to denounce the shah for making parliament irrelevant and controlling who could run for public office. Only now it was the turban instead of the crown calling the shots.

Hossein's carpet shop was sinking fast after the revolution.

So were other carpet operations around him. There were now few

foreign customers, and the prospect of one heading to far-off Mash-had seemed as likely as finding a gin and tonic in a mosque.

The revolution in the early 1980s was still thuggish and unpredictable. The war with Saddam's Iraq was heading into a gruesome new stage with mustard gas and other chemical weapons striking Iranian forces. Hossein had had enough. He left for Istanbul by train in 1986 with his brother, who later went back to fetch Hossein's wife and son. For the next decade, Hossein worked in Istanbul's carpet bazaar, starting as a salesman and ending up as a partner. He stashed away money and learned ways to make more.

His idea was to move to distant Bali and open a carpet shop. He liked that Indonesia was Muslim, but best of all, he felt he could corner the tourist market. Hossein returned to Iran to get their visas and finish some paperwork for the move. He had a few days to wait, so he took a sightseeing trip to Isfahan.

"It changed my life," he recalled. "The moment I saw the domes and the beauty, I knew I had found my real home. I called my wife immediately and asked if she would give up Bali for Isfahan. She loved the idea of coming back to Iran. She was tired of being a foreigner. Isn't it amazing how one decision can completely alter your life? For me, it was that decision to take a little trip to Isfahan."

Hossein opened a shop simply called Nomad, specializing in the coarse kilims and carpets of the tribes from central and southern Iran.

"Let's go see some carpets," he offered as we finished tea in the Mashhad hotel.

We headed down the long, straight boulevards of the city.

Our ride was a creaky old Paykan that made a metallic squawk at the smallest bumps. The boxy Paykan—or Arrow, as it was incongruously named—is a four-cylinder monument to Iran's quest for economic self-reliance. But it also represents the uninspired and insular ways Iran often goes about it.

The Paykan was born in 1967 as a copy of Britain's Hillman Hunter sedan. The Hillman Hunter ended production in 1979, but the Paykan lives on as an automotive time capsule. Almost nothing has changed: hubcaps that look like silver saucers; a glove compartment that could barely handle a pair of gloves; and the ignition

tucked under the thin vinyl ledge that calls itself a dashboard. The Paykan factory west of Tehran churns out more than five hundred cars a day. Demand remains propped up by a ban on full-scale car imports and the sky-high price of Nissans and other foreign models assembled in Iran. "The Paykan is like a vampire," an executive at the factory once told me. "It's immortal."

We pulled up in front of a doorway with cracked steps.

"We're here," said Hossein.

I followed him into a cavernous chamber rising four stories. Each level contained carpets shops with their wares spilling out into dusty corridors and stairwells. Mashhad, as a city, is a rather charmless sprawl with a jeweled center. We were just a few blocks away from the dazzling shrine of Imam Reza. But its grandeur doesn't travel far. The carpet hall reminded me a bit of the gloomy workshops in Mazar-i-Sharif.

Carpet merchants tried to lure me in. Hossein ran interference.

"No," he said firmly. "Not interested." I was happy not to have to make my typically lame excuses.

Most of the carpets we passed were handmade in local workshops. They were, in my opinion, perfectly suitable pieces that could be purchased for about $100 per square yard. Hossein thought they were boring and—even worse—just plain ordinary. Sort of like the Paykans of the carpet world.

"They just keep churning these out," he scoffed. "It's like Coca-Cola. You can find it everywhere. You want to see something good?"

"Sure."

"Follow me, my friend."

We walked around a pile of bread dotted with green mold. Why it was there, I'll never know. Because a moment later, a dapper man came darting out of a shop to embrace Hossein.

"Meet my old friend," Hossein said, pushing me toward the man. "No, he's more than a friend. He's like an uncle. No, he's even more than that. He's like . . ."

"His mentor," said Saher Houseini. "How about that?"

"Yes, mentor." Hossein smiled and the two men hugged again.

His shop looked like all the others: a small corner nook packed

with carpets. The walls were a bizarre green plaid that contrasted sharply with the piles of nomad-woven reds and grays. Saher wore a tidy tan suit with a vest and a green silk scarf worn as an ascot. He spoke English in a precise manner, weighing and choosing each word carefully as if he had a daily ration.

"Mr. Brian is a friend," said Hossein. "Show him the good stuff."

"Right. To the good stuff," said Saher with a bow. "As you wish."

He reached into an alcove and pulled out a hundred-year-old rug from Birjand, an area south of Mashhad that has been a center of low-quality workshop production for decades. This carpet, with simple white *guls* on a deep red field, was done by a tribe that was later absorbed into the factory weaving networks.

"You want the real story?" he said. "It's that no one in this country appreciates this type of carpet anymore. Few Iranian people care about these unique pieces. In the West, yes. But not here."

"Why's that?"

"Because we've been beaten down by this system since the revolution," he said. "We struggle for money. We struggle for freedoms. When you are struggling all the time you forget how to see beauty. You forget how to appreciate fine things. You know what's sad? Touch the carpet. Go ahead."

I ran my palm over the century-old pile. I wasn't sure what I should say. I just waited for him to continue. He did.

"This carpet has been touched and admired by people here for a hundred years—maybe more. Now, if I want to sell this carpet, I must send it abroad. It's gone from Persia, from its home, probably forever. This would sell for more than a thousand dollars in America or Europe. Here, I could get just a fraction of that, assuming someone would want it. We are sending our most lovely pieces away."

"I see what you mean," I said. "But they are making new carpets all the time. Won't these be the antiques of tomorrow?"

"It's different now," he answered. "Too many workshops. Too much chemically dyed wool. Not enough individual spirit left. You want to see what I'm talking about?"

He rolled out a Kurdish kilim, maybe thirty-five to forty years old. It had slanting stripes on the edges. The center was rows of

wavy lines that were interrupted and staccato, the Morse code of a lazy weaver or one running low on wool. But it was the corners that immediately caught Hossein's eye. Two braided tassels of camel hair and black wool dangled from one side.

"Very interesting!" said Hossein, falling to his knees and grabbing the braids. "If I'm not mistaken, it's probably the signature of the tribe."

"Like a cattle brand?" I asked.

"Exactly," said Hossein. "This was a way to identify their work. I haven't seen this in a long time. Where did you find it?"

His mentor was polite, but vague. I had spent enough time around carpet merchants to know the boundaries. They loved to talk about their special finds but would never divulge the precise details of how they got them.

"Look at this," said Saher, studying the kilim's broken lines and mismatched colors. "This is just beautiful. It's unique. It's fascinating. You could spend your life just studying this one kilim and wondering: What made her do this or that? Carpets are irrational, just like people. You in the West prize the rational. You want to understand everything. You can't think that way and really appreciate carpets."

"Or mystic poetry?"

"Yes, right, of course" he said. "Take a look at these pieces. They may be rational, but they are boring. Worthless, really."

He pulled out some small kilims made from a simple workshop pattern. The chemical colors were garish, like neon next to the muted antique weaves. Saher buys them for $10, washes them in hot water with strong detergent, and puts them in the sun to soften the colors. Then he sells them to another merchant for $20. They reach the European market at about $40.

"It's junk, but you have to make a living," said Saher.

Hossein listened politely to our conversation. I could sense he was bursting to talk.

"You talk about the mystic poets and the mystical side of carpets," he said to me. "I have a different idea. I think the true connection is with kilim. Why? Because the poets touch something so deep in our culture that we don't even know the origins. It's back before Islam, back to the things that really make us Persian. So if

you look at carpets, you must go back, too. It all started with felt. Then we have the flatweave kilim. Then comes carpets.

"This is why I think you need to go back to the kilim for answers about the mystery of the Persian soul," he continued. "The kilim is built simple and strong, but the surface can be infinitely varied and complex. Anyway, that's my theory."

It was good enough for me. I bought the Kurdish kilim for $150. Saher recorded the transaction in an old *Tom and Jerry* notebook. It's easy to forget the pop culture links between Americans and Iranians who came of age before the revolution. American television was a staple in Iran during the 1970s, and many Iranians remember their favorite shows and characters like lost chums: the detectives Columbo and Mannix, the Wild West of *Gunsmoke* and *Little House on the Prairie*; and the squealing muscle car tires of *Starsky & Hutch*.

After puttering around in a Paykan, I can understand the appeal.

Hossein had about an hour before the wedding. He offered to escort me to the Imam Reza shrine. It was never clear to me whether non-Muslims were allowed inside. Just in case, I worked out a cover story: I was a Bosnian Muslim. I figured the chances were remote of a shrine guard knowing the language of the former Yugoslavia—and recognizing that I can't speak it. I also know enough pidgin Arabic to support the Muslim guise.

There was probably no reason for the skullduggery. But Mashhad is one of Iran's bastions of conservative Islam. You just never know. "Take off your glasses and don't speak English," Hossein whispered as we neared the security checkpoint.

"My glasses?"

"They look too foreign."

"But I'm supposed to be foreign. I'm Bosnian, remember?"

"Trust me," he said.

I pocketed my blue Max Mara specs. Everything took on a blurry, underwater look.

We passed through without a problem.

"Can I put my glasses back on?" I asked. "I'm getting queasy."

"We're fine now," said Hossein.

It took four minutes just to walk across the outer courtyard. The shrine complex—bankrolled mostly by a powerful religious foundation—has swallowed up surrounding neighborhoods. When Hossein was young, the carpet bazaar abutted the shrine. Now, the bazaar is gone, replaced by a vast plaza overshadowed by new minarets.

Outside the shrine, we took off our shoes and stepped onto a sea of carpets spilling out from the majestic *ivans*, the subtly pointed arches that dominate Persian religious design.

"Machine-made carpets," scoffed Hossein. "But wait until you see inside."

I actually stopped in my tracks. Imagine St. Peter's Basilica covered from floor to ceiling in beveled mirrors that reflected light and color with a kaleidoscopic effect. Then add gleaming gold doors, glazed tiles in arabesque designs of blue and green, and acres of fine, hand-woven carpets made by the artisans of the Imam Reza Foundation.

We followed the pilgrims to the center of the maze. There, surrounded by hundreds of people straining to get nearer, was the gold-and-silver resting place of the imam. Guards carrying rainbow-hued dusting wands tapped worshippers on the shoulder if they become too aggressive in trying to reach the tomb. It's about as big as a one-room cabin, with openings covered by latticework of thick, braided gold. A glass wall separates men and women. Both hurl bits of green cloth—the color of Islam—and other material onto the tomb as symbolic offerings. Above, chandeliers of green and white glass hang from chains stretching more than five stories. They sway continually from the invisible forces of air currents and Earth's own passage through the heavens.

Some Shiites believe a pilgrimage to the shrine is just as spiritually important as the duty of visiting Mecca. Over the centuries, the site has been leveled, rebuilt, and expanded by the patronage of pilgrims and monarchs.

The impulse, as with many centerpieces of the Muslim world, was to create an earthly paradise. A leading authority on Persian architecture, the late Arthur Upham Pope, said this inspiration "finds

supreme expression" in the Imam Reza shrine. A place of almost equal opulence was created for Reza's sister, Masoumeh, in the holy city of Qom, south of Tehran.

I made no attempt to touch the tomb of Reza. I didn't want to fight the crowds or give anyone reason to notice an infidel in their midst, especially an American foolishly pretending to be Bosnian.

"Come," said Hossein. "There is more to see."

We wandered through some of the more than thirty rooms and bays. Hossein wanted to pray more. I sat on a carpet fashioned in the flowery Isfahan style. For a while, I simply watched the pilgrims pass over the alabaster floor made smooth by millions upon millions of visitors. There were soldiers in uniform; Shiite Arabs from Iraq in kaffiyehs, checkered head scarves; Baluch tribesmen from eastern Iran with their spotless white turbans; Turkmen with wrinkled lambskin caps.

Hossein tapped me on the shoulder. He was done praying. It was time to go. He made a quick stop in a side room that contained the modest sarcophagus of a mullah who had preached at an Isfahan mosque with architectural oddities known as the shaking minarets: pushing hard on one of the two towers will cause both to sway slightly.

We walked in silence back into the chilly night. There was one last place I wanted to see. Hossein knew it and led me there without a word.

We stood, side by side, under the enormous arched portal of the mosque of Queen Gawhar Shad, the patron of the once majestic Musallah in Herat.

I had wanted to come here ever since I trudged through the Musallah ruins and looked down at shards of cobalt blue tile embedded in the dirt. Here, the queen's mosque, which has been incorporated into the swelling Imam Reza shrine complex, stands as one of the surviving treasures of Emperor Timur's building boom.

Built in 1418, the mosque is one of the most striking examples of color and form. The high-gloss tiles flow in elegant harmony between turquoise, green, yellow, and black. Panels of crisp geometry pass to floral shapes and back again with seamless ease.

I tried as best I could to imagine this kind of beauty stretching out over the plain outside Herat.

"What are you thinking about?" asked Hossein.

"How it's amazing that this survived and the Musallah in Herat is in ruins."

"Oh," he said. "I thought you were thinking about carpets."

"Why?"

"Because I was. I was just trying to decide what is more impressive: a beautiful carpet or a mosque."

"What did you decide?"

"You need to ask? A carpet, of course."

Before leaving Mashhad, I paid one last visit to old Persia.

This one, however, was not to something tangible like Imam Reza's tomb or the queen's mosque. This was to an idea, a wisp of the Persian collective soul. To the north of Mashhad, where the city's grimy procession of auto shops and metal factories finally runs out, sits Toos.

The mystic scholar al-Ghazali was born here. But most, like me, come for Hakim Abolgasim Ferdowsi. His *Shahnama,* or *Book of Kings,* tells the story of the fictional hero Rostam and other adventures. The time is the dim, unstructured past. Certainly before Islam. Maybe even before the fire temples of Persia's Zoroastrians. It's something like the *Odyssey,* the *Iliad,* Norse myths, and Aesop rolled into one.

Rostam, like St. George, slays a dragon. He shows the ingenuity of Odysseus by using a two-pronged arrow to blind a rival. There is the story of the humble blacksmith Kaveh leading the uprising against the Arab snake-man Zohak, who was left chained to towering Damavand mountain. I remembered how I saw it that clear day after meeting Mohammad Reza in the Tehran bazaar.

Ferdowsi took up the unfinished *Shahnama* in middle age—sometime around 990—and worked for thirty years. He found generous patronage from the Sassanian rulers, who encouraged Persian lore to

counter the growing Arab influence. But new invaders later in Ferdowsi's life had no such interest. His last years, according to the biography in his tomb, were mired in "wandering, poverty and grief."

Ferdowsi is an essential element in the Persian blueprint. His life embodies what many Iranians still feel: Islamic by birth but linked by spirit to another, older array of attitudes and glories.

It's on display everywhere. Parents still pick ancient Persian names for their children, like Daryoush, after the royal line of Darius, or Moujgan, "eyelash," a traditional symbol of coquettish beauty. The Persian new year, *Nowruz,* is celebrated on the vernal equinox with tables decorated with seven items signifying prosperity and good fortune but whose origins are so old that scholars cannot agree on how they came about.

The Islamic establishment knows it's a losing battle to try to bury this past. But they still get in some jabs. On state-run television, the heroes always have solid Islamic names such as Mohammad or Ali, and the villains have the Persian ones.

Ferdowsi's tomb has no such cultural friction. It's solidly rooted in the pre-Islamic past. It was built in the late 1960s by the shah as a replica of the tomb of the exalted Persian king Cyrus the Great in Pasargadae in southern Iran.

I found a bench away from the souvenir stands selling plastic busts of Ferdowsi. His tomb, made of bone white travertine, is decorated with passages from his poetry. But what I came to see sits above the script. Carved in deep relief is the winged symbol of humanity and divinity of the Zoroastrians. Dark swallows darted around the tomb. A man beside me read the *Shahnama* to his sons.

I thought about where I would head next: to the very center of Iran. Zoroastrians are still strong there. I also heard I could find wild madder.

Outside the tomb, near a weed-choked parking lot where boys played soccer, a bedraggled man had placed a small scale for tourists. He also had small slips of paper. As I walked by, he grabbed my hand and put a scrap in my palm. It had just one word written in Farsi.

"Dream."

Once I got my Herat carpet properly cleaned, I realized why the *bazaari* thought I had overpaid. The weave was tight and finely knotted. But some of the colors, particularly the blues and ochers, appeared too sharp to be from natural dyes. Only the reds seemed to give off the comfortable warmth of madder.

Madder is the most widespread natural source of reds, but it is not the only one. Perhaps the most unexpected rivals throughout history have been bugs.

The best known is cochineal, a scale insect that lives on certain species of cacti in Central and South America. Native inhabitants as far back as 1000 B.C. knew how to extract bluish red dye from the dried remains of the female cochineal, collected when she was swollen with eggs. Spanish traders in the 1500s introduced the so-called scarlet grain to Europe. Some cacti were transplanted to places such as the Canary Islands and Java. Cochineal is still widely used as a food coloring.

Another red dye comes from an insect that infests oak trees and other plants in southern Europe and the Middle East. The scarlet obtained from the dried shells of the female shield louse was used by dyers in ancient Rome. Cochineal almost completely ended the dyers' interest in these insects in the 1600s.

A red also can be obtained from the bodies of the gum-lac scale insects from China, south Asia, and parts of Africa. The same bug is also a source of the resin used in shellac.

Red and purple dyestuffs with unreliable staying power include red ocher from soil rich in iron oxide; henna; the purple lichen archil; and Brazilwood trees.

There are hundreds of natural sources for other colors with varying degrees of fastness and durability. Some of those used in carpet production include:

Yellow: weld, pomegranate, chamomile, onion skin
Blue: indigo

BRIAN MURPHY

Brown: walnut
Black: acorn cups, oak bark

Primary colors are mixed to create greens, oranges, and other shades.

The merchant is God's friend.
　　　　　—Written on purple tile at an entrance to the Yazd bazaar

CHAPTER SEVEN

THE ROOT OF WILD MADDER

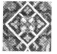 I found them in a grove of pomegranate trees.

There was no sign to direct me to where the dyers work. Only a quick glimpse of color showed the spot. Clumps of madder-dyed wool, drying on a wooden pergola, were kicked up by a lip-chapping wind coming from the direction of the city of Yazd to the north.

"Over there!" I said to the driver like a whaler seeing a spout. "There it is!"

"Where?" he asked.

"There!" I pointed. "See the red?"

He did. The car crunched over a gravel track toward the trees.

Finally, I was closing in on what I'd been chasing for years. Shortly after I became acquainted with Hafez, I found a second guide. I picked the madder plant as another beacon of my carpet education. I read about its remarkable history. I learned the scientific names of its dye properties. I saw the amazing variety of colors it produces on carpets. I found bits of madder red wool in the aban-

doned dyers' shack in Afghanistan. But, curiously, I still had not seen it.

I was told this part of central Iran still had madder fields. The best place to start, I reasoned, was with a dyer. I'd then work my way toward the madder.

Among the papers I carried on the trip were synopses of John Belchier's experiments with madder in the 1730s.

"You know what really got me interested in madder?" I told my translator. "This doctor named Belchier who found that eating madder will turn bones red."

"That doesn't surprise me at all," he said.

"It doesn't?"

"I guess you've never seen what the dyers look like," he said. "It gets in their skin, and with some of them, no amount of washing can get it out. It's a powerful thing."

The car stopped under a canopy of wool dyed madder red. I was about to enter the seesaw world of the traditional dyers.

By the 1950s, the obituary for natural dyes was being prepared.

The ancient knowledge of natural dyeing hung on in places that were either too remote or destitute to tap the rainbow of synthetic colors. But it seemed likely that madder, pomegranate, and the other natural dyestuffs would continue to drift to the margins of carpet making in the same way that painters gradually abandoned the natural recipes for pigments. A few textile historians and researchers also kept alive interest in traditional dyes in the West, but more for scholarly reasons than practical applications.

Among them was a German chemist, Harald Boehmer, who first encountered Turkish carpets on a high school teaching contract in Istanbul in the 1960s. He marveled at the difference between the harmony of the older, natural colors and the jarring brilliance of chemically dyed carpets. His investigations in the 1970s quickly confirmed his suspicions: the local knowledge of natural dye making was rapidly disappearing, including the recipe for the famous and

durable Turkey red dye from madder. He also found that few written records existed of the dyeing process. It was simply passed on through oral tradition. He became a color sleuth.

In a makeshift kitchen lab, he used a technique known as thin-layer chromatography, essentially breaking down an object's chemical fingerprint with a solvent, to identify the components of the colors on antique carpets. One by one, Boehmer began to map out the natural color sources.

In 1981, loaded with records about Turkey's natural dye legacy, he started to gain footholds in the villages. He helped establish a project known by the Turkish acronym DOBAG that has reintroduced natural dye making to western Turkish weavers.

It's part of a trend that has moved, in fits and starts, across some key carpet centers. The percentage of naturally dyed wool in Iranian carpets has steadily risen since the 1990s. Even Pakistan and India, often scorned as purely commercialized carpet producers, have started to promote naturally dyed pieces at international carpet fairs.

"This is a good trend. I hope it continues," said Majid Montazer, the head of the dye division at Tehran's Persian Carpet Research Center. "The natural colors are alive. They are like life. No, they *are* life. In life, nothing stays the same. It's like this for the naturally dyed wool. The colors are always changing with light, time, wear. There are small differences in the way the dye fixes to the wool. It's something very special."

But it was hard at first to believe I had found part of a revival at the place near the pomegranates.

The dyeing workshop was a cluster of run-down cinder-block buildings down the road from a neglected nineteenth-century caravanserai that was now home to lizards and nesting birds.

More than a hundred ten-pound bundles of spun wool—dyed red and burnt orange—hung from poles and a shaded stick grid. They reminded me of catches of octopus left to drain in the Mediterranean sun. The wool was gritty with the madder grains that didn't dis-

solve in the heated dye solution. Some dyers give the wool a final clear-water rinse to wash away the residue, which can weaken the wool and cause respiratory problems for the weavers. Here in central Iran—with fresh water scarce—the dyed wool was simply dried and shipped.

"We are simple people doing a simple job," explained the dye shop boss, Mujtaba Zareh. "God did the work to make nature and its colors. We just take what God has given us."

He also takes what poverty and war has thrown his way: illegal Afghan workers paid probably no more than $5 a day. Their arms, dyed to the elbows, show what job is under way. One Afghan was madder red. Another was the deep blue of indigo.

"Come," said Zareh, a fiftyish man with the taut physique of a jockey. "I will show you."

He led me into the dyeing chamber. It was lit by bare lightbulbs. Four copper vats—about the size of fifty-five-gallon drums—were on platforms with natural gas vents underneath to heat the dye broth. Copper is not the preferred material, since it can add a brown character to the dye bath, but Zareh has no extra money for upgrades. He dyes because that is what his father did. So did his grandfather.

"Who knows how far back?" he said. "It is what we do. It is what we are."

"And your children?" I ask.

He frowned. "You know, they don't want this life," he said. "My boys have gone to the city—to Tehran—to make a different life in offices. I am passing along this knowledge to these"—he lowered his voice—"Afghans. This is what's happening, I'm afraid. The country is changing. But never mind about that. Let me show you how to make this madder red you are so interested in."

I had read enough about the process to know his was full of cost-saving shortcuts. The first step, he said, was soaking the wool in a heated bath of *zaj*, the powder aluminum sulfate. This acts as a mordant—from the Latin *mordere*, "to bite"—to make the color affix permanently to the fibers. The choice of mordant also affects the final color. An iron-rich mordant will push the madder tones toward

rust. Alum-based fixers—like the *zaj*—encourage red and orange hues.

Then the madder bath is brewed. The ground madder root comes from fields on the other side of Yazd, he told me. The formula is simple: the final color of the wool depends on the amount of madder and length of soaking. Centuries ago, some dyers were said to toss in ox blood or other additives in attempts to enliven the colors. Dye formulas then were highly guarded trade secrets in a way similar to today's corporate mysteries such as base codes for popular computer programs.

"I don't know anything about calling this art," said Zareh. "It's a way to make a living. It's all I know. Do I really look like an artist?"

"What do you think an artist looks like?" I pressed.

He thought for a while. "Well, I don't know. It's not my concern," he said. "I have work to do. I can't sit around thinking about things like that."

I had arrived at his place excited at finally seeing this ancient craft firsthand. I left a bit saddened. The whole setting seemed to be on life support. The dyer's sons were away in Tehran. The Afghan workers could pull up stakes at any time.

Zareh told me he would work as long as his health held out. After that, he couldn't say whether his little dye operation would continue.

Zareh stopped me with a touch on my arm. He surprised me with a question.

"Are you happy with your life?"

I must have looked delightfully confused. He scratched his eyebrow and chuckled.

"Yes, I guess I am. Mostly. Yes, I'm happy," I said.

"So am I," he said. "I think you have the impression that I'm sad and lonely. I'm not. I take wool and make it more beautiful. I take joy in that. I also think it's nice that someone will make a carpet from it. It's like the wool is reborn into something else—like a caterpillar to a butterfly."

He gave me some strands of madder-colored wool as a gift. I left the compound. A few minutes later, I climbed to one of the ram-

parts of the abandoned caravanserai, whose mud-and-straw walls were slowly being reclaimed by the earth. I looked back at the dyers' compound. The wind had picked up. The madder red wool waved.

I took a small rock and dug into the floor of the caravanserai. I placed the wool strands from Zareh's shop in the small gouge and placed the rock on top so they wouldn't be carried away by the wind.

A group of birds watched. I like to think they snatched the wool after I left and used it in their nests.

We drove north toward the madder fields and back into carpet history.

The shah once tried to stop the clock.

Some accounts say it happened on January 1, 1900, by the Western calendar. But it's more likely that the royal decree was issued a few years into the new century during the tumultuous rule of Shah Mozaffar od-Din.

He outlawed the use of chemical dyes in hopes of halting their encroachment on Persian carpet production. It was, of course, a doomed defense.

Mozaffar's father, Naser od-Din, had shaken Persia from its isolation and forged new bonds with the West. These included giving European carpet operations important footholds in Persia. But when the chemical colors starting flowing from Europe, Naser tried to stem the tide. He had little success. There was always a bribe-hungry official willing to look the other way. Also, many black market sources were freely peddling the new reds, yellows, and other colors.

It's never been made clear why the Persian royalty got involved in the business affairs of lesser mortals. The Qajar dynasty at the time had much bigger troubles on its plate. Persia was shrinking. Russia had driven Persian control from central Asia. Britain had consolidated its sway over neighboring Afghanistan, helped in part by the defense of Herat. London then extracted some vital economic concessions from Persia.

The fact that the royal court had any attention left for carpets is an apparent sign of their deep importance as a cultural standard-bearer.

Rugs of questionable quality, the theory goes, were too much for Persia's bruised pride. The early chemical dyes tended to run if wet. They also faded into bland, muddy tones, nothing like the luminous patina of natural colors.

Mozaffar's decree added teeth to his father's softer approach.

The shah's shock troops, armed with firearms and swords, stormed dyers' workshops. Supplies were dumped onto public bonfires. Anyone found with the banned dyes was either hit with crippling fines or, in extreme cases, led off to prison—maybe after watching his shop go up in flames. It was very dramatic but wholly ineffective. The chemical dyes just kept coming.

It was a classic overreaction in Mozaffar's brief, and deeply flawed, reign. One carpet historian curtly summed up the monarch as "feckless, cowardly and sickly." The witch hunt for the chemical dyes, however well intended, added to the mounting resentment of Mozaffar, who was fond of European-style tails and spats at a time when few ordinary Iranians shared much affinity for the West.

The gripes against Mozaffar started to boil over in 1906. The powerful *bazaari* in Tehran closed their stores to protest the punishment of two sugar merchants who refused orders to lower their prices. Their defiance earned the two shopkeepers harsh punishment: caning on the soles of their feet. Workers around Tehran followed the bazaar's cue and went on strike. Clerics rallied the faithful in Friday prayers and urged for Islamic law to replace the shah's codes, an appeal that was tantamount to mutiny against the monarchy and worthy of a death sentence.

But instead of pinpoint strikes against agitators, the shah answered with blanket crackdowns. The country crept dangerously close to civil war. Mozaffar, although close to his last breath, faced a huge decision. In the closing hours of 1906, just days before his death, he signed a constitution that gave the public a greater say in political affairs. The merchants and mullahs—the leaders of the revolt—had beaten staggering odds.

The uprising is widely considered the starting date of Persia's modern era. It came just two years before another seminal event: the discovery of oil in Persia, which catapulted the region from sideshow to center stage. The Islamic clergy also hit pay dirt: confirmation of their enormous political power and how it could be mobilized. The revolt is often cited as the first stirrings of the Islamic Revolution that would sweep over the country more than seven decades later.

Mozaffar, too, is mostly remembered only for this landmark capitulation. But his battle against chemical dyes may deserve some fresh attention and evaluation. It could be seen as another early call to arms, one that's now being heeded by cooperatives and high-end carpet houses trying to revive the art of natural dyeing.

"Persia has always had an uncomfortable relationship with these chemical dyes," said Montazer of the Carpet Research Center. "It came from outside and, I think, has always remained a foreign thing even though many weavers took the easy road and starting using them."

The precise eureka moment of marketable chemical dyes is debatable. But it's possible to start the story from a very humble point: a lump of charcoal.

Charcoal was the type of business that made simple men rich back in the fifteenth century: low overhead and a captive market. All it required was heating wood in an airtight oven. Out came what every metal smelter needed. Charcoal burns hotter and cleaner than logs and was the most valuable fuel of the day. But it led to a classic case of demand outstripping resources. Trees were coming down too fast in Europe. Wood was getting scarce and more costly.

Metalsmiths started to look around for alternatives to fire their furnaces. Coal was no good because its sulfur and other impurities weaken metals. But in the early 1600s, an enterprising tinkerer named Hugh Platt had an idea: try heating coal with the same anaerobic charcoal-making method. The result was a porous and

high-carbon substance dubbed coke. Some other interesting by-products were also kicked up. Among them was a smelly and chemically complex goo they called coal tar.

A German chemist, Friedlieb Runge, started to play around with it in the 1800s.

Runge had already hit the bull's-eye once. He won considerable fame for isolating the first pure caffeine sample from Arabian mocha beans. He was in the market for another breakthrough to impress his friend and patron, the poet and science aficionado Johann Wolfgang von Goethe. Distilled coal tar yielded, among other interesting things, a colorless and oily compound called aniline.

This caught Runge's attention.

Aniline was first isolated in 1826 by the destructive distillation of the blue-dye-producing plant indigo. Aniline is getting right down to the basic levels of organic chemistry. Once there, scientists knew they could start remixing compounds in exciting new directions, ways that eventually led to drugs, plastics, rubber, and other applications.

In the early 1830s, Runge joined the small fraternity of scientists who were exploring laboratory-produced dyes. By the time Runge came along, no one had yet succeeded in making a dye that was beautiful, commercially viable, and nonfugitive, meaning it didn't easily run or fade.

On a hunch, Runge took aniline and mixed it with bleaching powder. Out came a brilliant blue. For the first time, dye makers had an alternative to the ancient menu of drawing blues from the indigo plant and other natural sources.

But it wasn't until about 1856 that a truly popular synthetic dye arrived on the scene. Pungent coal tar again was the start.

The quest this time was for quinine, which was then the sole treatment for malaria and available only from the bark of a South American tree.

Malaria had plagued parts of Europe as far back as antiquity. But there was a special urgency now for a new, easy quinine source: the expanding British Empire. A lowly mosquito threatened to complicate Britannia's reach through Asia and Africa. At least that is what

Her Majesty's envoys told the Royal College of Chemistry and its director, August Wilhelm Hofmann. What the queen wants, the queen gets. The quinine hunt went to the top of the lab's priority list.

Organic chemistry was in its infancy, but the rich mysteries of coal tar seemed a good place to start. Other researchers were already playing around with coal tar in tests that would eventually lead to cosmetics, flavorings, epoxies, and treatment for psoriasis.

Hofmann's brilliant teenage student assistant, William Henry Perkin, led the quinine team. One day, he was experimenting with aniline and ended up with an uninspiring dark slush. It seemed like another dead end. But when he tried to clean up his equipment with solvents, a vivid purple soup flowed out. Perkin quickly forgot about quinine. He was now a dye maker.

Perkin later called the dye mauveine, after the French name for the plants of the mallow family, which includes hollyhocks and the marsh mallow, whose roots provided a sweet, sticky treat that became the generic namesake for the sugar blobs roasting over today's campfires.

A synthetic dye was born. And not just any color: it was the legendary purple that was long the sign of royalty and privilege. Before, purple was obtainable only from the glands of certain mollusks and was more precious—and offered more vanity appeal—than pearls or gold.

There were teething problems with mauve, though. The color quickly faded on wool and cotton. Dyers were hesitant to make big investments. But some recognized the potential, Hofmann, Perkin, and the French fashion houses among them. In 1862, Queen Victoria gave the dye a royal plug by appearing in a mauve silk gown.

Perkin dropped out of college to start a dye lab and factory with the help of his father's seed money. He was soon in the thick of an international race to produce new synthetic colors. Just as the California gold rush was reaching its peak, chemists in Europe were prospecting for riches from coal tar and any other compound that looked promising. The first to the patent office stood to make a fortune. The new colors hit the market with the same interest as a hot

IPO these days. After mauve, the labs churned out shades at a rapid-fire pace. The lilac-hued fuschsin. The magenta roseaniline. Methyl violet. Bismarck brown. Aniline black. Columbia University gave Perkin one of his honorary degrees and acquired part of his laboratory.

Hofmann returned to his native Germany. It was a dynamic time. The combined forces of Otto von Bismarck's drive for Prussian greatness and farsighted industrial planning created a string of dye firms during the mid-1800s. Their names are now venerable and diversified powerhouses: Badische Anilin und Soda Fabrik (BASF), Farbwerke Hoechst, Friedrich Bayer, and Actien-Gesellschaft für Anilin Fabrikationen (AGFA).

One by one, the labs steamrolled over traditional sources of dye making. It was clear the glory days of madder were numbered. But it had been quite a ride.

Since antiquity, dyers had used the madder root in its native range across the eastern Mediterranean and central Asia. Small patches of cultivated madder eventually reached Europe. Merchant records and church ledgers note madder production in France and elsewhere as early as the seventh century, about the time Islam was spreading into Persia and elsewhere.

Charlemagne ordered it grown on his estate. Madder red was believed used on the marriage certificate of the Byzantine princess Theophanu to Holy Roman Emperor Otto II in 972 to seal a pact between the two powers.

Demand for madder red among textile makers was relentless. By the Middle Ages, European merchants had tired of dealing with the cunning Levant traders. Cultivating native dye-producing madder became a priority.

It wasn't a difficult task. Madder is a hardy plant that can withstand temperatures near freezing. There are thousands of species of madder, but only a small percentage contains sufficient quantities of the pigment alizarin and related components in its roots. It was sim-

ply a question of planting the most alizarin-loaded variety—*Rubia tinctorum*, or dyers' madder—and fine-tuning the crop with other wild madder species to best adapt to local conditions.

A serious madder boom was under way. The Dutch, whose horticultural brilliance fed the insane tulip craze of the early seventeenth century, took the lead in madder production. The French fought back with dyestuff-rich hybrids developed in Avignon and elsewhere. England, Switzerland, Russia, Italy, and other places joined in. Some accounts say Thomas Jefferson even kept a small patch of imported wild madder at Monticello along with herbs and medicinal plants.

The bubble burst in 1868. The place was Bayer's old laboratories in Wuppertal-Barmen, in the Rheinland industrial belt. Again, it all started with coal tar.

Two researchers, Carl Graebe and Carl Liebermann, found a method to chemically reproduce alizarin. The young and ambitious Perkin—still basking in the mauve fame—was also racing ahead with similar theories, but he was narrowly beaten by the German team. Their discovery was a sensation: the first synthetic dyestuff to withstand light and washing. And it could be made for a fraction of the cost and trouble of growing madder.

The crash was brutal. Between 1865 and 1875, the price of powdered madder root was in a free fall. In France, vast madder fields were dug up for vineyards.

At the St. Louis International Exposition in 1904, the pavilions were packed with the new high-tech wonders of the age: automobiles, telephones, and the outrageous prospect of flying machines that the Wright brothers had managed to get off the ground the previous year. A clever merchant popularized the ice cream cone. The third modern Olympiad was held as a country fair–style sideshow with the added embarrassment of something called Anthropology Days for athletes from Africa and other "uncivilized" points. The new dye-making giants were there, too. They spent lavishly on displays of their expanding spectrum. Their modern wares were shown—in ironic proximity—under the same roof as Oriental carpets. The two were heading for a shotgun marriage.

At the time, many of the new "Oriental" rugs in the Western markets were produced by European and American interests. Some firms set up workshops in Persia and elsewhere and shepherded the process from design to export. Others just cut to the chase. Weaving houses were established in England and other countries.

Synthetic dyes were a godsend to the all-important bottom line. Now, the companies could closely control and regulate the dye end of the business. The chemical dyes flooded the markets of Iran, Turkey, and other carpet lands. The village weavers, happy for the convenience and caring little for the ultimate aesthetics, were quick converts.

I was told there were still madder fields on the other side of the purple rock mountains ringing Yazd. But there would be a detour first.

I couldn't resist the city so deeply tied to one of Iran's oldest mysteries. It's a big one that may never be fully answered: When did Zoroaster walk these lands preaching about a single God, called Ahura Mazda, and the eventual triumph of good over evil on Judgment Day?

Some followers place Zoroaster all the way back to 6000 B.C., which would give the Zoroastrian faith bragging rights as the forerunner of all the monotheistic religions. Almost no serious scholar supports this time frame. But there's still ample room for conjecture. The most accepted range for Zoroaster's life is 1500 B.C. to 1200 B.C.—with some followers pushing it back to about 1700 B.C., said Jennifer Rose, who studies the faith at Claremont Graduate University, in California.

The date of 600 B.C. for Zoroaster is also widely discussed, but Rose and others believe it was the result of inaccurate calculations by the ancient Greeks.

"Every scholar writes about this [date] issue, and there's still no consensus," she said.

"The age he lived in is not really important," said Sohrab Yaz-

dani, one of the Zoroastrian elders in Yazd. "What's important is that what he taught is still alive today."

But struggling. There are probably no more than two hundred thousand Zoroastrians left worldwide, including communities in India, Pakistan, and North America.

In Iran, the cradle of the faith, there are probably no more than thirty thousand Zoroastrians, although census data show higher figures. It's one of the recognized faiths in Iran, but many Zoroastrians have joined other religious minorities in a steady emigration since the Islamic Revolution.

"So do you ever feel any pressure from Islamic authorities?" I asked Yazdani, an elegant man with a thin face and kind eyes.

"I'm not sure what you mean," he mumbled, looking around the hotel lobby where we had arranged to meet.

My translator winked at me. It was a sign for me to clam up. Two young men, one dressed in a well-tailored brown sports jacket, were lounging near the door.

In Iran, everyone's personal radar is finely tuned, even with the relative freedoms that started in the late 1990s. Any suspicion of eavesdropping or surveillance kicks in the default mode: extreme caution.

It took me a long time to get a proper fix on these tensions between Iranians' natural openness and their survival instincts. Iranian culture could not be called sheepish. Iranians are not shy about making their opinions known. And it doesn't have to be just big-picture politics. I've been at gatherings with Iranian couples arguing about the growing trend for nose jobs or whether slow seduction or wham-bam sex is more erotic. At a wedding reception in a well-heeled home, vodka-spiked punch was served downstairs, and upstairs a band kept the guests dancing until dawn.

Even the conservative side of society is encouraged to think and question. Debate and political action are fundamental to Iran's dominant Shiite Islam. I sat once with clerics in the city of Qom, the most respected center of Shiite learning in Iran, and heard their recriminations against some of the most strident Friday prayer leaders. The theologians felt the spirituality and peace of the mosque was

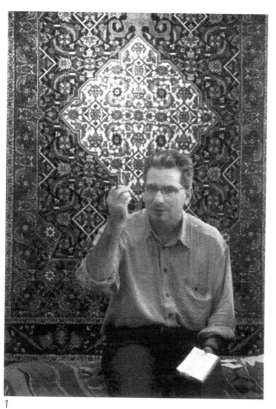

1) The author conducting an interview at the Miri carpet warehouse outside Shiraz.
2) Qashqa'i weaver at a village settlement near Shiraz.
3) Qashqa'i women singing traditional songs at their summer encampment in Fars Province, Iran. From right: new bride Zeynep Pakmanish and her sister, Maheen.

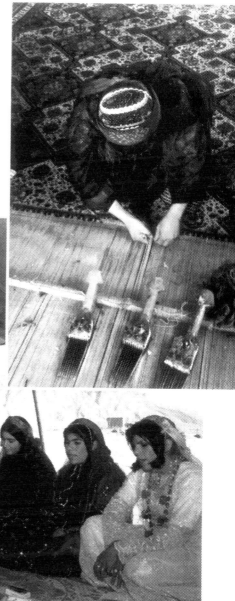

1

2

3

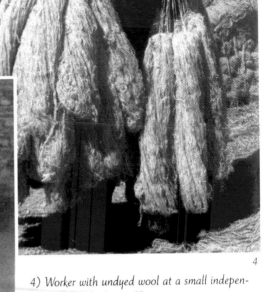

4

4) Worker with undyed wool at a small independent dye facility in Shiraz.
5) Dyeing wool in a madder solution in Shiraz.
6) Workers at the Miri dye factory outside Shiraz.

5

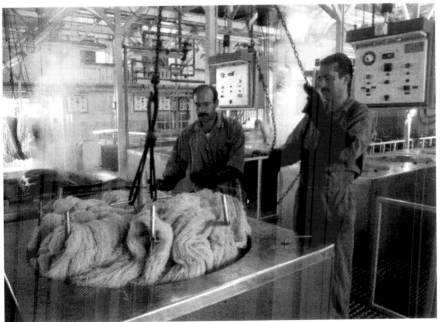

6

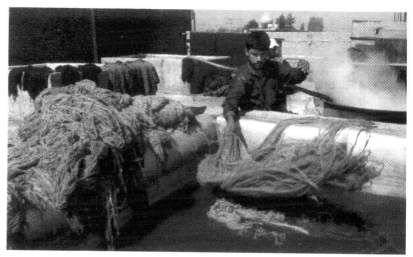

7) Workers at a small dye facility in Shiraz.
8) Workers dyeing wool in madder solution in Shiraz.
9) The author examining a copy of the famous Pazyryk carpet being made by Zeynep Pakmanish and other Qashqa'i nomads in Fars Province.

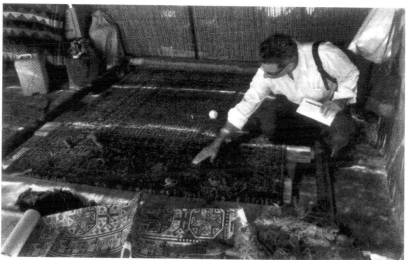

10

10) Qashqa'i woman spinning wool at the summer encampment in Fars Province.
11) Qashqa'i nomads spinning wool at their summer encampment in Fars Province.

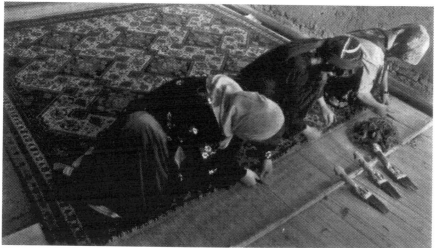

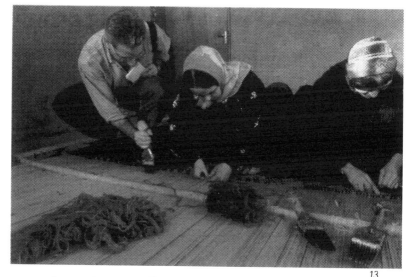

12) Qashqa'i weavers at a village settlement near Shiraz.
13) The author with Qashqa'i weavers at a village settlement near Shiraz.
14) Qashqa'i weaver at a village settlement near Shiraz.

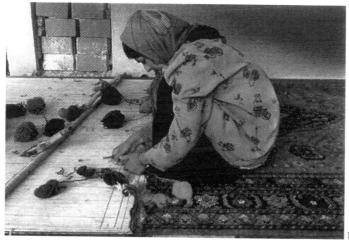

15

15) Qashqa'i nomads spinning wool at their summer encampment in Fars Province.
16) Qashqa'i nomad family eating in their tent at their summer encampment in Fars Province.
17) Carpet repairers in Saraye-Rahimiye, or "the House of Rahim," in the Tehran bazaar.

16

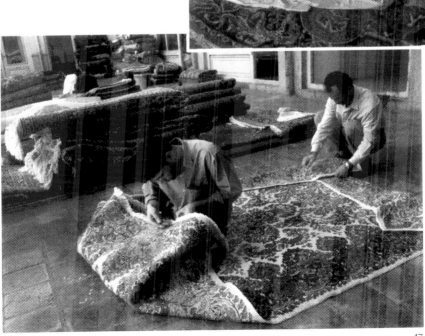

17

18) The Last Supper depicted in a carpet being carried through the Tehran bazaar.
19) The Tehran carpet bazaar.
20) The so-called Sufi carpet that was sold in 2004 to a New York collector.

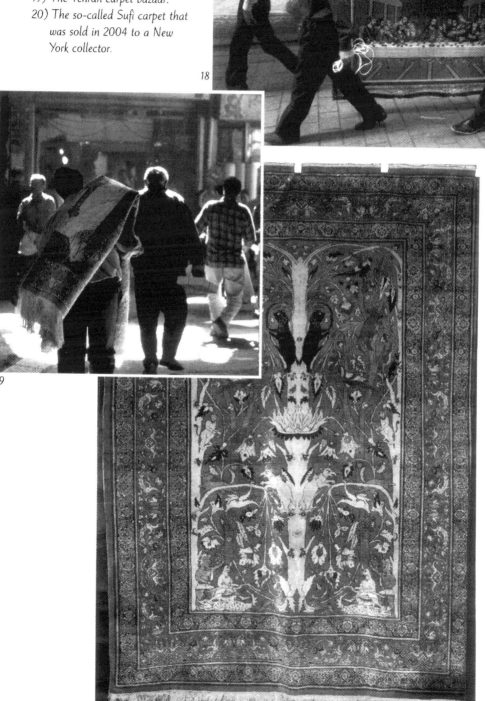

21) *Razi Miri.*

22) *Ethnic Turkmen women weaving a carpet in Malek-ali-Teppeh, Iran.*

23) *At a teahouse in Herat, an Afghan man rests in front of an unusual carpet with a village scene motif.*

21

22

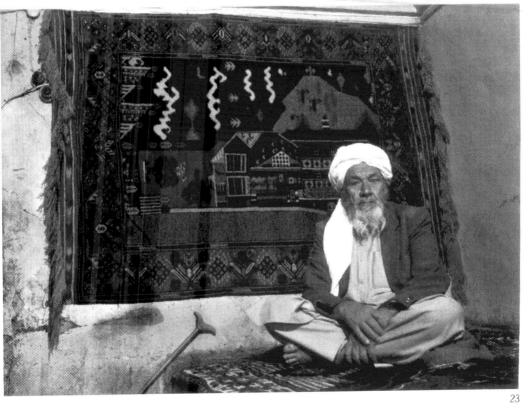

23

being crushed by politics and paranoid ranting about plots from the "enemy" West.

"The revolution said we want an Islamic republic, not an Islamic dictatorship," said Iran's first pro-reform president, Mohammad Khatami, in May 2002 in one of his sharpest salvos against the non-elected theocrats who hold all real power.

Khatami—a cleric himself who grew up near Yazd—was a significant jolt to the system. The huge support he enjoyed after a stunning win in 1997 put the hard-liners on the defensive for the first time since the revolution. It was hard to keep up with the changes. Reformist publications sprang up as quickly as judicial authorities shut them down. *Hejab,* the Islamic practice of keeping women covered in public, started shrinking to the point where some women could get away with a bulky sweater and a head scarf held on by hair clips. Student protesters and liberal parliament members crossed one of the ultimate red lines by publicly criticizing the supreme leader, Ayatollah Ali Khamenei. One popular fast-food place in Tehran showed Mickey Mouse cartoons on large TV screens next to portraits of Khomeini and Khamenei, which are found in nearly every business or public space. When I asked the owner if the juxtaposition was intentional, he gave a sly, knowing shrug.

Yet, if you look closer, you realize the early years of the liberalization were wide but shallow. This is perhaps one of the reasons why Khatami eventually lost his stature among reformers. What they crave cannot be satisfied by a cheeseburger or lipstick. They want to feel different. They want to junk that personal radar.

"You know what it's like to always be looking over your shoulder? To only really relax when you are behind closed doors with people you know?" a student told me in January 2003 after another wave of protests fizzled. "It's stressful. It's humiliating. It's frustrating."

"It's Iran," one of his classmates chimed in.

So this is why the Zoroastrian elder led me away from the hotel. There was something about those two guys that made him nervous. His radar was picking up something. Why take any chances?

"Look," he said when we were alone. "We have no problems with

anyone. We can practice our religion. We have schools. But that doesn't mean we're not watched. We are different. We are not Muslim and that's enough for some people to be suspicious. When any foreigner comes—especially a journalist—I'm extra careful. It's probably silly to be so cautious. But this is Iran. The red lines are always moving."

"Did you ever think about emigrating?" I asked.

"Never," he said. "This is our land. Every other religion is just a guest."

It's a credible claim. Zoroastrianism was the dominant religion of Persia centuries before Alexander the Great's arrival and remained the core faith until the Islamic armies conquered in the seventh century.

The Zoroastrians' sacred text, the Avesta, is a broad meditation on good and evil. God gives free will to choose either side with the obvious consequences: select good and good things will follow; select evil and you will cause harm to you and others. In the West, the faith's best-known feature is probably its fire temples, where cauldrons are tended and kept burning for centuries. Some of the biggest are now tourist attractions.

Yazdani, the Zoroastrian elder, was taking me to a special place: a private fire temple tucked into the narrow streets of old Yazd. The city is among the oldest population centers in the world, with an unbroken chain of habitation of at least five thousand years. It also contains some of the most enterprising engineering of the preindustrial world. Underground tunnels use gravity and the earth's pressure to irrigate arid fields. On many homes, chimneylike structures called wind towers capture the steady and powerful desert gusts. The wind can be funneled over water to act as an air conditioner.

Hafez came once to Yazd in his only significant sojourn from Shiraz, many accounts say. In his time, the city would have looked much like the area where I was walking: narrow alleys between windowless buildings of yellow adobe.

Yazdani stopped in front of a thick wooden door held together with nails as big as railroad spikes.

He fit a huge silver key into the lock. The door creaked open. We

were immediately hit with the smell of burning wood from deep below. Stacks of logs from apricot trees were piled in the entrance-way. The temple was through another heavy door. It opened into a square room with a towering ceiling. One wall shows the cypress tree, a symbol of strength and endurance. Along another wall are photographs of the dead.

"These are some of our people," Yazdani said. "You know we had no cemeteries. This is how we remember."

"No cemeteries?" I asked.

"There was the Dakhmeh," he said. "You sometimes call them the Towers of Silence."

Up until several decades ago, the Zoroastrian dead would be placed atop stone terraces on the hilltops. The weather and animals would do the rest. The practice ended in Yazd only when the city grew too large and apartments came within the shadows of the Dakhmeh.

"There is something else I wanted to ask," I said. "It's about car-pets. I read that some people believe the design we call paisley—you know, the flame-shaped motif—comes from the Zoroastrian fire temples."

"What do you think?" he asked.

"I don't know. It would make sense, I guess."

"You see, there are not always easy answers to everything. For some people, maybe it is the flame. For others, it could be the tree. Don't struggle with such things. I know it's hard. You see, some people look at fire and think of how it can cause destruction. Others will think of warmth. Others will think of light. It's all the same thing through different perspectives. Look at carpets that way, too, if you can. There is no real definition of beauty, is there?

"Come," he added. "Let me show you."

He opened a metal door to a tiny chamber. Inside, a fifteen-hundred-year-old fire smoldered in a metal cauldron. Everything in the room was covered with a shiny black resin from the smoke.

"Breathe deeply," Yazdani said. "It's good for you."

I had a lingering sinus infection from the Tehran smog. I wasn't sure whether inhaling smoke was exactly the best remedy, but its

dryness felt somehow cleansing and medicinal. He left me alone.

I stayed for quite a while and listened to the purr of the low fire. I prayed my normal prayers for my family. I then touched the wall. My fingers sank into the soft resin, leaving fingerprints that I imagine will be there for centuries.

Later that day, I wandered the bazaar with my translator. I purposely stayed away from carpet shops. I wanted to concentrate on finding the madder growers outside the city. A man came up and asked my translator for the time. We did a double take. It was the same brown sports jacket guy from the hotel. Coincidence? We're in a city of 350,000 people and bumped into the same person at locations several miles apart. Do the math.

Before I left Yazd, I climbed up to one of the Towers of Silence. The path slithered up a rocky hillside to the single entrance through the heavy stone wall. It felt like being in the crater of a volcano.

In the center was the pit where the tenders used to sweep the bones and desiccated flesh. The stones were worn smooth. It was just after sunset and growing chilly. I walked around the edge, trying hard to image the sight of bodies left for vultures and other carrion-eating birds. The funeral processions used to take hours to walk from Yazd to these hills, and mourners would stay for days in simple rest houses.

The evening calls to prayer started to come from the mosques in Yazd. It also was the time for the fire tenders to visit the Zoroastrian temples.

Early evening to me always seemed the best time for prayer. Twilight seems to hum with magic and invitations from the supernatural. I will never forget a dream I had when I very young. It was dusk. I looked across the street at white-sheet ghosts—the kind that would be in kids' dreams—hiding behind trees in front of my aunt's house. One of the ghosts yelled to me: "This is the only time we can play."

I watched the sky over Yazd turn a lovely watercolor wash of red. Then I opened my copy of Hafez at random. I hadn't done that in a while. I was curious to see what he had in store.

But it was already too dark to see the words.

I found a madder grower. He told me to meet him at school.

It's off the main highway on the outskirts of Ardakan, which would be just another hope-draining Iranian town if not for a surprise: the election of native son Khatami as president. The place had always managed to claw along with some madder production and carpets. But Khatami's rise required a serious hometown face-lift. Sidewalks were rebuilt; roads were repaved. The desert palms are kept tidy and trimmed. Poles stand ready for the colorful Islamic banners that are part of Iranian pageantry and propaganda.

As in almost every town, there are billboard murals for fallen soldiers from the 1980–88 war with Saddam's Iraq. In Ardakan, there are also well-tended beds for spring tulips, the flower that signifies martyrdom. Ardakan—at least while Khatami was in office through 2005—offered a sense of spirit and civic attention that is absent from most of the Iranian landscape.

"I have a theory about this," said Mohsen Barzegari, head of a carpet group that studies at Yazd University, one of the few state-funded centers seeking to revive traditional carpet weaving and dyeing. "We Iranians lead two lives. There is our home. This is our special place. The place where our hearts are happiest. There is the public space, too. But that is where we go to do business and other things. Our hearts are only really singing at home. Haven't you noticed that we love to put walls up to separate our interior world from the outside world? We like this definition. You must go inside the walls to really see Iran."

The classic and idealized Iranian house plan is a courtyard with a small fountain surrounded by walls. Sadly, many of these cozy gems have been bulldozed into oblivion in the cities—especially in teeming Tehran—to clear the way for stacks of apartments, monuments to the revolution and the tragic war with Iraq. Iran's population skyrocketed after the mullahs, led by Khomeini, called on parents to propagate an "Islamic army." Khomeini himself had two sons and three daughters.

At one point in the mid-1980s, Iran's population growth roared ahead at 3.2 percent, a spurt that helped double the population in just a generation. At the same time, the clerics were mangling the economy. The huge costs of the war were partly to blame. But so was the gross ineptitude of the clerics and their backers, who took control of one of OPEC's heavyweight producers without even a basic fiscal road map. Rural families packed up and headed for Tehran, Mashhad, and other cities, seeking work. In the 1980s, clandestine copies of John Steinbeck's *The Grapes of Wrath* were popular because of the empathy with the dust bowl migrants in the Depression.

Most of the old homes are gone. But walls remain. It's rare to find a family compound that's not enclosed, clearly drawing the line between the streets and what's permissible inside. It's the same in most of the Islamic Middle East. In Iran, there is an added context. I noted to Barzegari that the word *paradise* has roots in Persian. It describes a seductive Eden in the afterlife, a lush and fruitful garden. Many sources add a further description: the garden of paradise is surrounded by walls.

"That's right," he said. "This is a very, very powerful image. We want to try to imitate paradise as best as possible. We do it in our homes. We do it in the carpets."

"How?"

"Come now, don't you see? The weaver—whether he knows it or not—is making a version of paradise: a perfect, self-contained world. It's a place we all dream of being, isn't it? Don't you think sometimes that it would be nice to step into a carpet and be surrounded by that beauty?"

Barzegari led me around the classrooms of the two-story building dedicated to traditional carpet studies.

The program was started in 1996 with twelve students. Eight years later, it had more than 550 going for either a bachelor's degree or two-year associate's degree. The coursework is theoretical and practical: learning the history and all the techniques of handmade carpets. Seventy percent of the students are women.

"We were in danger of losing the knowledge of the carpets," said

Barzegari. "There was mismanagement of the carpet industry for so long. There was no central place to retain and pass along this tradition."

He led me into a room where students—all women—were practicing knotting techniques on small looms. I asked one, a pretty nineteen-year-old named Toroneh, what drew her to carpet studies instead of, say, computers or engineering. Her answer caught me off guard.

"My country," said the young woman, wearing blue eye shadow and perfect lipstick. "This is the art of Persia. I want it to continue."

She asked me to try to make a knot. I declined, remembering the snickers at my ham-handed attempt in Afghanistan.

"Please," she urged.

"Okay," I conceded.

I was a little better this time. It took me about three minutes to make a knot that should take less than two seconds. She didn't laugh—in front of me, at least.

Barzegari's cell phone rang. The madder grower had arrived. He was waiting outside in his car.

We drove out of Ardakan and into a wide, dry plain. To the north is the nasty emptiness of the Dasht-e-Kavir. The Great Salt Desert sits in the center of the country like a giant wedge of almost otherworldly perils. The few settlements in the interior cling to the hills separating the *kavirs,* the salt marshes, which are capped by a crust caused by surface evaporation in the nearly rainless climate. Below is a quicksandlike slosh that could swallow anyone foolish enough to venture into the basins. On the northwest corner of this void sits Tehran. The desert stretches eastward toward Afghanistan for 300 miles along its northern edge. It drops down to a single sharp point 120 miles to the south.

This is where the madder grower Ali Akbari took me.

I followed him down a thin path choked by weeds with delicate pink and green buds. His big belly jiggled, but he was nimble and sure-footed.

Suddenly, just after a small ridge, the land turned a vivid green. There it was. Finally. Wild madder.

"Is this what you wanted to see?" he said, opening his arms wide.

I waded into the field. I ran my hands over the tapered leaves, which bit back with tiny barbs along their edges and spines underneath. I sank low into the field. Tiny emerald grasshoppers leaped about. I noticed that the whole field seemed to be quivering. The madder leaves bounced from the grasshoppers' flight, and the plants' wispy stems swayed with the slightest breeze.

I, too, felt a bit tipsy. Robert Louis Stevenson famously wrote that "to travel hopefully is a better thing than to arrive." This observation has been repeated and revamped so many times, it's become a sort of proverb of the road. I certainly wasn't exempt from this truth. A leg of my carpet journeys was over. I had found my wild madder.

"Ready?" Akbari said. He clearly had had enough of watching me prowl through the madder like a madman.

"Sure," I said. "I'm ready . . . No, wait a second. One more thing."

I snipped off a few leaves and put them into my *Divan of Hafez*. In a few days, I would visit his tomb in Shiraz.

"So did you find what you were looking for?" he asked as we walked back toward the car.

"I think so. I mean, where do you end with carpets? You can never say, 'This is it. I know everything,' can you?"

"You can't say that about anything," he said as we approached his madder-grinding operations behind a cinder-block wall about a mile from the fields.

"You work with madder. Are you still learning about it?" I asked.

"All the time."

"Like what?"

"Like this," he said, pulling a pencil-size length of dried madder root from a pile. "There is no way to say exactly what color is in this root. It could be a blood red. It could be a rose. Maybe an orange. I know it doesn't really matter because it's all mixed together. But I'm making a point: This is nature. God's creation. How can you learn everything about God?"

Behind the pile of madder root was the grinding room. A massive

stone wheel—2.3 tons and more than six feet high—made a tight circuit around a granite base. Up until the 1940s, it was moved by a camel. It's now pushed along by a motor rigged up to a single car tire. Madder dust covered everything, including the lone worker, a thin and wrinkled man named Mohammad Fatouhi. The paprika-colored powder has even worked its way deep into his ears.

He's been doing it for fifteen years without a mask. I asked him if he knew about the old experiments with bone and madder.

"No," he replied. "But it makes sense. Look."

He gave a big grin. His teeth were stained orange-red.

"It's useless to try to brush it off," he said. "I gave up. It's part of me now."

I grabbed a few sticks of madder root before leaving. I shook hands with Akbari and his worker Fatouhi.

We were well on the way to Hafez's beloved Shiraz before I noticed my right palm. The creases—what fortune-tellers read—were colored red with madder.

May God protect that much-traveled one,
Followed by a hundred caravan loads of hearts.

—Hafez

CHAPTER EIGHT

TONGUE OF THE HIDDEN

 I arrived the way Hafez may have left.

The road to Shiraz squeezes through a notch in mustard-colored mountains. The pass is known as Allah Akbar, or God is Great. The lore of Shiraz says this is what first-time visitors blurt out when they see the city spread out on the plain below.

Hafez most likely made this climb out of the Shiraz valley on his way to Yazd in what possibly was his only significant time away from the city of his birth. Even today, separated from Hafez by more than six hundred years, it's easy to picture the scene.

He would have paused just before crossing under the mighty Quran Gate at the edge of the mountains ringing Shiraz. At that time, the stone arch had a top chamber holding two copies of the holy book rendered in exquisite *thuluth* calligraphy, which remains one of the most important ornamental Arabic scripts. Islamic tradition says travelers passing under a Quran receive blessings for their

voyage. Hafez, I guess, would have walked under the gate. He believed in the power of both words and the Quran.

Then he would have wanted to take one last look back at Shiraz, which was much smaller than it is today and nestled farther down on the flatlands. He would have been well past his prime physically—perhaps leaning on a walking stick—but near the peak of his artistic powers. He is sometimes depicted by artists as having sallow cheeks and a thick white beard. I see him that way, too.

His gaze may have fallen on a band of cypress and palms fed by the Roknabad River north of the city. This is where, more than a decade later, in about 1389, his body would be carried in a huge funeral cortege and buried on a gentle slope.

Pilgrims soon wore a path to the simple grave. Some set up camp for weeks. A rough dome was erected on the site, and centuries later, a stone colonnade was finished in 1773. Hafez's grave was eventually opened and his remains placed in a marble sarcophagus. The present Hafez gardens took shape in the 1930s. The designers were given a demanding commission: Find a way to make an earthly garden that evoked the interplay of spirituality and sensuality of Hafez's words. Few could argue that they fell short.

I will need to thank Mohammad Reza the next time I'm in Tehran. True to his promise, Hafez has been an engaging travel companion. In Herat, he helped me fathom the earthly desires for transcendent beauty that inspired the builders of the Friday Mosque and Queen Gawhar Shad's magnificent Musallah. He led me to the Sufis in Mashhad. I learned from him to watch for the gentle and lyric currents of Persia, so often obscured by the tensions, noise, and insecurities of modern Iran.

He gave me, too, some new and critical instincts. His verses flirt with many illusions and meanings at once. Carpets, I decided along the way, also should be viewed in this flexible and layered way. From the motifs, we can ponder the weavers. Study the colors and think of the dyers and how they mine nature. Run your hands over the wool and wonder about shepherds and spinners. See it all together and—as so many have urged—contemplate God and the

creative soul. Oscar Wilde may have recognized this when he wrote a line for the opium-smoking Lord Henry Wotton in *The Picture of Dorian Gray*. Wotton dreams of writing a book "as lovely as a Persian carpet, and as unreal." What exactly did Mohammad Reza have in mind when he steered me toward Hafez back in the Tehran bazaar? I will ask him.

But now it is time to visit Hafez's garden. He is called by many names. My favorite is the Tongue of the Hidden.

The smell of flowers is overpowering. I ascend the first eighteen steps to a portico with ten sturdy columns. Verses from Hafez appear above in a kind of infinite calligraphy that has neither a clear beginning nor end. Graceful blue shadows from rows of cypress fall over a reflecting pool. It brims with cool water from the Roknabad. Glazed tiles show tree branches filled with nightingales, which so often appear in Hafez's poetry as mystic messengers.

The tomb is up five more steps. It sits at the center of a thick alabaster base. Eight columns hold up a peaked copper dome. The underside is decorated with mesmerizing mosaic tile work that suggests both stars and flowers. I remain on the edge, waiting for the crowd to thin around the marble sepulcher. Most people touch it with their right hand and murmur the Quranic verses for the dead. They stand for a moment then move on to let someone else take their place. It would be hard to assemble a more eclectic bunch than the one around me. In the space of ten feet, there's a woman encased in a full, black chador; a young man with a Walkman and an Air Miami baseball cap; a father with the unshaven look typical of political hard-liners; and two teenage girls with gravity-defying head scarves and fire engine red lipstick. Lovers open volumes of Hafez at random and share a poem or a few lines. Any modesty—or fear—is cast aside for a while. Couples hold hands. Some kiss. This is still a rare sight on the Iranian streets.

The heartbroken also come. A young woman sobs and flips absentmindedly through Hafez. She keeps glancing at a limp note that looks as if it has been creased and opened many times. She places the note on Hafez's tomb, whispers something to herself, then folds the paper back into a tiny square and puts it in her purse. I learned later

it was a personal plea to Hafez to bring back her boyfriend. It was all so different from the Shiite traditions that emphasize mourning and penance on a grand, collective scale. Hafez never could stand bluster of any kind. His attitude prevails.

A section of the verse on his grave says:

Do not sit by my grave
Without wine and minstrel,
For I yearn to catch your scent
And rise up from the tomb,
Dancing in ecstasy.

In a side alcove, a group of college students take turns reading from Hafez. I tried to think of American undergraduates spending an afternoon with a fourteenth-century poet for pure pleasure. The best I can conjure is a few inspired young souls taking Thoreau to Walden Pond. You can see why many Iranians wince at suggestions of Western cultural superiority and being broad-brushed by the White House as part of an "axis of evil."

I caught pleasant whiffs of apple-flavored tobacco from a water pipe that was bubbling away.

"Would you like some?" asked a man in English.

"What?"

"I said, 'Would you like to join me?'" he repeated politely.

I nodded and sat down. The man ordered another water pipe mouthpiece for me. Years ago, when I was less familiar with Iran, I would never have accepted such an invitation from a stranger. I had a mental checklist of things to avoid. Chief among them: Don't say anything provocative in unknown company and avoid situations of possible entrapment at all times. One of my first as-signments in Iran was covering the trial of a German businessman, Helmut Hofer, who was sentenced to death for having an affair with a female Iranian medical student. By the time I saw Hofer—in September 1999 when the charges were dropped—he had shrunken to a scarecrow in prison pajamas after two years in cus-tody. His gaunt form came flooding back every time I was offered

clandestine booze or access to dissidents with unclear agendas.

Foreign journalists with the proper accreditation have considerable leeway in Iran, probably more than Iranian journalists covering the United States, but the rules can shift quickly. You don't want to be stuck on the wrong side at the wrong moment. I had lost some of the extreme caution of my first visits. But I was still on guard.

This guy, puffing away on aromatic tobacco and listening to people read Hafez *ghazals,* seemed harmless enough.

He introduced himself as a student; the "career" of many young people in a country with a jobless rate that could exceed 30 percent, according to some estimates. His name was Akbar. That's it. No last name. It seemed he, too, was sizing me up—and my notebook.

"You're a journalist, yes?" he asked.

"That's right."

"And you like Hafez?"

"I'm still trying to understand him, but, yes, I like him very much."

We chatted for a while and I was about to tell him a little about my carpet passions. He cut me off with a story.

"I love it here. You want to hear something strange? I see colors when I listen to poetry. Not all poetry, but definitely with Hafez. Like this one I'm reading now. I hear it and see swirls of red. All different shades—dark red, pink. Have you ever heard of such a thing? My friends think I'm crazy."

Amazing. Hafez had done it again, sending me off in another unexpected direction. I, indeed, had heard about these interesting color-sensing abilities such as Akbar's. It wasn't until later that I learned it had a name.

It's called synesthesia.

Put simply, it's sensory perception without the normal boundaries. The senses are all cross-wired to some degree. A common overlap is a smell triggering the memory of a place or the feel of silk being associated with, say, the color black. But in true synesthetes—

about one in every two thousand people, according to studies—the reactions are much more vivid and pronounced. One of the most investigated aspects of the condition—or gift, some say—is *hearing* color.

Sometimes it's a word. One synesthete described *Moscow* as dark green and *Daniel* as deep purple. Chat rooms on the Web are full of synesthetes overjoyed that there are others out there. Synesthesia—the etymological opposite of anesthesia—is still not fully understood and is the subject of scientific debates about brain function.

But for those who experience it, the cause and effect is clearly expressed. One wrote that the note E-flat is warm brown and E is bright green. Another saw numbers in different colors: one is dark blue, two is silver gray, and so on. Our language even gives a nod, perhaps indirectly, to these overlaps of hearing and color. Bright orange is "loud," while baby blue is "soft." The art world is reportedly studded with synesthetes. Franz Liszt is said to have visualized colors as he composed. The bold abstractions of Wassily Kandinsky were attempts to paint the colors of music. Each color, he wrote in 1910, has a special spiritual significance.

Could Hafez, too, have possessed these heightened perceptions of color? It would be easy to make a strong case. His verses are rich in references to color as part of his vocabulary to describe spirituality and divinity.

One color, however, stands above the rest for Hafez: red. It appears in the form of the classic red rose that signifies images such as the brevity of life, a sign of heavenly paradise, or awe of the Almighty. Blood, for Hafez, took on dual meanings as both life-sustainer and a wounded heart in need of spiritual medicine. The deep red wine of the famous shiraz grape is, by far, Hafez's most familiar allusion. It's the source of an endless literary tug-of-war. Some flatly reject any suggestion that Hafez—a Muslim who had memorized passages of the Quran—drank alcohol. Others argue with equal conviction that Hafez would not have passed up the liberating power of a good buzz.

There is substantial common ground, however. All serious sources concur that Hafez's references to wine and taverns and drink-

ing buddies are steeped in metaphor. Drunkenness is seen as the "intoxication" of spiritual ecstasy. The tavern host could be the *pir,* the spiritual guide, used to bring along young Sufis.

"Dye your prayer rug in wine / If the *pir* commands it," goes one of the most repeated lines from Hafez. It's often interpreted as a howl against convention. Without doubt, to pour wine on a prayer rug would be insulting to Islam and God. But, some scholars contend, Hafez was saying that even that gaffe is better than following pompous and self-satisfied mullahs who have given up on a true spiritual life.

In Hafez's day, physicians used the powder from crushed rubies in an electuary for heart ailments. Such is the visceral power of red.

Red—whether from soil, plants, or blood—was certainly part of prehistoric rituals and lore. Almost any path through history will include touches of red. In Hebrew, Adam signifies red earth and was created out of red clay. In Greek mythology, red roses arose from the blood of the handsome and ill-fated Adonis. Alchemists who hunted for the fabled Philosopher's Stone formula believed the final mixture, able to turn cheap metals into gold, would be red. Some studies suggest seeing red actually sparks the human metabolism. No wonder it's beloved by advertisers. Red is regal. Red is sexy.

I asked Akbar, my new synesthete companion, why he thought he perceived Hafez's verses as the color red.

"Passion—for life, for God, for everything," he said simply. "What else could it be?"

I left the tomb and wandered through Hafez's city.

Very little of what he knew remains. Just some of the old city walls and street patterns have survived the more than six centuries.

But I sensed the spirits that seduced him all his life. Shiraz does not have the artistic glory of Isfahan or the religious energy of Mashhad. It can't come close to the raw urban power of Tehran. Its style is exemplified in the gardens of Hafez or the other great mystic poet, Saadi, who died about thirty years before Hafez's birth.

Saadi's tomb sits above a pool of beautiful fish. Shiraz is easy, a pleasant half beat slower than the rest of Iran's major cities. I always described it to American friends this way: big and brash Tehran is New York; jasmine-scented Shiraz is New Orleans.

Politics is also taken with a bit of cosmopolitan moderation in Shiraz. The city has really seen it all. The region around it is called Fars, which inspired the word *Persia*. Shiraz has been part of the region's identity since the empires of antiquity. Before the Islamic Revolution, an English-language university in Shiraz supported by the shah brought many U.S. professors and students. Even during the darkest days after the revolution, foreigners still trickled in. The city remains a significant tourist stop, even for Americans, who come to visit the twenty-five-hundred-year-old ruins of Persepolis.

"We try to keep things in perspective. We take the long view of things in Shiraz," a hotel worker told me in 2002 after hard-liners had a surprisingly difficult time mobilizing big anti-Israel marches when ten Iranian Jews were tried and convicted of spying.

I made a point of finding a bakery.

In Iran, these are often busy affairs with customers snatching up the oven-hot flatbread as fast as it is slapped on the counters. The task of kneading dough is usually left to boys. This is what some chroniclers say young Hafez did from midnight to dawn to help his struggling family after his father died. Accounts of Hafez's life are incomplete and sometimes contradictory. He'd like that, I think. For him, the mood always was tastier than the meat.

His birth date is even unclear. It's placed somewhere between 1320 and 1326. One of the most vivid sketches of Hafez's youth, in a work called *The Tavern of Biographies,* written in 1627, has him leaving the bakery and enrolling in school. There, he perfected his ability to recite from the Quran by memory. He also tried his hand at poetry. But he was considered a failure. One night, the story goes, he prayed and wept. He then had an odd dream that night: he was being fed sweets by a man who told him "the doors of all the sciences are now open to you." The next morning, he recited a lovely original verse in public. Astonished listeners asked for more. Hafez had become a bard. There is no hard evidence to support this tale,

and some scholars dismiss it as pure fantasy. But no one has offered a more convincing alternative. So it stays my favorite.

Hafez's later life emerges from the shadows, but just barely. There is general agreement that he spent most of his twenties as a court poet under the patronage of a young ruler named Abu Ishaq Inju, who was inclined to hand off the ordinary matters of state to underlings and immerse himself in the stable of artists and sages he kept satisfied with a steady trickle of meals from the kitchens and trinkets from the treasury. Hafez was establishing himself as a mystic of extraordinary talent. But he was also a realist. He did nothing to displease the king or threaten his position. The Persian royal courts were special worlds with special rules. Where else could he find such a life of artistry and pleasures?

Court poetry—full of smoldering passions and theatrical wordplay—developed into an enjoyable counterpart to the solemn rituals of Islam. The crafty poet could get away with much. References to wine, music, and sex could be interpreted literally by readers so inclined. But if challenged by angry clerics, the poet could hide behind his craft and call the lines just lively metaphors for faith and passion. The poets also rarely lost sight of who was paying the bills. The monarch would get an ample dose of lavish, or sometimes slavish, attention in the verses and could be referred to as "the beloved."

The poetic style was designed to be autobiographical, with the author and his emotions often center stage. How much was genuine and how much was just literary fluff will probably always remain just a guess. One respected Hafez translator, A. J. Alston, called it "that characteristic Iranian intermixture of sensual and mystic sensibility that Westerners find so hard to fathom."

Abu Ishaq's genteel ways may have cost him his throne—and his head. A warrior-ruler named Mubariz stormed Shiraz, and Abu Ishaq was beheaded in 1354. Mubariz, a Sunni zealot, had little sense of religious moderation. He sent inspectors to close the taverns and impose a strict form of Islam. Hafez was apparently disturbed by this change of fortune. "For the time of timidity has come," wrote Hafez. "The age of abstinence has dawned."

But Hafez was never one to fight the tide. He seemed to have

kept some connection to the new court. If nothing else, he needed the income. At one point, he even freelanced as a secretarial scribe for another poet. He also may have watched one of Mubariz's sons, Shuja, grow up while in the royal court.

The boy had mutinous intentions. Shuja turned against his father, who was blinded and jailed. Life grew easy again in Shiraz. Drinkers were no longer hounded. Shuja's court swelled with benevolence for poets and artists. The only major problem was the royal family itself. Shuja and his brothers, along with a shifting cadre of allies, fought constantly for the throne. Shah Shuja managed somehow to remain on top from 1358 to 1384, although with at least one retreat and return to Shiraz during the time.

It may have been too much for Hafez. At some point, various accounts say, he tried to leave Shiraz behind. He set off for Yazd, but apparently did not find favor with the city's ruler and returned home after a short while.

There's another story that's told about Hafez trying to break with Shiraz. It's said he accepted an offer from wealthy Indian patrons to be their honored guest. But, the story continues, when Hafez reached the Strait of Hormuz he was stunned by the vastness and force of the sea and turned back for home. Many scholars consider this story little more than colorful legend, but it's still passed along to Iranian schoolchildren today.

In Hafez's later years, Persia was under siege. The Mongol forces of Timur were swallowing Persian territory. Some foolhardy bands went down fighting Timur's superior cavalry and army. Other leaders more concerned with self-preservation accepted Timur's primacy and paid him riches in exchange for their lives. Timur swept toward Shiraz shortly before Hafez's death. A delightful story has Timur summoning the aged poet. He asked Hafez to explain his lines that said he would give the cities of Bukhara and Samarkand, both jewels in Timur's empire, away to a slave. "It was through such generosity that I was reduced to my present circumstances," Hafez is said to have replied. Timur apparently took the joke well. The meeting—a charming duel of pen versus sword—may never have happened. Or perhaps it did. Here, too, scholars struggle in

vain to give clarity to the murky clues Hafez left behind.

Hafez may have married and had children. Some scholars believe that he mourns the loss of one of his sons in a poem that begins: "At the cost of swallowing his blood / A nightingale acquired a rose."

Even Hafez's death is tied up with an improbable—but compelling—narrative. Lore says that an austere imam, who chafed at Hafez's loose habits and Sufi nature, refused him a full Muslim burial. But the throng of admirers insisted. They decided to ask Hafez himself to resolve the impasse. His lyric verses were cut into couplets. A young boy was asked to draw one from a bin.

Hafez' reply from the beyond:

Neither Hafez's corpse, nor his life negates,
With all his misdeeds, heaven for him waits.

The imam relented.

I, too, had come across a Hafez verse while in his garden. I wrote it down and planned to recite it to Mohammad Reza when I next returned to the Tehran bazaar. I thought these lines would be appreciated by a *bazaari*. Hafez explores the great leveler:

Do not be either grieved or elated,
Since profit and loss are canceled by death.

I wandered over to Shiraz's Vakil Bazaar. It has a pleasant little courtyard shaded by fruit trees. I sat and read more Hafez, and, for once, didn't plan to see what the shops had to offer.

It didn't work. My willpower broke. I put down the book and stepped into a covered alleyway. Immediately, a pile of ocher and red caught my eye. It was a collection of nomad *mafrash*, flatweaves stitched into a box shape to hold bedding and other supplies. They smelled strongly of animals and the land.

"Ah, I see you are a friend of Hafez," the merchant said, pointing to my book. "We all are his friends here in Shiraz. How do you find him?"

"Interesting. Confusing. Inspiring. Beautiful," I answered as honestly as I could. "Everything, I guess."

"Good." He beamed. "Very good. That's right."

"So how much for the bag?" I asked, trying not to stray too far from the point.

"For you, Mr. Friend of Hafez, what do *you* say? What do *you* want to pay?"

Oh, my. Here I was, back at this again. I never had much patience for the "as-you-like" price offers of Middle Eastern cabbies, merchants, and others, none of whom ever expect a low-ball reply. This time, however, I thought I'd give it a try.

"As *I* like? Really? Fine. I like about twenty dollars."

"For a friend of Hafez, okay," he said too quickly. "Pick the one you want."

I was stunned. I thought I was taking a small stand on behalf of my compatriots, carpet novices who have been overcharged and underappreciated for as long as there have been collectors. Turns out, I didn't get the last laugh; I probably paid too much. I handed over two tens and rummaged through the musty stack of carpet bags. Even if this merchant was snickering behind my back, I figured I could endure it for twenty bucks.

As I was leaving the bazaar, I saw a group of Iranian teenagers all standing slack-jawed and looking at the ceiling. In the best gawker tradition, I looked up, too. I saw nothing unusual. Then I realized they were staring at music speakers.

"It's L.A. music," one of the girls said, obviously taking pity on my confused expression. "This is amazing."

It's another of those shifting red lines that Iranians are always talking about. When these teens were born in the mid-1980s, almost all music was outlawed. Now, the bazaar in Shiraz was piping in a bluesy Farsi-language tune from an Iranian-American band in Los Angeles, the hub of the Iranian exile community and often nicknamed Tehrangeles.

I could only marvel at it all. Mashhad now has a Coke bottling plant. Rich Iranian women in leafy north Tehran throw Botox par-

ties. Authorities must bus in school kids to the annual demonstrations outside the former U.S. embassy to keep the crowd size respectable. The taboo of questioning the supreme leader has been toppled. As the revolution moved into its second quarter century, the mullahs were still in charge. But there were many cracks in the foundation.

I made one final visit to Hafez. This time it was at night.

There was no breeze. The smoke from the water pipes wafted in lazy, crab-shaped clouds. I looked for my new friend Akbar, who saw Hafez as red. He said he might be there. He was not.

I ordered a delicious local sweet called *faloudeh,* a chilled dessert made of shredded starch bathed in rose water syrup or lemon juice. Someone was playing a dulcimer. A man was carving a small box from pear wood. The curled shavings piled up on the toe of his boot.

My wife sometimes talks about being wise enough to recognize a perfect moment when it comes along. I only regretted I couldn't share this one with her.

In the offices of Tehran's foremost carpet officials, a dye master once placed two tile-size rugs side by side. Both had the same motif and knot count. Everything was the same except for the wool. One carpet was colored with natural dyes. The other was all synthetic.

"Okay, you pick," he challenged me. "Which is which?"

"This is natural," I replied, pointing to the carpet with the more muted yellow.

"Wrong," laughed Majid Montazer, head of the dye division at the state-run Persian Carpet Research Center.

At least I was in good company. Montazer said even his colleagues—with textile degrees and decades of experience around carpets—did no better than pure guesswork. About half correctly picked the naturally dyed carpet.

"I've been doing this for a long time and even I can get it wrong," he told me.

His little experiment was more than just an office stunt. It touches directly on a subject that may get more attention, and raise more blood pressures, than any other in carpet circles: chemical versus natural dyes.

No one could disagree that an interesting, sublime, and expertly woven carpet can be produced with synthetically dyed wool. In fact, many have. Quality isn't really the issue. It's more intangible, as are many of the disagreements among carpet experts. It's about aging with grace.

The overwhelming view among the carpet intelligentsia is that natural dyes are vastly superior. The chief reasons are the much-revered patina and *abrash* of older carpets exposed to sunlight and normal use. The patina is often described as a mellowing of the colors into an eye-pleasing sheen. The *abrash* is the slightly uneven hues that emerge as a carpet ages. The reason is that different dye lots, even of the same color, can fade at different rates.

The best analogies I can offer come from buildings: the earthy tones of many old palazzi in Rome or the weather-beaten shin-

gles of New England cottages. There's now a warmth and sooth-ing quality that is somehow more satisfying than the original look.

But only natural dyes can achieve this charm, many carpet ex-perts say. Even the best chemical colors fade rather than mature into a patina. Chemical colors, meanwhile, cannot produce an au-thentic *abrash.*

My Herat carpet was apparently a hybrid.

The several tones of brown on the border edges carry a distinct *abrash* and are clearly natural colors. The yellows and blues that appear in the central *guls* and elsewhere seemed too vivid to come from sources such as weld or indigo. I remembered my wrong choice at the research center but concluded these sections were from chemical dyes.

So did the carpet repairer in Tehran who fixed some worn and frayed areas after it was cleaned.

"No doubt this is chemical," he said, running the tip of his scis-sors along a band of yellow. "The red, on the other hand, is a nice natural from madder. It must have been in a dark place. There's not much fading, but look here."

He tipped the carpet into direct sunlight and showed me the slight—but undeniable—shifts in the red hues in the central field and the outer borders.

"This is very common," he said. "It's much easier to find natural reds in places like Afghanistan. The dyers still can get their hands on madder. The other colors are much more difficult, so they turn to chemical colors. Oh, yes, very common. By the way, if you don't mind the question, how much did you pay?"

I lied, remembering the merchant who was shocked at the $400 price.

"One hundred and fifty dollars."

"Fair price." He nodded. "At least the main color of the carpet is natural."

This kind of conversation has been going on since long before this carpet was made.

In 1916, a time when synthetic dyes were storming into wide-

spread use, a member of England's Craftsman movement, Ethel M. Mairet, wrote that "the chemist has invaded the domain of the dyer, driven him out and taken over his business, with the result that ugly color has become the rule for the first time in the history of mankind."

She described chemical dyes as "hard and unsympathetic," while colors from nature were "alive and varied, holding the light as no chemical color can hold it."

Science seems to agree. Madder is a good example. Its principal coloring agents are alizarin and purpurin, whose effect can be closely re-created in labs. But madder can contain about two dozen other coloring components that appear and bond randomly. Under a powerful microscope, the subtle variations of color are evident.

Robert Chenciner, author of a comprehensive history of madder red, described it as "similar to a Pointillist painting where the rainbow dots of color merge into pulsating color when viewed from a distance."

The uniformity of synthetic dyes can't do this.

The editor of *Hali,* which is considered by many to be the most respected periodical on carpets and textiles, called chemical dyes a "no-no" in terms of potential artistry and "cause enough" for a rug to be banned from the magazine's annual fair.

"However strong, bright, fast [and] consistent modern chemical synthetics are, they lack the necessary individual variations of different dye lots," said Daniel Shaffer. "[They] never mellow or mature over time, remaining hot and harsh over the decades."

Few would argue with this. But not all adopt such a hard line.

Mark Hopkins, the president of the New England Rug Society, senses an unjustified snobbery around natural dyes, since many fine carpets produced since the late nineteenth century contain at least some traces of chemical colorings.

"For example," he told me, "I've got a smashing Baluch rug that I picked up for a song in California because it had—ugh!—a few touches of synthetic light pink. Graphically, the color works per-

fectly, but its presence totally scared the dealer and, apparently, several buyers. Silly stuff."

Even some of the top carpet restorers use chemically dyed wool because of the ease in fine-tuning the color to match the original, natural tones.

Carpet houses also will go to great effort to effect the patina of an old, naturally dyed piece. Chemical baths, abrasive rubbings, tea washing, and long exposure to direct sun are just a few of the methods to "age" new rugs. The results, at best, can add some harmless character to a carpet. At worst, carpets can be left looking bleached or muddy.

The abrash, too, can be concocted. Some modern weavers purposely mix slight variations of the same color to create the effect to try to boost the carpet's appeal to buyers.

One carpet dealer promises a classic "antique look" for reproductions of the flowing floral patterns created by William Morris, an illustrious nineteenth-century British designer, poet, writer, and, finally, socialist activist.

Mr. Morris would not be pleased.

"Everything made by man's hand has a form which must be either beautiful or ugly; beautiful if it is in accord with nature, and helps her; ugly if it is discordant with nature, and thwarts her," he once said in a lecture. "It cannot be indifferent."

Question: "What goes through your mind when you finish a carpet?"
Answer: "Unemployment."

CHAPTER NINE

NOMAD SONGS

 The sisters sang:

Remember, unless you've suffered from the coldness of winter,
you cannot appreciate spring.

I am suffering the same with love: lovely and painful.
I would give my life for the beautiful sight of your eyes just once
more.
If only I knew you would return, as I know spring will.

I sat back on the cushion in the nomad tent and shut my eyes. I
listened to the song cascade along the line of Qashqa'i women. Two
sisters sang the refrain. Eight others answered as the chorus. There
were no instruments, just their voices in a style that reminded me of
a river stone: solid and pleasantly smooth.

"That's interesting," said one of the sisters, a newlywed named
Zeynep, when I told her my impression of their songs. "That's not
my feeling. I think of a long, steady rain."

A powerful and happy image, I thought. This is a place where it's a joyous event any time the clouds open up.

We were in the high tablelands northwest of Shiraz that serve as the summer grounds for the Qashqa'i, which can be pronounced *kash-gai-ee*. When I arrived, most of the group had already moved to the winter sites in the less-exposed valleys deep with clover and grasses for grazing. Just a few tents were left in the summer plain. The last carpet of the season was nearly complete.

There were two reasons I sought out these nomads.

One was their acclaimed skill at the loom. No mention of Persian nomad carpet weaving is complete without proper homage to the Qashqa'i.

The other motive was to see how they were making use of their carpet-making flair. I had heard the Qashqa'i were increasingly offering it to the highest bidder. Carpet export houses, both big and small, have been turning to the Qashqa'i and other traditional weavers for years to produce high-quality carpets in whichever motifs and colors were moving in the market at any given moment.

Making carpets to fit the tastes of consumers is nothing new. It's been going on, in one way or another, for centuries. What I wanted to see was how the Qashqa'i were keeping their balance amid competing forces.

The pull from one side is from the paymasters. Many Qashqa'i weavers consider themselves fortunate to be hired to make "imported" designs and get paid for it. More commissions mean more money. That is good.

From the other direction, there's the tug of tradition. There's always the risk, although still slim, of failing to preserve the distinctive Qashqa'i style, such as diamond-shaped *guls* and a scattering of random animal and human figures. That is worrisome.

At least this is the simplistic equation I thought was tearing at the Qashqa'i world. I soon realized I was guilty of the worst kind of Western myopia. All my assumptions about these nomads and their relation to carpets proved to be quaint and romantic. I wanted to believe one thing. What I found was another.

It started with the songs.

There are many theories on how natural sounds influence folk music. The sacred music of Hindus is believed to carry inspiration from sounds of wind and animals. The great American composer Aaron Copland felt everyone was "born to certain inherited sounds" from their surroundings and culture, and these beats and creaks could be translated into music.

This may also hold true for carpets, I started to think.

The traditional motifs and color choices are often regarded as distinctive as a signature. With a bit of practice and knowledge, it becomes easy to pick out the general area of a carpet's origin. A carpet—like a song—has a rhythm, cadence, and tone. Taken collectively, the carpets become like an anthem for a tribe or region. At first, I thought I was onto something original. I had only to browse through some carpet literature to discover that this bridge between carpets and music was built long ago and has been heavily traveled.

After that, though, there are different paths. One of the stickiest points is over tribal designs. There are plenty of opinions—but very little agreement—as to the meanings of various patterns, shapes, and *guls*. Carpet texts and conferences are packed with points and counterpoints on how to identify and analyze various tribal pieces. There are those who think it's essential detective work that brings depth and context to carpet studies. Others consider such cataloging just plain silly. They see it as uncomfortably precise in a field that's full of ambiguities.

Just look at the Qashqa'i.

The Qashqa'i, like every Persian group, bump and grind against other clans and ways of life. It's part of great crosscurrents that have been churning for centuries across these lands.

Some theories say the Qashqa'i *guls* were inspired by the lavish medallions of rugs from seventeenth-century Persia. Another suggestion traces the Qashqa'i influences all the way back to Turkey.

Their songs may offer some clues. Follow them and they, indeed, lead back in the general direction of Azeri lands in northwestern Iran and, like a river delta, fan out into the Caucasus and western Turkey.

Some of the books exploring the "musical" links of carpets suggested that some tribal weavers memorize their carpets' motifs as someone would learn to play a song, replacing notes for knots in patterns such as red-red-yellow-black-red and so on. I rephrased my question to the weaver-singer Zeynep.

"I'm sorry," I told her. "I know you told me the songs remind you of rain. But what about with carpets? Do you see carpets as a kind of music that you reproduce with colors?"

I expected her to laugh at such an academic concept. Instead, she whispered something to her sister. Her sister whispered back.

"Oh, yes, I know what you mean now," she told me. "Carpets do have a song. You are right. But it's a different thing. It's an inner song."

"Please explain," I asked.

"I can't," she demurred.

"Why?"

"How do you explain a sound? How do you explain a color? It just is. It's the memories that are important."

"Memories?"

"I see a shape and color and it means something to me. Maybe it looks like a bird I saw one day when I was young or maybe it's the color of some mountain I know. What *you* see is what *you* see. What *I* see is what *I* see. There is no right way to sing a song, is there? There's no right way to see a carpet. So it's an inner song that everyone has. Do you understand?"

Again, I was humbled by a carpet weaver. I expected simple people with simple ideas, not a lecture that I struggled to grasp. When will I learn?

Zeynep Pakmanish was married only a week before my visit.

She still wore her bridal gown, a shimmering polyester confection of white lace and gauze that was bought in the Shiraz bazaar, not far from where I bought my *mafrash* for $20. She may wear the gown for a year, along with a special neck-hugging clip that signifies she is wed. Her makeup was almost theatrical: thick mascara, cherry red lipstick, and oily foundation. Her sister, eighteen-year-old Maheen, is not yet married and wore a long skirt of glittery red material. She had just a touch of eyeliner.

They both looked very serious as they sang that afternoon. It's not often, I guessed, that they sing for foreign guests.

The other singers, ranging from teenage girls to their aunts and mothers, were all dressed in the same extravagant colors. Water is scarce, but their outfits were spotless, except for the dusty edges of their long skirts. I've spent time with Balkan Gypsies, whom some call Roma. The outward similarities with the Qashqa'i could be purely coincidental. But perhaps there could be some long-ago link as groups roamed and mingled through the ethnic crazy quilt that includes Asia Minor, the Caucasus, and the rolling plains past the Caspian and Aral seas.

The Qashqa'i could fit into any plausible theory. They have no written language of their own. The story of their origins, mostly told in their Azeri Turkish dialect, is a net cast wide, drawing in Turks, Kurds, Persians, Arabs, and a host of others.

Even thinking of the Qashqa'i as a unified tribe is wrong. It's the name adopted centuries ago for a confederation of nomadic groups and subtribes dominated by Turkic speakers who started moving out of the Azerbaijan region as early as the thirteenth century. The precise reason for the migration is unclear, but it was a time when a Turkic dynasty known as the Seljuks were in control. They opened new trade routes and administrative corridors that could have paved the way for an ethnic migration. Slowly, the core population of the future Qashqa'i confederation drifted farther south over generations.

They passed through some of the most illustrious carpet areas, including the Kurdish mountain strongholds and the lands of the an-

cient pastoral tribe called the Lurs. The Qashqa'i possibly soaked up inspiration and expertise along the way. This ancestry could help explain their mastery at carpets.

"We must make our own beauty," whispered Zeynep's husband (and distant cousin), Ali Reza Hassani, as the songs continued. "We carry what we need. It's not enough to just have things to cook and take care of our children and animals. We need the songs."

They ended.

Everyone in the tent begged for a new one. I think it was because no one was prepared to move. The carpeted floor of the tent had been filled with a massive meal of pickles, chicken, lamb, canned tuna, rice, and a favorite treat of rice and batter cooked into a crunchy wafer known in Farsi as *tah-deeg,* "bottom of the pot." It was so pleasant to sit under the coarse wool tent with an overstuffed belly and feel the cooling afternoon breeze.

"Just one more song. That's it. I have work to do," Zeynep said after some light badgering. She started singing.

"What is this one about?" I asked her husband.

"Ah, this one is good," he said. "It's about love and sickness and the eyes of deer."

"Are all the songs so sad?"

"What do you mean?"

"Sadness," I repeated. "Don't they sing happy songs?"

"These are songs about life," he answered, squinting at me as if I was a bit dense. "Life is not all happiness or all sadness. Life is life."

I was about to relax and listen to the last song when I realized something was out of place. It was a flash of cartoonish colors under the carpets Zeynep had woven for her dowry. There, at the base of everything around these proud carpet makers, were cheap machine-made rugs. This was not something unusual in an Iranian home; good-quality, handwoven carpets are beyond the means of many Iranians, and machine-made carpets are a cheaper alternative. But I didn't expect to see this out here in the nomad camps.

"How can this be?" I asked after the song ended.

"You ask questions that are beyond me," said Ali Reza. "You need to find the elders. They know about such things."

I started across the tan dirt plain to see if any elders were still around.

A few sheep were penned up awaiting the trip to the winter pastures. The other animals had been moved earlier with the bulk of the tribe. Clumps of tattered cattails and white-capped thistles poked from the gullies that trap the precious rain runoff. An orange sun sat just on the lip of ridges around the valley. Long late-afternoon shadows stretched in my direction. One of them was four-legged. A nomad dog stiffened and snarled as I approached. Another shadow had a thin line that rocked like a pendulum. It was an old woman spinning wool.

"Can I come closer?" I yelled.

She waved me on. "Yes, please. The dog is friendly," the woman said.

The mutt was baring its teeth. I thought back to the dog fights in Mazar and held my ground. "You're sure?" I queried.

The woman stopped work for a moment and took a half step toward the dog, pounding her foot hard on the ground. The dog tucked its tail and backed down immediately. I became an instant admirer of this woman, who then introduced herself as Golnaz Abbasi.

She wore a heavy necklace decorated with coins and old keys. Her hands were covered with lines of faded henna tattoos that were now the color of eggplant. With quick flips, she spun a pear-shaped plumb that twisted the raw wool into thick threads to be dyed later for carpets. I asked her age. She had no idea. What she knew is that her children have children.

"We call that a grandmother," I said.

"I guess that makes me old and wise," she said and laughed.

That was my hope. The part about being wise.

She kept spinning the wool as she listened to my questions. I was curious mostly about why Qashqa'i weavers would have machine-made carpets. It seemed an affront to their traditions. But it also— once again—reminded me that my priorities and values about

carpets are often far removed from the people who create them. The machine-woven carpets bothered me and upset my pastoral notions of nomadic life. It didn't seem to trouble the Qashqa'i, though.

Golnaz Abbasi explained that there were two types of carpets for the tribe: the special ones used as dowries and heirlooms, and others used simply to cover the floor. If machine-made carpets serve this functional role, then why not use them? she asked.

She put down the wool. I guess she decided it was worth trying to bring me up to speed.

"When I was a girl, we lived in a way that was different than now," she told me. "I don't remember seeing money. We made what we needed. Carpets, clothes, what we ate—it all came from us. But I am not saying it was better. Oh, no. Don't think that. I am saying it was different. I think we are a little better off now."

"In what way?"

"The government sends teachers for our children. We can go to doctors. We are not isolated. This is progress for us. In the old days, I would probably be dead by now. My parents died young. It was harder then."

She proudly showed me the fillings from some dental work done in Shiraz. Then she pointed across a clearing to a girl spinning heavy wool for use as tent ropes. Golnaz explained with admiration that the girl, Fatima, was literate. Teachers visit the nomads up to the fifth grade. Some boys continue their education in Shiraz and other towns. Few girls go on. But the fact that Fatima could read was a marvel to the older woman.

"Imagine that," Golnaz told me. "A girl like that reading and writing. You talk to me about carpets. I'm talking to you about education for our children. You cannot compare, can you?"

I wasn't about to disagree. To break an awkward silence, I asked to see inside her tent. Her family, too, was getting ready to move to the winter lands. Clothes were packed into woven travel cases like the one I bought in the Shiraz bazaar. Cooking pots—all black and dented—were lashed together by their handles. The floor was covered by a large machine-made carpet they had bought several years earlier. I looked it over closely. It was just as the *bazaari* had told

me: computerized looms were capable of making acrylic thread reproductions right down to the human imperfections in the originals. It doesn't take a keen carpet eye to notice the difference between handwoven and machine-made products. But a dead giveaway is the back of the carpet. The machines make a uniform warp-and-weft grid that looks wholly different from the variations and slightly wavy warps and wefts of hand-knotted carpets.

"What are you doing down there?" Golnaz asked, watching me study the carpet.

"I'm just looking," I said, wincing with embarrassment.

"Why?" she said. "Do you want it?"

"No, no. It's just interesting to me to find this type of carpets with the Qashqa'i."

"As I said, you should think about how we now have girls who can read. I don't know why you are thinking so much about carpets anyway."

Months later, I recounted this conversation with one of the foremost experts on the Qashqa'i, the professor and prolific author Lois Beck.

She knew instantly what I was describing. She has lived with the Qashqa'i. Her books are widely considered among the definitive English-language works on their lives, traditions, and struggles.

I had blundered into one of the central quandaries of the Qashqa'i and, for that matter, of many tribal and immigrant groups around the world forced to splice parts of the dominant culture onto their own. For the Qashqa'i, Beck pointed out, the trade-off is to become more "Persianized" in exchange for greater literacy, broader horizons, and more ways to make money for modern amenities.

"You have to look at it like a circle," Beck said. "The Qashqa'i are like everyone else in that they want things that will enrich their lives and make life easier. They want a vehicle instead of having to walk. The women want a sewing machine instead of having to stitch by hand. There are all sorts of material things they have or want to have. To get these, however, means entering the other world—what we call the Persian world—to get them. We see the results across the board. The children are using more and more Persian words and

forgetting the Azeri spoken by the Qashqa'i. The Persian lifestyle, like the machine-made carpet you saw, is moving into their world from all directions. There is probably no bigger issue dividing and polarizing the Qashqa'i than this whole Persianization."

I mentioned the nontraditional carpets I saw woven by Qashqa'i women. Here, Beck took a different tone. It's true, she said; the commissioned motifs are not all part of Qashqa'i historical memory. But the outside pay is an important new dynamic in Qashqa'i society. It elevates the power and influence of women, just as I had observed with the Turkmen weavers years before. Carpets bring in money. And money brings stature for the breadwinners and options for their families.

"Face it, it's hard for the Qashqa'i to make a living. You saw it. It's not an easy life. If they can improve their situation by making carpets for someone, then they will do it. It's a global trend, you know. Weavers are making carpets for the highest bidder everywhere. Why not the Qashqa'i? This is why they don't fight it and say, 'We will do only our designs and so forth.' The ability to bring in money is a much stronger force. This explains why they are pretty relaxed about it."

"But their songs are so sad, it seemed to me," I said. "Is this always how it was?"

"Don't forget the Qashqa'i are a people separated from their ancestral lands," she told me. "How and why it happened, we don't fully know. But it's clear by their language and physical characteristics that they are not from southern Iran. It comes out in their songs. They are lamenting ways of life that are gone, strong leaders who are no longer among them, a homeland that no longer is. When the women sing of lost love or yearnings, it's all part of deeper longings. It's an allegory.

"It's like the Sufi way," she added to my surprise. "Nothing is as it seems."

Back in Zeynep's tent, which was still full of plastic party streamers from the wedding reception, work had resumed on her carpet. It was a nearly completed copy of the famous Pazyryk carpet, ordered by a German client through the Miri family in Tehran. The Miris have become major international players in a growing trend: commissioning tribal and village weavers to create high-quality carpets using naturally dyed wool.

I watched Zeynep and her two new sisters-in-law, Layla and Fatima, work on the last few inches of the carpet. When it was done, the rest of the tribe would pull up stakes for the winter grounds. The Miri company was paying them a total of about $300—or about $7 a day—for their work on the carpet. It would cost the German client probably ten times that price.

This is the step in the carpet trade where the real money is made.

Weavers typically are paid only a fraction of a carpet's ultimate market price. The reason is straight from Economics 101. If one weaver doesn't want the work, there is always another competent replacement willing to take the commission. It naturally drives down the rates the weavers can command. But it offers a steady supply of work to those willing to accept the terms.

Zeynep and her relatives were not too picky. They gladly took the Miri work. The alternative was buying their own materials, weaving their own carpets, and seeing what they could get with the Shiraz *bazaari*.

"What goes through your mind when you finish a carpet?" I asked Zeynep.

She didn't hesitate with her answer. "Unemployment."

"But wouldn't you be happier if you made your own designs and tried to sell them on your own?"

"No," she said, obviously growing a bit impatient.

"Why not?"

"Look," she said, stopping her weaving for a moment. "You foreigners come here from your comfortable lives and make judgments about us. We do what we need to do. If we need medicine, you can't buy it with wool or carpets or chickens, can you? No, you need

money. That is the modern world. Just because we are not settled doesn't mean we have different rules. Unfortunately, that's not true. If the Miri carpet business gives us a way to make money, then we will accept it and be grateful. I will have my own children soon. I want a better life for them."

Her sharp tongue caught me off guard. "I'm sorry if I offended you," I said. "I didn't mean to."

"I'm not angry at you," she replied. "We get upset when people think the nomads should have different ideas and dreams than those who lives in homes. Are we really not all the same?"

She went back to work.

The carpet she was finishing is more than just a new prize for the German client. The Miri system is part of the worldwide trend among commercial carpet groups to revitalize the use of natural dyes and classic motifs.

It begins with designs sketched out on computers on a narrow side street near the Tehran bazaar at the Miri headquarters. The specifications—size, colors, wool thickness and quality, whether silk highlights are needed—are passed on by email to the Miri base outside Shiraz.

From here, the natural dyes are made and the entire order packet is sent to nomadic or village weavers around southern Iran. Quality control inspectors pay impromptu visits on the weavers during the production. The finished carpet—if it passes scrutiny—goes to Miri showrooms or to affiliated dealers in Europe or the United States.

The economic food chain is a rapid feast from minnow to king-fish.

A carpet pulled at random from the Miri dyeing works offers a typical example. Order number 1023 was a traditional Kurdish-style design (about 4' by 6'3") with an above-average knot count of about 170 knots per square inch. The village weavers took about four months to finish and were paid the equivalent of about $250. The carpet cost the client, a German surgeon, more than $2,000.

A total of about eleven thousand people are involved in the Miri carpet network, from wool spinners to designers to weavers. About fifty of them work for Mr. Honest at the dye plant.

Sadegh Abedi—whose first name means trustworthy—drove me out to the factory from Shiraz. We passed sad and untended vineyards. Some wine historians contend the twisted vines are the original source for the famous varietals from France, Australia, and elsewhere known as shiraz or syrah. But many experts think it's just a linguistic quirk and the name actually comes from a source in the Rhône Valley in France. Nevertheless, the Iranian shiraz grape makes a decent wine that was certainly part of Hafez's world. A few Iranian bootleggers still keep the tradition alive. Police raids against the bathtub vintners are noted as small items in the papers.

"But it's not very good wine the way they make it," said Sadegh.

He glanced over and saw I was taking notes. "I mean to say I *heard* it's not very good. I've never tried it, you know."

"Of course you didn't," I assured him. "Someone must have told you."

I knew the rules of the Iranian social game very well by now. Don't press new acquaintances too far for details of their life behind closed doors. No one wants to be cornered. They will tell you eventually if trust is established. Being offered a drink is one of the defining moments for an outsider. It means your vantage point on Iranian society has improved. For many Iranians, a beer or a scotch is more than just a forbidden pleasure. Younger Iranians see it as mud in the eyes of the mullahs and their rules. Some older Iranians, especially those openly nostalgic for the days of the shah, savor a taste from the past.

The weed-clogged vineyards made me think of Hafez possibly enjoying a glass at a Shiraz tavern. It also reminded me of a friend in Tehran, a retired hotel worker, who told me how thugs with sledgehammers stormed into the wine cellar after the Islamic Revolution. He will never forget the sounds. He described the boots crunching on broken glass and the explosions of the champagne bottles as "more powerful than any mullah's rants."

☙

How Iran reached that moment of fury is not a simple case of victor and vanquished. It's easy to blame the hubris of the last monarch, Mohammad Reza Shah, for allowing pockets of resentment to grow into a full-scale revolution.

But a detailed memoir by one of the shah's former generals and confidants, Hussein Fardust, describes a more insecure figure. The shah appeared unprepared—and sometimes unwilling—to handle the complexities of Cold War politics and the burdens and blessings of the country's oil riches. The job of running Iran was thrust upon him. He came to the throne as a cloistered thirty-one-year-old who had been sent to a Swiss finishing school for refinement and Iran's top military academy to try to add a touch of grit.

His father, Reza Shah, was forced to abdicate in 1941 under pressure from the Allies who worried that Iran could side with Germany in World War II. Fardust said the shah recalled every detail of his last moments with his father.

Fardust said Reza Shah asked his son: "Can you keep the throne?" The father begged for a clear answer.

Mohammad Reza could only nod.

Thirty-eight years later, on January 16, 1979, the shah and his third wife walked to the plane that would carry them away. The shah stashed a small packet of Iranian soil in his pocket. His wife carried away the title of shahbanu, or empress, which was created for her. "His body was riddled with cancer," Fardust told his biographer. "He was a broken man."

Shahpour Bakhtiar, the newly appointed prime minister, was left with the impossible task of fending off Khomeini and his revolution. He asked the shah where he should send his daily reports.

"I do not need reports," the shah said, according to Fardust. "Do what you deem is necessary yourself."

And the last king of the Persians boarded a blue-and-silver Boeing 707.

The shah's father had given him advice on how to survive World

War II: "Bow your head till the storm passes." But the tempest led by Khomeini years later was even stronger than the war. It had been brewing for a long time.

A little-remembered uprising in the Qashqa'i lands was part of it.

In the early 1960s, the Qashqa'i led revolts against attempts by the shah to tighten controls over tribal areas. The military countered with an offensive to seize nomad weapons. The tribal leaders fought back. More troops were sent. The situation threatened to collapse into anarchy. The shah selected a general named Bahram Aryana to crush the rebellion.

It was a fateful choice. Aryana styled himself after Napoleon— even going so far as to dress in imperial French style—and was known for his insatiable appetites for booze and high-class prostitutes. In the field, he was a severely flawed tactician. In one operation, he ordered a brigade into a valley without support. About fifty tribal guerrillas staged an ambush and left no survivors.

Eventually the shah sent in cooler and more experienced commanders. The revolt was put down and many tribal leaders were executed.

But there was a powerful message from the mess in Fars. It showed that weaker forces could spook one of the largest military and security machines in the Middle East.

This was again played out in 1963 on the bigger stage of Tehran.

In March of that year, the shah ordered paratroopers and his feared secret police, known as SAVAK, to raid a seminary in Qom where Khomeini had been preaching against the monarchy and its backers. Students were killed and Khomeini was detained. It was just the beginning of several dramatic months that pushed the shah's back to the wall.

In June, Khomeini was arrested again. For the shah's regime, the timing was bad. It was just before the Shiite commemoration of Hussein's seventh-century martyrdom on the battlefield in Iraq. The events quickly turned into protest marches in favor of the cleric. The shah's forces were caught flat-footed. Some riot police units were overwhelmed by demonstrators and stripped of their weapons.

Then the shah caught an unexpected break. Restaurant owners

offered all protesters free lunch. The streets cleared as they took up the offer. That gave the shah's forces time to regroup and launch a punishing counterattack. The tide turned. The protesters eventually fell back.

In his memoirs, Fardust says few realized how close the 1963 unrest came to driving the shah out of Iran. If the protesters had moved strongly on the royal palace, Fardust speculated, the shah probably would have taken a helicopter to the airport and fled.

"His departure would have demoralized the Imperial Guard and they would have surrendered to the people," he wrote.

But the shah's regime survived, shaken yet apparently no wiser about how to allay the feelings on the streets.

In late 1964, just seventeen months after the pro-Khomeini demonstrations, the parliament narrowly approved a U.S.-urged bill extending diplomatic immunity to American military advisers, their families, and even support staff. The vote was taken after Washington agreed to a $200 million loan. Such exemptions for foreigners had been applied before by Persian kings. But Khomeini portrayed this one as an outrageous provocation. It was just the type of act he needed to push the resentment of the shah to a new level: something clear, current, and comprehensible to all. Khomeini—always a great orator—outdid himself this time. He cleverly used the shah as an example to mock the law's imbalance:

"Even if the shah himself were to run over a dog belonging to an American, the shah would be prosecuted. But if an American cook should run over the shah, the head of state, no one would have the right to interfere with him."

Khomeini continued: "The government has sold our independence, reduced us to the level of a colony, and made the Muslim nation of Iran appear more backward than savages in the eyes of the world. Scholars, students! Centers of religious learning! Najaf, Qom, Mashhad, Tehran, Shiraz! I warn you of a danger."

About a week later, Khomeini was ordered to leave Iran. He was escorted to Turkey and later went to Iraq.

In 1971, the shah gave Khomeini another sharp weapon with which to attack the Pahlavi dynasty.

This time it was a party. But a kind of party that Iran had not seen for centuries.

The holder of the Peacock Throne decided, with a bit of fudging, to mark the twenty-five hundred years since the founding of the first Persian Empire. The shah presided over a gala amid the ruins of Persepolis. Thousands of costumed vassals passed by in a procession intended to reinforce the shah's pretentious claim of connection to the great imperial dynasties before Islam.

French caterers flew in everything but the caviar, Iran's other "black gold" after oil. The guest list included nobility, statesmen, and envoys from around the world. The White House sent Vice President Spiro Agnew. Britain's envoys were Queen Elizabeth II's husband, Prince Philip, and their daughter, Princess Anne.

Khomeini issued a widely distributed statement from Iraq predicting "even more distasteful events" for his country.

We pulled into the Miri dye factory, a sparkling-clean enclave in a rough industrial district about fifteen miles north of Shiraz. The rules say the workers must be clean shaven and have spotless uniforms. The site was selected because of the availability of clean mountain water from a nearby dam. The operation was light-years away from the dye shacks I had visited south of Yazd.

I was served tea and fruit. The walls of the office were covered with beautiful photographs of landscapes and nomad carpet weavers. I told Sadegh how surprised I was to find machine-made carpets in the nomad camps. He shook his head.

"You noticed one of the big pities of our country," he said. "There is no reason for machine-made carpets to be in an Iranian home or anywhere in this country. But, as you noticed, it is the case. Decades ago we had a saying that there were three things in everyone's home: a handmade carpet, a Quran, and a book of Hafez. Now, the Quran is put away because of politics and anger at what the mullahs are doing to strangle Iran's spirit. The carpet is too expensive and is replaced by a cheap machine-made one. All that's left is the book of Hafez."

"And will that go?"

"Then there is no hope for this country," he said. "But it won't happen. Hafez is our blood. You cannot drain the blood."

"And carpets? There is so much competition from around the world now. Will Iranian carpets keep their place?"

"This is a tougher question," he said. "We have to convince people—in Iran and around the world—that the Persian carpet is the best carpet. The legacy of our people is written out in wool and silk. No one else can say this. The Indians can't. The Chinese can't. Pakistanis can't. They try to bend carpet history to fit their needs. But it's our job to make sure the world knows the importance of the Persian carpet."

"How are you doing this?"

"We are trying to revive the culture of carpets," Sadegh said. "But listen closely: this is different from just making carpets. Carpets have always been made in Iran. We're talking about the culture: the knowledge and appreciation of the natural dyes, the love of the artistry of carpets. A harmony is what we are talking about, a harmony between the people, the history, the stories, the land. This is what we are trying to save. Come. I will show you."

He led me into the dye plant.

It was in a high-roofed building that resembled an aircraft hangar. Everything—down to the cement floor—was impeccably clean. Sadegh used to work in the petrochemical industry and was drawn into the Miri carpet operations through distant family connections. He values efficiency but realizes that even the most carefully planned dye formulas and processes cannot guarantee consistent color. Nature is not that accommodating.

"We can try and try, but nature is always one step ahead of us," he told me as we walked through the plant. "I guess that is a good lesson. It's humbling, don't you think? Look around. We have all this machinery and computers, but we are still left at the mercy of the madder root or the walnut or the pomegranate."

The assembly line works in three shifts around the clock. The Miri family designed a rack system with fourteen arms, each one capable of holding up to twenty-six pounds of wool. The process

moves from washing to dyeing to drying. The ingredients for the colors—madder, walnut, pomegranate, and others—are doled out according to precise formulas. Wastewater is used to irrigate the trees and flower gardens around the plant.

In a room above the dye-making floor, a dye specialist was struggling to get the colors right for repairs on a 150-year-old carpet with chalky blue borders and a ruby red interior decorated with peacocks, birds, and human forms.

"We try our best," Sadegh said. "We can get very, very close to making the same color. You may not even be able to see it well with your eyes. But you know in your heart it can't be done. No two natural colors are exactly the same. This is the mystery. This is infinity."

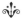

I'm a believer.

But my sense of the Almighty is not as a string puller or interventionist. I imagine God as a kind of divine courier. He keeps sliding us invitations—to make that call, to strike up that conversation, to help that person. Often the timing is bad or there's hesitation on our part. The chance is gone. The trick, I feel, is keeping the channels open through whatever means work: faith, curiosity, or just plain stubborn hope. Because a moment may come that's wondrous. It's that instant of clarity and uncluttered judgment to chase an opportunity or idea that you know—you just *feel*—is right. The ancient Greeks called the concept *kairos,* which encompassed both good timing and seeing a moment in its full context. This, to me, is a divine gift.

Something like this happened to me in a taxi heading north from Shiraz.

I was thinking about my visit to the Hafez tomb and how it all tumbled back to that chance meeting with Mohammad Reza in the Tehran bazaar. At my side was some fresh carpet information I'd picked up at the dye shop. In the stack was a Farsi-English carpet magazine, *Farsh,* which is partially funded by the Miri family.

I thumbed through it. A strange carpet caught my eye.

It was unlike any I had ever seen. A weird collection of surreal beasts and horned men floated around a single tree that rises through the center of the carpet. The caption gave only the briefest information: a Heriz piece woven in the mid-nineteenth century. The next page contained some short essays about the carpet.

At least one expert thought it was woven by Sufis.

"See this?" I blurted to my translator. "See what it says? Sufis!"

"You can't escape them," he said and laughed.

"Guess not."

"And look where the carpet is now," he said, pointing to the tiny print on the side of the page.

It was at a carpet shop in New York.

As quickly as that, I had a new goal: to find this dealer and this odd and alluring carpet that unexpectedly crossed my path.

PART III

THE MARKET

You will find, be it for a year, a month, a week, a day, or even an hour,
that you will pass your time agreeably.

 —James J. Morier, THE ADVENTURES OF HAJJI BABA OF ISPAHAN

CHAPTER TEN

A HINT OF SAFFRON

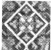 I had been warned.

 Don't travel the Iranian highways at night unless it's absolutely necessary, many Iranian friends advised. I listened. I nodded. But I didn't take it to heart. I had some harrowing road trips under my belt: New Delhi to Agra, Ankara to the Iraqi border, around lawless Iraq, Ikbol's dusty blast to Herat. There's no way, I thought, that this could be worse.

Wrong.

For pure, jaw-clenching panic, nothing for me has rivaled the dark mountain highway from Shiraz to Isfahan. I guess there were two lanes in each direction. But it's hard to be sure. Most drivers treat it like an open ribbon of asphalt in a free-flowing game of chicken. Nerves of steel are needed. Mine were pounded rapidly into oatmeal.

Even in daylight, I'm jumpy on Iranian highways. Everyone is well aware of the country's scary accident rate. Night journeys like

mine are simply a way to foolishly push your luck. More than 25,000 people are killed on Iranian roadways each year. Compare that with nearly 43,000 traffic fatalities in 2003 in the United States, with a population more than four times greater than Iran's 65 million. Iran's safety record grew so worrisome that the World Bank drafted a $60 million loan in 2004 to improve highway safety.

The common wisdom is that Iran's toll would be even higher if not for state-controlled prices for air travel, which is a relative bargain but carries its own risks. Iran Air's fleet includes rented old Tupolevs from the former Soviet bloc and prerevolution Boeings, which cannot get direct servicing and parts because of U.S. sanctions. They are kept flying with bits scavenged from grounded planes or obtained through roundabout sources. Iran Air once came up with ads using winged relics of ancient Persia over the unsettling motto "Where flying is a myth." The billboards quickly came down.

The *Tehran Times* newspaper offered a chilling list to explain the highway carnage: "Dilapidated vehicles, reckless driving, insufficient emergency assistance, lack of communication facilities, and inadequate emergency centers."

Add to that the sheer terror of night travel. Cars zoomed by, sometimes missing one another by inches. And sometimes not. We passed several horrible wrecks, including one still burning on the outskirts of Shiraz. Trucks, some literally groaning and swaying under overweight loads, did as they pleased. One diversion—apart from imagining my obituary—was checking out the wild or cryptic stabs at English painted on the back of trucks and buses: Good Bay, My city-Love city, Pise be on you, Allah is Kink.

Lily, my translator and friend, wisely demanded that the taxi company provide anything except a Paykan. We got a Peugeot. There's a trade-off, though. The Paykan can't hit 100 mph, which seemed to be the speed our driver yearned for even in the most hair-raising congestion.

I looked at Lily in the backseat. She gave a weak smile. Not very reassuring. I had a sudden desire to call home and talk to my wife,

hopefully not for the last time. But there was no cell phone network out in the mountains of southern Iran.

The driver, at least—bless him—was calm. He was humming something and drinking tea from a flimsy plastic cup, that he wedged between his thighs when he needed both hands on the wheel. My adrenaline rush faded. I finally dozed off.

I awoke when the car began to slow. "Isfahan," the driver announced with a smile as city lights suddenly engulfed us. We had made it!

The air smelled of sweet, wet wood and the mossy Zayandeh River that disappears into a salt flat not far from where I'd found my wild madder. The graceful arches of the four-century-old Sioseh Pol, a bridge named for its thirty-three vaulted chambers, were illuminated like private stages for families, lovers, and cats on late-night strolls. The river was low and slow. It had a sheen like freshly licked candy.

In the morning, I would seek my pal Hossein Payghambary. We had parted in Mashhad with a promise to meet the next time in Isfahan. He told me his shop had moved since my last visit years earlier. I'd now find him on a street named Saadi. Hossein always seems to bring interesting tidings.

Saadi is considered, along with Hafez, one of the twin literary giants of Shiraz. Saadi died about 1290, a generation before Hafez's birth, and many parallels have been made between the two poets. Saadi, too, began as a Quranic student and was later drawn by the mystical call of Sufism. Unlike Hafez, though, Saadi traveled. For decades, he roamed through the Middle East, India, and North Africa. He returned to Shiraz as a sort of learned vagabond, filling his poems and prose with stories and anecdotes alongside musings on life and love. But he never appeared to be on cordial terms with time. He often described life as too short and too littered with missed opportunities.

"Life is snow, the sun is burning hot," he wrote when nearly fifty years old in his well-known collection called *Golestan,* or *The Rose Garden*.

But he was not gloomy about accepting mortality. Instead, he found solace in transformation and rebirth in different forms. In a lovely poem, he describes a raindrop falling into a sea and being swallowed by an oyster. The oyster made the raindrop part of a pearl that would adorn a king.

Under his shrine in Shiraz, beautiful fish swim in an underground pool. Visitors drop a coin and make a wish. The fish don't scatter as expected. They are accustomed to the sound of someone's hopes plunking into the cold water—like the raindrop in the poem—and fluttering down into the rocks.

I'd always considered Hossein somewhat of a poet in his own right.

Nothing is written down. His lines, instead, are slipped into his rapid-fire way of speaking. He has an innate talent for turning a clever phrase or making a simple observation seem wonderfully sage and homespun. It's a common gift among the best carpet merchants I've met. Hossein just seems to do it better than most, and always with a boyish joy though he's solidly in middle age.

One of his snippets remained for years tucked in my wallet on folded notebook paper. It was something he said in our first meeting at his shop in Isfahan in 1999, shortly before the Tehran merchant Mohammad Reza filled my head with Hafez. I must have been rambling about one trouble or another. I don't remember. But I recall him stopping me in midsentence with a flash of his palm.

"Don't worry," he said. "The bread always comes along. Maybe some days it's dry. Maybe some days it comes with chicken and cheese."

I jotted it down and stashed it away. Perhaps it was a bit too close to fortune cookie wisdom for some tastes. But it worked for me: pure trust in the belief that life will somehow provide. I'd bring it out from time to time and reread it. My wife says I should study it more often.

Anyway, I was ready for more. There was a glaring hole in my self-styled carpet education: watching sellers work and trade and plot. I couldn't think of a better starting point than Hossein. He seemed to me linked by energy and spirit to something essentially Persian, like Hafez, Saadi, or carpets themselves.

One of the classic studies of the Persian disposition—at least from a Western perspective—is *The Adventures of Hajji Baba of Is-pahan.* It's almost biblical in its structure: a mix of parable-like chapters tracing the charmed life of Hajji Baba, who was given the name because he was born while his parents were on a pilgrimage to the holy Shiite site of Karbala in Iraq. With blind luck and sharp cunning, Hajji Baba vaults from being a barber—his father's profession—to a lifetime of amazing reinvention: from bandit to doctor to scribe to merchant to statesman. Along the way, Hajji Baba encounters the full gamut of Persians' most noble traits of hospitality and honor. There's also, however, no shortage of flawed characters and hypocrisies, including moonshine-guzzling Muslims and loopholes such as *sigheh,* or the mullah-blessed system of "temporary marriages" that can provide religious cover for affairs or prostitution.

The book was published in 1824, using a variant spelling of Isfahan common at the time, and much still rings true. It remains recommended reading for diplomats and business executives seeking to improve their grasp of the Iranian psyche. The novel is often placed in the rarefied company of similar socionarratives such as *Gil Blas* or *Nicholas Nickleby. Hajji Baba's* author, James J. Morier, had a privileged perch from which to observe Persians. He was part of a Swiss family of merchants and diplomats and became a naturalized British subject. In 1808, he was posted as an assistant to the British embassy in Tehran and, six years later, was named ambassador. His early travel memoirs earned him considerable income and top billing in London's literary circles.

Hajji Baba and his chameleon life is a product of fiction. But, undoubtedly, Morier drew inspiration from the Persians he knew. I would venture that one of them must have been like Hossein.

He had that Hajji Baba mix of wit and buoyancy. He knows how to stay afloat.

"Hello! Welcome!" Hossein cried as we embraced outside his shop. "You made it. Thanks God. You see my shop? Not bad, no?"

"*Mabrook,*" I said, using the Arabic word for congratulations. "You are becoming quite the carpet pasha."

"You are too kind." He smiled. "But I can't lie. God has been good. I'm just enjoying it while I can. You want to see the square again? Of course you do. We can see the shop later. Come."

He took me by the hand.

Saadi Street runs directly into one of the most breathtaking sights in all Iran: the enormous square that was the centerpiece of Isfahan's renaissance of building and culture under the two-century-long Safavid dynasty, which began about the time Columbus was making his Atlantic crossings.

The square has gone through several names, most recently changing from Shah Square to Imam Square after the revolution. But it has never lost its ability to humble any visitor. It reminds me of walking through a thick forest and suddenly coming across a vast lake. Crowded Isfahan gives way to an open space 1,650 feet long—about a third of a mile—and about 530 feet wide. It could hold five football fields with room to spare.

The great Savafid builder-king, Shah Abbas I, used it for polo, a sport born in Persia and being revived by a core of Iranian players who rejoined international competition in 2003. At the north end of the square is the towering entrance to the city's great bazaar. On the western edge sits the palace of Ali Qapu, which was the Safavid center of government. It faces, across the square, the solid and dignified Sheikh Lotfollah Mosque with tiles of blue and white swirls over coffee-colored backgrounds and arches adorned with the finest calligraphy of the early seventeenth century.

But it's the square's southern flank that holds my gaze. It happens to everyone. A turquoise dome, 171 feet high, rises over a complex that is considered by some as the apogee of Persian Islamic architecture. Now known as the Imam Mosque, it has two mighty minarets

over an outer portal. Mosaic panels resemble prayer rugs. There's a well-known rhyme believed coined in the Savafid days: *Isfahan nesf-eh jahan,* "Isfahan is half the world." From this angle, it's easy to see that it wasn't just pure conceit.

"Enough?" Hossein said. "You can come back later. Let me show you the shop."

On my first visit, Hossein worked out of an alcove in a corner of the square. The new place, still called Nomad, showed that Hossein was doing something right. It's an airy space with two floors. Carpets and kilims are stacked neatly. A courtyard has a worn carpet for catnaps by his staff—his "boys," as he calls them—or even a customer needing a few winks.

"And we now have free internet for the clients," Hossein boasted. "This isn't Afghanistan or Saudi Arabia. So many travelers come here and are surprised—maybe I can use the word *shocked*—to see us online."

I wasn't. I had spent much time in Tehran's internet café society. It's another of the amazing paradoxes of theocratic Iran. The conservatives in the 1990s expended huge resources trying to block Western videos and music but let the internet develop with almost no restrictions. Nearly anything—from news to porn—is just a click away. Meanwhile, thousands of blog sites act as a parallel reality. They are part salon, part therapist's couch, part soapbox, all with the liberating candor of anonymity. Anything goes, including plenty of jokes and jabs about the mullahs and their backers.

One goes like this: A hard-line Friday prayer leader dies and his son sits in the bathroom during the funeral. "What's the matter?" ask the mourners. "I like it in here," the son says. "The smell reminds me of my father's sermons."

A photomontage that made the internet rounds showed the supreme leader, Ayatollah Ali Khamenei, as a whip-snapping dominatrix. Hossein has a Yahoo! email account.

In February 2004, a quarter century after the revolution, one Iranian American blogger got downright nasty:

"To celebrate the Islamic Revolution's 25th anniversary, I took a

big shit in the airport washroom and chanted a *salavat* [a line of praise for prophet Mohammad] over the steamy chunks."

Hossein led me around the shop. He coolly avoided any mention of buying. But I somehow knew that I wouldn't leave Isfahan empty-handed, either.

"I want to make my shop like a place where you come and sit and relax. Like an old *chaykhane*—you know, a teahouse. In fact, do you want tea now? It's very good. We have a special way of making it. We use a hint of saffron and cardamom."

"But you want people to buy the carpets, too," I prodded.

"They buy. When people feel good, they feel good about buying."

"This is your philosophy, I guess."

"It's not mine. Oh, no. It's a fact ever since the first carpet sellers. The successful merchants are like matchmakers. They are just there to help the person fall in love with a carpet. You need to feel love for the carpet you take home or I consider it a failure. The sellers who don't do well are trying to force this love by trying to make someone buy something they don't want. And, we all know, you can't force love."

"You'll show me this, I hope," I asked.

"How can you ask such a question?" He smiles. "You can stay as long as you want. Watch, learn, have our tea, eat our food. But I see you're impatient. Let's start now with your lessons. I will teach you one important thing to remember. The hand should never shake when you reach out to help someone."

"I don't understand."

"I mean that you must be honest and sincere in everything. This carpet business is full of sneaks and cheats. I try my best not to be among them. But you watch me and you decide if I'm worthy of God's blessings."

But first we ate.

Hossein insisted I have lunch at his home. To the Persian mind,

in fact, there was really no reason to make an invitation. It was fully expected that a visitor who had traveled so far would come for at least one meal, if not many.

Hossein's wife, Janileh, seemed slightly offended that I was staying at a hotel rather than their apartment, which was in a new building with a security gate and parking, seen as a symbol of success in middle-class Iran. Hossein said something to her in Farsi that I guessed was an explanation of foreigners' quirky habits and inhibitions. She nodded and looked at me with a sad-eyed expression that was uncomfortably close to pity.

"Do you mind if I pray?" he asked.

"What? Of course not," I said. "Why do you ask such a thing?"

"You are the guest. I just thought it might make you feel awkward—being American and all."

There it was again. I've been in this situation countless times with Iranians. There is a widely held perception of the United States as a plastic place scrubbed clean of faith and spirituality. Of the many misunderstandings between Iranians and Americans, this is one of the most unfortunate because it's so off base and, if clarified, could help redefine how average Iranians view their counterparts in the "great Satan" or "world arrogance" or whatever epithet is popular at the moment.

I've often tried to explain the profound religious dimensions of the United States. I remind them that America has always been a hothouse of religious fervor all the way back to the *Mayflower*. Names like Providence, New Haven, Bethlehem, and San Francisco—not to mention "In God We Trust"—are just a few samples from the country's religious underpinnings. A December 2002 survey by the Pew Research Center for the People and the Press found that 59 percent of American respondents described religion as "very important" in their lives. That was far above the closest industrialized nation, Britain, where 33 percent felt the same way. Japan was just 12 percent. France was even lower: 11 percent.

But Iranians, and many others around the world, are blinded by what I call the *Baywatch* effect. For years, the show was one of the

most popular scraps of U.S. pop culture grabbed by illegal satellite dishes across Iran. It's amazing—and a bit frightening—how many Iranians feel that buffed and bronzed lifeguards represent a window into the entire U.S. culture. Some Iranians are genuinely shocked, and maybe even a bit disappointed, to hear alternative versions of my country: charitable organizations; homeless shelters; hospitals and schools run by religious orders; or just plain time-clock-punching workers. It's not an attempt to gloss over America's many flaws, but rather to offer some balance. This is what I think Iran's president, Mohammad Khatami, had in mind when he proposed a "dialogue among civilizations." It was a good idea blasted to bits by hijackers with box cutters on September 11, 2001.

Hossein set out a prayer mat in the corner of the living room. I sat nibbling on raisins and watching his wife set out the meal. We would eat Persian-style on the floor over a plastic tablecloth. Hossein and Janileh also sleep on the floor on bedrolls. Their two children, however, demanded ordinary Western beds.

"The old ways are dying," said Hossein. "There's not much we can do."

"Well, you're one to talk," I said. "You have internet in the shop."

"Exactly." Hossein grinned. "I'm just saying the old ways are fading. You told me you saw it yourself with the Qashqa'i. But I didn't say it's all bad. Ignorance and poverty is not something you want to keep, is it? Sitting in the dark because you don't have electricity isn't so good. I'm not complaining. I'm just amazed at how fast it's all changing.

"Here," he continued. "Look at this."

He showed me one of his favorite pieces: a Senneh kilim from the Kurdish areas of northwestern Iran. It had the typical repetitive motifs that, to him, represented tiny rabbits and fish. These are finds he won't sell—unless finances force him.

"What I'm afraid of is that we lose the sense that the world is a big, mysterious place where all kinds of things are possible," said Hossein. "Being modern is one thing. But I hope this doesn't mean

losing wonder and awe and a sense that God is watching us. If that happens, my friend, these kinds of carpets will be no more. They come from that type of imagination. What I'm trying to say is that good carpets—or any art, I think—come from people who ask questions about life and try to see things that aren't there. People who think they know all the answers and just create things to sell are making nothing but junk."

"I didn't know you were such a philosopher," I said.

"This isn't philosophy, my friend. It's just me and my heart talking. That's one of my faults, I guess. I can't keep things in."

"Well, some people would call that honesty," I said.

"I agree," he said. "But in the carpet business honesty is not always so good. It can make you poor."

Lunch was served. Janileh had prepared *abghosh,* literally "water meat," a traditional Persian stew of navy beans, onions, potatoes, lamb, and slabs of fat. Most Iranians mash bread into the *abghosh* to make a dense mush. I prefer to leave mine alone and eat it like soup. We picked at a bowl of salad greens and crispy radishes with our fingers. I looked down at my sweater. Just a few *abghosh* stains. Not too bad. At least I was getting better at eating on the floor.

I was also making some progress with my own special carpet hunt.

I had contacted the dealer in New York. It turned out the merchant, Joseph Hakimian, is an Iranian Jew who left the country in the early 1960s and hasn't returned since the Islamic Revolution. He gave me a bit of bad news, though. That silk Heriz with the possible Sufi connections had just been sold. But the buyer was a New Yorker. Joe Hakimian said he would try to arrange a viewing the next time I was in the city. Then he asked an unexpected favor of me: find a *Divan of Hafez* with the poems in both the Farsi original and English translations. Joe's Farsi was getting a little rusty.

I pulled out the magazine page with the image of the Heriz carpet. I wanted Hossein's opinion. I still wasn't convinced this carpet was worth the trip to New York.

"Some people think it was made by Sufis," I told him. "What do you think?"

He looked it over for several minutes, sometimes pulling the picture right up to his nose to study details. Many ordinary Heriz carpets, typically with a bold central medallion, are often downgraded by serious collectors and curators because of the area's long association with commercial rug dealers in the West. This carpet was clearly an original.

"Hmm," he hummed. "Interesting. Very, very interesting. This carpet is a world of dreams, my friend, as a carpet should be."

The carpet's central field is a mellow gold tree with long, elegant branches. The background is madder red. Around the tree float creatures that would be at home in the fantasies of Hieronymus Bosch or Spanish Inquisition woodcuts. At the bottom edge of the carpet, serpent-carrying imps sit astride beasts that appear to be half turtle and half rabbit. Blue dragons with spotted bodies curl through flower-sprouting vines. Above them, freakish human-faced monkeys fire arrows at winged animals with bird heads and bearlike bodies.

At the carpet's center, white doves sing from a nest. But the bird in the middle is a two-headed oddity. Above them, a pair of indigo bears climb upward on the tree. Two peacocks—often interpreted as the symbol of paradise or royalty—look outward near the top of the carpet.

Hossein finally looked up at me. He had a look of delight that I hadn't seen before.

"You say this carpet is in New York?" He smiled. "I can say this: it's definitely worth the trip to see this. It's calling out to you. Am I right? Then, my friend, you really must go. I always try to follow my instincts. That's my advice."

"Well, what do your instincts tell you about this particular carpet?"

"I see the touch of the Sufi," he said. "Yes, most definitely. This carpet is trying to show another world, one of beauty and crazy imagination. Oh, yes, I see a Sufi hand here."

"You want to hear something?" I asked him.

"Always, my friend."

"Remember I told you about Mohammad Reza? He's the carpet dealer in Tehran who started my interest in Hafez and mysticism. Well, he told me I had to try to learn the language and poetry of carpets. I felt I was going along okay. Then I come across this carpet and see that even experts can't decode it. It tells me there isn't really a carpet language to master, just bits and hints."

He clapped his hands.

"Finally you are getting it!" Hossein laughed. "It's life. Life doesn't have a dictionary. Carpets don't either. They are full of little miracles. At least I believe so. Think about it: I wouldn't be in Isfahan now if I didn't take that trip while waiting for my visa. Think of all the things that bring you to any moment, like us sitting here now. There are thousands of events and moments of chance that go into anything. Don't think so hard, my friend. It's just life."

"That's just what one of the nomads told me," I said.

"That's good advice."

"You think I try too hard?"

"That's not it. This nomad is telling you that life cannot be controlled and you can't try to make sense of everything. We need imagination. We need fantasy. The carpet like the one you showed me reminds us of this. They are more important than Picasso to me. I'll tell you why. Picasso had the chance to travel and see the world. These weavers maybe never saw any of the things he did. They just knew goats, mountains, sky, and their village. Then they are able to come up with amazing images. Go see this carpet.'

We drove to his shop in Hossein's Peugeot 206. He had a small Qashqa'i carpet over the backseat. Iranians joke that this model Peugeot is popular because there are only 206 workdays a year after all the religious and revolutionary holidays. Hossein doesn't follow this rule. He works hard.

"Nothing makes me happier than getting a carpet or kilim into the hands of someone who really appreciates and loves it," he told me. Then he winked: "And, of course, separating them from their money is nice, too."

This is essential Hossein. He makes the sale, but somehow he manages to make his customers believe they've gotten more than just a carpet. I wonder how many people—like me—wrote down a Hossein quotation that ended up on postcards or on refrigerator doors. He calls his shop Nomad for a reason. He specializes in nomadic weaves from across Iran. To him, there's an honesty to the pieces that can't be reproduced in village or workshop settings.

"The difference is like a perfectly tended garden and the wild beauty of nature or the desert," he said. "Really, I see it that way. The nomad weavers are doing the weaving for themselves, from their own heart and mind. It may not be technically perfect like from some expert weavers. But that doesn't matter. It's pure and real. You don't judge beauty by how tight the knots are or if the wefts are perfectly straight. Beauty is sincerity. You can tell the difference between the hug of a real friend and someone who doesn't care for you. That's what I'm taking about."

I told him more of my time with the Qashqa'i and how they were making commission carpets for the Miri family in Tehran.

"Yes, yes. I know," he sighed. "The real good pieces are always getting harder to find."

Hossein also takes the nomad idea a step further. It's known around Isfahan that his doors are open to those souls struggling to find some roots. He's hired dozens of impoverished boys with no knowledge of carpets. "I see something in them that they cannot even see," Hossein said.

One of his prize protégés is Hamid, a skinny young man who's learned carpets and enough Japanese to handle the steady stream of package-tour customers basking in the good exchange rate between the yen and the Iranian rial. In this way, Hossein again reached back to Morier's Hajji Baba, who often benefited from the help of strangers and followed their example.

"*Chetouri,* Hamid," said Hossein as we entered the first floor of the shop.

"*Chetouri, agha.*"

"Any customers?" Hossein asked.

"Not yet."

"Good," Hossein said to me. "We have time for tea."

"The kind with the saffron?"

"Always with the saffron." He smiled. "Come."

We walked up the steps. The main showroom is upstairs. There are several hundred pieces, from rough nomad kilims to small silk floral carpets churned out in Qom to the north. "I have no interest in these," Hossein said, tapping on the stack of silks. "But, you know, the Japanese want them. We may say otherwise, but we are all victims of the market."

That's been the case for a long time.

Europeans have been well acquainted with Persian carpets for centuries.

Paintings from before the Renaissance depict carpets as symbols of refinement, beauty, and exotic mystery. At some point along the way, Westerners went from being distant admirers to active buyers. That forced some profound changes. Iranians even have the same saying: money talks.

Western tastes began determining what was coming off the looms. The weaving houses themselves moved west. In about 1608, King Henri IV of France set up carpet weavers in the Louvre. Later, carpet workshops were established at an old soap factory, the Savonnerie, near Paris, and in the central French town of Aubusson to churn out copies of Turkish rugs and other designs. The English, Flemish, and others also got into the business.

As always, competition bred innovation. In the case of carpets, it was who could make them fastest and cheapest. By the mid-1800s,

steam-driven "power looms" had revolutionized the entire carpet industry. Suddenly, any design could be quickly reproduced without teams of weavers. The idea was hatched by a prolific Massachusetts inventor and industrialist named Erastus Brigham Bigelow, who was looking for an automated method to make lace for stage coach seats. It was modified for carpets and other textiles. Bigelow was already rich, and the idea made him richer. He later made an unsuccessful run for Congress and was one of the founders of the Massachusetts Institute of Technology. His likeness is among the nineteenth-century "Men of Progress" at the National Portrait Gallery in Washington, D.C.

About the time Bigelow was making his mark, a firm based in Manchester, England, that took the name Ziegler was developing another idea that would jolt the carpet industry: forget the European knockoffs and hire Persian weavers to make the real thing.

The enterprise, Ziegler and Co., appeared around Sultanabad (now called Arak), in central Iran, in the late 1860s with the idea of exporting Persian carpets back to Britain and beyond. It worked. The made-for-export carpet was born and soon blossomed. Ziegler provided what the customer wanted: conventional aspects of traditional Persian patterns in soft reds and other colors popular for European and American drawing rooms.

By 1883, Ziegler was working with major Western retailers such as B. Altman and Liberty of London. The Ziegler designs were painted onto special graph paper, with each square representing a knot, and sent to Sultanabad for production. The local weavers liked the steady pay, which sometimes came in the form of opium, historians say.

Ziegler wasn't the only carpet cartel for long.

Imitators sprang up. The succession of "world expositions" at the turn of the century helped bring Persian carpets to the masses. Traditional weavers were quickly shifting their work to fill the export demand, despite orders in the late 1880s forbidding Persian weavers from using "European" designs and chemical dyes.

Much has been written about Ziegler's venture, and some of it carries a distinctly disapproving tone similar to today's attacks against Starbucks for allegedly homogenizing a market. But there's little doubt that Ziegler helped popularize the Persian carpet. And—in a bit of market irony—some of the so-called mass produced Zieglers now fetch a considerable price at auction as rare and coveted pieces.

In April 2004 at a Sotheby's auction in London, a late-nineteenth-century Ziegler Mahal carpet (16'8" by 14 feet) sold for $271,060. Just a few weeks earlier in Scotland, the bidding on a bigger Ziegler (13'2" by 23'1") shot up to $239,115. The auction house Lyon & Turnbull had set the pre-bid estimate as low as $5,400. "The [auctioneers] carpet and textile experts . . . must still be pinching themselves to make sure they aren't dreaming," said the commentary in *Hali* magazine.

I wondered if the current flood of export-oriented carpets, such as from the dank workshop I visited in Mazar-i-Sharif or the lavish Miri system, will ever produce such high-priced heirlooms.

"I don't think so," Hossein countered.

"Why?" I asked.

"No soul," he said simply. Then he nudged me before I could reply. "Watch this."

Over in the corner, his top "boy," Hamid, was showing some silk rugs to two young Japanese women covered in very conservative *hejab*. It's not uncommon to see foreigners more faithful to the Islamic strictures than many Iranian women, who have pushed the limits as far as just a baggy sweater and head scarf barely hanging on. And when they couldn't tilt the scarf back any more, in 2004 they started attacking the *hejab* from the other direction: wearing slacks that first exposed the ankle and then began creeping higher.

"They won't buy," Hossein said, gesturing toward the Japanese.

"Why not?"

"I can just tell. I just know. Maybe it's the way people look at the carpets. It's just a feeling."

"How often are you wrong?"

"Almost never."

"But can't you convince someone to buy?"

"Yes, of course," he answered. I had obviously hit a nerve. "But—"

"Let me guess," I interjected. "It doesn't feel right."

"Not bad, *agha.*" He smiled. "You're learning."

"You keep saying I'm learning, but I still don't know what."

"That the best carpet men—the ones who really care about the carpets—are matchmakers. Remember I told you this before? I should repeat it. Listen again closely. This is the most important thing I can tell you. A person comes into the shop looking for love. They may not know it, but they want to fall in love with a carpet. They want to see one and say, 'Oh, yes, that's it. That is for me.' Our job is to figure out how to make that moment happen. You can't force it. That's what the bad merchants do. They look at their job as a challenge. They think, 'How can I get this person to buy something he doesn't want and pay a lot for it?' They like this challenge, but it's not honorable or correct. It's like trying to sell cigarettes to someone who doesn't smoke. Get it?"

"Sure. But doesn't your so-called bad carpet seller make more money?"

"Money, my friend, can't fix a broken soul. Besides, I do all right."

Two Russians walked up the stairs.

"Watch this," Hossein whispered to me.

It was time to watch him go to work.

"Welcome, my friends," Hossein said to them in English. "I remember you."

"You do?" one of them said.

"Of course. You bought an Isfahani carpet, am I not right? It was last year, if I remember correctly. Would you like to see more?"

Within minutes, the two men were standing before an empty patch of floor. Hossein then started to unfold a collection of newly

made carpets with the floral medallions typical of Isfahan weavers. He showed them about ten pieces and then let them study the carpets alone.

Hossein came back to his desk, where I was sitting.

"They will buy," he whispered. "It's just a matter of getting them the right carpet. Watch. They will look over these carpets, which are nice but not so good. Now I'll show them some more expensive pieces and they will really notice the difference."

The Russians presumably had the cash. They were technicians at the Bushehr nuclear plant on Iran's Persian Gulf coast that was built under a pact with Moscow. At the time, the United States and others were pressing Iran to prove its nuclear energy ambitions were not a cover for an arms program. I wanted to talk to the Russians about the project. Hossein gave me a withering look. "No politics in the shop," he said. "That's a rule you must respect."

I did. I sat back as Hossein returned to the Russians.

"Now, my friends, you will see something special," he said with a grin.

The Russians nodded as the finer carpets were laid at their feet.

"So," Hossein said after a while. "Would you like to see some beautiful antique pieces?"

In the end, the Russians bought two Isfahani carpets for about $1,500 each.

"Come," he told them. "Have some tea. It has a touch of saffron."

In the corner, Hamid was putting away the silk rugs. Hossein was right. The Russians were smiling. The Japanese left empty-handed.

I wandered alone into Isfahan's Great Bazaar.

Hossein was busy at the shop. He offered to have Hamid accompany me. But I wanted to try something. Throughout *The Adventures of Hajji Baba,* the barber's son always managed to find some

wise or crafty ally to help him land on his feet. The reason, it can be argued, is that Persia rewards those open to its possibilities. I sought to learn whether any of this magic still remained.

I entered the bazaar through the towering main gate off Imam Square. A flock of black birds, bunched together and moving in unison, swooped low and then shot off in the direction of the grand mosque at the other end of the square. I carried very little money. I was becoming more discriminating in my carpet buys thanks to Hossein, but I still didn't fully trust myself and my impulses. Hossein had already set aside a Senneh kilim for me.

I brought the magazine image of the Heriz carpet in New York. I hoped—in a replay of a Hajji Baba story—I'd come across someone who could tell me more about it.

I didn't have to wait long to attract attention. Three men sharing a hubble-bubble with nice aromatic tobacco beckoned me over. Normally, I would have waved them off and continued on. But I was in my Hajji Baba mode. I walked over.

"You are welcome," one of them said in fine English. "Where are you from, sir?"

For some reason, I sidestepped the question about my nationality. I usually say Irish, which is my second passport courtesy of a grandfather from County Cork. My press card lists me as Irish, which has helped lighten lots of heavy conversations about America.

I held back a bit with these three men. They were peppering me with questions. I started to worry. The third degree was getting more intense. Was I traveling alone? Why didn't I have a camera if I was a tourist? Was I staying in a hotel?

"This isn't your shop?" I asked, gesturing toward a carpet stall a few yards away.

"No," said the English-speaking man. "We are just watching it for the owner. So, I see a notebook in your back pocket. What is that for?"

I made quick good-byes and stood up. It was only then I realized that a group of young men had moved in behind us and were blocking the way. They were not in uniform. But they wore the beards

that often distinguish Iran's most conservative factions: the Revolutionary Guards and the Basiji vigilante units they control. I was alone and—really for the first time in all my travels through Iran—feeling very vulnerable.

"Sit down, please," said the English-speaking man, a bit more forcefully. "We are just curious about your business."

"Look," I said, still standing. "It's very easy to explain. I'm a journalist. I'm also doing some research on carpets. That's it."

I decided it was probably better if I didn't draw Hossein into it.

"You have a press card?" the man asked. He translated for the unsmiling human roadblock behind me.

I pulled it out. A veteran Iranian journalist once gave me the tip that I should always keep an expired press card along with the current one. Few authorities bother to check the date, he said, and it's not a problem if it's confiscated. I handed the man the card from my last trip a few months back.

He looked it over and handed it to one of the presumed Basij. True to form, no one checked the date.

"Ear-laand," one of the younger bearded men said.

"Yes."

"England?"

"No, Ireland. Ear-laand. It's different," I said. The English-speaker translated.

"Passport," the younger bearded man demanded.

"Hotel," I said. "At the hotel."

Actually, it was in my front pocket. Street crime in Iran is not very confrontational, usually car radio thefts or the whole car itself. But one scam is common: men posing as an undercover police officer asking for passports and then fleeing. A Western passport can fetch a good price on the black market.

"I will show you at the hotel," I repeated. "Okay, let's go. To the hotel? Okay?"

I wanted to get moving. Being in public was my best defense. I also wanted to preempt any idea of continuing this grilling in a Basiji compound or some other closed-door venue where, I guessed,

they might not be so polite. I knew normal authorities would simply check out my press card and I'd be on my way. The Basiji—if, in fact, these guys were part of the vigilante corps—are more of a wild card. If they perceived I broke some rule or posed some threat, I could be in for a nasty time before I could reach someone for help.

The men passed around my press card and spoke in normal tones. They assumed, correctly, I knew only a smattering of Farsi. I strained to catch any of the few words I know. I took a few steps back toward the bazaar gate. No one stopped me. I took a few more. Nothing again. I started walking away from the men.

"Mister!" one of them yelled sharply.

I froze. I turned and one of the bearded ones was coming forward.

"Mister, your card," he said, handing me back my press credential. "Sorry. Have a good time in Iran. Good-bye."

And that was it. I never knew who those guys were.

I was suddenly alone again. The Heriz carpet would have to wait. I just wanted to get out. I started to leave—on legs that I just realized were a bit shaky.

"Mister," someone yelled. "Wait."

Now what?

"I saw everything," said a slim man coming toward me. "You all right?"

"Sure," I said. "They were just asking questions. It's over."

"No, mister, it's not," he said. "This is a shame. I am Majid. This is my friend Matin."

I shook Majid's hand. Then something unexpected happened: Matin, a young woman in a canary yellow head scarf, put out her hand. This is just one of the many awkward moments in Iran's constantly revised social codes. Do I shake her hand? Doing so would be in open violation of postrevolutionary orders banning physical contact between unrelated members of the opposite sex. But the rule had become so ignored that it seemed almost quaint.

Lovers walk hand in hand in big cities with little concern. But there are reminders that red lines still exist. In 2003, an Iranian actress was sentenced to seventy-four lashes for kissing a young actor

on the cheek during a public ceremony in Yazd a year earlier. The sentence was suspended, but it was widely interpreted as a warning shot from conservatives. As many observers have noted with irony; it's outlawed for a man and woman to shake hands, but they can cram themselves into the backseat of a shared taxi.

It's all part of Iran's maze of contradictions. The cries of "Death to America" may be loud, but no other Muslim country in the Middle East has such a vast pool of die-hard American admirers.

I didn't take Matin's hand. I thought maybe the interrogation crew was still watching and just needed an excuse for round two. She smiled. She understood.

"Have a tea with us," she said. "We will pay. We are sorry for what happened to you. Is this your first trip to Iran?"

"No," I said. "I've been here many times. But this is the first time I've been questioned on the streets. What's happening?"

"Oh, nothing," she said. "It's just fear. They know they can't survive, and this makes the fear worse."

"*Who* knows this?" I asked, already knowing the answer.

"The hard-liners, the mullahs, the people holding Iran back," Majid jumped in. "We are the future. It can't be avoided."

This young couple—in jeans and fake Adidas sneakers—is part of something that frightens Iran's theocrats like nothing else. The challenges to the regime grow ever bolder and bigger.

The reason is written on census documents: more than half of Iran's population was born after the 1979 revolution and few have inherited its zeal.

I've seen it at rallies. In October 2003, thousands of Iranian women wore white head scarves and men carried white flowers in a sign of hope as they went to greet human rights activist and lawyer Shirin Ebadi after she won the Nobel Peace Prize.

I've also heard it on the streets. "No to religious fascism," protesters chanted during demonstrations at Tehran University.

I've even heard it in the green marble *majlis,* or the parliament.

Just before parliamentary elections in February 2004, more than a hundred lawmakers issued a taboo-shattering document. It was a

letter of dissent, claiming hard-liners had rigged the vote in their favor by the mass disqualification of reformist candidates. What broke new ground was not the complaint. It was who the letter was addressed to: Supreme Leader Khamenei, whose followers consider him above reproach and answerable only to God.

"The popular [1979] revolution brought freedom and independence for the country in the name of Islam," the missive went. "But now you lead a system in which legitimate freedoms and the rights of the people are being trampled in the name of Islam."

Bull's-eye. This is perhaps the most essential element for understanding Iranian politics. The revolution sought to topple the shah. But most revolutionaries had no intention of replacing the monarchy with an all-powerful Islamic rule.

In early 2004, I saw a bootleg video of the film *The Lizard* before it began breaking box-office records in Iran. The story is about a fugitive inmate who disguises himself as a mullah and manages to bluff his way along. The most popular scene is when the thief-in-robes declares that not all clerics deserve respect. My host rewound the video and played the scene five times in a row. Iran's leaders quickly had enough of the satire. They pressured the film's producers to pull it from theaters.

There was a film in 2001, *Swan Song,* that had a scene showing morality police harassing two young lovers. The boyfriend finally snaps and attacks the officer.

"You don't understand us!" the actor cries. "We are the new generation!"

The audience in the theater applauded and whistled. Some gave the scene a standing ovation. Then the movie hall began to empty. Many people had come just to see this scene again.

I asked Majid if he had seen the film.

"Oh, yes," he said. "I think six times."

We parted and I walked alone to my hotel. I saw Hossein that evening but never told him about the incident in the bazaar. I was afraid he might go looking for the men. Why invite trouble if these guys were real Basiji?

I stopped by Saadi Street before leaving Isfahan the next morn-

ing. I taped a note of thanks to the door of Hossein's shop. Just then, the skies opened. The street sweepers in the huge square stopped work and ran for cover from the downpour. It came down in fat raindrops as in Saadi's poem about the pearl.

In the desert on the way back toward Tehran, the rainstorm had ended. Wildflowers were opening their petals.

The carpet from Herat, cleaned and repaired, found a place under a bookcase in my home.

The titles on the shelves above it include a series of classic stories I received as a gift from my wife. Among them is the collection of tales that contain Aladdin's adventures.

It's one of the indelible images of Western fantasy: Aladdin on a flying carpet swooping over the city domes.

Trouble is, the flying carpet legend is full of holes. The biggest one concerns Aladdin. He never piloted one.

The story is found in *The Arabian Nights Entertainments,* a collection of ancient Indian, Persian, Chinese, and central Asian tales probably crafted along the Silk Road. In *Arabian Nights,* the story-teller is the clever and enchanting Scheherezade. It was her turn to wed the Emperor Shahryar, who had become so disgusted with the treachery of his first wife and sister-in-law that he vowed to marry a new wife every day and have her executed the following morning.

Scheherezade conceived an ingenious plan. She told him a tale—often bawdy and filled with interesting low-life characters. The ending was always a cliff-hanger. The king begged to hear what happened next and let her live another day to find out. So it went for 1,001 nights. The king spared her life.

But there's no flying carpet in the story of Aladdin, the lazy son of a tailor from Muslim China—probably now what's called central Asia—who was tricked into fetching the magic lamp but managed to keep it and use it shrewdly to his advantage. The only carpet in the tale is one Aladdin ordered conjured to cover the path of the princess he loves.

The closest any of the traditional stories comes to a flying carpet is one about Prince Ahmed and the fairy Pari Banou that includes a fabric described as a kind of magic portal. "Whoever sits on this tapestry may be transported in an instant wherever he desires to be," promises a roaming salesman in the story set in southern India.

In another of the tales, "The City of Brass," King Solomon is carried aloft by the wind on an alabaster throne adorned with red gold

and precious stones. On his right are the kings of man. To his left is the lord of the jinn, the cunning magical creatures that legend says were created from the fire at the dawn of time.

In the Quran, Solomon can control the winds. Some Islamic folk stories speak of a silk carpet or fabric he could command to fly.

Some scholars maintain that the true origin of the flying carpet myth still awaits discovery.

You want to drink champagne but pay for Coca-Cola.
—Ali during bargaining for a carpet

CHAPTER ELEVEN

JESUS PRICE

Memo to myself: Don't make important plans with an opium addict.

Seems obvious enough. But I didn't really add it to my blacklist until after my cell phone rang one evening while I was stuck in one of Tehran's monstrous traffic jams. It was Ali. He was speaking in something between a whisper and a wheeze.

"Mr. Brian? This is Ali. I don't feel good, Mr. Brian. I think maybe I can't go."

"What? You're kidding!" I snapped. "What's wrong?"

"I don't feel so good, Mr. Brian."

"What's wrong?"

"I am just not well. Please, Mr. Brian, don't be mad."

"Well, what do you expect? You know we're all set for tomorrow morning. The car is ready. Now you say you can't go! This is a big problem, Ali. A *big* problem."

"So sorry," he whimpered.

"Well, that doesn't help. What am I going to do now?"

The taxi crawled forward. We were now in front of an electronics store showing *Finding Nemo* on a big screen. The connection with Ali faded. I shifted to the other side of the backseat.

"Ali, you still there? Ali? Ali?"

"Yes, Mr. Brian. I hear you. It's my health. It's not good."

"I guess I have to live with that, *don't I?* I really don't have much of a choice, *do I?*" I said, trying to rub it in. "I guess there's no trip if you can't go, *is there?*"

"No, no, Mr. Brian. That's what I am trying to say. I have arranged everything. You remember Yazdan from my shop?"

Barely, I thought.

"Well," Ali continued, "he will go with you. That is okay, yes?"

I wanted to scream at him some more. But I softened a bit after hearing he had arranged a stand-in carpet hunter. Also, the Tehran smog had given me a raging sinus headache that sapped my energy to argue. There were no views of distant Damavand mountain these days. Even the Elburz slopes just north of Tehran looked as if they were airbrushed with a layer of brown. The thought of escaping to Iran's glorious countryside—and gulping down some clean air—had made the eye-watering pain easier to bear.

Ali had promised a short stab into the mountains southwest of Tehran to look for carpets and kilims for his shop in the bazaar. I didn't want to call it off. I had long wanted to tag along on a carpet safari like this and wasn't sure when I'd get another chance.

"Fine," I huffed. "Fine. You know I'm very disappointed about this, though."

"Oh, Mr. Brian, please. Don't be mad. My health. My heart. What can I do?"

I knew Ali was hooked on opium, the Persian drug of choice for centuries but declared illegal in the 1950s. I'd guessed he walked on the wild side with other mood adjusters, too. But in the past, Ali (whose name I have changed here because of his outlaw habits) had always managed to keep it together and make our appointments at his shop, often late, yet that's better than a no-show. If I wasn't so furious this time, I'd be worried. He really didn't sound well.

"Mr. Brian, you still there?"

"Yes," I sighed.

"Yazdan is good. He knows everything. If you want to buy something, he will help. He will make sure you don't pay too much. Sometimes with foreigners, these guys will try to get a Jesus price."

I had to smile. This was my absolute favorite ditty from all the nonsense and proverbs and blather I've heard from carpet sellers. Ali says it often. But he doesn't remember how he came up with "Jesus price"—his term for a sky-high payment for a carpet. With a name like Ali, he definitely was never an altar boy. "It just hit me," he once told me. Maybe the opium helped.

"Sure," I agreed. "No Jesus prices. I'll check with Yazdan. I hope you feel better, Ali. I'll call you when we get back."

I heard something like a hum from him and the line went dead.

The taxi was now moving at about walking pace up a highway near a giant mosque complex that's been under construction for years. Tehran may be the capital of the Islamic Republic, but it has a mostly secular feel compared with the shrines of Mashhad and Qom or the forests of slender minarets in Istanbul or Cairo. Men stood on the highway shoulder waving shepherd sticks. It's the signal that they keep a few sheep or goats penned up in a vacant lot or alley. This black market trade is more than a way to bypass the higher costs with a butcher. It's a commentary on how fast Tehran has swelled with opportunity seekers from the provinces, whose rural ways still cling to life amid one of the world's most smothering cityscapes.

The next morning, I rolled out of Tehran with Yazdan and a surprise guest: a seventy-two-year-old carpet seller in a tweed cap. They call him Hajji since his pilgrimage to Mecca a few years back. He's from Hamadan, a very ancient city southwest of Tehran. We headed in that direction.

Ali had promised me this trip for a long time.

He spoke of his carpet hunting with an almost hushed reverence. His voice would drop and he'd sweep his hand—usually with a

smoldering Marlboro—to show the possibilities beyond the Tehran city limits. His quarry was very specific: the older, one-of-a-kind carpet or kilim sitting in someone's home or forgotten at the bottom of the stacks in some far-flung bazaar. He called these finds "a heart piece"—another great phrase from his wonderfully fluid English vocabulary.

"You know, Mr. Brian, it's getting harder and harder to get these unique pieces," he told me once. "Some people have just given up. They just order by phone, saying 'We need thirty Tabrizi.' It's like the tire business or something for them."

His collection shows his taste. Many of his pieces are stunning and highly unusual, some of the best I've seen in the bazaar. There are old nomad carpets from the Qashqa'i and Lurs. Pastel florals from Kashan with a fine, mellow patina. Antique Senneh kilims. Giant Bakhtiari carpets from the 1930s with their classic panel designs. And more.

He hooked me. Ali became my merchant of choice in the bazaar. My old friend Mohammad Reza didn't seem to mind me spending time in another shop. He was coming less and less to the bazaar anyway. His health was slipping, but he told me it was nothing serious. He promised me he had many years left.

A good *bazaari* can make anything seem believable. And Ali can bullshit with the best of them. But he balances it with an honest respect for the artistry of the loom. He soon had me looking at pieces through new eyes. Carpets in hotel shops and boulevard windows that once intrigued me now seemed hackneyed and uninspired. The real action was finding that heart piece. If I was serious about building a modest—but worthwhile—collection, I need to be more patient and selective, he told me. He is, of course, right. Hossein had the same advice at his carpet shop in Isfahan. Slowly, they and others gave me some backbone. I was no longer easy prey for carpet sellers as I was in my neophyte days back in Afghanistan.

Ali's character building didn't come for free, though. He never missed a chance to try to sell me something. But now, at least, I believe there's more intelligence to my purchases from Ali over the years.

First, I selected a large, madder red kilim decorated with starburst motifs made by the Shahsavan, a tribe in northwestern Iran known as "those who love the shah" for their help in defending Persia's borders over the centuries. Next it was a deep pile runner, also in madder red, from Iranian Kurdistan. Then I bought a fabulous fifty-year-old Caucasian soumak, a type of flatweave. This one is populated by hundreds of animal figures, each unique, on a background of chalky rose. I tried hard to knock the price down to a few hundred dollars. He appreciated the effort, but laughed: "You want to drink champagne but pay for Coca-Cola." The price stayed firm.

"When I get out of the city, my mind just goes," Ali told me when we were planning the carpet-hunting trip. "It's like an adventure. I am always thinking, 'Maybe, Ali, this is the time you find that real heart piece. The one you've been seeking all your life. The one that you could never sell because without it you couldn't live.' I wonder if there is a carpet out there like that. I think, yes, there is such a piece. I just haven't found it yet. I will. But even if not, the search is wonderful."

Ali will have to depend on the stocky and quiet Yazdan this time. Hajji was a competitor and had his own agenda. Several hours' drive out of Tehran, we dipped into a valley alongside a riverbed with only a small trickle winding through boulders and sun-bleached logs. Some hawks circled above in a cornflower blue sky.

We were entering a land that's been the backdrop for some of the most extraordinary searches in history. I doubted whether any of my travel companions knew the stories I'd been reading. But Ali and his "Jesus price" were a funny coincidence, for these mountains and flat-bottomed valleys figure in some of Christianity's most curious quests.

Many of those quests center on a once magnificent complex known as the Throne of Solomon.

It's off in the range of mountains lined with smugglers' paths that rises just west of Hamadan and tumbles over Iran's borders into Iraq and Turkey. At some point, back in the uncharted past,

the cornerstone was laid near an alpine lake fed by a deep spring. By the sixth century, heading into the glory days of Persia's Sassanid dynasty, the area had evolved into a place of high religious importance. A sprawling Zoroastrian fire temple covered the site. Excavations suggest a sanctuary of resonant beauty, an interplay of fire and water and graceful arches that became hallmarks of Islamic architecture in later centuries. In 2003, UNESCO added the Throne of Solomon to the World Heritage list.

The more than three centuries of Sassanid rule spanned an amazing period of religious and political changes on Persia's doorstep.

In the early fourth century, the Roman emperor Constantine allowed Christianity to emerge from the shadows, and he lavished attention on the city on the Bosporus that would bear his name, Constantinople. Rome's power began to wane. Byzantium's star was on the rise. In Arabia in about 612, Mohammad began preaching the revelations that came to him in a cave near Mecca. A few decades later, Islamic armies would set off on campaigns of conquest.

By the early 600s, just a few decades before Islam broke out of its birthplace, the Sassanid generals were growing edgy. Byzantine forces were pecking at the fringes of Persian territory. Meanwhile, a power vacuum was growing in Middle Eastern parts of the old Roman Empire. The Persians struck decisively, and Damascus fell easily. In 614, the Sassanid army, urged forward by an expansionist king named Khosrow II, captured Jerusalem, perhaps aided by throngs of Jewish vigilantes eager for payback against the Christians. Among the booty hauled back to Persia was a relic of staggering consequence: the timbers revered as the True Cross of Christ's crucifixion.

It remained in the Sassanid vaults for more than a dozen years, apparently first kept in the imperial city of Ctesiphon near present-day Baghdad. But soldiers and zealots from Byzantium didn't give up. They made steady advances against the Persians following surprise victories in Armenia. The Christian forces were driven, in part, by an enormous sense of self-appointed responsibility: the belief that Christendom was depending on them to re-

gain the Cross. Sassanid lines gave way. Their forces retreated back toward the fire temple and its hilltop defenses, perhaps bringing the True Cross from Ctesiphon as a bargaining chip as their losses mounted, although the movement of the relic is not clearly documented.

In the space of a few chaotic months in 628, Khosrow II was dethroned and executed by his son, who took the title Kavadh II and reached a peace deal with the Byzantine commander.

The True Cross was returned to Christian hands. The Sassanid's Zoroastrian kingdom survived this one, but not for long. Arab forces bringing Islam would have control of Persia less than twenty-five years later. Islam would wash over Jerusalem in the twelfth century. The True Cross was captured again and, this time, would disappear without a credible trace.

Scholars have raised some compelling questions about the historical ripples of the True Cross battles. Among them: did Mohammad and his followers pay attention to the events and could they have helped shape Islamic ideas about martyrdom and religious warriors? The same could apply to Christians. In some ways, the campaign to reclaim the True Cross could be seen as an early taste of the Crusades and the romantic legends they produced.

None of them burned brighter than the Holy Grail. It's one of the most enigmatic creations of the Middle Ages; a thing of such supreme power and importance that only the bravest and most chivalrous should attempt the search. For what, though? There is no shortage of theories about the Grail, possibly from the Old French word *graal,* meaning "dish" or "salver," but many other derivations are suggested. It's most commonly described as the vessel used by Christ at the Last Supper and later used to collect his sweat and blood during his final hours. Others describe it as something akin to the Holy Spirit and able to bestow wisdom and revelation. Perhaps, as some suggest, it is not an object at all, but unshakable faith in sanctity and its power. The Grail, in other words, could be all things to all seekers.

The purported location of the Grail was equally vague, ranging from Britain to points far south and east. Some stories bring the

Grail all the way to the mountaintop Throne of Solomon, or Takht-e Suleiman, which was given the name of the Old Testament king after the Islamic conquest. In the Quran, the wise Solomon holds power over nature, animals, and even the magical jinn. The Takht's remote and almost mystical location—and ties to the Sassanid plunder of Jerusalem—offered tantalizing hints to some medieval minds that it could be home to the Grail castle and its lord, who was known as the Fisher King, among other names. Could the Grail, the seekers wondered, have been taken by the Sassanid raiders and stashed away in the recesses of the fire temple as the Byzantine forces closed in?

It's not known how many medieval Grail hunters ever ventured to these mountains where I was seeking carpets. If they did come, however, it's likely the Grail wouldn't have been their only quest.

One more—and powerful—legend links this corner of Persia with romantic Christian visions; those of a perfect Christian kingdom of the East ruled by a sage monarch many called Prester John. Some stories describe him as a descendant of the priestly Persian caste called the Magi, who, their followers believed, would one day lead an army to drive Muslims from the Holy Land. Belief in Prester John was so fervent in the late twelfth century, just after Jerusalem fell to the resilient Kurdish fighter Saladin in 1187, that papal envoys were instructed to try to make contact. Prester John was sought in India and even Africa. The vigil was also kept in western Persia, where tradition says three Magi—the Wise Men in the story of Christ's birth—began their journey to Bethlehem bearing gold, frankincense, and myrrh.

In *The Travels of Sir John Mandeville*, a fantasy-laden travelogue written in about 1366 by an unknown author, some lines send seekers in my general direction. It says Prester John's main palace is in the city of Susa, the ancient realm of Elam where the first Persian kings built a vast palace and ziggurat more than twenty-five hundred years ago. It's on the western piedmont of the Zagros Mountains looking toward the Tigris delta. We would not travel that far south.

Hajji asked the driver to slow down.

He had a plan.

We would first head to a scattering of villages on a rocky plain near Hamadan. Hajji had been here years ago and picked up some fine pieces that he sold for three times the price in Tehran and even more abroad. Sometimes he'd find a real steal. More than a few times, he'd arrange a straight swap: a family's old handwoven gem for a brand-new machine-made carpet. The villagers, he said, would be quick to make the deal, feeling they had completely out-witted him and fearing he'd change his mind. If they were on the compassionate side, they might even have wondered if the old Tehran *bazaari* was growing a bit senile to trade new for old.

"Those were the days," said Hajji, who has a jarring combination of silver hair and jet-black eyebrows. "It was a lot easier then. Now we have all these bloody middlemen."

They've changed the carpet hunt in Iran to a great degree. A spike in carpet prices in the 1980s got many more Iranian locals into the act. They made pacts with nomads and village weavers for their pieces—both old and new—and started bringing shipments directly to Tehran or the lesser carpet bazaars around the country. The dedicated carpet hounds like Hajji and Ali must now seek the weavers who are still outside the middlemen's networks or somehow intercept the pieces before they reach the bazaars, where the prices will definitely be higher.

The whole process is more haphazard than I expected.

We pulled into a mechanic's shop in a small village. A guy looked up from under the hood of a Paykan.

"*Agha, salaam,*" said Hajji. "We're looking for some carpets. Any weavers around? Anyone collecting around here?"

The mechanic rubbed his grease-streaked cheek.

"I think there's a guy from Qom who's around," he said. "I heard he was buying up some carpets to take to Tehran."

"Good," said Hajji. "Where can we find him?"

"Go down the road a few kilometers and ask," he suggested. "I think he has a little storeroom down that way."

We did, but found nothing. We bounced from teahouse to candy seller and back to an auto garage. Some people had heard of the elusive Qom carpet hunter. Others hadn't but offered other leads on weavers and carpet liaisons. The hours passed. We were no closer to a good carpet than when we'd started. I imagined desperate Grail hunters resorting to the same imprecise methods, asking locals and heading any way their fingers pointed.

"So now what?" I grumbled.

"Patience," said Hajji, smiling. "It's like fishing. It takes patience."

A few more stops and finally a nibble: we got an address of a carpet middleman in a village called Asleh. We roared down a road between wheat fields. Chickens scattered as we arrived. Take away the metal doors and Asleh would no doubt look unchanged from the days of the search for the phantom Prester John. Everything was daubed with mud and straw. Hajji rapped on a door. A tiny, birdlike man answered.

"We'd like to see your carpets, please," Hajji said. "Maybe we can make a deal."

"My carpets?" the man said quickly. "Who said I have carpets?"

"We heard it around."

"Well, then they were lying. I haven't had carpets in weeks. I had two nice pieces back then. But I sold them to a shop in the Hamadan bazaar."

"Are you sure you're not holding out?" Hajji questioned. "We are willing to pay right now for the right piece."

"I tell you, *agha,* I have nothing to show you. I wish I did."

Hajji and Yazdan left their business cards.

"If you ever find anything interesting, let us know," Hajji said.

We were off again. The birdman suggested we try the carpet bazaar in a bigger town, Faliman. We found it tucked away down in a courtyard shaded by a huge willow. But Hajji and Yazdan were not impressed with the shops. They just peeked in and left after a minute or two.

"Why don't you look some more?" I asked. "Couldn't there be a great find tucked away in the back?"

"It's a waste of time," explained Yazdan. "I can usually tell right away if it's worth looking. It's true that you can find gold in the ruins, but not here. You know how I can tell? The carpets on the walls. Almost always the shops put their best pieces on display like that. What they had hanging here is junk. So the chances of finding a good piece hidden away is almost nothing. You have to pick the right shop to look."

"So where to now?" I asked.

"I guess we're off to Hamadan."

Hamadan's carpet bazaar is not a single collection of shops and re-pair nooks as in Tehran. Instead, it's scattered in hallways and court-yards throughout the city, which was called Ecbatana more than twenty-seven hundred years ago and served as the capital of a Zoroastrian people known as the Medes, whose tribes included the Magi. In recent centuries, Hamadan has served as an important clearinghouse of carpets and flatweaves from parts of western Iran, including highly respected weaving centers such as Malayer, Arak, and Bijar.

"Now we will see something," said Hajji.

We passed through Hamadan's star-shaped main square. It's a lovely sweep of nineteenth-century brick and wood buildings topped by green copper roofs that let the heavy winter snow slide off. Hajji remembers coming here as a boy and listening to radio broadcasts of news from the World War II fronts.

We followed him down an alley awash in a dull yellow from low-watt bulbs. Soon I was sitting on a stack of carpets. I settled in to watch Yazdan go to work. The merchant flicked over carpet after carpet. Bits of loose tobacco—used as a moth repellant—spilled onto the floor from between the carpets. Yazdan needed only a sec-ond to make his assessment. He kept his beefy arms folded. Dust clouds rose off the carpets. Everyone was sniffling.

"Stop," Yazdan asked. He bent down to look more closely at the piece. It was a six-by-four-foot Arak floral, dominated by pastel reds.

"How much?"

The merchant offered up a rial price equal to about $700.

"You're joking," Yazdan said. "That's a Tehran price."

"Right, right." The merchant smiled. "We'll talk later. I'll put this aside. You want to keep looking?"

"Go."

Nothing more caught his eye.

"Thanks," said Yazdan. "I'll think about it."

"What about the Arak piece?" the merchant begged. "You want me to hold it?"

"I said I'll think about it," Yazdan said coolly. "By the way, I'm just curious. How much for those four carpets on the wall?"

They were seventy-year-old companion carpets from Kashan, a town on the edge of the Dasht-e-Kavir that was once a center for the great court carpets of the Safavid dynasty. The merchant floated a price of 180 million rials: about $22,500.

Yazdan rolled his eyes and left.

"So did you see anything interesting? " I asked as we walked away.

"Absolutely nothing," he said. "You can see this type of stuff any-where. You must understand that Ali and I are looking for some-thing that stands out. I'll know it when I see it."

It happens. Yazdan told me about bumping into a peddler in Arak a few years ago who was carrying an old Malayer with a lion and sun motif, long a symbol of royal power in the Persian world and into central Asia. Yazdan bought it on the spot for about $700. It was sold in Tehran for $2,500. Most other times, the acquisi-tion is less impulsive, he explained. A merchant will allow Yazdan to take the carpet back to Tehran for study. If he wants to keep it, the money is wired to the merchant's account.

The shops were closing for the evening. Yazdan tried one last place. Immediately, he knew it was a mistake. The best that the merchant could offer was something from his own weaving factory:

a modified copy of the tree-and-floral patterns on a 150-year-old carpet at Tehran's Carpet Museum.

"My father used to have five hundred weavers," said the merchant after sending his Afghan helper out to bring us tea. "I have fifteen girls. This is the real story, isn't it? The whole Persian carpet business is in decline. We stay in this business out of love. That's it. There's no other motivation."

He unrolled a twenty-foot scroll of graph paper with hand-colored florets and *boteh,* the paisley shape. This was the latest carpet under way in his small factory. The merchant went over to chat quietly with Hajji once he found out he was a fellow Hamadani.

"See this? This is what's killing us," Yazdan whispered to me. "We keep doing the same old things: copies of copies. What do you think India and Pakistan and China are doing? The same thing, only theirs are cheaper and sometimes even better quality. The only way for the Persian carpet to survive is through unique pieces. We should encourage the nomads and village weavers to just go with their imaginations like the old times. This is the thing that Iran can do and other countries really can't. I really believe this."

"But you haven't seen anything here like that so far," I said.

"I know," Yazdan said, popping a sugar cube between his teeth and taking a loud sip of tea. "It's a bit depressing."

The next morning, Hajji asked for a side trip before heading back to the bazaar.

"Where?" I questioned.

"The tomb of Bu-Ali Sina, of course."

"Who?"

"You call him, I think, Avicenna."

"You're kidding? He's buried here?"

"You seem surprised."

"I am. I always imagined him somehow part of Isfahan or just sort of wandering around Persia."

"Well, then." Hajji smiled. "You know only part of the story."

In fact, I didn't even know his real name: Abn Ali al-Hosain Ibn Abdullah Ibn Sina. Latin translators of his many works shortened it to Avicenna, a physician and philosopher of remarkable breadth. His *Canon of Medicine* remained a principal medical text for centuries in parts of Europe and Asia.

Avicenna's life straddled the end of the first Western millennium. Europe was dominated by the intrigues of the Holy Roman Empire. But these were decades of considerable artistic and academic achievement in the Persian world. Ferdowsi was finishing his *Shah-nama* epic. Al-Ghazali's *Alchemy of Happiness* and other works were published. Avicenna, too, was deeply influenced by Aristotle and other Greek philosophers. But his main preoccupation appeared to be healing the body.

Hajji and Yazdan stood silently before his grave, a massive slab of white marble and yellow alabaster surrounded by twelve pillars of rough granite. Display cases hold archaic medical instruments such as vessels for bloodletting. The walls are decorated with samples of medicinal plants he explored: crowfoot for headaches, wild thyme as an antiseptic, St. John's wort for bladder troubles, wormwood for fevers, and dozens more.

The place had none of the inherent romance of Hafez's burial site. It was more of a shrine to a fully realized Renaissance man who lived many centuries before da Vinci.

"Did you say a prayer?" I asked Hajji as he left the grave site.

"Heavens, no!" He growled. "I save that for Allah. I just ask Bu-Ali for wisdom."

"And maybe some luck in the bazaar today?" I offered.

"Don't make jokes about Bu-Ali. It's not becoming."

I shut up.

About an hour later, we entered a very old and very lovely carpet bazaar at the end of a maze of alleys. Finally, this is why I had come. I never could have found this place on my own. And even if I'd managed to stumble across it, the merchants would have been con-

fused as to how to deal with me. This is a place much deeper into the carpet universe than the commercial bazaars accessible to outsiders. Here, merchants barter and sell with other merchants. It was a glimpse behind the scenes, like finally seeing the busy kitchen of a favorite restaurant.

Business was slow when we arrived. Sellers sat around the steamed windows of a tea kiosk no bigger than a phone booth and gossiped and read the morning papers. Empty birdcages hung from the limbs of a grapevine left to meander where it pleased. A few of the men recognized Hajji and gave their salaams.

Yazdan nudged me. "Look at that," he said.

An unusual carpet hung on the back wall of a little shop. The piece showed a sun rising over a mountain peak, maybe Damavand or Hamadan province's smaller but still majestic 11,716-foot Mount Alwand. At the bottom was a lion flanked by two trees in the well-known weeping willow style. The top edge was kilim.

The door was open, but the shop was empty.

Yazdan marched in and examined the carpet. It had coarse knots of scratchy wool.

Parts of the blue center panel were almost worn down to the foundation warps and wefts. But Yazdan couldn't take his eyes off this piece.

"Now, this is what I'm looking for," he told me. "I know this is one of a kind. I've never seem anything like it." He pulled out his mobile phone and hit speed dial for Ali.

"I found something interesting . . . No, here in Hamadan . . . don't know . . . Maybe . . . I'll let you know . . . 'Bye."

"What did he say?" I asked.

"I should check it out," said Yazdan.

"He say anything about not paying a Jesus price?"

"He didn't have to. I know not to pay it."

"How's his health?"

"He didn't sound much better. I worry about him sometimes. He should slow down and stop smoking . . . cigarettes and other things. But don't tell him that! He'll get mad at me."

"Now what? We find the owner of the shop?"

"Not so fast, my friend," said Yazdan. "We'll come back. Let me think about this carpet. You have to learn patience. That is the thing that will keep you from paying a Jesus price, like Ali says."

"Where is this carpet from?"

"I call this one something like a lost carpet," said Yazdan. "That means it's a special design from the imagination that could be hard to pin down."

The willow design told him it could be from the nearby areas of Bijar or Zanjan. But the coarse weave suggested a *gabbeh,* a tribal style most common in southern and western parts of Iran.

"Then again, *gabbeh* carpets are mostly chemical dyes," Yazdan added. "This one looks like it has a lot of natural dye, maybe all natural. It needs a lot more study."

He walked away from the shop.

"You're not going to ask about it? " I wondered.

"Sure, but not now. I know another place I want to look," he said.

We went into a chamber in the corner of the courtyard. It had a dented *101 Dalmatians* wastebasket. Yazdan had been here before and picked up some interesting tribal pieces. The owners—two brothers—immediately got to work. Carpets were being flipped over one after the other.

"Wait," he said. "This one."

One brother pulled out an older Qashqa'i piece with holes and frayed edges.

"And?" Yazdan asked.

The price was about $300.

This, of course, was just a starting point. Yazdan would get down to real bargaining if he were serious.

"Let me sleep on it," he said.

"As you wish," the brothers said.

Remarkably, it was all so cordial. There was none of the pressure and cajoling of the normal bazaar. These were pros dealing with pros. The rules were clearly different.

We wandered back toward the lion-and-sun carpet. Along the way, Yazdan discreetly asked about the price with other mer-

chants. Turns out, the shopkeeper had tossed out a price of about $350 a few weeks back when another carpet hunter came poking around.

Yazdan entered the shop. He waited for the merchant to make the first move. As expected, he went for $350. Yazdan said nothing. He simply made a move to leave.

"No, no. I think we can do better," the merchant blurted.

Words and gestures flowed back and forth between them for about twenty minutes. In the end, Yazdan walked away with the carpet in a blue plastic bag. The merchant held a check worth about $120.

"I can live with that." Yazdan winked. "I think I won that one."

Another merchant stuck his head out from a doorway. "Hey, *agha,* you like rare pieces, right? Want to see another?"

He dug into a hidden stack and pulled out a mat-size carpet. It had the image of the last shah. The merchant held it up for just a few seconds. Then he stashed it away again before anyone else could see.

On the drive back to Tehran, we stopped for tea at a traditional Persian *chaykhane.* We removed our shoes and sat on raised wooden platforms covered with cheap and badly stained carpets. The tea came with slices of tiny lemons full of seeds.

I asked for a water pipe, a favorite diversion since the magical hours at Hafez's tomb.

"It's no longer permitted," the waiter said with a string of apologies.

The reason was vague. All he knew was that the police had come a week earlier and told them to pack up the water pipes. Some rumors said it was to end the trend of women smoking. Others thought it was part of a broader antismoking drive. Regardless, another red line had shifted. This one hit home.

I glumly watched workers in the trees. They were stringing

wands of neon lights for the upcoming festival to mark the birth of the Mahdi, the twelfth and so-called hidden imam of the Shiites. The Twelver doctrine says the Mahdi "vanished" from the world of mortal perception as a young boy in about 874 in Samarra, Iraq. Shiites believe he remains spiritually connected to the world and able to intervene in its affairs, but cannot be seen. Only at the end of time will he return to restore perfect justice.

It was the Savafid dynasty that brought Persia the Twelver dogma, which back in the sixteenth century was an esoteric and mystical cult with Sufi roots. Sunnis also have the idea of Mahdi, meaning "divinely guided one;" but rarely does the interpretation go as far as a messianic figure.

In many ways, the story of the Mahdi has rarely been more important. It shows an indelible bond between Christianity and Shiite Islam at a time when misunderstandings and hatreds threaten to crowd out reason. There's more than just a shared Judgment Day belief. Shiite tradition says the Mahdi will lead a procession of other prophets. Jesus will be among them.

"I bet you didn't know that," said Hajji.

I didn't.

Back in the car, the driver turned on the radio for a traffic report. It said the smog levels in Tehran were rising to unhealthy levels. In a half hour, we'd be back. I popped a precautionary aspirin for the headache I knew would come.

I tried calling Ali. His cell phone was turned off and there was no answer at home. I'd try to find him later down in the bazaar after I paid a visit to Mohammad Reza.

I hadn't seen Mohammad Reza since before my trip to the Hafez garden in Shiraz. I had lots to tell him.

Carpets are embedded in Iranian memories. When we are little, we crawl on them with our noses pressing up against the wool. We take our first steps on them. We raise our family on them. When we are old, we rest on them. We may die on a lovely carpet. I think that would be a nice way to go.

— Laila Dadgar, director of the Tehran Carpet Museum

CHAPTER TWELVE

PICASSO'S BIRDS

 I stood in front of the little space where Mohammad Reza had first read me Hafez years before. Or at least I thought it was the spot.

It was packed high with overflow carpets from repair shops clustered in this corner of Tehran's bazaar. I began to wonder if I'd gone astray after turning off the broad passageway that slopes down from the Cobblers' Gate. Could I have drifted off on a wrong staircase or alley? I tried to find a familiar landmark amid the jumble of signs, carpets, and jury-rigged power cables. Yes, this was the place. I was sure of it now. But where was my old friend?

I looked around for help. I came without a translator, expecting to find Mohammad Reza with little trouble. I caught the eye of a carpet repairer, an older man with a felt skullcap. He looked up, squinting and blinking, from his intricate needle-and-thread work. "Excuse me," I said slowly in English to see if he understood. "I am looking for a man. His name is Mohammad Reza. He had a shop here."

The man shrugged. He hadn't grasped a word.

"*Agha,*" a younger man cut in. "I heard you. You wanted Mr. Mohammad Reza, right? You asked about his shop. You know, he did not have a shop here."

"What? But I've been here before. I'm certain this is the place."

"I am sorry for my poor English," the man said. "I am saying this man, *Seyed* Mohammad Reza, didn't have his own shop. He was working here. He was helping with carpet repairs. He knew carpets very well. He was a very nice man. A good Muslim."

" 'Was'?" I said. "He's not here anymore?"

"No, *agha,* he is gone."

"Gone?"

"I mean, he is no more. *Agha,* I am sorry to say he is dead."

I sat down on a pile of carpet fragments. The news stung. Grief isn't always measured in how long you've known a person. It's how that time was spent and the mark that was left.

It's true that Mohammad Reza had told me on my few previous visits that his health was slipping. But the news was always mentioned as an afterthought, just some passing nuisance that was not too serious.

The rest of the story was summed up quickly by the young man. Mohammad Reza had stopped coming to the bazaar a few months back. No one recalls exactly what kind of problem he had. I seemed to remember something about his heart, but I wasn't sure anymore either. He had sublet the space in the bazaar.

"I knew some of this," I told the man. "I first met him when he was inspecting a carpet under repair. But I always thought it was his shop. I never thought to ask."

Mohammad Reza, I learned, occupied one of the many middleman roles in the bazaar.

He would take worn carpets from merchants and have them repaired at his own expense. When they sold, he would get his cut. After he became sick, his little nook was taken over by the surrounding merchants and repair shops as a storage area.

"I am sorry, *agha,*" the young man said. "Did you know him well?"

"No. I mean yes," I stumbled. "I mean we met years ago. We talked about carpets and Hafez. He read me some Hafez. It's a long story. I visited a few more times after that. He told me his health was bad, but I never really believed it was serious, for some reason. You know, I don't even know his last name. He might have told me, but I've forgotten."

"I believe we called him *Sayed* Tabasi."

"Tabasi," I repeated. I couldn't recall ever hearing this name. It was an awkward moment. After all the interviews and research I did with other people in my carpet travels, I barely knew anything about the person who helped me set off.

"Yes, we think this was his home," the man said. "Tabas. It's far away in the desert. Do you know it?"

That would make sense. Tabas, I learned, is an outpost near the center of the Dasht-e-Kavir. I remembered how Mohammad Reza talked to me about the desert and its colors.

Last names in Iran are a living map of migrations and regional roots. After taking power in a 1921 coup, Reza Khan, who would later become Reza Shah, the first king of the doomed Pahlavi reign, began requiring surnames as part of an effort to impose more Westernized standards. Many people simply built an adjective out of their profession or, more often, their home areas. Khomeini, for example, came from the town of Khomein, about 220 miles southwest of Tehran, where his rustic boyhood home has been turned into a kind of shrine-museum. A former Iranian president and wily power broker, a pistachio baron named Hashemi Rafsanjani, has family ties to the southeastern town of Rafsanjan.

"Do you know where I could find Mohammad Reza's family in Tehran?" I asked the young man.

"No. I think maybe some of the carpet repairers may know. You want to try?"

I was given directions to one of the carpet restoration shops dotting the floors above the main level in the bazaar. The workers had no idea about anyone called Mohammad Reza Tabasi. The carpet bazaar fraternity seemed not as tightly knit as I'd suspected. They suggested another shop, where a burly man with metal shears was

trimming the pile on a newly repaired section of carpet. He remembered Mohammad Reza but couldn't give me any leads outside the bazaar.

So it went for about an hour. I was no closer to finding out anything more. I was even beginning to question the news about his death.

I could easily have spent days chasing down tips and hints. There wasn't time. Also, the bazaar's support network wasn't in full gear for me. Since I was only in the market for information—I wasn't spending money—the motivation to help was sharply diminished.

I headed out of the bazaar carrying the picture of the carpet in New York. I had started calling it the Sufi carpet. I had wanted Mohammad Reza's opinion. Even more, though, I needed his advice about my idea of traveling to New York to see it. The trip once seemed so fated. I had invented my own drama that somehow all the mystic energy from Hafez and the other Sufis pointed me toward this carpet. It makes a nice, tidy script. But was I overreaching? Ali and his ramblings about heart pieces actually started my second-guessing. He said these special carpets could be anywhere, like Yazdan stumbling across the sun-and-lion piece in Hamadan. But he also told me the carpet hunters must work hard to find such pieces. They rarely, if ever, just fall into your lap. Like my Sufi carpet.

I imagined that Mohammad Reza and I would study the pictures of the carpet. We would hash over its merits. I would tell him about Ali and his opium and his Jesus price. Mohammad Reza would bang his flyswatter and we would share a laugh. And he'd tell me my first impulse was correct: follow this carpet.

Anyway, that's what I imagined.

Instead, the reality: I walked slowly back toward the Cobblers' Gate with the clippings about the Sufi carpet in my shirt pocket. I passed the stacks of carpets in the House of Rahim chambers. I didn't go in. Some boys from the shops asked if I was interested in any carpets. Just look, they pleaded. I waved them off and kept going.

The next day I had an appointment in south Tehran to meet political hard-liners to discuss the fallout from the parliamentary elec-

tions in February 2004. Reformers claimed the outcome had been hijacked by conservatives after the regime's ideological watchdog, a twelve-member body called the Guardian Council, banned thousands of liberal candidates. The meeting wasn't far from Behesht Zahra, the Paradise of Zahra, Tehran's huge main cemetery near the ever-expanding mausoleum complex of Ayatollah Khomeini.

I went to the interviews with a copy of Hafez.

Afterward, I took a taxi to Behesht Zahra. The highway in front of the cemetery links noisy Tehran to the seminaries of Qom, where the main exit to the holy city is strangely dominated by an amusement park and stands of fake palm trees. At the stretch of the road near the cemetery, still narrow before broadening out in the desert, child flower sellers peddled roses with discolored and withered edges. Perhaps, when these children grow up, they will become grave washers or assistants to the clerics who read prayers for a fee.

I entered the Paradise. I had been here before.

The first time was to see the site where Khomeini made a historic address on February 1, 1979, after returning from exile in France. Khomeini had been scheduled to appear first at Tehran University. But in a shrewd change of plans, he snubbed the elite and made his first major public address to the masses at the cemetery.

I came again to the Paradise years later with ailing victims of Iraqi chemical attacks from the 1980–88 war. They came to pray before the graves of other veterans in the well-tended martyrs' section.

On another occasion, I visited after witnessing the public hanging of a small-time thief. He did an unforgettable thing right before the noose was placed around his neck and yanked up by a crane. He kissed the rope.

I had no idea whether Mohammad Reza was buried in the Paradise of Zahra, a daughter of the Prophet Mohammad. I still knew nothing more than the sketchy details I had from the bazaar. But it felt right to be there. I wasn't sure I'd ever get to the bottom of the story of his death. Yet I didn't want to put him behind me without some token of repayment. He took the time to serve me tea and read me a little Hafez. I never had the chance to tell him in full what those small acts meant and where it led me. I wanted to describe the

madder fields or the evening puffing apple-flavored tobacco at the tomb of the poet. I wanted to tell him about how my fingers pressed into the soft resin inside the fire temple in Yazd and left prints that may be there for centuries.

I took out my first copy of Hafez's *Divan,* the dense and difficult translation I bought shortly after meeting Mohammad Reza. The book's jacket was torn and stained. There was a waxy smear from a candle stub in Herat. I left the book on a stone wall and walked away.

Nearby, a family was gathered around a grave. They were chatting and nibbling snacks. I took a short stroll through the rows of tombs. It was a dreary afternoon with no sun to brighten the marble graves or dry the puddles.

When I came back, the book was still there. The wind made the pages flap like an injured bird. I turned the book so the binding was facing the wind. Then I noticed something sticking out from the pages. I gave a tug. It was one of the madder leaves I plucked from the field near Ardakan. They were now stiff and brittle. I left them pressed in the pages and put a small rock on the book's cover to hold it steady.

It started to rain. My cab was waiting. I headed north, back to Tehran. The cab's windows began to fog up. Beads of condensation rolled down like tears.

In his address at the cemetery that chilly first of February—just hours after returning from exile—Khomeini praised all who took part in the uprisings against the shah.

"To those who joined us, we tell them thank you," Khomeini told the crowd as hands reached up to try to touch his robes.

The debt of gratitude passed squarely through Tehran's bazaar.

As the protests against the shah swelled in late 1978, the leaders of the bazaar made an important decision. They closed up. Then businesses around Tehran did the same for any number of reasons: fear, solidarity, lack of customers, or simply to wait for calmer times.

The shuttered bazaar, however, was an act of civil disobedience with potent historical context for Iranians.

In times of upheaval, the bazaar often helped shape the outcome.

Perhaps its most famous dissent was during the so-called constitutional uprising in 1906 that began when two merchants were caned for allegedly overcharging for sugar. The protesters cracked the royal monopoly on power and are often credited with laying the ideological foundation for Khomeini's revolution decades later.

In 1921, the pragmatic bazaar leadership generally stayed on the sidelines during the coup that ended the Qajar dynasty and ushered in the Pahlavi era several years later. But they shut again in 1960 following parliamentary elections many claimed were rigged by pro-shah forces. The results were canceled.

Such acts strengthened the deep bonds between merchants and mullahs.

A key intersection of mutual support are quasi-religious associations called *hay'at*. These groups traditionally served as a loosely organized society to promote shared goals and virtues, something like an Iranian version of Freemasons. The real power of the *hay'at*, however, has always been reaching all-important consensus between the bazaar's cash and the clerics' moral clout. The *hay'at* network in the 1960s and '70s helped bankroll the clerics who were preaching against the shah and distributing cassette tapes of Khomeini from exile.

Khomeini was, by many measures, an astute tactician. He knew how to best tap the powerful suspicions and insecurities among ordinary Iranians. He never veered far from one simple, but explosive, message: the shah was eroding Islam and was a pawn of Western interests who cared only for Iran's oil and other natural resources. To Iranians, who jealously guard Persia's honor and dignity, almost nothing is worse than being called a pawn.

It's more than a convenient simile. Chess always has been a popular pastime in Iran. The word *checkmate* comes from a Persian phrase, *shah mat*, "the king is dead." Khomeini had a soft spot for the game. Several years after the revolution, he overruled lower clerics who had declared it *haram*, forbidden to Muslims because of its links to gam-

bling and idolatry. Khomeini allowed it. If he played, it's likely he was good. During the revolution, he used the pieces at his disposal wisely, including the important support from the *bazaari.*

But, ironically, the shah's downfall may have marked a turning point for the bazaar. Its ability to influence affairs has been on a falling trajectory ever since.

Part of the reason is economic evolution. During the 1990s, the Iranian marketplace went through a transformation. Foreign brands—from computers to cosmetics—began to reappear. Shopping malls and chain stores sprouted in Tehran and elsewhere. The traditional *bazaari* leadership took a bigger hit than just increased competition. The new economy eroded their monopolies on import and export; the centerpieces of their clout. Even the Iranian language recognized the shift. In Tehran, the term *bazaari* took on a more generic connotation to encompass the entire Iranian merchant class rather than just the conservative bastion in the old bazaar district.

Then came a serious blow to the political credibility of the old-time *bazaari.*

In the 1997 presidential elections, a powerful *bazaari*-led political group—their motto was "inviting good and avoiding evil" — backed the losing candidate, Ali Akbar Nateq-Nouri, then speaker of the *majlis,* the parliament. Nateq-Nouri was expected to crush a former librarian and cleric, Mohammad Khatami, who had little more than a charming smile and a hazy platform about "Islamic democracy." But Khatami's ideas burned like a summer wildfire, especially among the legions of freedom-hungry young Iranians. Khatami's landslide victory—and again four years later in 2001— left the bazaar foundering in the political backwash.

"The old-style bazaar as a political force is dead," said Ebrahim Yazdi, a prominent opponent of the theocracy who returned to Iran in April 2002 after eighteen months of cancer treatment in the United States. "To me, it's just another sign that the regime is on life support but pretends it's vibrant and healthy."

On the date marking the twenty-fifth anniversary celebrations of the revolution, a friend slowed as he drove over a distressed bridge

in central Tehran. I had crossed it many times before but never realized its significance to Tehranis. They call it the "test bridge" because it's near the center for driver's license exams. It was also one of the first major structures built by revolutionary engineers after the fall of the shah in 1979.

"Look at it," my friend said. "This tells a lot about where our country has gone."

The asphalt on the bridge was chipped and, in some places, completely worn down to rows of rusting iron support rods.

That night, I watched a fireworks display from my hotel window. A flute player down by the pool—now cracked and drained of water—gave a medley of tunes from Broadway and movies. He wrapped up with *The Spy Who Loved Me*.

The next morning, I went back to see the Miri family.

They, too, were fascinated by the Sufi carpet in New York. But I couldn't shake the gnawing doubts about heading off on this path. All I really had were magazine clippings and promises from Joe Hakimian that he would try to persuade the new owner to give me a viewing. I didn't even know the owner's name.

It all suddenly seemed rather flimsy.

Especially since I had envisioned this carpet as an endpoint. I had decided that should I go, New York would mark a final leg in my string of journeys. I'd take stock afterward as to whether to continue with this carpet obsession or chalk it up as an interesting, yet temporary, interlude.

So why the hesitation? The Sufis and mystics had never let me down. Every time I drifted into their worlds, I've been rewarded beyond my expectations. Yet that was in places such as Mashhad and Shiraz, not a shop a few blocks south of Central Park.

I'm worried that this kind of Sufi generosity doesn't travel well. Here's a nightmare that keeps cropping up: Hakimian treats me as if I'm some bothersome fool, and I struggle to draw some inspiration from the carpet and end up no closer to figuring out what all

this fascination with Hafez and madder and nomads and everything else was all about. That's it, really. It's what I fear most: a big letdown after so many marvels and memories and, perhaps, some little miracles.

The carpet world can be so overwhelming: so vast, so subjective, so contradictory, so bloated with self-professed experts. But I feel I'm getting closer to something lean and genuine. It can't be called truth. That doesn't exist in art. In fact, I don't even think of carpets in purely visual terms anymore. Instead, it's like I'm developing a sharper way to hear the voices and murmurs locked away in them. Were these hints of the secret language Mohammad Reza had described? I think so. But I also sense it's a fragile thing.

A disappointing trip to New York could, I fear, wipe it away.

I'm at a crossroads.

And there's no Mohammad Reza to set my course. His death has left me shaken and unsteady. The Miri family had been so helpful with opening the doors of their dye factory to me. I was again looking to them for, maybe, one more nudge in the proper direction.

The Miri compound is on a small side street of spice sellers and tailors near the bazaar. It was the beginning of Muharram, the ten-day Shiite period of mourning and parades of ritualized self-flagellation and pounding drums to mark the battlefield death of the martyr-saint Hussein. Black banners hung from poles and storefronts. I knocked on the metal gate. It was forged thick and solid. Overhead, a tile painting depicts a lion attacking a cow. The image was used by a Qashqa'i chief more than a century ago, but its precise meaning is lost. One idea is that it symbolized the chief's power and prowess. Another is that it dates back to the Zoroastrian new year, Nowruz, with the lion as the young month devouring the passing month.

An attendant let me into the courtyard. The Miri family has painstakingly re-created a traditional home from Persia's golden Safavid era. A fountain dominates the garden. The building is made of narrow, dull yellow bricks made from the region's ocher-colored earth, which gives older parts of the city a pale, sun-baked aura. An inscription above the front door says "Art is inside."

The setting reminded me of famous Persian miniature paintings of seductive courtyards of fountains, fragrant blossoms, and cascading bougainvillea. The scenes are influenced by the Islamic ideal of paradise in the afterlife. The Miris' eight-sided fountain is part of this spiritual longing. The octagon is viewed by some Persians as a transitional form between the circle of the heavens and the square that represents Earth.

I was led into the foyer. A display on a table contained madder and other natural dye sources. All the rooms and corridors radiate from a central domed atrium rising four levels. Another saying is written in the tiles. It's from the mystic poet Rumi, the spiritual father of the dervishes. "Love and an unbound heart is our mystery," goes the saying. "The task is ours, for He is with us, in us. The era of selling timeworn thoughts is over. We sell new ideas. That is our business."

Razi Miri, the managing director, greeted me in his living room-size office. On the wall are pictures of his grandfather, Mustafa Miri, and great-grandfather, Mohammad Hadi Rouholamin. The Miri family has been trading in handwoven carpets since 1820. Mustafa Miri began exporting to the Middle East in the 1930s and later to Europe, with the help of brothers who were working in the Tehran bazaar.

For generations, the antique carpet trade made the Miri clan rich. But when supplies of quality older pieces began to shrink, the Miris looked for new opportunities. In 1988, they embarked on the idea of using natural dyes and hiring weavers such as the Qashqa'i. Some detractors call the commissioned pieces too contrived and mercantile. But it's hard to argue with the cash register: clients are willing to pay top prices. No Miri carpet will be sold for less than $720 per square meter, or about $67 a square foot. Some Miri creations can cost tens of thousands of dollars.

Razi has a professorial bearing. He speaks slowly and thoughtfully. There are hints of wealth. His shoes look handmade of the softest leather. He has a nice manicure.

"I know you came to talk about a specific carpet," he began. "But let me say something first. I think there is a prejudice in the West against carpets."

I put down my teacup.

"You do? But I think carpets are very popular in the West."

"Wait," he said. "Let me explain. It's not a prejudice of hate. It's a prejudice of ignorance. There are few Westerners who have the ability to see that carpets are works of art. That's what they are, you know. It's like a painting you can walk on. But do many people in the West consider carpets in this way? I don't think so. Here, look at this."

He pointed to the large Miri re-creation of an antique Heriz covering the floor of his office.

"You can travel for hours and hours on this carpet and each journey takes you somewhere new. I never get tired of looking at it, learning from it. Now, look at the carpet behind you on the wall. I've been looking at it for something like twenty-five years. And just last week I noticed that some of the motifs that I thought were flowers were actually the heads of birds."

I turned around to study the carpet on the wall. I couldn't see the bird figures.

"There," Razi said, pointing. "Keep looking."

The bird forms finally became clear, as if I were seeing the less-obvious side of an optical illusion.

"The thing is that we don't know everything about any hand-made carpet, really," he continued. "It would take a lifetime just to study every detail of this one on the wall. Imagine one bigger and more complex—"

"Like this carpet in New York," I cut in. "The one I found in *Farsh* magazine."

Razi smiled.

"I'm so very glad you took an interest in this piece," Razi said. "It's very, very unusual. I like the idea that it's pulling you toward it."

"Why? I'm having the opposite feeling. I'm having some second thoughts about whether it's worth trying to hunt it down. It was sold, you know."

"No, I didn't know," he said. "But why are you having doubts? About what?"

"It's hard to pinpoint, really. I'm just worried I'm getting in over my head. I realize there's so much about carpets I don't understand, but I think I'm starting to figure out what's important to me and what's not. I'm wondering if this Sufi carpet is going to help me. It's just very daunting."

"Ah," Razi said. "But that's the beauty of it all. With carpets, you are always learning and always discovering. Look, you've been at this for—what?—a few years? I've been around carpets all my life, and I am always coming across pieces and motifs that surprise me. It never ends. Does this scare me? Not at all. It's like a good marriage: an endless attraction. Like the day we found out about this special carpet, the one you call the Sufi carpet."

He told me that the Miri family and Joseph Hakimian were long-time friends. Joe occasionally sends photos of unusual carpets to the Miris for their opinions.

"It's a friendly thing we do," Razi said. "One day, he tells us he's found this very unique piece and asks if we'd be interested in taking a look. Of course, I say. Then when the photo arrived, we were stunned. This was a very, very interesting carpet. It was even beyond our knowledge."

"So you asked some experts for their opinions?"

"Exactly," Razi said.

Razi and his family compiled four essays on this carpet. Each, as Razi had predicted, interpreted the motifs in different ways.

Ali Hassouri, a designer and architect, saw traces of a group of Sufi weavers active in Tabriz until the early 1920s. They were considered the last of a group that preserved so-called other world motifs such as dragons, snakes, demons, and surreal flowers that were first created during the time of Hafez. Hassouri believed this carpet seeks to evoke a supernatural world with links to magical allegories and the jinn of Muslim folklore. Hassouri also noted popular Azeri colors such as scarlet and light blue as further evidence the carpet was from the Tabriz region.

"As you can see for yourself," wrote Hassouri, "the other world is the world of calm and peace where man and demon coexist peacefully . . . such a serene world can only be mystical."

Another opinion was offered by Nami Petgar, a Tehran-born artist, who asked: "Is it the tree of the soul?" He sees the array of weird creatures as possible symbols of the inner conflicts and energy of the "hero": a dark-skinned man who appears ready to stab the demon at the base of the carpet.

The half-human, half-monkey creatures along the inner border of the carpet also could represent evolution, he theorized. Finally, he suggested, the group of birds at the heart of the carpet could suggest humanity at its most pure and innocent.

The essay by Shahin Shahin, a U.S.-based researcher, also sees references to evolution and the dawn of time. "It is, indeed, the mystery of life," she wrote.

Finally, Razi Miri's cousin, Saleh, found the carpet to be an attempt to display the "never-ending cycle" of the known and phantom worlds. Paradise, guarded by man-ape archers, is depicted in the top half of the carpet, he wrote. Hell, with its odd beasts and horned imps, sits below.

"This message is about life and its significance," Saleh wrote. "It is a strong image, which intends to shock . . . The revelation of the path of life is not a light subject. It requires attention and meditation. The eye travels from evil to good."

He also notes that the mirror-image design of this carpet, which reminded him of Rorschach ink-blot tests, sends an important message about mortal limitations.

"Perfect symmetry calls for a sense of perfection," he wrote. "It cannot be in the hands of humans. It comes from somewhere else. The perfection is God's work and should be contemplated as such."

I finished reading each of the short passages. Razi had waited patiently.

"You see," he said, "there is never one way to look at a carpet. It is the biggest mistake anyone can make with carpets like this. You just cannot say, 'This motif has this meaning.' Only the maker knows. We can appreciate it only from afar. You can say, 'I think, I feel, I believe.' But you can never say, 'I know.'"

"What do you see in this carpet?" I asked.

"I knew you would get around to asking," he said with a laugh.

"I guess my answer would be a bit mixed. I could see the hand of the Sufi in this carpet. It definitely has a mystic quality. But, you know, you can never be one hundred percent certain."

"And that doesn't frustrate you?"

"Why do you keep coming back to this idea? No. On the contrary, it's the thing that makes carpets fascinating. I think Picasso said something like, How can you hear the song of a bird and not want to know the meaning of this beauty? This is why you will go to New York to try to see this carpet. Don't you know? You are hearing the song of Picasso's birds."

Before leaving Tehran, I passed by the bazaar to see Ali the opium puffer. We had an appointment. As usual, though, he was late.

A young carpet tout approached me. "Come, just look at my friend's shop," he urged. "Just look. I will tell you when Mr. Ali returns." After all this time around carpets, I foolishly broke rule No. 1: Ignore the lads trying to coax you into a shop. I tried Ali's cell phone, but it was off. I gave in.

"But I'm just looking. I'm not interested in buying anything," I told the boy. "Just until Ali arrives."

A true amateur move. I knew it. But I still followed the boy. The owner whipped out some obviously new workshop carpets that were treated to resemble old silk. I knew a lot of the tricks now. So why was I sitting there pretending to be interested?

"Okay, just for fun," I said. "How much?"

He said $1,200.

"You're not serious?"

"Ah, I see you know your carpets. For you, nine hundred."

And gradually the price sank lower and lower until it reached about $350.

"So let me ask you something," I said to the merchant, a plump man whose shirt was much too small for his belly. "You really think someone would pay twelve hundred dollars for this piece? It's hard to believe."

"I see you know your carpets a little," he said. "So I will tell you something. This is one of the most true things you will hear in the carpet bazaar. Remember it. There are three prices. There's the price between carpet sellers, there's the price for people who know something about carpets, and then there's the minister's price."

"Minister's price? What's that?"

"That is for the diplomats, businessmen, and wealthy tourists. I was starting you off at the minister's price."

"So you're really cheating them?"

"Don't say it like that, *agha*. Twelve hundred dollars to some people is like a cup of tea to me. If they can pay it, then let them. I am not stealing bread from their mouth."

"But you are telling them this carpet is old and valuable when it is not."

"What is valuable? If they like it, they like it. *Agha,* you are too harsh with me."

Just then, some other men pressed their way into the shop. They didn't look pleased. Neither, in fact, did the owner. They started to argue. It seemed that the carpet boy worked for several shops. They were quarreling over who had spotted me first.

"I'm just looking," I said meekly.

No one paid any attention. The shouting was getting louder. There were a few shoves. The whole episode moved out into the passageway. The *bazaari* were gathering. Things were getting out of hand.

I just sat there, nursing a lukewarm glass of tea. There was no way I was going to get into the mix.

Then the shop door burst open. The owner stalked in. There was a bloodstain expanding across his shirt. Someone had stabbed him in his massive gut.

"It's okay," he growled. "It's just a cut. But this isn't over. Wait here a minute. I'll be back."

He took something from the drawer of his desk and left the shop. I waited about five seconds and did the same. I think he yelled for me to return. I didn't turn around. I didn't go back to

Ali's shop, either. I knew the way out of the bazaar by heart.

Later, I remembered Razi's reference to Picasso. I searched for the actual quotation, which is often translated as: *Everyone wants to understand painting. Why is there no attempt to understand the song of the birds?*

I get it. Why should I stop now? I sent a message to Joe Hakimian. I asked him to contact the carpet's new owner. If he'd let me see it, New York would be my next stop.

And New York did adopt me.
Just like you and the city of Shiraz adopted each other, Hafez.
—Manchoucher Parvin, from his poem "There's No Place Like Home"

CHAPTER THIRTEEN

EAST FIFTY-SEVENTH

 A quick storm had just washed over Manhattan. It was now moving out to sea. The streets had that unmistakable smell of warm asphalt bathed in cool rain, like water from a garden hose in summer. I jumped over a puddle into East Fifty-seventh Street. The carpet was close now.

It was just a few weeks after I had asked Joe Hakimian to contact the carpet's new owner. The owner agreed, a bit reluctantly, to let me see it. But he allowed only a brief window. I booked a flight.

It was a peculiar dash home.

I was born in the New York area. I later lived and worked in the city for years. Visits back were easy and familiar no matter how long I'd been away. But this one felt a little off center. I knew exactly why. The context seemed wrong.

With carpets, I'd always been the foreigner, the curious outsider. The carpets held the memories and continuity of the place. The roles on East Fifty-seventh were reversed. The Heriz silk was the exotic guest. I was just another guy on the sidewalk sipping coffee from

those iconic Greek-themed paper cups that promise "We are happy to serve you."

Walking over prime midtown real estate, I thought back to very different terrain: the hardscrabble Badghis province of Afghanistan and the Turkmen girl weavers. Of all the unexpected places that carpets have led me, that small room in Badghis remains the most haunting. I often wondered why these girls, who had so little, never asked me about America's consumer cornucopia. Now the reason seemed obvious. It was simply inconceivable to them. How could they grasp so many choices and people paying so much to make them? One of the girls did ask something. She wondered if it was true—*really true*—that American girls can ride horses. This was her way of weighing the difference between my culture and hers.

The fog is thick at both ends, however. It's doubtful any of the young clerks, rolling back their metal grates on East Fifty-seventh, could get their minds around the thin dreams of Badghis. The store names are a roll call of pricey status: Louis Vuitton, Tiffany & Co., Chanel, Prada, Mont Blanc. Just one suit by Brioni would be more money than an entire Afghan village may see in years. Or look at it another way. Americans spend nearly $7.5 billion a year on snack chips, which dwarfs the estimated $4.4 billion estimated gross domestic product for all of Afghanistan, not including its illegal opium trade.

The prices for some of the carpets from Joe Hakimian's vault would also stagger the village weavers. The Sufi carpet had sold for $85,000. The new owner, I'm told, is a very wealthy, intensely private man who wanted nothing to do with me or my carpet hunt. I could see the carpet and that's as far as he would go.

I found the Hakimian address. The lobby guard wore one of the American flag lapel pins that became so popular after 9/11, the event that sent me on my first trip to Afghanistan. A slow elevator took me to the second floor. The glass door was locked. It always is for protection. At night, the Hakimian family adds a two-inch-thick steel gate. Joe Hakimian's daughter, Rebecca, buzzed me through. She knew I was coming. She's not big on formalities or chatter. She got right to the point.

"He's here," she shouted to someone in a back storeroom. "Could you get the carpet?"

"Is your father coming?" I asked.

"On the way," she said.

I had spoken with Joe by phone. We had not yet met.

I waited in the showroom like someone on a blind date. I had studied the picture of this carpet and its weird universe of creatures so often, the edges of the pages I'd cut from *Farsh* magazine were smudgy with fingerprints. I had talked for hours about it with Razi Miri, whose reference to Picasso had helped persuade me to come all this way. But would it disappoint in person?

Two Polish workers carried in the carpet. It was wrapped in waxy, waterproof paper, which barely made a sound as the tape was undone and the flaps pulled away.

One of the men placed the rolled carpet on the varnished pinewood floor. He gave it a slight nudge. The carpet, whose tag read "19th century Heriz silk, 8'3" by 6', catalogue number 5063," silently uncoiled and filled a space the size of a dining room table at my feet.

There it was.

The Poles went back to work. I was alone. I stood still—a bit dumbfounded—for a moment, like a tourist finally standing before a landmark he knew only from books. Then I bent low and touched the carpet's edge. Silk doesn't retain heat as easily as wool. Silk seems cooler. I ran my fingers through the fringe and combed it straight. About 150 years ago, when this carpet first came off the loom, I'm sure someone else did this same quiet grooming. It's a natural reflex. Sadly, we will never know his thoughts. Was this carpet a masterpiece or a flop in his eyes? I think of the creator as a man. If, as some suspect, this is from a master workshop, it's very unlikely a woman would have been allowed. It's a shame, really. I have come to look at carpets as an extension of the feminine spirit and imagination; one of the greatest, and least acknowledged, aesthetic contributions of women over the centuries.

I would have liked to think that a woman made this Sufi carpet, too. But I can't.

My eyes darted over the carpet, picking up the forms and motifs I knew so well from the pictures. I tried to slow down, as the Sufis had suggested. There was no rush. I had all morning.

Then I jumped at the sound of a deep voice behind me.

"Well," said Joseph Hakimian, who had quietly slipped into the shop. "I hope the trip was worth it."

It was.

Details emerged up close that were undetectable in my magazine clippings.

The outside border is a parade of tiny piglike forms and horned spirits. The mysterious monkey-men, which some saw as guarding the "upper world" of paradise, wear a sneaky smile. Tan veins run through some of the leaves. There is also more *abrash* than I expected and some parts showed heavy wear. Clearly this carpet was used in a home or some place with foot traffic for a while. I had always imagined it as purely ornamental.

The silk knots also produced a common dual-hue effect: from the south end the reds run toward rust and apple, but looking from the north it shimmered a light pumpkin orange. The shifts come from the angle of the knotted silk.

"It's something, isn't it?" Joe Hakimian asked over my shoulder.

Its origin made the carpet even more remarkable. The Heriz region, about forty miles west of Tabriz in the northwestern corner of Iran, has been associated with a very distinct central medallion and floret style for more than a hundred years. Trade is the reason.

The area became one of the centers for Iran's carpet export boom in the second half of the nineteenth century, led by Ziegler and others. The lavish old Persian motifs became particularly popular among Gilded Age American customers. The Tabrizi merchants needed competent weavers to fill the orders, which were often living room–size pieces that required months to make. They turned to the Heriz villagers.

But the energy of the commerce also gave a boost to the entire region.

Master weavers—working independently from the commercial export network—went through a kind of renaissance in the nineteenth century. Their workshops favored fine silks that, some experts believe, were influenced by Sufis.

This is where the carpet at my feet could have taken form. There are certainly many carpets considered more valuable or significant. Some were right there in Hakimian's back room. But I question the wisdom of any real ranking system. Such exercises are for the unimaginative, I've decided. This I've learned: a carpet's true importance is what it brings to the owner's life, not what it means to a textbook.

"Take your time. Enjoy it," said Joe. "You may never see something like this again. When you're done, I'll be in my office."

Joe Hakimian is a sturdy man in his sixties, just a few big meals short of rotund, with eyes that are still young and curious. He likes to pepper guests with questions. Then, remarkably, he sits back calmly to await the answers. He listens in complete silence, patiently, calmly. It's a rare trait.

I had many questions of my own. My first one made Joe chuckle.

"Will you miss this carpet I came to see?" I asked.

"Are you kidding?"

"No, seriously. Did you ever think of not selling this one?"

"The answer is a definite no." He smiled. "I am a businessman in the business of selling rugs. If you get attached to the merchandise as a businessman, you are dead."

"I see your point," I said. "But what about this one? The Miris and others saw something extremely interesting here. Some thought there was a definite Sufi influence in the motifs."

"How did a guy like you—where did you say you were born? New Jersey?—get interested in Sufis?" he said, abruptly changing the subject.

I told him: the Tehran bazaar, the mystic poets, the Sufi *khaneghah* in Mashhad where I did the *golbang*, this carpet. I then told him about Mohammad Reza.

"That's too bad," said Joe. "He was right to tell you what he did. Look, you want to know about this carpet? I'll tell you a story. I travel all over Europe looking for extremely rare pieces. I was in Germany. I wasn't there to find an odd piece like this one. I usually deal in decorative pieces, sixteenth- and seventeenth-century pieces. You know, the Shah Abbas period. These are real masterpieces.

"It was 2002. I was at a German auction house where I frequently get pieces. The minute I saw this one I knew I wanted it. It wasn't because of its interesting character or these maybe Sufi motifs. Sorry, my friend. It was because I had success with strange carpets like this before and I figured I could sell this one.

"Anyway, I saw that the pre-auction estimate was low, and the other dealers in Germany don't tend to like these types of carpets. So I figured I wouldn't have much competition. I placed a bid. You know, I never do it in person. Always by phone. Because if the others know it's me bidding, then the prices may go up. I got it very cheap—for about eleven thousand dollars. They were stunned at the price. I would have gone higher."

How this carpet reached Germany may never be known. The auction house bought it from the estate of a German collector, but after that the trail grows cold. The collector's family has no record of how he obtained the carpet.

"Unfortunately, it's rare to have the full history of an antique piece like this," Joe said. "The story is always incomplete."

"Or waiting to be discovered," I offered.

"That, too," he agreed.

Later that day, Joe was bidding on some carpets from the estate of the late tobacco heiress Doris Duke, who had filled her Hawaiian hideaway, Shangri La, with one of the world's richest collections of Islamic art before her death in 1993. As always, Joe was making the offers by phone.

"Sorry, but I'm really busy with this auction. How about dinner tonight? We can relax and I'll tell you everything."

"Even the name of the client who brought the carpet?"

"Everything but that," he chided. "He asked me to respect his privacy. I have to do that."

"Any hints at least?"

"Okay, how about this? He's a Wall Street trader. He's a passionate collector of art and antiques. He has a town house that he's renovating on Fifth Avenue. That give you a picture?"

"Sure, that he's very rich."

"Most definitely."

"Anything else?" I pressed.

"He's what I call the ideal client."

"What do you mean?"

"I mean these are people we love. I call these guys the ultimate buyers. Forget about the designer and architect. The ultimate buyer is not just a guy with a lot of money. It's a guy who buys art. He collects paintings. He travels and goes to museums."

"And he's one of them?" I asked.

"You saw the carpet he picked. He knows what he's doing."

We made our plans for dinner.

"By the way," Joe said as I was leaving. "I forget to tell you thanks again for the present. I really enjoy it."

"My pleasure."

Joe was deep into the English-Farsi *Divan of Hafez* I found for him in Tehran. I waited until I was back in Europe to mail it, though. Nearly every package I've sent to the States from Iran has been picked apart by U.S. inspectors. Long before 9/11, Iran was in the crosshairs of customs agents and other watchdogs. Iranian goods, including carpets, spent more than a decade on the blacklist.

On October 16, 1987, near the end of eight years of war between Iran and Iraq, a lone blip appeared on a Kuwaiti radar screen. It was a missile. Air defense teams scrambled to try to intercept it with a surface-to-air rocket. Too late. The powerful Chinese-made Silkworm missile, capable of sinking a ship, nosed downward toward a Kuwaiti oil tanker flying the U.S. flag as part of Washington's effort to protect oil traffic in the Persian Gulf. The American captain of

the tanker *Sea Isle City* and more than a dozen crewmen were injured.

The White House laid blame on Iran, calling it "an outrageous act of aggression." Within days, there was a response by President Ronald Reagan, who had sided with Saddam's Iraq in the war. U.S. Navy destroyers bombarded an Iranian oil platform in the gulf allegedly used as a military outpost.

Congress, meanwhile, was pressing hard for more action. The wounds of the 444-day hostage crisis in Tehran were still raw in Washington and politically sensitive among voters at home. Before the end of the month, Reagan put in motion an order to ban Iranian imports and halt exports to Iran of goods with possible military applications. The loss of Iranian oil to the United States was minimal. Iranian crude at the time accounted for less than 1.5 percent of the total American imports.

But America's door suddenly was shut to other, nonstrategic, Iranian goods: pistachios, caviar, and, of course, carpets.

There were some early loopholes. Iranian carpets already ordered or under contract were exempt. This led to a wild race to slip under the wire. New production rugs and some rare antique pieces flooded into the U.S. market in a matter of months. The laws of economics came into play: when supply shoots up and demand stays static, prices fall. It was a prime opportunity to snatch up some historic bargains for high-quality carpets from centers including Isfahan, Heriz, and Bijar, in the Kurdish northwest of Iran.

"The embargo brought an amazing influx over a short period of time. You could pick up remarkable deals for a while, basically paying then what is the wholesale price now," said Mark Kambourian, president of the Oriental Rug Retailers of America, a trade group formed in 1969.

Warehouses became so stocked with unsold Persians that there was never really a shortage despite the embargo. Many dealers also used Canada as an illegal back door into the States. The risks of being caught—though relatively small—meant that often only lower-grade carpets arrived via the smuggling routes. "This was bottom-of-the-barrel stuff," said Kambourian, whose family has

been in the carpet trade since 1896. "A lot of these pieces are still lingering around. No one really wants them."

The embargo also occurred when Iran's carpet rivals, led by China, Pakistan, and India, were stepping up their quality, including imitations of classic Persian designs. Most important, the so-called new carpet nations started tailoring designs to meet the dimensions of American homes and shifting their palettes to the pastels and lighter shades favored by U.S. consumers.

The workshops of the Iranian competitors also began using higher-grade wool, particularly from New Zealand and Belgium, and discovered the attraction of natural dyes to gain some credibility with more discriminating clientele. Even those sticking with chemical dyes enhanced the techniques for "aging" new carpets so the result was less garish.

Some collectors and specialized dealers lamented the loss of a Persian pipeline. The average U.S. consumer, however, didn't know the difference. In general, the new carpet production from points east of Iran was seen to be on a near par with Persian workshops. And any perceived shortcomings were often compensated for by an attractive price tag, especially on carpets from China.

There was really nothing new about this kind of market-driven production. Iran's rivals had learned well from Persia itself. More than a century ago, Ziegler and others were doing the same thing. The subcontinent and China were just copying the strategy on a bigger and faster scale.

Before the 1979 Islamic Revolution, Iran had about 80 percent of U.S. Oriental carpet sales, industry experts estimate. A generation later, it was down to less than 20 percent of a market estimated at $1.25 billion.

"I would say the mystique of the Persian rug lost some of its luster," said Kambourian. "It used to be that the Persian rug was the unrivaled top of the heap. This was already happening before the embargo. The embargo just brought this point to everyone's attention."

On March 17, 2000, Secretary of State Madeleine Albright announced that the ban was being lifted. Iranian "luxury" imports, in-

cluding the mainstays of carpets, pistachio nuts, and caviar, were again welcome.

It was a clear overture to the reformist administration of Iran's president, Mohammad Khatami, who had taken office three years earlier. In diplomatic terms, it was an important opening. Economically, it was barely a footnote. The United States maintained its commercial boycotts on Iran, which has cost American companies billions of dollars in lost contracts that were gladly picked up by Europeans and Asians. But Washington's hand was open and ready for Tehran's next move. It was a hard slap. The religious-political citadel around Supreme Leader Ayatollah Ali Khamenei, which dictates all policies to the president on down, denounced the U.S. gesture as a charade. "We reject it outright," said Hassan Rohani, a former deputy speaker of Iran's parliament and part of the ruling inner circle.

But business is business.

Iranian carpet dealers soon began trying to claw their way back into the U.S. market. They found a very different landscape from when they were forcibly evicted in the Reagan era. The carpet mentality of the subcontinent and China is fast-paced and opportunistic. The old-line Iranian exporters had already lost ground to this type of competition in Europe. Now, it was waiting for them in the country where they used to be the undisputed leaders.

"The embargo really was a watershed for the industry," said Ron O'Callaghan, a New Hampshire dealer who specializes in internet sales and information on carpets. "For the Iranians, the carpet business is big, but essentially it was run like a cottage industry. They just weren't prepared for this big and aggressive factory system in China, India, and elsewhere that took over the U.S. market. This stuff just pours in by the container load and it sells. How do you compete with that?"

For many American dealers, Iran also had become a kind of terra incognita. Lots of U.S. carpet shops had drifted away after the Islamic Revolution, bitter over the hostage taking at the U.S. embassy and frightened by the ferocity of the Iran-Iraq war, which most seriously disrupted some of the Kurdish weaving centers on both sides

of the border. Those Americans who restored their old carpet contacts had to reacquaint themselves with new and complicated export rules laid down by the clerics.

"Even when the embargo was over, there was a reluctance by lots of U.S. dealers to get a visa and go back over to Tehran," said Kambourian. "It was the whole climate of things. The dealers just found it easier to do business in China and other places."

The embargo years also coincided with the rise of another serious force in how carpets are made, marketed, and sold: interior designers and decorators.

Jacqueline Coulter, the head of the carpet section at Sotheby's in London, ticked off the three main elements of the carpet market. The first two—tribal pieces and classical antiques—are important for many serious collectors but are relatively small factors in the overall picture. Then there are the repercussions from the big decorators. The ripples extend far and wide.

"Decorators have become a powerful force in setting carpet prices and what is hot," she said. "Every dog has its day."

The prevailing bark: very pale colors that offer the widest range of decorating possibilities. The "language" of the carpets I was encouraged to learn—the motifs, the small imperfections, a sense of the carpet's lineage—become just backseat voices. Demand forces the prices high for decorator-attractive pieces "whether they are worth it or not," Coulter said.

"We shouldn't kid ourselves that most carpets come out of some pure, noncommercialized state. Tailoring carpets for Western tastes and markets has been going on a long time," she continued. "About the only exception worth noting among contemporary carpets may be tribal production. But it's relative, really. I mean how can you say what is more pure and uncorrupted? It's like the difference between naïve painting and salon painting. Is one better than another? With carpets, this is a discussion that will go on and on without any conclusion."

There is one aspect that Coulter is clear about, though. The fakers are good and gaining ground. The ability to use chemicals and washes to mimic the natural aging process has become so advanced

that the average buyer is virtually helpless. Iranians do it, but some of the prime manipulators are in India and China. It could, Coulter worried, become a house of cards.

"Faking has become so good that there are real fears it could destroy confidence in the market. That would be devastating," she said.

"The whole market is built on confidence. If that starts to crumble, we are in trouble. It's really worrying. There are some fundamentals that people have to hang on to if they are going to spend a lot of money on a carpet, an 'If this is this, then that is that' sort of mentality. If it's not there—or there are serious questions about these core assumptions—then we are lost. How can you look someone in the eye and say 'It's definitely worth spending the money' if there are questions? Carpets don't come with an artist's name and very rarely have a date. The idea has been if it's old, then it has a certain value and rarity. If fake old carpets start confusing the buyers, the whole system is thrown out the window."

I met Joe Hakimian for an early dinner. We walked up Second Avenue to a Persian restaurant owned by a 1970s-era goalie for Persepolis, one of the perennial powerhouse clubs in Iranian soccer.

Joe was in a good mood. He had bought a 130-year-old silk Heriz from the Doris Duke estate auction. It was an entirely different species from the quirky Sufi carpet I had come to see. The Duke estate piece, from her Park Avenue residence, was classic: a floral central medallion with a palmette border. The Christie's catalogue had estimated the carpet (about 11'10" by 9'9") at between $10,000 and $20,000. Joe's winning bid was $47,800. He would have gone higher.

"This business is like a sponge," he told me. "Whatever you put on it disappears right away. Then you have to wring out something for yourself later."

"Like the silk Heriz? Not the Doris Duke one. The one I came to see," I asked. "You did all right on that one, it seems."

"Sure, yes, on that one. But don't forget, this is just one carpet. I admit it's an interesting piece with a curious history. I've learned not to get too emotional about any carpet, though. You can't start a love affair that you know will end with separation."

"Have you given any more thought to the theory that this carpet is a kind of Sufi expression of the cosmos?"

"I have," he said, "and I can tell you this: I'm not a scholar, but I like the story and it seems plausible. So why not? A carpet can, in the best cases, take us outside of ourselves to a place that's calmer, more orderly, more beautiful than this one. This one seems to have accomplished this. So, like I said, why not see the Sufi hand in this? It's probably impossible to ever find the truth one way or another."

"And that doesn't bother you?"

"Bother me? Are you kidding? Haven't you learned anything? Mystery—the unknown—is the best friend of carpets like this one. You know, this is the real McCoy. Think of Hafez. His verses speak on different levels at the same time, don't they? Well, it's no different with a carpet like this. If we could talk to every weaver and find out exactly what he was trying to represent, would we want to do that? It would ruin the magic."

I let Joe order. Out came a spicy lentil soup followed by a delicious eggplant stew. It was a welcome break from the typical fare in Iranian restaurants: kebabs, rice, raw onion, and yogurt.

We talked of Mashhad, his birthplace. I told him how the shrine of Imam Reza has swallowed up the old carpet bazaar. He also asked me about Tehran, where he grew up in the well-off north Tehran district. His father managed to keep the family afloat working as a traveling middleman, finding leather, furs, rugs, and other objects around the country and trying to sell them to *bazaari* in Tehran at a small profit.

Joe's family lived around the corner from Iran's populist prime minister, Mohammad Mosaddeq, who challenged the shah's powers and led a movement that nationalized Iran's oil industry and eventually forced the shah to take exile in Rome. Joe remembers in 1953 when pro-shah riots broke out and crowds pelted Mosaddeq's home with stones, to the delight of the CIA and other Western agencies.

Among the American operatives accused of supporting the shah's cause was an old Mideast hand, Kermit Roosevelt, grandson of President Theodore Roosevelt, and Norman Schwarzkopf, Sr., father of the U.S. general who led the forces that drove Iraq from Kuwait in 1991. Mosaddeq's coalition crumbled. The shah returned. Some analysts wonder whether the Islamic Revolution would have even occurred if the monarchy had been allowed to founder in the 1950s.

Joe's last trip back to Tehran was just before the revolution. He visited family and did some carpet shopping. It was a strange return. The last thing he had expected was to be matching wits with Iranian carpet merchants. He had left for the States in 1962 with plans for a very different life. He was accepted by North Carolina State University to study electrical engineering. It wasn't his first choice of a major; he'd have preferred architecture or something in the arts. But his English at the time was weak, and the figures and mathematics of technical study were much easier to digest.

He started to tell his story.

"I just drifted into this field." He smiled. "I'm really a self-made man. I started from zero, but maybe the fact that I was raised on a rug gives me this deep attraction to art. I don't know. I really should have studied architecture."

Instead, he had his electrical engineering degree and headed to the General Telephone and Electronics labs in Queens as a research technician. After work, he rode the subway to Brooklyn for company-paid night classes at Polytechnic University for his master's. There were other pressures. He was also supporting his mother, who came to New York after her marriage fell apart. It wasn't exactly tough times. But it also wasn't Joe's image of the American Dream.

"I was very bad in the lab," he admitted. "It was a job, though."

But GTE changed that. The company announced it was closing the Queens site and relocating to the Boston suburb of Waltham. Joe decided he couldn't bring his mother to new surroundings cut off from the lively Iranian community in New York.

"I resigned," said Joe. "I thought I could get another job. But, you know, there was nothing out there. There was a big recession

going on in the electronics industry at the time. I was running low on money and I needed something to do."

So he drifted down to the wholesale carpet district in Manhattan. He had about $9,000 saved from his GTE job. He started buying old carpets. They were still plentiful in the early 1970s, including caches from the pre-Depression days when many fine and rare pieces were coming across the Atlantic.

"I was lucky, because I really didn't know what I was doing. I would just buy things on instinct, and, somehow, I made money on the resale," Joe told me. "Don't forget, the market was very strong in those days, and there were dealers coming from Europe to New York virtually every week collecting the old rugs."

His beginner's luck didn't hold, however. After a few years, his small financial reservoir was running dry.

"I made too many mistakes and I didn't have any more money to buy carpets and I was stuck with rugs I couldn't sell," Hakimian recalled. Just then—in mid-1973—a dealer offered him $13,000 for his entire stock. He was saved. "That money brought me very good luck," he said.

For a while, he had his eye on a nineteenth-century silk Heriz, about eight by twelve feet, with a classic medallion motif and some worn areas. "I bought it for something like two thousand dollars," he remembered.

"Then I brought it down to the wholesale market. I didn't know what to ask, but I knew it was worth much more than two thousand. So there were a couple of old men. They were very conservative. They were also carpet brokers. We didn't really know what we were doing. I took the rug to them and said, 'Do you have somebody for this?' They said, 'We think we do.' I said, 'What can you sell it for?' They said, 'Maybe seven to eight thousand.' I said, 'Forget it. I want thirteen.' I was a young kid. We sold it for ten thousand dollars in the end."

The man who bought the Heriz had ties to the Tehran bazaar. He took the carpet to Tehran for expert repairs. And then the carpet returned to New York cleaned and fixed. It was sold for $100,000, a monstrous sum for a carpet at the time.

"The guy who bought it was very wealthy and connected to the shah. He died and I lost track of the carpet. I'd love to know where it is now. But anyway," said Hakimian, snapping back from his daydream. "That ten thousand was a big break for me. I started making contacts with other antique carpet dealers and tracking leads on interesting carpets. I was single. I had some money. I started to be daring."

He started to make a name as a sharp-eyed "picker," hitting estate sales, flea markets, shops, anywhere to find a carpet at a good price. He'd then try to sell the piece to a wholesaler. Eventually, he built a nest egg to open FJHakimian on East Fifty-seventh Street. The first initial is for Farhad. The second is for Joseph, the anglicized version of Yusef.

"This is my biblical name. It's a lot easier for Americans to pronounce, so it stuck. Now I'm Joseph or Joe," he said. "The story of the Iranian Jews is a whole other thing."

Judaism in Persia makes Islam seem like a newcomer.

Jews—forcibly or by choice—moved eastward into Persia as early as twenty-seven hundred years ago. Later, the first great Persian Empire, the Achaemenian, spread into Babylon and absorbed many Jewish communities. After the conquest, King Cyrus allowed Jews to return to Jerusalem. The Zoroastrian rulers were reasonably tolerant of religious differences and set the tone for centuries to come.

Some biblical stories praise Persian benevolence. But not all was calm in the Diaspora. The Old Testament's Book of Esther tells the story of the niece of a Jewish adviser in the Persian royal court. She becomes queen and manages to persuade the king to reject calls growing from advisers to wipe out a Jewish population on a date chosen by *pur*, or lot. The change of heart is still marked each year by the festival of Purim.

Until the arrival of Islam in the seventh century, the Jews in Persia had long periods of acceptance punctuated by purges by kings fearing challenges to their political might or convinced of Jewish disloyalty. Islam brought a new order. Jews, Christians, and Zoroastrians were allowed to practice their faiths, but not without paying a special tax and consenting to lesser status in the courts and society.

Some reports describe scenes with chilling modern connotations, such as Jewish ghettos or Jews and other non-Muslims forced to wear color-coded badges or belts for easy identification.

The past century has been one of Jewish decline in Iran. The exodus began after Israel declared independence in 1948. It picked up significantly after the Islamic Revolution, although the theocracy acknowledges Judaism as a legal faith and sets aside a Jewish seat in parliament. In the Iranian mind, there's a fine—but still distinct—line between Israel as a state and Judaism as a faith. No more than twenty-five thousand Iranian Jews are left.

Joe has only distant relatives there now. He has considered going back for a visit, but he has a nagging worry that something will happen to keep him there. We left the restaurant and walked a block. We decided to keep walking. It was a nice night. Joe had some time before one of the late trains to his town on Long Island.

"Do you think it's strange that I've been following this carpet all the way from Iran just to see it for an hour in your shop?" I asked him.

"Not at all," Joe said. "In fact, I think it's wonderful."

"Why's that?"

"Passion, Brian, that's why. Didn't Hafez teach you anything? It's all about that inner fire. Passion makes things happen. That's really what it's all about, don't you think?"

"I think you're right."

We crossed Fifth Avenue, the future address of the Sufi carpet that had already traveled from Persia to Germany to Joe's shop.

"So maybe you can someday find that carpet that saved you with the ten thousand dollars back in the 1970s?"

He smiled.

"Yes, why not? Maybe I'll start my own carpet hunt. You've inspired me."

The next morning, I had a few hours left in New York before heading home. Hafez was not done with me yet.

At a bookstore, I asked about any titles on Hafez or mysticism. The clerk didn't offer much help. I turned to leave.

"Wait," said another saleswoman from behind the counter. "Did you say Hafez? I think I remember something."

She typed an entry into the computer.

"Here," she said. "Found it. I remember hearing about this book somewhere. We don't have it, though. Sorry."

I copied down the title: *Dardedel: Rumi, Hafez & Love in New York*. I thought I was done when I said farewell to Joe. But Hafez handed me one last hunt.

It took a few days of emails and calls to track down the author, an Iranian-born poet and semiretired economics professor named Manoucher Parvin. I called him in Ohio, where he's been living since the late 1970s.

He was almost giddy at the unexpected chance to talk to a stranger about Hafez. *Dardedel,* the Persian word in the title of the book, means something like a discussion with no boundaries or inhibitions. It has an almost spiritual idea.

"You mean you've actually been to Shiraz? To the Hafez tomb?" he asked.

"I have."

"Oh, then, we have lots to talk about."

Parvin left Iran in 1955 on a slow SAS propeller plane. He made a brief stop in Copenhagen before setting off for New York. He was just sixteen and had a plan to study at the Colorado School of Mines. It was just after the dizzying collapse of Mosaddeq's government and the return of the shah. Parvin was pumped full of nationalist spirit. He wanted to get his education and return to Iran and help develop the country's mineral wealth. But America and its optimistic energy changed him. Mining suddenly seemed part of the past. The future was tied up in transistors, circuit boards, and a futuristic thing called a computer.

He never made it to Colorado. Instead, he enrolled in electrical engineering courses at the University of Toledo, in Ohio, where he had some relatives. Gradually, he let go of his personal promise to return to Iran.

Another dream was taking shape. It was one where he was living in New York. He couldn't shake the images of the city from his first days in America as a bewildered teenager roaming Manhattan all the way from Wall Street to Harlem. "It was like a giant growing out of the land," he would recßall. "There was poverty, wealth, life, decay, everything. Here I was, this boy alone taking it all in. There was fear, anxiety, excitement, anticipation. How can you ever forget this?"

He returned to the city in 1963 to get a doctorate in economics from Columbia University. He stayed in New York until 1978, teaching at Columbia and Fordham University.

As he expected, he fell in love with the city. But there was still another yearning. It was for an uncluttered place for contemplation. He found it far away in the Sonoran Desert in Arizona. It reminded him of the dry expanses of his homeland. An idea took root.

It finally developed into a series of lyric poems. They tell the story of a Professor Pirooz, who leaves New York to try to ease his "spiritual emptiness" in the Arizona desert. Suicide is on his mind. Then he encounters Rumi and Hafez in the forms of giant saguaro cacti. They persuade Pirooz to postpone any attempts at suicide for at least a year and return to New York. The spirits of Hafez and Rumi follow. Hafez becomes a taxi driver. Rumi takes the form of various New York characters.

"I'm trying to connect East and West, past and present, science and spirituality," Parvin told me. "I believe we all are on journeys like this, even if we realize it or not."

"What do you think about carpets?" I asked. "Do you think maybe they present some of these dual struggles?"

"Let me put it this way: In Persia we see poetry in carpets. Carpets speak in a special, beautiful language. It can be hard to hear in the modern world."

"Wow, that's precisely what a carpet dealer in Tehran told me years ago. He's the one who introduced me to Hafez."

"A wise man," said Parvin.

"I need to ask whether the part of the book in the desert is also autobiographical. I mean, did you go there thinking of killing yourself?"

"No," he said softly. "I did not go to the desert to commit suicide—not that at times in my life I have not contemplated it. I am, and always have been, very disappointed with the world as I found it and my hopelessness to change it."

"In what way?"

"You know what my real first impression of America was?" he said. "It wasn't of its greatness. It was of its failings. I thought that America is not living up to what it claims to be: a place of compassion and hope. Yes, it's there. But it could be so much more. I think I do my little bit, but I feel this country is going to sleep and forgetting the promise it gave to the world."

"Is this why you go to the desert? To escape?"

"No, not at all," he said. "It's to grow. I've been studying neuroscience. Let me tell you something about the brain. It's always changing, adapting. Every new word you learn—anything new and important—opens new synapses. New connections. I really believe there's a power of place, too. Our environment works on us on a biochemical level. The smells, the reflection of the sun, the slight changes in the magnetic field. All this works on us. This is why I go to the desert. I come out with new thoughts, a freshness, a little sense of hope.

"You must have felt this," he continued. "It's at the heart of everything. It's really the ultimate paradox. The universe is trying to change us, just as we struggle to control the universe. Every place, I think, has its special power. We just have to recognize that and try to feel it."

I hung up the phone and pulled down a big atlas. On a hunch, I found East Fifty-seventh—not the street, but the longitude: 57 Degrees East. I traced my finger down the line. Through Russia. Just east of the Caspian Sea. Down into the Dasht-e-Kavir emptiness.

I stopped. The line runs almost directly through the desert town of Tabas.

This is where the *bazaari* in Tehran guessed Mohammad Reza was born or was connected by ancestors. It could be where the late evening sky reminded him of the hues on his old silk Heriz: the car-

pet I saw that first day with him in the Tehran bazaar. The one he said he would never sell.

The one that is now somewhere in a dark storage vault under the Tehran bazaar or perhaps in the stacks of carpets in someone's shop. I feel I never lived up to his task of learning the language of carpets. It's a language too rich and intricate for one lifetime.

I still just know a few words.

A LAST STORY

There's one more story to tell.

I've waited until now because I wasn't sure how to do it. I finally have an idea.

It begins with desperation or joy or hunger or whatever was going through the mind of Majit Enderva when he, his best friend, and two other Iranians crossed into northern Greece on a May night in 2001. The four illegal immigrants had floated across the river from Turkey in an inflatable boat and celebrated with a meal of bread and oily fish in tins. Then they set out on their first steps into the European Union. Stretching out before them were hopes of work, money, and opportunities unthinkable back home. First, though, they had to get across this dark no-man's-land of brush and marsh.

They crossed under a wire.

The first explosion in the minefield instantly killed the man who had organized the trip over the well-known smuggling route. The remaining three started to run. The next blast from an old M14 antipersonnel mine sent jagged bits of casing and gravel tearing through twenty-six-year-old Majit Enderva and his companions. The puck-sized mines, with about a one-ounce explosive charge, are designed to maim but not kill. But these men—like others who have made the fatal mistake of wandering into the border mine-fields—had no sturdy boots or equipment to buffer the blast. The shrapnel sliced right through their sneakers and light clothes.

Chunks ripped apart the right calf and knee of Aydin Nefes Semedizade, who was Majit's closest friend from as far back as they could remember. Aydin crawled toward Majit, expecting at any moment to trigger another mine that would shred his face and chest.

"I touched him and knew he was dead," Aydin said weeks later from his hospital bed in Alexandroupolis, the provincial center of Greece's northeastern corner and not far from the minefield. "I was thinking: 'Why? Why did I do this? Why am I here?' "

Aydin was the lone survivor.

284

I went back to the village where he and Majit were born to re-
search a story about what drove them to seek their fortunes in the
West. The place is a cluster of single-story cinder-block huts called
Malek-Ali-Teppeh. It sits on a stunningly flat plain near Iran's bor-
der with Turkmenistan. It took all day to drive from Tehran with an
Iranian colleague who served as an interpreter. We interviewed
Aydin's parents, who served us tea and cucumber slices in their
home. The villagers said Majit's family was too distraught to see
visitors. I didn't press it.

As we were leaving, a woman ran up.

"Wait, wait," she yelled. She carried a rolled-up carpet.

She was out of breath. My colleague had to calm her down to
understand what she was trying to say. It was Majit's mother.

She was weaving this carpet when Majit left by bus for Istanbul
with Aydin. It was now finished. She wanted me to take it.

"My son will return home cold and without life," she told me in
a rapid string of words without pause. "I was thinking of him all
the time I was making this carpet. There's some of him still alive in
it. I can feel it. Please take it with you back to the place he tried to
reach. Maybe something of my son is still alive in his carpet. If it
makes the journey, maybe he will rest peacefully. This is the least I
can do. It's the only thing I can do."

I took it and made an offer to pay. She just turned and walked
back home, leaning into a wind filled with bits of dry sagebrush
that stung any exposed skin.

The carpet is now in our small home on the coast of Arcadia in
southern Greece. It sits on a tile floor near a fireplace. It's a very,
very ordinary little rug: the classic geometric patterns of the Turk-
men in red on a milk chocolate background. The borders are sim-
ple purple and red snippets of the main motif. The wool is coarse
and machine-spun. The colors appear all chemical. The whole ef-
fect is rather muddy and uninspired.

Any serious collector would scoff at it. A sharp-witted *bazaari*
could, with some white lies, get perhaps $100 from a hapless
buyer. All in all, this carpet is entirely meaningless—not even a
blip—to those who rank such works.

But, for me, it's my most prized piece.

It just took me a while to realize its true value.

This mother's carpet is my unbroken link to the idea I've been chasing during these years among weavers, dyers, and merchants. This unassuming little patch of wool and cotton is part of a story as intimate as a mother's tears and as vast and timeless as a young man setting out to find something bigger beyond his stifling village. And I am forever part of it.

Who knows where this carpet may end up many decades from now? Maybe it will find its way to some flea market or estate sale. It will sit ignored and unwanted, I imagine. It would be seen as nothing more than an unexciting sample of Turkmen weaving from the beginning of the millennium.

Majit, his mother, and I will be there, too. But no one will notice. We are tucked away in the carpet's hidden narrative that someone, with time and a bit of luck, could unlock.

All carpets possess these inner histories. I hope with this book to remind people that they are there, waiting.

That's all. That's what I've learned after so many conversations and so many miles.

It may not seem like much. To me, though, it's seductive and remarkable.

I stopped writing a while ago to stand in our stone courtyard and watch a sunrise over the Aegean Sea. It was the color of the pink-red slices from the local oranges in the groves below. Across the Aegean is Turkey. Across that is Iran. Across that is Majit's village.

I wondered if his mother ever thinks of her carpet anymore and whether I did what she asked.

Later, I set off with my daughter to search for some wild madder on the mountains. We didn't find any.

But I know it's there. We just have to keep looking.

EPILOGUE

Some changes have occurred since the trips chronicled in this book.

A paved road now links Herat with the Iranian border. Ikbol can now do the round-trip and be home for lunch.

The Herat region's former overlord, Ismail Khan, was removed as governor in 2004 after factional clashes. He was demoted to the more humble position of water and energy minister in the national government.

Abdul Rashid Dostum, the warlord who ruled areas in and around Mazar-i-Sharif, ran for president in 2004 and finished fourth. But the winner, Hamid Karzai, kept Dostum in the government fold. In January 2005, a suicide bomber tried to kill Dostum after open-air prayers for a Muslim feast that marks the end of the annual hajj period. Dostum was not harmed. Dostum is among several high-profile Afghan figures included in reports by rights groups seeking investigations into possible war crimes during Afghanistan's decades of civil strife.

In Iran, the mayor of Tehran and a former Revolutionary Guards commander, Mahmoud Ahmadinejad, was a surprise winner in the June 2005 presidential elections. He succeeded the moderate Mohammad Khatami, who could not run for the third time because of term limits. Ahmadinejad's victory consolidated conservative control over Iran's political affairs and raised tensions in the international showdown over Iran's nuclear ambitions.

The carpet I viewed in New York is in its new home somewhere on Fifth Avenue.

In early 2005, I visited the Al-Hussein Mosque in Cairo during a Sufi ceremony. Men sat in long rows and joined in flowing chants about God's graces. Skinny alley cats wandered among them and through the legs of worshippers crowded around a golden tomb, which local tradition says contains the head of the early Muslim martyr Hussein. I followed a gray cat out a side door and onto a busy market street. I stepped into a shop stocked to the ceiling with jars and vials of essential oils and henna. I asked if there was also madder. The shopkeeper yanked at a bottom drawer, whose cheap wood was swollen from winter humidity. He rummaged around and found a discolored plastic bag. It held a few spoonfuls of coarsely ground madder.

No one had asked for it in a long time.

SOURCES

Interviews and personal experiences form the core of this book. Many other sources were consulted for specialized information and historical accounts. The experts and others who assisted me are noted in the text or the Acknowledgments. The following is a selection of the books, essays, articles, websites, and other resources used.

GENERAL BIBLIOGRAPHY

Anquetil, Jacques, *Carpets: Techniques, Traditions and History.* London: Hachette Illustrated UK, Octopus Publishing Group Ltd., 2003.

Armstrong, Karen. *Islam: A Short History.* London: Phoenix Press, 2001.

Ascherson, Neal, *Black Sea.* New York: Vintage Books, 1996.

Byron, Robert. *The Road to Oxiana.* London: Macmillan & Co. Ltd., 1936. Reprinted, London: Penguin Books, 1992.

Edwards, A. Cecil. *The Persian Carpet.* London: Duckworth, 1953.

Eiland, Murray L., Jr., and Murray Eiland III. *Oriental Rugs: A Complete Guide.* London: Lawrence King Publishing, 1998.

Ford, P. R. J. *Oriental Carpet Design.* London: Thames & Hudson Ltd., 1989.

Frishman, Martin, and Hassan-Uddin Khan, eds. *The Mosque.* London: Thames & Hudson Ltd., 1994.

Glassie, Henry. *Turkish Traditional Art Today.* Bloomington: Indiana University Press, 1993.

Grimal, Pierre. *Dictionary of Classical Mythology.* London: Penguin Books, 1991.

Hafez. *Divan of Hafiz.* Edited by Allameh Ghazvini and Dr. Gh.

Ghani. Translated by Henry Willberforce Clarke. Tehran: Peik-e-Farhang. 1997.

————.*The Hafez Poems of Gertrude Bell.* Translated by Gertrude Bell. Bethesda, Md.: Ibex Publishers Inc., 1995.

————*In Search of Hafiz.* Translated by A. J. Alston. London: Shanti Sadan, 1996.

Helfgott, Leonard. *Ties That Bind: A Social History of the Iranian Carpet.* Washington, D.C.: Smithsonian Institution, 1994.

Nasr, Seyyed Hossein. *Islam: Religion, History, and Civilization.* San Francisco: HarperSanFrancisco, 2003.

O'Bannon, George. *Oriental Rugs: The Collector's Guide to Selecting, Identifying and Enjoying New and Vintage Oriental Rugs.* London: The Apple Press, 1995.

Pope, Arthur Upham. *Introducing Persian Architecture.* Shiraz, Iran: Asia Institute Books, 1969.

Pourafzal, Haleh, and Roger Montgomery. *The Spiritual Wisdom of Hafez.* Rochester, Vt.: Inner Traditions International, 1998.

Stone, Peter F. *The Oriental Rug Lexicon.* Seattle: University of Washington Press, 1997.

AFGHANISTAN

Dupree, Nancy Hatch. *An Historical Guide to Afghanistan.* Kabul: Afghan Tourist Organization, 1971.

Ewans, Martin. *Afghanistan: A Short History of Its People and Politics.* London: Curzon Press, 2001.

IRAN

Boyle, John A., ed. *Persia: History and Heritage.* London: Henry Melland Ltd., 1978.

Fardust, Hussein. *The Rise and Fall of the Pahlavi Dynasty: Memoirs of Former General Hussein Fardust.* Translated by Ali Akbar Dareini. New Delhi: Motilal Banarsidass Ltd., 1999.

Kemp, Geoffrey. *Forever Enemies? American Policy & The Islamic Republic of Iran.* Washington, D.C.: The Carnegie Endowment for International Peace, 1994.

Mottahedeh, Roy. *The Mantle of the Prophet: Religion and Politics in Iran.* Oxford: Oneworld Publications, 1985.

Sciolino, Elaine. *Persian Mirrors: The Elusive Face of Iran.* New York: The Free Press, 2000.

Wright, Robin. *The Last Great Revolution: Turmoil and Transformation in Iran.* New York: Vintage Books, 2001.

MADDER AND BONE: A PROLOGUE

Bromiley, Geoffrey W. *The International Standard Bible Encyclopedia.* Grand Rapids, Mich.: Wm. B. Eerdmans Publishing Co., 1988.

Chenciner, Robert. *Madder Red: A History of Luxury and Trade.* London: Curzon Press, 2000. Reprinted, London: RoutledgeCurzon, 2003.

Forbes, R. J. "Alchemy and Colour." *CIBA Review* 5 (1961).

Herodotus. *Histories.* New York: Penguin Books, 1954.

The Royal College of Surgeons of England: www.rcseng.ac.uk.

CHAPTER 1: THE TEHRAN BAZAR

Iran Media Guide (2004).

Lagasse, Paul, Lora Goldman, Archie Hobson, and Susan R. Norton, eds. *The Columbia Encyclopedia.* 6th ed. New York: Columbia University Press, 2000.

Miller, Madeleine S., and J. Lane Miller. *Harper's Bible Dictionary.* New York: HarperCollins Publishers, 1973.

Moghaddam,. Abbas. "A Short History of the Tehran Bazaar," Tehran: Chamber of Commerce, Industries & Mines, newsletter, February 1994.

CHAPTER 2: FLORENCE OF THE EAST

Babur. *The Baburnama: Memoirs of Babur, Prince and Emperor.* Translated by Wheeler M. Thackston. New York: Modern Library Classics, 2002.

Gannon, Kathy. "Human Rights Group Wants Probe into Reports of Atrocities in Northern Afghanistan." The Associated Press, November 1, 1998.

SOURCES

Lamb, Christina. *The Sewing Circles of Herat: A Personal Voyage Through Afghanistan.* London: Flamingo, 2003.

United Nations Educational, Scientific and Cultural Organization (UNESCO). *UNESCO's Cultural Sector in Afghanistan.* Paris: UNESCO Publishing, 2002.

The World Factbook. Washington, D.C.: Central Intelligence Agency, 2003.

CHAPTER 3: THE SANDSTORM

Gore, David. "My God—Maiwand!": www.britishempire.co.uk. A detailed account of how the British were defeated in July 1880 while trying to put down an Afghan rebellion.

Shankar, Sidhartha. *A Study in Scarlet.* London: The Sherlock Holmes Society of London. A web review of Sir Arthur Conan Doyle's 1887 story *A Study in Scarlet.* www.sherlock-holmes.org.uk

Nasr, Seyyed Hussein. "In the Beginning of Creation Was Consciousness." *Harvard Divinity Bulletin* (Fall/Winter 2003).

CHAPTER 4: GIRLS AT A LOOM

Blood, Peter R., ed. *Afghanistan.* Washington, D.C.: Federal Research Division, Library of Congress, 1997.

Fox, Ernest. *Travels in Afghanistan: The Adventures of a 1930s Mounted Explorer.* The Long Riders' Guild Press, 2001. www.thelongriders guild.com

O'Bannon, George W. "The Saryq Main Carpet." *Oriental Rug Review* 8, no. 1 (Dec./Jan. 1988).

Sienknecht, Hans. "The Pinner Turkmens." *Hali* 133 (March/April 2004).

Graham, Stephen. "Afghan Women Still Struggling Against Prejudice, Culture of Violence." The Associated Press, March 8, 2004.

Turkmenistan. Library of Congress, 2004. A U.S. government country study.

Wegner, Dietrich H. G. "Pile Rugs of the Baluch and Their Neighbors." *Oriental Rug Review* 5, no. 4 (1985).

Wright, Richard E. "In Search of Turkmen Carpets." *Oriental Rug Review* 9, no. 5 (1989).

Zafiropoulou, Simoni. *In Quest of Alexander the Great.* Athens, Greece: Genous Publications, 2003.

CHAPTER 5: TOMB OF THE SAINT

Khan, Aamir Shafaat. "Carpet Exports Hit by Afghan Repatriation." *Dawn* (newspaper, Karachi, Pakistan), July 14, 2002.

Pourziai, Mehrnoosh. "A Report on the Conditions of Young Children in Rug-Weaving Sweatshops." *Sobhe Emrooz* (newspaper, Tehran), February 23, 1999 (English translation from www.iran children.org, 2001).

Silvers, Jonathan. "Child Labor in Pakistan." *The Atlantic Monthly,* February 1996.

Tucker, Jonathan. "Afghanistan and the Silk Road.: *Hali* 131 (November/December 2003).

CHAPTER 6: ALCHEMY OF HAPPINESS

Aghevli, J. D. *Garden of the Sufi: Insights into the Nature of Man.* Atlanta: Humanics Limited, 1998.

Dalrymple, William. *From the Holy Mountain: A Journey in the Shadow of Byzantium.* London: Flamingo, 1998.

Hourani, Albert. *A History of the Arab Peoples.* Cambridge, Mass.: The Belknap Press of Harvard University Press, 1991.

Islamic Philosophy Online, Inc.: www.muslimphilosophy.com.

Palmer, E. H. *Oriental Mysticism.* London: The Octagon Press Ltd., 1974.

Sharif, M. M. *A History of Muslim Philosophy.* Lahore: Pakistan Philosophical Congress, 1999.

Watt, W. M. *Muslim Intellectual: A Study of al-Ghazali.* Edinburgh: Edinburgh University Press, 1963.

CHAPTER 7: THE ROOT OF WILD MADDER

Boyce, Mary. *Zoroastrians: Their Religious Beliefs and Practices.* London: Routledge, 2001.

Davoud, Ebrahim Pour-e. *Introduction to the Holy Gathas.* Tehran: Faravahar Publications, 2000.

Garfield, Simon. *Mauve: How One Man Invented a Colour That*

Changed the World. London: Faber and Faber, 2000.

Kriwaczek, Paul. *In Search of Zarathustra*. Blaine, Wash.: Phoenix, 2003.

Larsen, Janet. *Iran Population: Birthrate Plummeting at Record Pace*. Earth Policy Institute report, December 28, 2001.

Sandberg, Gösta. *The Red Dyes*. Asheville, N.C.: Lark Books, 1997.

Tanavoli, Parviz. *Kings, Heroes & Lovers: Pictorial Rugs from the Tribes and Villages of Iran*. London: Scorpion Publishing Ltd., 1994.

CHAPTER 8: THE TONGUE OF THE HIDDEN

Duffy, Patricia Lynne. *Blue Cats and Chartreuse Kittens: How Synesthetes Color Their Worlds*. New York: Times Books/Henry Holt & Co., 2001.

Motluk, Alison. "How Many People Hear in Colour?" *New Scientist*, May 1995.

Sami, Ali. *Shiraz*. Shiraz: The Learned Society of Pars, 1958.

CHAPTER 9: NOMAD SONGS

Beck, Lois. *Nomad: A Year in the life of a Qashqa'i Tribesman in Iran*. Berkeley: University of California Press, 1991.

Perlove, Nina. "Inherited Sound Images: Native American Exoticism in Aaron Copland's Duo for Flute and Piano." *American Music*, Spring 2000.

CHAPTER 10: A HINT OF SAFFRON

Dole, Nathan Haskell, and Belle M. Walker, eds. *The Persian Poets*. New York: Thomas Y. Crowell & Co., 1901.

Ittig, Annette. "Ziegler's Carpet Cartoons." *Hali* 80 (April/May 1995).

Morier, James. *The Adventures of Hajji Baba of Ispahan*. San Diego: Simon Publications, 2001.

CHAPTER 11: JESUS PRICE

Norwich, John Julius. *A Short History of Byzantium*. London: Penguin Books, 1998.

Mandeville, John. *The Travels of Sir John Mandeville.* Translated by Dr. Charles W.R.D. Mosley London: Penguin Books, 1983.

United Nations Educational, Scientific and Cultural Organization (UNESCO). *Report of the 27th Session of the UNESCO World Heritage Committee,* 2003.

CHAPTER 12: PICASSO'S BIRDS

Clark, Emma. "Underneath Which Rivers Flow: The Symbolism of the Islamic Garden." *Hali* 128 (May/June 2003).

Halliday, Fred. *Dictatorship and Development.* London: Penguin Books, 1979.

Hassouri, Ali et al. "A Viewpoint: Articles About a Carpet Woven in Heriz." *Farsh: Iranian Hand-Woven Rug Quarterly,* nos. 21 and 22 (2002).

Jevremovic, George. "Rug Farming in Anatolia." *Oriental Rug Review* 8, no. 4 (1988).

CHAPTER 13: EAST FIFTY-SEVENTH

Parvin, Manoucher. *Dardedel: Rumi, Hafez & Love in New York.* Sag Harbor, N.Y.: The Permanent Press, 2003.

Strock, Carl. "In Praise of Heriz Carpets." *Oriental Rug Review* 15, no. 5 (1995).

A LAST STORY

Landmine Monitor, International Campaign to Ban Landmines: www.icbl.org.

SHORT SECTIONS

KNOTS

Bier, Carol. *Symmetry and Pattern: The Art of Oriental Carpets.* The Textile Museum and The Math Forum @ Drexel, http://math forum.org/geometry/rugs/.

CARPET HISTORY

Edwards, Mike. "Searching for the Scythians." *National Geographic,* September 1996.

SOURCES

Walter, Chris. "An Ancient Carpet in Urumchi." *Oriental Rug Review* 8, no. 2 (1988).

Longstreth, Bevis. "The Riddle of the Pazyryk." *Hali* 137 (November/December 2004).

NATURAL COLOR SOURCES

Anderson, June. *Return to Tradition.* San Francisco: The California Academy of Sciences, 1998.

CHEMICAL VERSUS NATURAL DYES

Gibson, Clare, ed. *The Earthly Paradise of William Morris.* Kalamazoo, Mich.: Dovetail Books, 1996.

FLYING CARPETS

The Arabian Nights Entertainments. Translated by Sir Richard Burton. Norwalk, Conn.: The Eastern Press, 1981.

Tales from the Thousand and One Nights. Translated by N. J. Dawood. London: Penguin Books, 1954.

ACKNOWLEDGMENTS

This space is too short to properly thank all those who helped with this project by offering their encouragement and expertise. Many of the scholars, carpet experts, and others are cited in the pages. I want to mention some who are not.

They deserve much more praise than these few words.

My agent, Robert Shepard, took a vague idea and—with patience and wisdom—helped mold it into something richer and more elegant. He's a friend, a visionary, and, above all, an optimist. There's no better combination.

Then my brilliant editor, Denise Roy, took over. The book is much better because of her inspired touch and guidance. I'm proud to take a place on her bookshelf.

Danny Shaffer at *Hali* magazine and Mark Hopkins at the New England Rug Society took the time to read parts of the manuscript and helped fill the many gaps in my carpet knowledge.

Others who deserve my profound thanks include Afshin Valinejad, Lily Sadeghi, Daryoush Sadeghi, Ali Akbar Dareini, Mohammad Reza Damirchi, Hasan Sarbakhshian, and The Associated Press for giving me some of the best jobs in journalism.

I could go on forever about what my wife, Toula, brings to my life. Every page of this book bears her imprint, whether correcting a mistake, smoothing out a rough patch, or adding her sharp insights. Her native language sums up nicely what she means to me. She is my alpha and omega.

Finally, I must thank my daughter, Zoe. She tells me she's tired of hearing about carpets all the time. We're done.